Creative Photoshop

For my father, Gary Lea.
If he were here to see this, I'm certain he'd be proud.

Creative Photoshop

Digital Illustration and Art Techniques Covering Photoshop CS3

Derek Lea

ELSEVIER

AMSTERDAM • BOSTON • HEIDELBERG • LONDON • NEW YORK • OXFORD
PARIS • SAN DIEGO • SAN FRANCISCO • SINGAPORE • SYDNEY • TOKYO
Focal Press is an imprint of Elsevier

Focal Press is an imprint of Elsevier
Linacre House, Jordan Hill, Oxford OX2 8DP, UK
30 Corporate Drive, Suite 400, Burlington, MA 01803, USA

First published 2007

Notice
No responsibility is assumed by the publisher for any injury and/or damage to persons
or property as a matter of products liability, negligence or otherwise, or from any use
or operation of any methods, products, instructions or ideas contained in the material
herein. Because of rapid advances in the medical sciences, in particular, independent
verification of diagnoses and drug dosages should be made

British Library Cataloguing in Publication Data
Lea, Derek
 Creative Photoshop : digital illustration and art
 techniques covering Photoshop CS3
 1. Adobe Photoshop 2. Digital art – Technique 3. Image processing – Digital techniques
 4. Computer graphics
 I. Title
 006.6'86

Library of Congress Control Number: 2007929969

ISBN 978-0-240-52046-9

For information on all Focal Press publications visit our
website at www.focalpress.com

Typeset by Charon Tec Ltd (A Macmilan Company), Chennai, India

Printed and bound in China

07 08 09 10 11 11 10 9 8 7 6 5 4 3 2 1

Working together to grow
libraries in developing countries

www.elsevier.com | www.bookaid.org | www.sabre.org

ELSEVIER BOOK AID International Sabre Foundation

Contents

Foreword

Back in the early 1990s, people in the former Eastern Bloc countries were just getting used to their new freedoms. I was at university, and one of my lecturers commented that after so many years of state-controlled media, television was their window on the world. It's something that's stuck with me, and I think that if television can be a window on the world, then perhaps Photoshop is a window on the imagination.

Round about the same time, in the early 1990s, the first versions of the program were being developed very much with photo editing in mind. I remember getting my first Macintosh and installing an old version of doubtful legality. (Hey, I was just a student!) Having scanned in some photos of a fellow journalism student, and cropping his head into a triangle shape, I began duplicating it across the document and applying different combinations of sharpen, blur, and posterize filters to each version of his now sorry-looking face.

I knew what I was created wasn't at all good, but others were impressed for roughly 15 minutes which made me feel like I'd been a bit of an Andy Warhol – for just about that long.

Fast forward 5 or 6 years and while I still couldn't create anything from my own imagination using Photoshop, or even crayon for that matter, I had discovered a man who could. Derek Lea was producing illustrations for us on Computer Arts magazine, the likes of which we'd never seen. A colleague of mine at the time suggested that not only should we ask Derek to create an image for us, but what if we asked him to produce a step-by-step article, complete with screenshots, showing how his piece was developed. I called Derek up, he accepted and I promised him a beer the next time I was in Toronto.

We didn't realize it at the time, but we had unleashed a new force in the world of art and illustration. Derek was showing our readers how they could use Photoshop creatively and artistically. Pretty soon other magazines both within our own group, and rivals, picked up on Derek's talent. He's gained illustration clients around the world, written books and won awards.

His edge is that he won't stand still. He has a knack for finding new corners of the program to exploit and innovative ways of doing so. He's pushed the boundaries not only for his own art, but also for thousands of up and coming artists who also want to create onscreen the visions they have in their minds. If you've bought this book, you're about to discover what I mean.

Some of the commissions I've sent to Derek over the years appear in these pages, where you can follow how they were made and aside from feeling honoured to have been asked by the author to write this foreword, I'm kinda proud these images have made it in. That's because my own Photoshop creativity languishes back where it was in the early 1990s. I figured I'd quit while I was ahead after my Warhol-esque effort. I stick to the words, but Derek Lea is certainly your man for the pictures.

Garrick Webster
Editor, Computer Arts

Introduction

Photoshop and me

When I first discovered Photoshop, it was 1993. I started a new job as a designer at a clothing company. It was a really horrible job, but at least they bought me a new scanner. In those days a lot of scanners came bundled with Photoshop. The first thing I did when I opened the scanner box was to take the Photoshop 2.5 discs and put them in my jacket pocket. When I got home that night, I installed Photoshop on my Mac IIci at home, and my life began to change. I know it sounds ridiculous, but in hindsight, that was a pivotal moment for me.

I had been working in Adobe Illustrator for a few years by then, but Photoshop seemed like a bottomless pit of creative possibilities. There was so much I could do that at times I didn't even know where to start. I began spending hours and hours every night just experimenting. As a result of this endless experimentation, I gained enough knowledge and experience to successfully land myself a position as a professional retoucher at a photography studio. This meant that I could spend all day, every day, working in Photoshop.

The problem with hiring artists to do retouching work is that although they may be good at it, they get bored. I was no exception. Yes, I was getting good at making cheap jewelry look expensive, and making static cars look like they were in motion, but the novelty of those achievements wore off quickly. Frustrated and bored with my work, yet still in love with Photoshop, I began to deviate from working with photography in the classic sense. On my own time, I started to experiment with different methods to create artwork within Photoshop. I began entering contests and then winning awards. The next thing I knew, I had art directors calling with commissions and just like that I became a digital illustrator.

Illustrating digitally allowed me to work all day, every day within Photoshop. But this time, I wasn't limited to retouching photographs anymore.

Another pivotal point came when my work was noticed by the world's best-selling creative magazine: Computer Arts. I was featured in Computer Arts and developed a working relationship with them that continues to this day: They started asking me to not only illustrate, but to write for them as well. Working with Computer Arts really lit a fire under me creatively. The commissions from them constantly demanded new things and challenged me both creatively and technically. I cannot

stress the importance of my work with them enough, as my contributions to Computer Arts eventually provided the starting point for much of the content you'll find within this book.

Why does the world need another Photoshop book?

As a Photoshop neophyte in the early 1990s, I was always hungry for resource materials. I would scour the local bookstores looking to be informed and inspired. What I noticed then was that Photoshop books, more or less, fell into one of two categories.

There were books that contained beautiful collections of digital art. These books would inspire me with their rich and thought-provoking images, but they lacked detailed instruction on how to achieve those results. Apart from artistic inspiration, these books really didn't offer much to a guy who wanted to learn how.

The other option was books of a more instructional nature. Generally offering lots of information, instruction, helpful hints, and tips, I found these books always lacking in the inspiration department. Granted, I found some useful information in these books, but more often than not, I had to read the chapters on faith alone. Basically, I would hope that afterward, I could do something remarkable on my own with the knowledge they contained, because the imagery within those books never really impressed me.

What you hold in your hands is the book I always wanted. My aim is to inspire you as well as inform you. I have spent a great deal of time perfecting a variety of artistic styles and working practices in Photoshop. And I have also spent a great deal of time producing images that I hope will inspire you to learn. This book is for those of you who not only appreciate art, but also want to know in explicit detail, how to create it on your own. There seems to be an infinite amount of Photoshop books out there, and many of them are excellent. However, I still haven't found that perfect book that inspires as much as it instructs. After all these years I came to the conclusion that the book I was after didn't exist, so I decided to write it myself. If you are reading this right now, chances are you've been looking for the same thing too.

How to use this book

This book is a series of projects. Each chapter opens with an inspirational image, and the step-by-step instructions required to recreate that image immediately follow. You'll find all of the resource files needed

to create each image on the accompanying CD. This book is written in a non-linear manner, meaning that you do not have to start at the beginning and progressively work your way toward the end. Each chapter is independent of the others, so you can start wherever you like and move around randomly from one chapter to the next. Pick a chapter with an image that inspires you and follow it through to fruition, it's as simple as that.

This book includes variety in not only style and subject matter, but also in technique and working methods. You'll find a vast array of tools, features, and options as you work your way through. Fundamental and essential working methods will appear repeatedly, but each chapter definitely has something unique to offer in terms of both technique and artistic style.

A guitar teacher once told me that the best way to teach someone to play is to get him or her working on something they like straight away. Forget showing them all of the chords or notes when it makes no sense to them yet, just get them to do something they're interested in. That is the approach I have taken here. You'll get your feet wet while producing something worthwhile, and at varying stages in the process you'll begin to understand the value of what you've done. When knowledge begins to fall into place as you work, and it most certainly will, the proverbial light comes on. At that point, you'll really begin to see the potential of what you've learned. So don't limit yourself to simply finishing the chapters in this book. Try to think of ways that you can take what you've learned from each chapter and use it to create original artwork of your own.

Basic Photoshop knowledge

Creative Photoshop is not a beginner's guide, nor is it exclusively for experts. It falls into that mysterious category in-between often referred to as intermediate. The idea of what an intermediate user does or does not know will often vary depending upon whom you're talking to. I have written this book assuming that you, as the reader, know your way around Photoshop and understand the basics. I am assuming that you have an idea of what the tools do, what layers are, the difference between vectors and pixels, etc.

Numerous functions and tools within Photoshop will be explored in depth, via the step-by-step instructions in the following chapters, however you'll need to know the basics to follow along with ease. For those of you who possess more ambition than Photoshop know-how, I can certainly relate. As a beginner, I would've picked up this book

too. My advice to those who are just starting out, is to get familiar with the Photoshop Help menu. Any time you get stuck, you can do a specific search. The results will explain anything you need to know about using a tool or function in Photoshop. Once you find what you're after, you can continue following along where you left off.

Expert tips

In addition to step-by-step instruction and inspirational imagery, you'll find hundreds of expert tips scattered throughout this book. Some of the tips pertain to the instructions on a particular page, but many are additional hints and pieces of advice which will prove useful for almost anything you set out to do within Photoshop. Feel free to flip around the book and examine different tips, just as you would randomly flip from chapter to chapter. Tips are divided into six categories, represented by different icons below:

Shortcuts

These time-saving tips will shave hours off of your time-spent working. Whether it is a keyboard command or a quicker way of doing something, these tips will allow you to spend more time creating, rather than spending all of your time executing certain tasks the long way.

Info

These tips contain useful tidbits and extra information that may not be addressed in the step-by-step instructions within each chapter. Or additional, more detailed information is provided to accompany a specific stage in the process.

On the CD

These tips will point you toward the specific files required to follow along, wherever necessary.

Caution

Be extremely careful when you see this tip. You are being warmed of potential pitfalls and must carefully pay attention to prevent things from going horribly wrong.

CS3

This tip draws your attention to functions, features, and/ or tools that are available only within Photoshop CS3.

Creative tips

Creative tips provide valuable hints and advice regarding the artistic process of creating within Photoshop. Everything from unconventional tool usage within Photoshop itself, to hints on how to extract resource materials from the physical world surrounding you, is included here.

Become part of the Creative Photoshop community

Your exploration into the artistic side of working with Photoshop does not end with this book. Visit the Creative Photoshop website and explore the user forum. Share knowledge with, and ask questions of other readers. Be sure to post your finished images within the user forum for everyone else to see. Submit the works you've created by following the chapters here, or post your own work, showcasing your new creative Photoshop skills.

Join the Creative Photoshop community at: www.creativephotoshopthebook.com

Be sure to visit the site periodically to get news regarding appearances, as well as purchase exclusive merchandise and limited edition prints as they become available.

Acknowledgements

First and foremost, a massive thank you goes out to my wife Janet. She has always encouraged and supported me. Even when I decided that writing a book would be no problem with a brand new baby in the house. And speaking of babies, a big hug and thank you goes out to our wonderful daughter Charlotte. Her mission thus far seems to be teaching the old man that there is much more to life than work. She is succeeding.

Thanks to my mother for always being supportive in my pursuit of art. She always made sure that I received art supplies every year at Christmas. I imagine she plans to continue the tradition with her new granddaughter, hint hint.

Thanks to Garrick Webster for writing the foreword to this book, and also for being the person responsible for turning me into a writer all those years ago. I'm glad that I know exactly who to blame for all of this. Thanks to Philip Cheesbrough for changing my life by introducing my art to the entire world, seriously Phil, it may seem insignificant to you but this was a life changer.

A very special thanks to all of the editors I've worked with over the years: Dan Oliver, Andrea Thompson, Paul Newman, Gillian Carson, Vicki Atkinson, Dom Hall, Joseph Russ, Alex Summersby, Shaun Weston, Tom Mugridge, and anyone else that I may have forgotten to name here. Also, a huge thanks goes out to all of the art directors who have been, and in many cases, continue to be a pleasure to work with: Roddy Llewellyn, Esther Lamb, Johann Chan, Matt Harvey, Martha Weaver, Dyan Parro, Domenic Macri, Jeff Kibler, Mike Mansfield, and the dozens of others that I am surely forgetting to mention here.

Special thanks goes out to Rob Wright at the Toronto Star newspaper. He was the first person to ever commission my work regularly, and although he claims that he was only exploiting me at the time, this was integral to me becoming a successful illustrator. He just won't admit that he had anything to do with it.

Thanks to all of my friends and family who have donated their modeling services over the years.

Thank you to Orlando Marques for agreeing to photograph the model that you see on the cover. Thanks to Josie Lyn for agreeing to be that model. And thanks to Carla Marques for her excellent work on Josie's hair and makeup. You were all a pleasure to work with and thank you for donating your services to such a worthy cause.

A very special thanks goes out to Steve Caplin. Every once in a while you come across a truly selfless person, and that is Steve. His enthusiasm for this project and willingness to offer advice were invaluable. Everyone should check out his book *How to cheat in Photoshop*; it is the perfect companion to this one.

A massive thanks goes out to Mike Shaw, senior quality engineer at Adobe. He agreed to go through this manuscript in microscopic detail, which was a daunting task to say the least. His meticulous work was helpful in so many ways that there literally isn't enough room to go into it here. Thanks again Mike.

Also, I'd like to thank Valerie Geary, Emma Baxter, Marie Hooper, and everyone else at Elsevier/Focal Press. You are an exceptional group of people and every step of this process has been a pleasure because of you. I am looking forward to the next edition.

Thanks to Sean Palmerston at Sonic Unyon Records for arranging permission to use the Nein's press photo. And thanks to Mark DiPietro of Teenage USA Recordings for allowing me to reproduce the Weekend's press photo.

And finally, a huge thank you goes out to all of you who read my books, tutorials, articles, and like my artwork. Thanks for all of your e-mail messages; I get so many from all of you that I cannot possibly reply to all of them. Please don't think that your feedback is unappreciated if I do not reply to you, that is not the case. There just aren't enough hours in each day for me to reply to everyone.

PART 1
Drawing and Painting

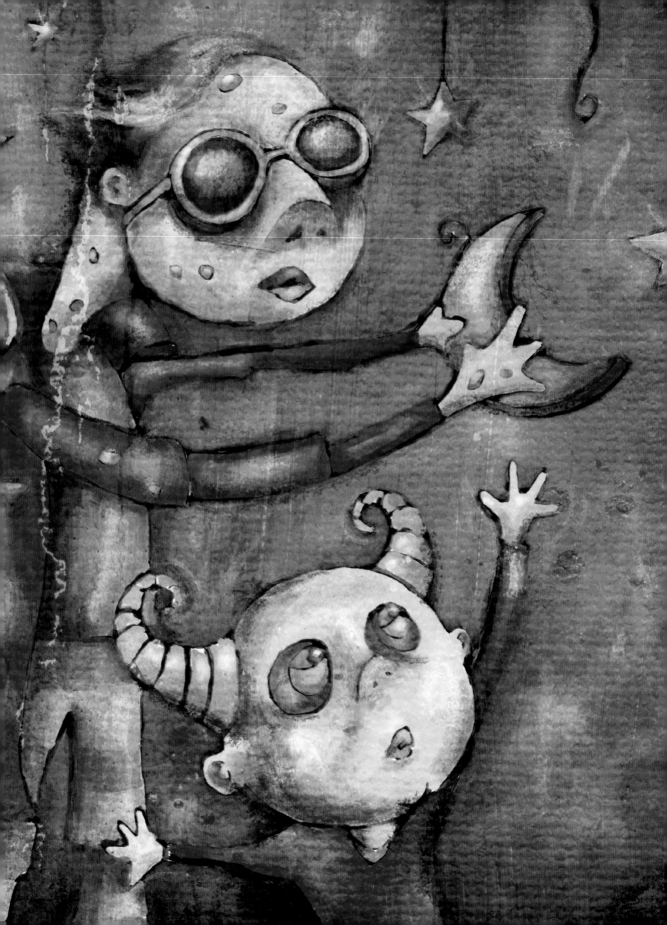

Chapter 1

Painting in Photoshop

The simulation of natural media is always a tricky prospect when working digitally. There are endless filters and niche applications out there that promise convincing results. However, quick fixes and prefab effects often result in disappointment. When painting digitally, the old saying, 'if you want something done right, do it yourself' comes to mind, and this is exactly what you'll learn to do in this chapter. Photoshop may not be the first application that you think of when you're setting out to paint. However, taking a closer look at what Photoshop has to offer in terms of paint tools will reveal that everything you need is there. Equally as valuable when it comes to painting, are all of the image compositing tools at your disposal. A successful painted result relies not only on actual brush strokes, but also on the way that the image is carefully constructed within Photoshop.

The Brushes palette is an excellent resource for crafting convincing and customized brush looks. Whether you want to simply tweak a preset brush tip, or create something entirely new to paint with, everything you need is there. Layers are invaluable tools when painting too, as they allow you to separate the applications of paint, giving you the flexibility to edit specific painted regions and colors without affecting the rest of your image. In addition to editing advantages, layers also allow you to easily and gently build up brush strokes within your file, resulting in a beautiful and authentic appearance.

The Brushes palette is a bottomless pit of options and flexibility when it comes to painting in Photoshop. There is a little something in there to suit any user or simulate almost any artistic style. In this chapter, rather than predictably going through every single feature within the brushes palette like a list, you will focus more on establishing a logical method of working, as well as explore the techniques involved in building up a realistic looking painted file.

When it comes to working, Photoshop nicely addresses the issue of translating your traditional tools from within the tactile realm into their digital counterparts. The swatches palette can be thought of as your artist's palette, allowing you to store all of the colors you're going to use. The tool preset picker is a fantastic place to store your brushes as you create them, allowing you to switch back and forth between your own custom tools instantly. When you decide to use Photoshop as your digital paint tool, you'll never run out of paint or canvas, you'll never misplace your favorite tool, and you'll never have to worry about cleaning your brushes at the end of the day.

1 | Open up the sketch.jpg file. Starting with a sketch is an essential part of the process when painting in the tactile realm, and working in Photoshop is no exception. The main difference here is that in this case the sketch is scanned rather than being drawn directly onto the canvas. Once you've opened up the sketch, select the brush tool. In the brushes palette, enable the smoothing option at the left. We're going to work with this option enabled for the entire chapter, because smoothing guarantees that your brush strokes contain nice, smooth curves. And that is an essential quality when you want your painting to look convincing.

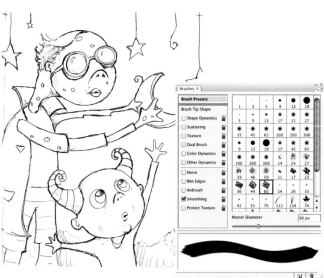

Default brushes

Although Photoshop is equipped with a plethora of excellent brush libraries, we're going to focus on some simple default brushes capable of producing exceptional results.

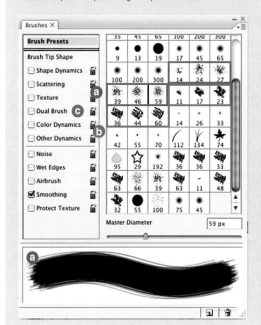

a | The Spatter brushes may not look like much within a vast list of presets, but these simple clusters of spots are very useful. There are a number of different tips and sizes to choose from. Regardless of which option you go with, any spatter brush gives the effect of using a brush with some stray dry bristles sticking out around the edges. Painting over top of colored regions of the canvas with a spatter brush allows you to create a bristled, tactile effect.

b | The chalk brushes are denser than the spatter brushes but equally as useful. Strokes created with chalk brushes do not have any stray bristles sticking out the sides, but they do provide a nice rough effect at the beginning and ending of each stroke. They are ideal for establishing basic, yet convincing, colored regions within your painting.

c | The Dual Brush option is an excellent tool that allows you to combine two different brushes within a single tip. Why do we point out this single feature amid a sea of others? Well, using the dual brush option allows you to quickly and easily combine two brush tips to create a new one. We'll explore this feature in detail using custom brush tips later in this chapter.

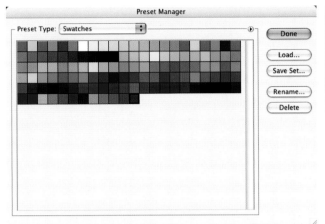

The sketch file needed to follow along with this chapter and create the featured painting is available on the accompanying CD. This file can be found in the folder entitled chapter_01.

2 | Now, the next thing we're going to do is establish the swatches palette as our paint palette and fill it with our own set of colors unique to this painting. By doing this, we can return to the swatches palette and select one of our custom colors at any point later on. Choose Edit>Preset Manager from the menu. Choose swatches from the Preset Type menu. When the swatches appear, click on the first swatch and then shift-click on the last swatch. This will target all of the swatches. When all of the swatches are targeted, click on the delete button. After they're all deleted, click on the Done button to exit the Preset Manager and you'll notice that Swatches palette has been emptied.

Saving swatches

When you hit upon a combination of swatches you like, it is possible to save them for use at a later date. Simply choose the save swatches option from the swatches palette menu. This allows you to name, and then save your swatches as a library file. Save this file anywhere you like. You can always reload your saved swatches by choosing the load swatches option from the swatches palette menu and navigating to your saved preset file. If you place your library file in the presets/swatches folder within the Photoshop program folder, the library will appear within the list at the bottom of the swatches palette menu, next time you launch Photoshop.

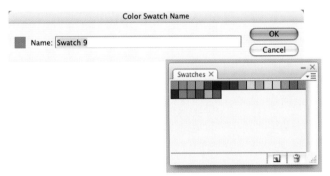

3 | When the swatches palette is empty, click on the foreground color swatch in the toolbox to access the picker. Select a new foreground color from the picker and click OK. Move the mouse over the empty area of the swatches palette. You'll see it temporarily switch to a paint bucket. When you see the paint bucket, click to add the new color to the swatches palette. Name your new swatch when prompted and then click OK. After naming, the new color is added to the swatches palette. Use this method to add a variety of colors to the swatches palette. This is an excellent way to exercise a little forethought, establishing a pre-defined color scheme to work within before you begin painting.

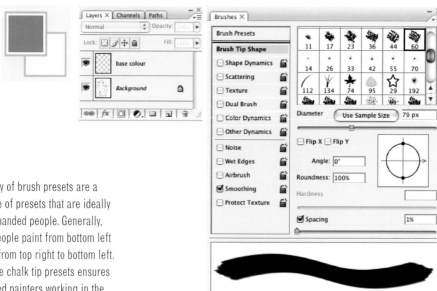

Brush angles

The chalk family of brush presets are a
perfect example of presets that are ideally
suited to right-handed people. Generally,
right-handed people paint from bottom left
to top right, or from top right to bottom left.
The angle of the chalk tip presets ensures
that right-handed painters working in the
typical manner get the majority of available
brush width from each stroke. If you're
left handed, try rotating the angle in the
brushes palette. You can specify any angle
you like and this will likely vary from preset
to preset. Try starting somewhere between
37° and 45°, and experiment from there.
Besides rotating the angle, you can enable
the Flip X option instead. This flips the
brush tip horizontally, creating a mirror
image of the brush tip.

4 | After selecting the brush tool, choose the largest chalk brush preset from the
brushes palette. In the brush tip shape section of the brushes palette, increase the
diameter of the brush. You want a large brush here because first, we want to cover
most of the background with color, giving us a new base color other than white. Leave
the spacing option enabled but reduce the amount to 1, so that there is no stepping or
spaced brush marks present within your strokes. Choose a foreground color from the
swatches palette and click the create a new layer button in the layers palette.

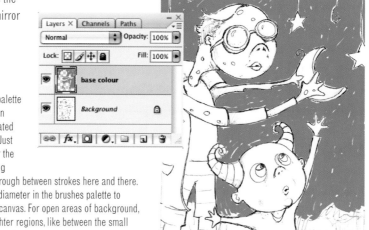

5 | Target your new layer in the layers palette
and begin to paint a series of strokes on
the new layer. Focus on the areas indicated
by the sketch that are the background. Just
start painting some strokes, don't cover the
line work of the sketch on the underlying
layer, and allow a little white to show through between strokes here and there.
Also, increase and decrease the brush diameter in the brushes palette to
accommodate different regions on the canvas. For open areas of background,
use a very large brush diameter, for tighter regions, like between the small
figure's fingers, use a much smaller diameter.

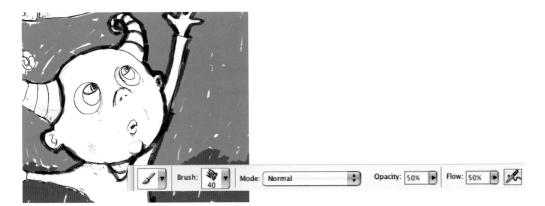

6 | Choose a different color from either the picker or one of your own custom swatches and paint the background area at the bottom of the canvas. When you're finished, choose a black foreground color and create a new layer in the layers palette. Target the new layer and use the brush to begin tracing the black outlines of the underlying sketch on this new layer. Reduce the opacity of your brush in the tool options bar to 50%, so that there is a translucent effect as you paint small strokes over top of each other.

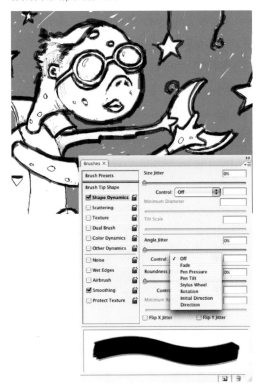

Locking layers

Working on a series of layers allows us to nicely build up a flexible painting. However, it is important that you pay attention to which layer you have targeted as you paint. As your file gets bigger, it will become easier and easier to accidentally paint on the wrong layer. To prevent accidentally painting over the wrong layers, simply lock the layers that aren't in use in the layers palette. Choose the lock all option just to be safe and remember, you can always go back to an old layer and edit it, you just need to unlock it first.

7 | Return to the brush tip shape section of the brushes palette often use this area to vary the angle of the brush as you paint. You'll need to tweak the angle often when painting around areas like the heads of these creatures. If you don't adjust the angle at times, there will be areas where the brush strokes appear too thin compared to others. Click on shape dynamics in the brushes palette to enable shape dynamics and then click on the angle jitter control menu to view the options.

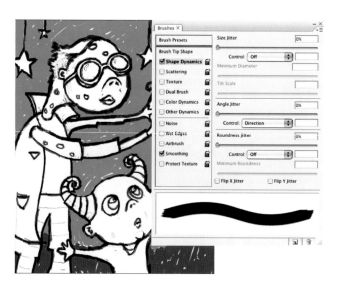

Current tool only

In the tool preset picker you will see an option for the current tool only. Enable this option for the duration of this chapter. Enabling this option will only show presets for the brush tool, rather that the saved presets for all of Photoshop's tools. Because we're only using the brush tool from here on it, there is no need to view other tool presets.

8 I Choose the direction option from the control menu, but leave the angle jitter amount set to 0. This causes your brush to base the angle of the brush tip on the directions of your stroke as you paint them. Because we still want a somewhat smooth edge to the strokes, the amount is set to 0. The more you increase the amount, the rougher the edges of the strokes will appear. By simply enabling the shape dynamic function, we can save ourselves the trouble of having to constantly adjust the angle as we paint. Finish painting the black outline

Brush Presets versus Tool Presets

When you save one of your current brushes as a tool preset, not only are all of your Brushes palette options saved within the preset, but also all of your tool options bar items are included as well. If you wish to save a brush preset without the tool options bar items being included, do so via the Brushes palette menu. Choose New Brush Preset from the Brushes palette menu to save your current brush, adding it to the list of presets in the brushes palette, independent of the tool options bar items.

9 I Reduce the opacity of your brush to 25% and then open the tool preset picker at the far left of the tool options bar. Click on the create new tool preset button. When you are prompted, name the tool 'Chalk Blender'. Disable the include color option and click OK. This brush is now added to the preset picker with all of the brush palette options and dynamic functions intact. You can access it directly from the preset picker from now on. Create a new layer in the layers palette and ensure that it is targeted.

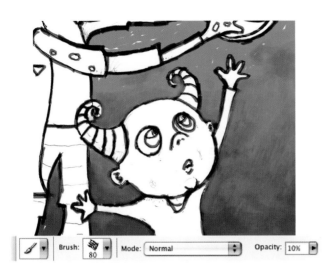

Using a stylus

You can indeed paint with a mouse, but it can be a laborious task at times. It is certainly not the most intuitive way to paint. If you plan on doing much painting in Photoshop, it is definitely worth investing in a pressure-sensitive tablet and a stylus. Drawing with a pen is much more intuitive and easier than drawing with a mouse. Also, there are a number of dynamic brush functions that work with pressure sensitivity, tip angle, and stylus rotation. So yes, you can complete this chapter and learn about painting while using a mouse. But if you really want control when you paint, a stylus is a worthwhile investment.

10 | Use your current brush, set to 25% opacity, to blend the background fill colors together on the new layer, this is precisely why we named the preset 'chalk blender'. Start by painting strokes over the areas where light and dark colors meet. Paint dark strokes over light areas and vice versa. Go back and forth painting like this until colors begin to blend together. Change the direction of your brush strokes as well as the size of your brush tip often. Also, if using an opacity of 25% is not allowing you to get a blend effect that is as smooth as you'd like, try reducing it when necessary.

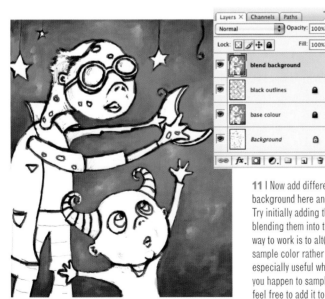

11 | Now add different colors from the swatches palette into the background here and there using the same brush on the current layer. Try initially adding them using a higher brush opacity setting, then blending them into the background using lower opacity settings. A quick way to work is to alt(PC)/option(Mac)-click on areas of the canvas to sample color rather than always returning to the swatches palette. This is especially useful when blending as you can sample 'in-between' colors. If you happen to sample a foreground color using this method that you like, feel free to add it to the swatches palette so that you can access it later.

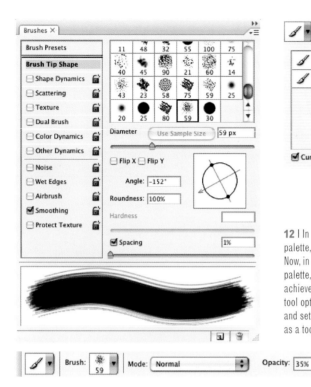

12 | In the brush presets section of the brushes palette, select the spatter 59 pixels brush tip preset. Now, in the Brush Tip Shape section of the brushes palette, adjust the angle of the brush tip until you've achieved the roughest looking stroke possible. In the tool options bar, set the opacity of the brush to 35% and set the flow value to 15%. Save this new brush as a tool preset and name it Spatter rough.

Flow

While opacity controls how transparent or solid your strokes will appear on your layer, it is the flow setting that controls how much paint is deposited within a brush stroke as you paint. By reducing the flow drastically, like we've done here, the brush stroke will look dryer, because less paint is deposited. Increasing the flow will cause the bristles that make up the brush stroke to be less pronounced, like the stroke is heavier with paint and the space between the bristles is filling in.

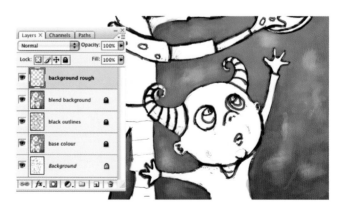

13 | Create a new layer and use your newly created tool preset to paint over areas of the canvas on this layer. Increase or decrease the opacity as required and use colors from the canvas or the swatches palette. The goal here is to paint with the new brush over areas that look very smooth. Because of the brush tip and very low flow setting, the resulting strokes will add a rougher, more textured feeling to the areas you paint. Using large brush strokes and bold colors will pronounce the rough effect. Use this effect sparingly as it can tend to overpower an illustration.

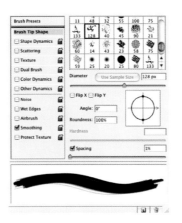

14 | Open up the brush1.jpg file. Choose Edit>Define Brush Preset from the menu. Name your brush and return to the working file. Choose your new custom brush tip from the end of the list in the Brush Presets section of the Brushes palette. In the Brush Tip Shape section of the brushes palette, set the spacing to 1. In the tool options bar, set the opacity to 50% and the flow to 15%. Save this brush as a new tool preset. Use this same method to open up brush2.jpg and brush3.jpg and save them as new tool presets, using the same spacing, opacity, and flow settings.

Dual brushes

Now we'll explore the dual brush function in the brushes palette, creating entirely new brushes from combinations of custom brush tips.

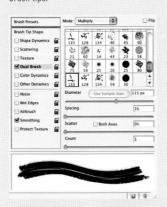

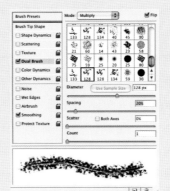

1 | Choose your first custom brush tip from the tool preset picker. Then, in the brushes palette, click on the Dual brush label at the left side of the palette to enable the dual brush function and access the settings.

2 | Choose your second custom brush tip from the tool preset picker. Enable the random brush flip option at the upper right and set the mode to multiply. Increase the spacing to about 20%, you'll notice that it looks like a chalk pastel stroke in the preview.

3 | Leave the opacity and flow at their current settings in the tool options bar and then add this new dual brush to the tool preset picker. Because it looks like a chalk pastel, go ahead and name it something appropriate.

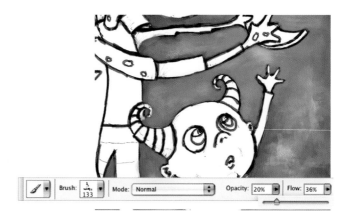

Defining Brushes

When we created custom brushes from images previously, the images were black and white only. However, you can use a color or grayscale image as well. The advantage to using black and white is that you can get a good idea of how your resulting stroke will look from the image used to define the brush, Black areas will deposit paint and white areas will not. A grayscale brush tip will deposit paint according to the density of black it contains. Color images are converted to grayscale when you define brush tips from them.

15 | Now that you have added three new custom brushes and a new dual brush to the tool preset picker, use them to paint some rough strokes on this layer. Just because the presets contain embedded settings for opacity and flow, that doesn't mean that you can't change them each time you use them. Use a variety of colors, brush sizes, opacity and flow settings, to introduce some very real and tactile feeling brush strokes on the current layer. Again, ensure that you do not overdo it as these new brushes, which produce such distinct strokes, can visually overpower the softly blended background quite easily.

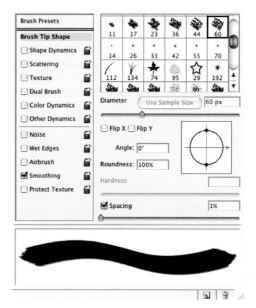

16 | When you're finished, target the top layer and then shift-click on the layer directly above the background layer in the layers palette. This will target all of your paint layers. Choose Layer>New>Group From Layers from the menu to add them to a group. Because we're going to start painting the other image components, this grouping of layers will help us keep things separate and organized. Create a new layer for the base color of the figures. In the brushes palette, choose one of the default chalk brush tip presets. Ensure that smoothing is enabled and in the brush tip shape section of the palette, reduce the spacing amount to 1.

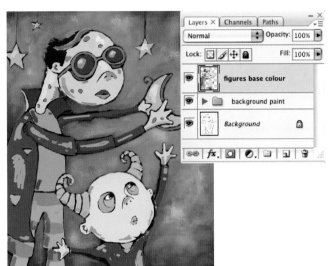

17 | In the tool options bar, set the opacity of the brush to 100 and set the flow to 50. Add this brush to the tool preset picker and name it 'base color' as we'll be using it to create a flat, colored base, for the figures and stars. Use this brush to add flat color on the new layer in all empty regions of the figures and the stars. Choose colors from the background via the eyedropper or select them from the swatches palette. Increase or decrease the size of the brush tip as necessary.

Brush size

When you have a brush selected, a quick way to increase or decrease the brush size incrementally is to use the square bracket keys on the keyboard. Press the ']' key to increase the diameter, or press the '[' key to decrease the diameter. This is a great method for adjusting size on the fly.

Importing brushes

The brushes used to create this chapter's painting are on the CD in the folder entitled chapter_01. You can load the brushes by choosing the load tool presets option from the tool preset picker's palette menu. Navigate to the aforementioned file and these brushes will become available in the tool preset.

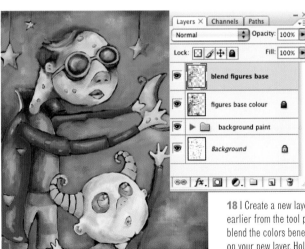

18 | Create a new layer and select the chalk blender preset that you created earlier from the tool preset picker. As you did earlier with the background, blend the colors beneath this layer, together with the chalk blender preset on your new layer. Hold down alt(PC)/option(Mac) to quickly sample colors from the canvas and then paint with your newly sampled colors in the appropriate areas until sharp areas of color begin to blend together on this layer. Feel free to alter brush size and opacity as required. Also, feel free to add new areas of color on this layer to indicate the highlights and shadows.

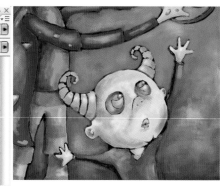

19 | When you are finished adding colors and creating a blending effect on this layer, create a new layer and target it in the layers palette. Select your spatter brush preset from the tool preset picker. Now use the spatter brush to paint some light, yet rougher brush strokes over your recently blended areas on the new layer. Use colors sampled from the canvas or from the ever-growing amount of custom swatches in the swatches palette. Vary the brush size and opacity as needed. You probably want to leave the flow setting fairly low, so that the bristles remain pronounced in each stroke.

Brush opacity

When you are working with the brush tool, a quick way to alter the brush opacity is to simply use the number keys on the keyboard as you paint. Just type the opacity value you're after and it will automatically change in the tool options bar.

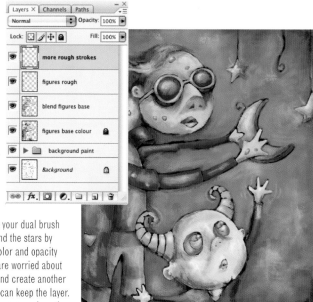

20 | Now use your three custom brushes as well as your dual brush to really add a sense of roughness to the figures and the stars by painting with them on the current layer. Vary size, color and opacity as needed. Also, if you feel like experimenting, yet are worried about making a mistake on your current layer, go ahead and create another layer to work on. This way, if you like the effect you can keep the layer. If you don't like it, you can always delete the layer or even reduce the opacity to lessen the effect.

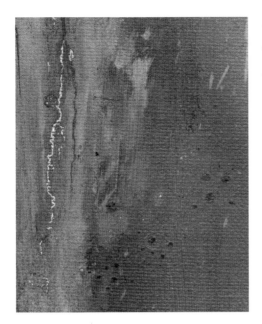

21 | Now, the painting techniques that you've used so far are certainly successful in creating a realistic painterly effect. However, when painting digitally, no matter how convincing your brush strokes are, it is the smooth and perfect surface that ruins the authenticity you've tried so hard to achieve. In order to remedy this, it is often helpful to involve something genuine. Open up the painting.jpg file. This is a desktop scan, in grayscale, of a section of an oil-painted canvas. We're going to add this to our painted file to make use of the canvas texture and the cracked paint effect.

Saving tool presets

To save all of the tool presets that you've created from existing brushes as well as custom brushes you've defined from image files, launch the Preset Manager. Choose Tools from the preset type menu and click on one of your own brush tools, Hold down the shift key and click on the remaining brush tools you created. When they are all selected, click on the save set button to save them as a separate file on your hard drive. Loading the preset file later on is as simple as clicking the load button and navigating to your saved preset file.

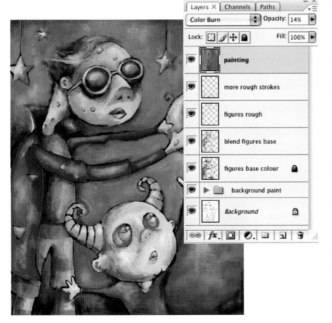

22 | Use the move tool to click on the painting. jpg canvas and drag it into your working file as a new layer while holding down the shift key. Holding down the shift key ensures that it lands in your file in the proper position. Ensure that the new grayscale paint layer is at the top of the layers palette and change the blending mode of the layer to color burn. Reduce the opacity of the layer to 14% and you'll see that a surface texture effect is beginning to take shape as the colors on the underlying layers become darker and more saturated.

23 | Now duplicate your painting layer by dragging it onto the create a new layer button at the bottom of the layers palette. Change the blending mode of your duplicate layer to vivid light and increase the opacity to 35%. Finally, duplicate your current painting copy layer and then change the blending mode of the recently duplicated layer to soft light to intensify the surface texture effect within the image.

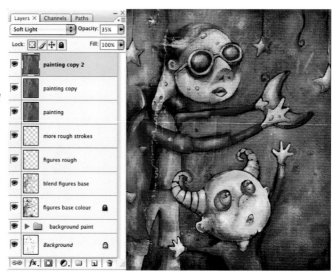

Examining your technique
Now that you're finished, let's take a closer look at some of the things that make this the ideal process for painting digitally.

a | When you customize your own brushes, and especially when you create your own brush tips from images, saving your tool presets is a very good idea. This ensures that they are always available to you. And saving them as a preset library file ensures that you can access them at any point later on, within this or any other Photoshop file.

b | Building up your own custom swatches in the swatches palette is the digital equivalent of a hand-held painter's palette. Your colors will always be available to you here. Choose the Save swatches option from the Swatches palette menu to save them as a file on your hard drive. You can load them or replace an existing set of swatches by choosing either option from the Swatches palette menu and navigating to your saved file. Swatches can also be saved or loaded in the Preset Manager.

c | Keeping different elements and different stages in the process separated on a series of layers allows you enough flexibility to revisit things later and alter them. You can target individual layers and edit or mask their contents. Also, you can insert adjustment layers between layers to affect only certain portions of the composition.

d | Using a real world surface texture is an excellent way to add another level of authenticity to your painting. The simple grayscale scan used here on a series of layers helps to remedy the ultra-smooth digital canvas surface, making it more realistic in the end.

Regardless of the style or subject matter you choose while painting in Photoshop, the method of working I've described in this chapter will aid you in creating successful, and highly editable, works every time.

Creating Characters with Shape Layers

When it comes to creating flat, sharp, and colorful characters in Photoshop, it is always advantageous to involve the use of vectors. Vectors are mathematical objects that define shapes or curves. Unlike pixels, vectors are resolution independent. This means that they can be scaled to any size, edited, or transformed an infinite amount of times without any deterioration of clarity or loss of detail. In Photoshop, vector art can be integrated into your image files in the form of paths, vector masks, or shape layers.

Different vector tools and functions are suited to a variety of different tasks in Photoshop. In this case, the creation of whimsical character faces is ideally suited to working with shape layers. A shape layer can be created with the pen tool or any of the shape tools. What causes one of these tools to create a shape layer, rather than a path, is the designation that you choose in the tool options bar. Shape layers allow you to build up stacks of resolution-independent shapes that are absolutely perfect for tasks like creating faces. The available preset shapes are excellent building blocks for features and the pen tool affords you the flexibility to create any custom shape you desire.

Once you create a number of shape layers, the flexibility doesn't end there. When you select more than one shape on a layer, you'll notice that there are number of options available for creating compound shapes. You can add, subtract, intersect, and exclude shapes as well as perform a plethora of alignment options to get your complicated features placed exactly where you want them on the face.

Like traditional layers, shape layers can also be linked or grouped so that multiple elements across a series of layers can be moved, rotated, or scaled together at the same time. No matter what style of face you're creating, when it comes to flexibility and versatility, shape layers are the absolute key to success.

1 I The first thing you need to do is to open up the background.jpg file. This brightly colored painting provides an ideal backdrop for the bright, whimsical characters we're about to create in this chapter. All of your shape layers will be added to this file to create plethora of strange creatures. To get started, select the pen tool. Then, in the tool options bar, ensure that the shape layers function is enabled by clicking on the button at the left. Press 'd' on the keyboard to set your foreground color to black and zoom in closer on a section of the background.

Project files

The background image file for this chapter can be found in the folder entitled chapter_02. Although you'll be creating your own characters by following along, you may find it useful to have a look at the three sample character files included within this folder for reference purposes.

2 I Click and drag to create a curved point with the pen tool. Move the mouse, then click and drag again to create another curved point, joined to the previous point by a line segment. Repeat this method, making your way back to the original point. Click and drag on the original starting point to close the shape. Once the shape is closed, select the direct selection tool. Use the direct selection tool to click on the individual points that make up your curved shape. When you click on a point, the Bezier handles that define that point will become visible.

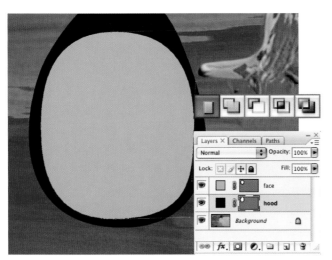

3 | Click and drag the Bezier handles to reshape the curves and move the points with the direct selection tool until you have achieved the desired shape. When you're finished, select the pen tool again and click on the foreground color swatch in the toolbar to launch the picker. Choose a blue color from the picker to change the foreground color to blue. Ensure that the create new shape area option is selected in the tool options bar, and then use the previous method to create a smaller blue shape on a new layer. Edit the points and curves with the direct selection tool, using the previous method.

Affect which shape layer?

You've probably noticed by now that before you create a shape layer, I instruct you to set the foreground color in the toolbar first, specifying a fill color for your new layer before you create it. However, you've probably also noticed that there is a color swatch in the tool options bar that allows you to specify the fill color of a shape layer too. Before you choose a different color from the swatch in the tool options bar, you need to pay attention to a small chain-link button to the left of it. When enabled, this option affects the properties of the current layer, meaning the layer you already created. So when this option is enabled, changing the color in the tool options bar will affect your already existing layer. If you disable this option, your current shape layer will remain unaffected when you choose a new color. But any new shape layer you create will use the new color selected in the tool options bar.

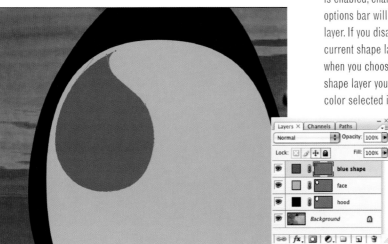

4 | Specify a darker blue foreground color. Select the pen tool and ensure that it is set to create a new shape layer in the tool options bar. This time, when starting your shape, just click once instead of clicking and dragging, then move the mouse, and click and drag. This will create an initial sharp, or corner point, and your second point will define the curvature of the line. Click and drag to add more curved points and then, when returning to your starting point, just click. By clicking once on the starting point, you ensure that this point remains sharp, not curved.

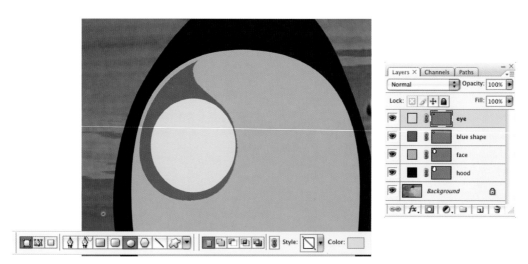

5 | In the tool options bar, select the ellipse shape tool and then disable the chain-link button by clicking on it, so that the new color we choose from the swatch in the tool options bar is not applied to the currently targeted shape layer. Click the color swatch in the tool options bar and select a dirty yellow color from the picker. Ensure that the create new shape layer option is enabled and then click and drag, while holding down the shift key to create a perfectly circular shape layer. You can reposition the entire shape layer with the move tool.

Which tool do I use?

Using the move tool will allow you to move an entire shape layer around on the canvas. However, if you want to move your shapes around within your layer, you'll need to use the path selection tool. Simply click on the shape you wish to move and drag it with the path selection tool. This is especially useful when your shape layer contains more than one shape and you wish to move shapes independently of each other.

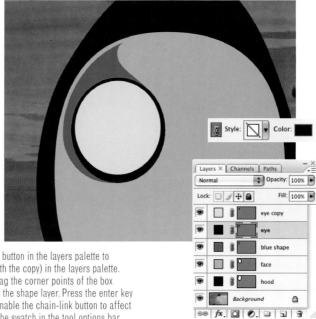

6 | Drag the shape layer onto the create a new layer button in the layers palette to duplicate it. Target the original layer (the one beneath the copy) in the layers palette. Choose Edit>Free-Transform from the menu and drag the corner points of the box outwards to increase the size, and alter the shape of the shape layer. Press the enter key to apply the transformation. In the tool options bar, enable the chain-link button to affect the current layer. Then specify a black fill color via the swatch in the tool options bar.

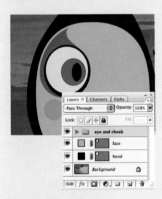

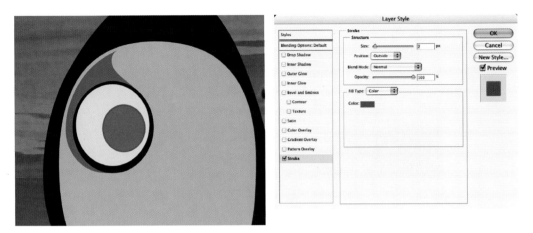

7 | Target the top layer in the layers palette, so that your next layer will be created above it. Again, use the ellipse shape tool to draw a smaller circle in his eye area. Ensure that the create new shape layer option is enabled as you create the circle. Next, change the fill color of the new layer to red via the color swatch in the tool options bar. With this new layer targeted, choose the stroke effect from the layer styles menu at the bottom of the layers palette. Add a darker red stroke to the outside of the circle.

Finish, group, duplicate and flip

Complete the eye area and add a cheek detail. Then flip the artwork to the other side of his face.

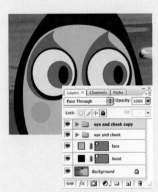

1 | Use the same methods to create two new shape layers. One containing a black pupil shape, and another containing a purple cheek shape. Target all of the eye and cheek shape layers in the layers palette. Type Control(PC)Command(Mac)-g to group them.

2 | Select the move tool and ensure that your group is targeted. Hold down the alt(PC)/option(Mac) and the shift key as you drag the artwork to the right side of his face, creating a duplicate of the group, aligned horizontally.

3 | Choose Edit>Transform>Flip Horizontal from the menu to horizontally flip your duplicated group. Expand the duplicated group in the layers palette and target the red iris layer. Shift-drag to the right on the canvas with the move tool, repeat this process with the duplicated pupil shape layer. This will remedy his cross-eyed appearance.

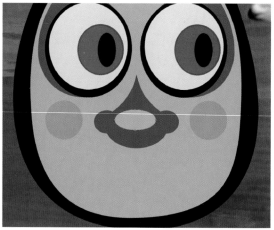

8 | Collapse the group in the layers palette. Use the eyedropper tool to click on the dark blue area around his eye, sampling it as the current foreground color. Use the Pen tool to create a new shape layer in the middle of his face. Carefully draw a nose shape with the pen tool. Take your time, clicking once to create sharp points, clicking and dragging to create curved points. Edit the shape with the direct selection tool wherever necessary. Next, select the ellipse shape tool and draw a lighter blue ellipse over his nose on a new shape layer.

Subtracting and combining shapes

Now we'll explore how multiple shapes can be used together within a single shape layer, producing a nice nostril highlight at the same time.

1 | Select the ellipse shape tool, and select the create new shape layer function in the tool options bar. Create a light blue ellipse on the canvas, over his nostril as a new shape layer. Use the Path selection tool to reposition it if necessary.

2 | Use the Path selection tool to drag the shape to the right and down a little while holding down the alt(PC)/option(Mac) key, duplicating it. With the duplicate shape selected, click on the subtract from shape area button in the tool options bar.

3 | Click the combine button to create a single shape, resulting from the subtract operation. Alt(PC)/Option(Mac)-drag this shape to the right with the Path Selection tool. Choose Edit>Transform Path>Flip Horizontal from the menu. Press Enter and adjust the positioning of the flipped duplicate shape if necessary.

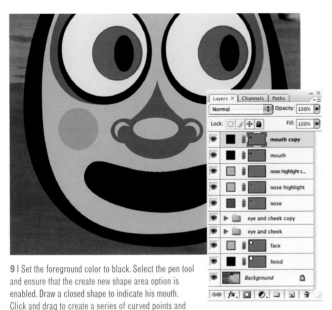

9 | Set the foreground color to black. Select the pen tool and ensure that the create new shape area option is enabled. Draw a closed shape to indicate his mouth. Click and drag to create a series of curved points and use the direct selection tool to edit your points and curves until the mouth shape is looking just right. Duplicate the mouth shape layer in the layers palette so that there are now two of them. Target the duplicate mouth layer and press the link button in the tool options bar, so that when you change the color, this layer will be affected.

Switching to a selection tool

When you are working with the Pen tool, you can temporarily switch to the direct selection tool by holding down the Control(PC)/Command(Mac) key. When you are working with a shape tool, holding down the Control(PC)Command(Mac) key with temporarily switch your tool to the Path Selection tool. Releasing the Control(PC)Command(Mac) key will revert back to your original tool.

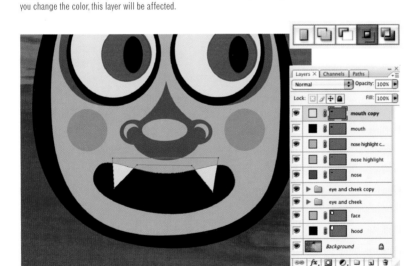

10 | Click the color swatch in the tool options bar. When the picker opens, move the mouse out over the yellow part of the eye on the canvas and then click to select this yellow as the fill color for this shape layer. Click OK and select the pen tool. Choose the intersect shape areas option in the tool options bar and then draw a closed shape that contains two fangs that overlap the mouth area. As you draw, you'll see the layer content disappear and then only reappear in areas where the new shape overlaps the existing shape within the current shape layer.

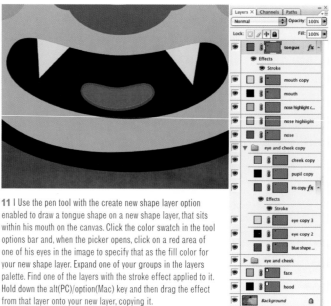

11 I Use the pen tool with the create new shape layer option enabled to draw a tongue shape on a new shape layer, that sits within his mouth on the canvas. Click the color swatch in the tool options bar and, when the picker opens, click on a red area of one of his eyes in the image to specify that as the fill color for your new shape layer. Expand one of your groups in the layers palette. Find one of the layers with the stroke effect applied to it. Hold down the alt(PC)/option(Mac) key and then drag the effect from that layer onto your new layer, copying it.

Combining shape components

The shape area functions in the tool options bar provide nearly everything you need to create diverse and unique composite shapes. However, there may be instances where you wish the visible results were indicative of one actual shape or perhaps you wish to perform different shape area functions on the resulting shape. In these cases, simply click on the combine button in the tool options bar to change the group of shape components into a single, editable shape. Be cautious when combining, because once you combine the shape components they are no longer editable as separate components. If you keep the components separate you still have the option of altering the physical qualities of the shape, as well as changing any shape area functions applied to your individual shapes.

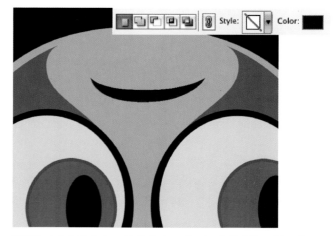

12 I If the chain-link button is enabled in the tool options bar, disable it. Then click on the color swatch in the tool options bar and select black from the picker. If you do this while the chain-link button is enabled, it will change the color of your tongue shape layer. Disabling it ensures that only a new shape layer will contain black. Also, ensure that you set the style setting back to none, otherwise the next layer you create will have the previous layer's stroke style applied to it. Use the pen tool, with the create new shape layer option enabled to draw a forehead wrinkle shape.

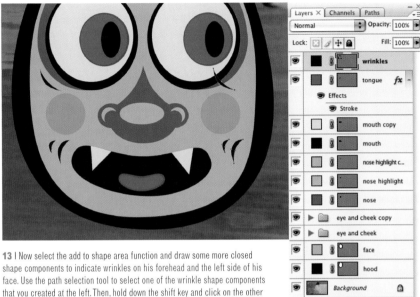

13 | Now select the add to shape area function and draw some more closed shape components to indicate wrinkles on his forehead and the left side of his face. Use the path selection tool to select one of the wrinkle shape components that you created at the left. Then, hold down the shift key and click on the other wrinkle shape components at the left to select them as well. While holding down the alt(PC)/option(Mac) key, click on the selected shape components and drag them to the other side of the face, copying them.

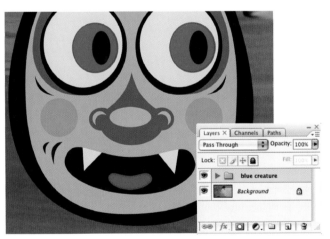

14 | Now, to flip your duplicated wrinkles over, choose Edit>Transform Path>Flip Horizontal from the menu, so that they look like they belong on the right side of the face. Reposition them if necessary with the Path selection tool. Your top layer is currently targeted in the layers palette. Hold down the shift key and click on the shape layer directly above the background layer. This targets the new layer, the top layer, and all layers and groups in-between. Now choose Layer>New>Group From Layers from the menu to add all of the targeted content to a single group.

Custom shapes

When you have spent some time creating a shape of your own with the pen tool or by editing a preset shape you may wish to save it for use layer on. To do this, simply select the shape with the path selection tool and choose Edit>Define Custom Shape from the menu. This will allow you to name the shape and save it. The next time you select the custom shape tool, your custom shape will appear in the list of presets available in the tool options bar.

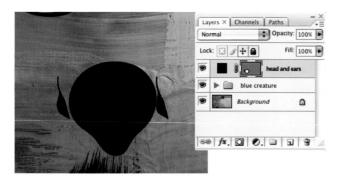

15 | It is likely that by now, you are becoming familiar with the process of creating new shape layers. So let's put that familiarity to work again. Navigate to another area of the canvas. Use the pen tool, set to create a new shape layer, to draw the shape of the alien's head. Never mind the fill color of your layer at this point. Next, select the add to shape area option in the tool options bar. Draw an ear at the left of his head. Then use the path selection tool to alt(PC)/option(Mac)+shift-drag his ear to the other side of the head, copying it.

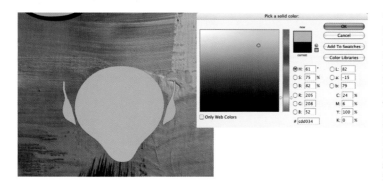

16 | Flip the copied shape component horizontally via the same methods you've used previously for flipping other shape components. Use the path selection tool to position it exactly where you want it on the layer. Now, double-click your shape layer thumbnail in the layers palette. This will launch the picker. Choose a new light green fill color for your layer and click OK. You can change the fill color of any shape layer at any point by double-clicking the layer thumbnail. As you can see now, there are numerous ways to specify and edit the fill colors of your shape layers.

Changing the fill color

Another way to quickly change the fill color of a shape layer is to start by targeting a shape layer in the layers palette. Next, choose a foreground color from the picker. Then, type alt/option-delete on the keyboard to fill the layer with the new foreground color.

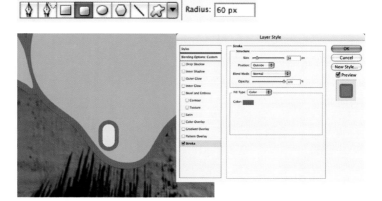

17 | Add a stroke effect to this layer. Use a darker green color, a generous thickness, and position it outside, so that it surrounds the exterior of the shape components. Select the rounded rectangle shape tool in the tool options bar. Set the radius very high. Then click and drag to create a tooth shape on a new shape layer. Change the fill color of the layer to light yellow. This layer automatically has the previous stroke effect applied to it. Double-click the effect in the layers palette to edit it, reducing the size of the stroke.

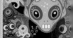

18 | Use the path selection tool to select your tooth shape component and alt(PC)/option(Mac)-drag it to the right to copy it within the shape layer. Repeat the process again until there are three teeth on this layer. Target all the three shape components and then click on the align vertical centers button in the tool options bar to align the shape components. Use the pen tool to create an antenna shape on the left side of the head, on a new, different colored shape layer. Ensure the link button is disabled in the tool options bar, and set the style back to none in the style picker.

Build half of the face

Put your new shape layer skills to good use as you create all of the details for the left side of the face on a series of shape layers.

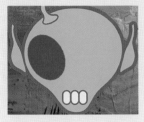

1 | Use the methods employed so far to create a new, red, elliptical shape layer. Choose Edit>Free>Transform Path from the menu. Drag the corner points to resize, then click and drag outside of the box to rotate. Press Enter to apply the transformation.

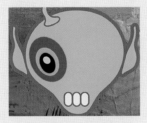

2 | Use this method to create a smaller, orange ellipse shape layer on top of the red one. Then repeat the process again, creating a smaller, black ellipse shape layer. Create a white ellipse shape layer overtop of the black ellipse and reduce the layer opacity.

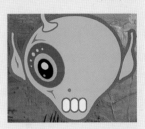

3 | Use the pen tool, the ellipse tool, and the skills you've learned so far to create the rest of his face details on a series of new shape layers until the left side of his face is complete. Target all of these layers, including the antenna layer, and add them to a new group.

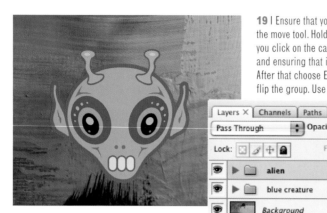

19 | Ensure that your group is targeted in the layers palette and select the move tool. Hold down the alt(PC)/option(Mac) and shift keys as you click on the canvas and drag to the right, duplicating the group and ensuring that it stays aligned vertically with the previous group. After that choose Edit>Transform>Flip Horizontal from the menu to flip the group. Use the move tool or the arrow keys on the keyboard to adjust the positioning on the canvas if necessary. Target all of the layers and groups that make up the alien character in the layers palette and add them to a new group.

Transforming and flipping artwork

You don't always have to go to the edit menu each time you wish to perform a transformation or flip a layer, shape component, or group. Simply type Control/Command-t to activate the free-transform command. You'll see the bounding box appear, allowing you to transform your object, layer, or group. While the bounding box is present, right-click(PC)/control-click(Mac) within the box to access a pop-up menu. Alongside other options, you'll be able to flip your artwork by choosing the appropriate option from the menu. As always, pressing Enter will apply the transformation.

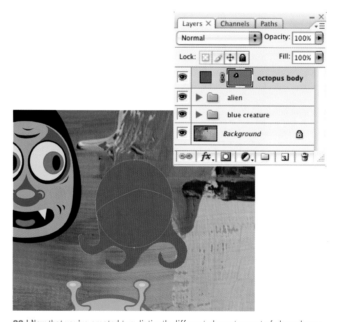

20 | Now that you've created two distinctly different characters out of shape layers, storing each in a group of its own, create one more for the sake of diversity. Use the pen tool to click and drag, creating a closed object that resembles tentacles on a new shape layer. Specify a green fill color and then switch to the ellipse tool. Ensure that the add to shape area function is enabled in the tool options bar. Click and drag to create a large ellipse that overlaps the top of the tentacles shape on the same layer, creating a strange octopus body.

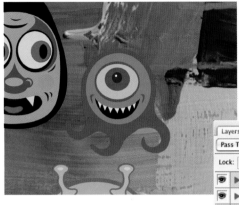

21 I Again, as you've done with the previous two characters, create a series of new shape layers to add the character's essential features and details to the file. All of the methods are the same as before. Even the mouth, although it has more teeth, can be created by using the same methods that you used to create the blue creature's mouth earlier on. When you're finished, target all of the shape layers that make up the octopus in the layers palette and add them to a new group.

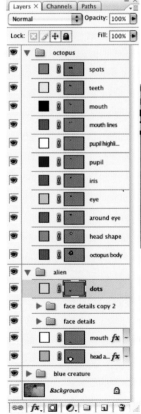

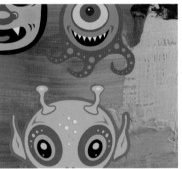

22 I Now, just because your finished creatures are neatly organized into groups in the layers palette, it doesn't mean that you can't add more shape layers within a group or edit existing ones. Here, new shape layers were added to the octopus group as well as the alien group. Spots were added to the tentacles of the octopus on a new shape layer, and spots were added to the alien's forehead using the same method. Each new layer was placed in the appropriate group, ensuring that the layers palette remained organized.

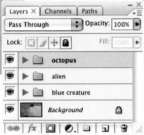

Examine the CD files

At this point in this chapter, you should have the three main characters completed and organized into groups. Everything you need to know to effectively create the characters has been outlined on the previous pages. However, if you still find yourself confused by a small detail or are scratching your head over something, have a look at the sample files on the CD. The files are called: sample-1.psd, sample-2.psd, and sample-3.psd. Each file contains a single character group and you can inspect the shape layers and components in detail within these files. The sample files can be found on the CD in the folder entitled chapter_02.

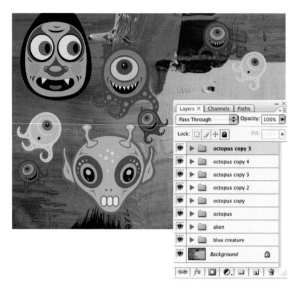

23 | Duplicate the octopus group. Use free transform to rotate, resize it and move it to another location on the canvas. Double-click individual layers within the group and change their fill colors. Delete the shape layers that make up his mouth by dragging them into the trash in the layers palette. Then add a new shape layer that contains a small black ellipse to the group, creating a new mouth with a different facial expression. Use this method to create a number of different octopus groups on the canvas. Alter colors and shape layers as you see fit.

Changing fill content

Shape layers are solid fill color layers with vector masks attached to them. You can change the solid color to a gradient or pattern fill by choosing Layer>Change Layer Content from the menu and then either choosing the pattern or gradient option found there. If you're feeling adventurous, you can also change the layer content to that of any of the available adjustment layer options included in the list. No matter what option you choose, the existing vector mask will remain intact.

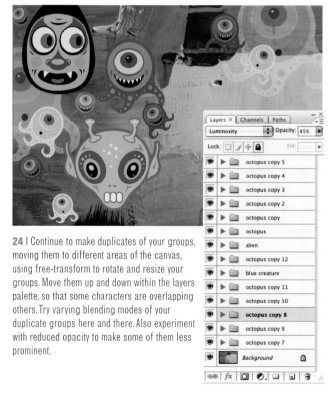

24 | Continue to make duplicates of your groups, moving them to different areas of the canvas, using free-transform to rotate and resize your groups. Move them up and down within the layers palette, so that some characters are overlapping others. Try varying blending modes of your duplicate groups here and there. Also experiment with reduced opacity to make some of them less prominent.

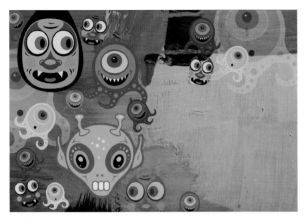
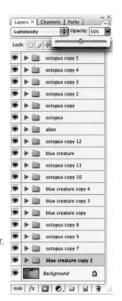

25 | Duplicate the blue creature group. Move it to another location and use free-transform to resize and rotate the group. Repeat this process over and over, adding a number of blue creatures to the scene. Inside some of your groups, disable the visibility of some of the layers, or delete them, so that only selected portions of the characters face remain visible. Like you did previously with the octopus, move duplicate groups up and down within the layers palette, altering the blending modes and opacity settings of entire groups as you go.

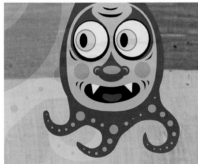

26 | Use these methods to introduce a variety copied alien groups into the image as well. Alter blending modes, opacity, and try disabling the visibility of some layers. Try combining some of your duplicates into groups as well. Here, this creature was created by adding a blue creature group and an octopus group into a new group. The blue creature was positioned on top of the octopus and the fill color of the octopus layer was changed to match the blue creature's fill color. Then, the blending mode of the new group was changed to luminosity.

Hiding versus deleting

When you are creating duplicate character groups and wish to remove layers from the group, disable them rather than delete them. You can disable the visibility of any layers you wish to hide, and when you transform an entire group, these hidden layers will be transformed alongside the rest. This is a better option than deleting as it gives you the option of making the layers visible again if you change your mind later on.

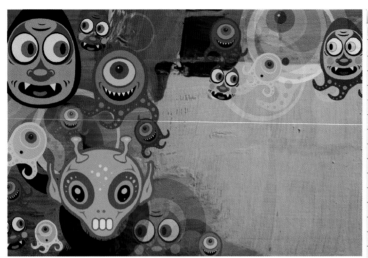

27 | Now that you're finished with the character groups, apply the same methods you've used so far to create some shape layers out of basic shape combinations. Use the subtract and add to shape area options freely. Also, have some fun with different blending modes, color fills, and layer opacity settings. Drag all of the new shape layers beneath the character groups in the layers palette, so that the new shape layers are used to enhance the painted background, rather than overlapping the creatures. Place the new shape layers in a group of their own, just to keep the layers palette organized.

Examining your shape layer masterpiece

Now that you're finished creating the image, let's take a final look at some of the exceptional features and techniques involved.

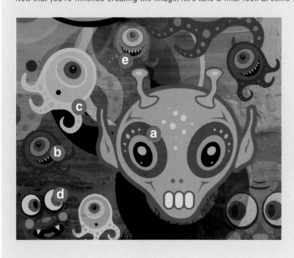

a | By duplicating a group of features, you're not only cutting your work in half, but you are effectively creating an identical set of features for the other side of the face.

b | One great thing about shape layers is that you can change the fill color at any point, so duplicate groups can look diverse, rather than monotonous.

c | Replacing something as simple as the shape layers that make up the mouth in a duplicate group can completely change the emotion of your character.

d | When you're spreading duplicate groups around the canvas, disabling the visibility of base layers within a group can result in ghostly, floating creatures, rather than identical duplicates.

e | Experimenting with blending modes allows you to use your characters in subtle ways. In this case, the creature enhances the background using only its luminosity.

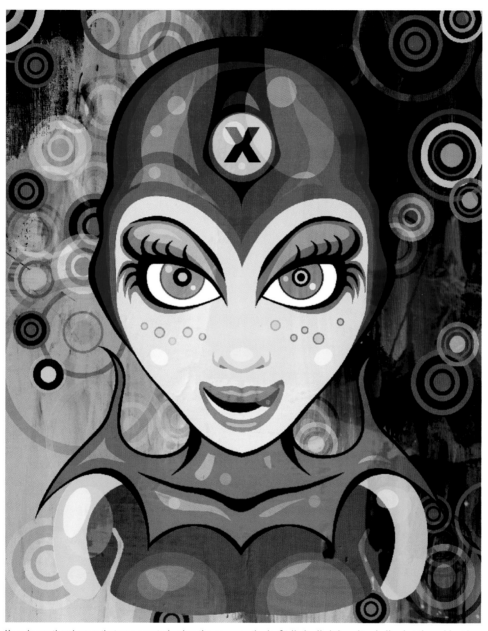

Here is another image that was created using the same methods. Stylistically it is quite similar, but the subject is a little different. There is a lot you can do when you begin experimenting with shape layers, groups, blending modes, and underlying textures. Subject matter can be anything you like; you're only limited by your imagination.

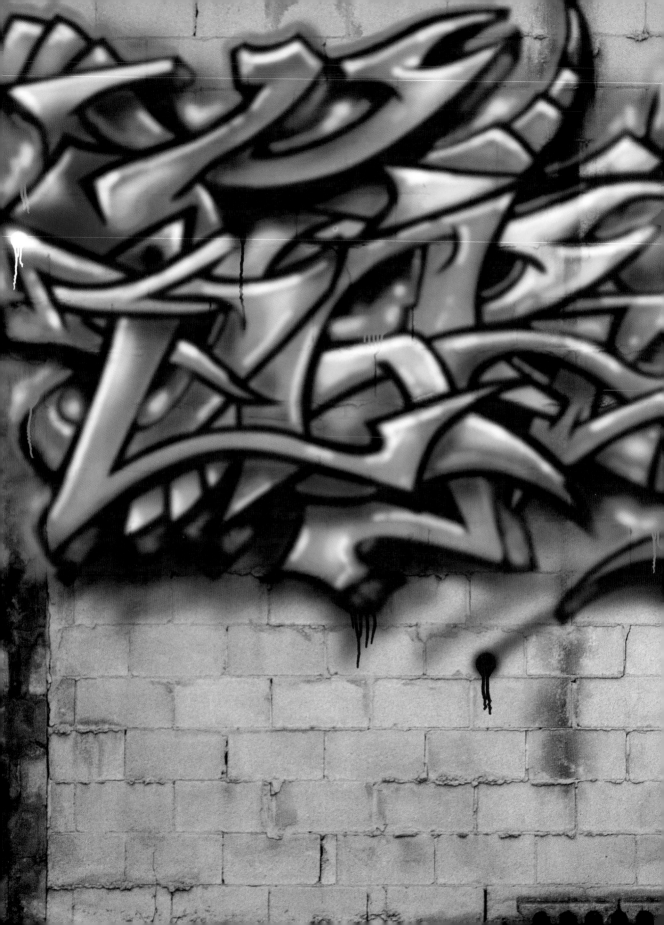

Graffiti Spray Paint Art

To create realistic graffiti art, you no longer have to hit the streets with a backpack full of spray cans, looking for that secluded area where you won't get caught. You don't need to place yourself at the mercy of the elements, and you don't need to break the law. All that you need these days is a digital photo, a scanned drawing of your plan, and a little Photoshop know-how.

Photoshop offers all of the tools necessary to add innovative digital graffiti to any photographed scene. Brushes, selections, and layer blending modes are essential Photoshop tools to get the job done. In this chapter, the standout features are the brush tool's airbrush option and flow settings. Above all other features, these are key ingredients in producing convincing graffiti art. These two features give the brush tool its authentic spray paint feel and allow you to produce convincing spray paint results.

However, in order to make things feel real, you'll also need to incorporate some real world imperfections. While producing real spray paint art, you get annoying drips littering your masterpiece when you apply too much paint to a single area at once. And although this imperfection is something you'd try to avoid in the real world. Here, in the digital realm, that imperfection is required to lend authenticity to your art.

For the authentic spray paint look, you'll need to incorporate the real thing. In this particular case, I've incorporated some basic paint drips, done traditionally, into the digital composition, giving it an authentic feel. And rather than creating a digital backdrop for the graffiti art, it is painted directly on top of a photo of a bare wall, using layer blending modes to make it look as if it really belongs there. So remember, when creating realistic graffiti in Photoshop, it is not just paint techniques that you'll need to employ, but innovative image composition methods as well.

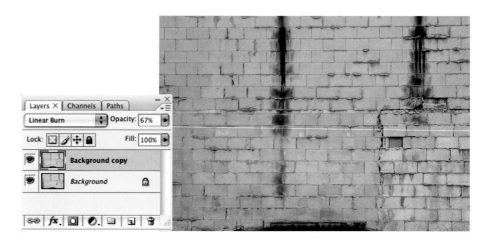

Project files

All of the files needed to follow along with this chapter and create this urban masterpiece are available on the accompanying CD. Files for this chapter can be found in the folder entitled: chapter_03.

1 | Open up the wall.jpg file. This will act as your background for the image and this file will become the bottom layer of our multi-layered working file. The first thing you notice about the wall is that the darker details are not pronounced enough. Perhaps the original photograph was a little overexposed. To remedy this, drag the background layer onto the create a new layer button at the bottom of the layers palette to duplicate it. Target the duplicate layer and change the blending mode of the layer to linear burn. Reduce the opacity of the layer to 67% so that the burn effect isn't overpowering.

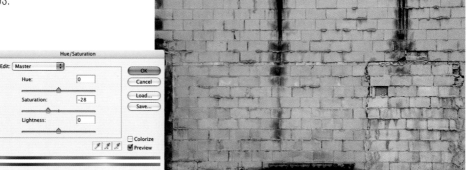

2 | In order to make the painting stand out even more, let's reduce the amount of color in this already very neutral feeling background. Click on the create new fill or adjustment layer button at the bottom of the layers palette to access the pop-up menu of adjustment and fill layer options. Choose hue/saturation from the list to create a new hue/saturation adjustment layer. Reduce the saturation by around 28 to remove color from the underlying layers. Click OK.

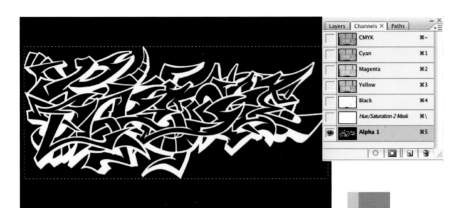

3 | Open up the drawing.jpg file. Choose Image>Adjustments>Invert from the menu to convert the artwork to a negative. Type control(PC)/command(Mac)-a to select all and then type control(PC)/command(Mac)-c to copy the selected image. Return to your working file and navigate to the channels palette. In the channels palette, click on the create new channel button at the bottom of the channels palette to create an empty alpha channel. Target your new alpha channel and type control(PC)/command(Mac)-v to paste the copied art into your new channel.

Go your own way

The black and white art here is a very sharp and finely tuned piece of artwork. However, what makes every graffiti artist unique is his or her style of drawing. Feel free to carefully draw your own black and white artwork and substitute it for the one used here. There is no part of the process more appropriate to express your individual style than the black and white art stage. You can create any subject you like, but try to make it a nice, sharp piece in solid black and solid white. This will help to keep the channel clean, resulting in a nice, clearly defined selection border.

4 | Ensure that the new channel remains targeted and then click on the load channel as selection button at the bottom of the channels palette. Return to the layers palette and click on the create a new layer button to create a layer at the top of the stack within the palette. Press the 'd' key to set your foreground color to black. Then, ensure that your new layer is targeted and type alt(PC)/option(Mac)-delete on the keyboard to fill the current selection with black on the new layer. Type control(PC)/command(Mac)-d to deactivate the selection.

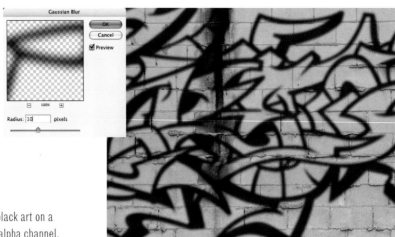

Inverting images

Because you are pasting black art on a
white background into an alpha channel,
it needs to be inverted first, so that the
art is white and the background is black.
A quick way of inverting your art is to
type control(PC)/command(Mac)-I on the
keyboard. Or, you can leave your art in its
positive state and double click your alpha
channel in the channels palette. Then, from
within the channel options, change things
so that color indicates selected areas
rather than masked areas before you paste
your copied art into it.

5 | Use the move tool to position the layer contents a little higher on the canvas.
Change the layer blending mode to multiply and then reduce the opacity of the
layer to 75%, providing a hint of transparency. With your black outline layer
targeted, choose Filter>Blur>Gaussian Blur from the menu. Enter a radius setting
that softens the edges of your black line work. Softening the edges, combined
with the layer blending mode of multiply, is what will give the art on this layer the
appearance of being sprayed onto the wall. Be careful not to soften the edges too
much, you still want your artwork to look like something.

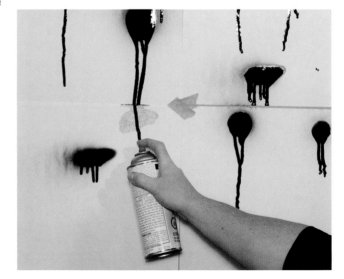

6 | Now, as mentioned in the introduction,
sometimes you need to resort to the real thing
to achieve authenticity in your digital art. Here,
a series of black paint drips were painted on
a white piece of paper. Holding the can in one
place while spraying allows you to build up
enough paint in that spot so that it begins to
run. Black and white were used because these
paint drips, after being scanned, are destined
to be used to create custom selections within a
series alpha channels.

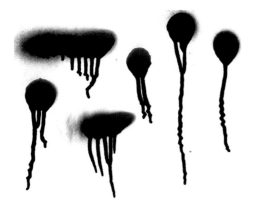
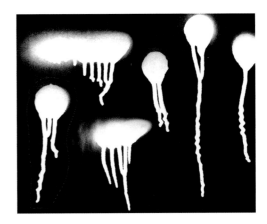

7 | Go ahead and paint your own drips if you like. If you're doing it on your own, be certain that the paint is completely dry before you scan it. Spray paint is difficult to remove from any surface, that's what makes it so appealing for outdoor art. If you'd rather focus on Photoshop instead of making a mess, the dirty work here has already been done for you. Open up the drips.jpg file. This is a desktop scan of a group of spray paint drips. Invert the file and then use the lasso tool to draw a rough selection that contains one entire drip.

Adding a paint drip

Paste a copied paint drip into your alpha channel, using the visible composite channel to aid with proper positioning.

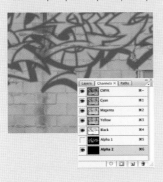
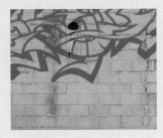
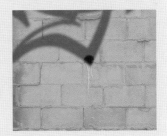

1 | Copy the selected drip and return to your working file. Create a new channel, ensuring that color indicates masked areas (the default setting). Target your new channel and enable the visibility of your CMYK composite channel in the channels palette.

2 | Now that you have your new channel targeted and your composite channel visible, paste the copied art into your new channel. Choose Edit>Free Transform from the menu. Shift-drag a corner of the bounding box inward to reduce the selection contents.

3 | Click and drag outside of the bounding box to rotate the contents as necessary. Click and drag within the bounding box to position your drip over a corner area of your black outline art. Press enter to apply the transformation.

Placing drips

When placing a drip area within the image, try to think of where it would occur realistically. When working traditionally, you know that drips occur because too much paint is applied in a single area at one time. So try to look at areas of the art where a spray can is likely to spend a lot of time. Corners are a perfect place. Actually, anywhere where two lines meet means that the spray can will deposit more paint in that area. Working along these lines will aid in achieving a realistic result. However, don't let the rules of the real world deter you from adding a drip where you think it will look good. Although we're using the laws of nature as our guide here, they certainly don't bind us.

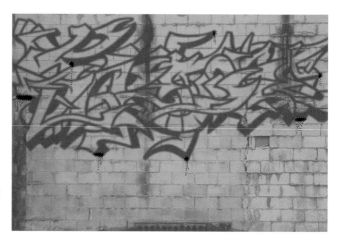

8 | Use this method to copy selected drips from the drips.jpg file and paste them into your alpha channel. Keep the visibility of the composite channel enabled to help you position your drops properly and use free-transform to adjust size, rotation and placement. When you have a number of drips in your channel that sit nicely over appropriate areas of the image, load the channel as a selection.

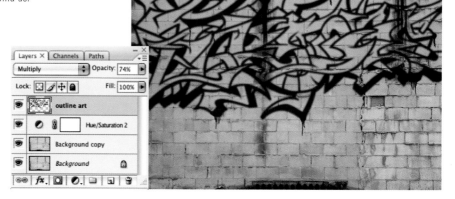

9 | After generating the selection, click on the CMYK composite channel at the top of the channels palette to target it. Next, click on the eye icon to the left of your alpha channel to disable the visibility of that channel, causing the red overlay to disappear. Return to the layers palette and ensure that the layer containing your black outline art is targeted. Fill the current selection with black on this layer and deselect. If you haven't changed your foreground color, it should still be set to black. In this case, all that you need to do to fill the selection is to type alt(PC)/option(Mac)-delete. Then type control(PC)/command(Mac)-d to deactivate the selection.

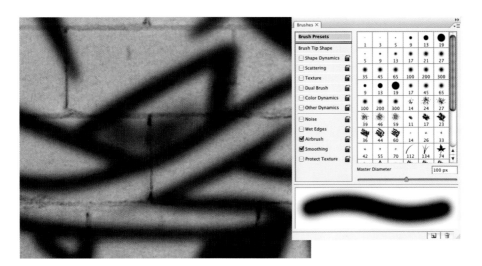

10 | Select the brush tool. In the brushes palette, choose one of the soft round brush tip presets. Disable shape dynamics because we do not want the actual thickness of the stroke to change. Enable the airbrush option as well as the smoothing option. Leave the brush opacity set to 100% but reduce the flow to 30% in the tool options bar. Try painting a few strokes at various areas on the black layer that surround the outline art. The longer you stay in one place with the mouse button down, the more the paint will build up in that area.

Saving your Tool Preset

When you've hit upon a combination of brush settings you like, you can save the brush in the current state as a preset, to access it again directly at any point later on. Just open the tool preset picker at the far left of the tool options bar. Once the picker is open, just click on the create new tool preset button to add your current tool to the list of presets. From that point on, your brush will reside within the preset picker for immediate access.

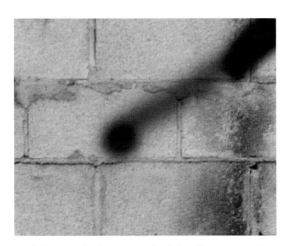

11 | Reducing the flow forces the brush to behave like true spray paint because paint is deposited in your stroke at a slower rate. Move the mouse quickly while holding down the button to paint a light stroke or move slowly to paint a darker stroke. The faster you move the mouse, the less paint there is deposited in the stroke because the flow cannot keep up with you, just like real world spray painting. Try creating a stroke very quickly while holding down the mouse button, and then staying completely still at the end of the stroke while continuing to hold down the mouse button. This will cause paint to build up in the area where you are hovering, just like it would if you were using a real spray can.

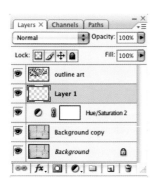

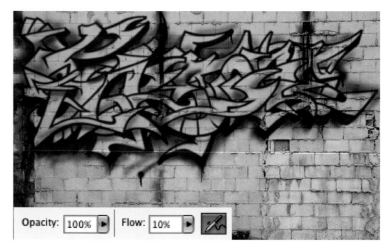

12 | Use this method to add some primarily lighter strokes around the edges and over top of the black outlines, giving it an authentic look. Also try increasing the brush size and reducing the flow so that it looks as if the spray can was held further away while you were painting on the wall. Continue painting on this layer until you think the black spray paint effect is complete. Also, if you feel that you need some more drips on this layer, use the methods employed previously to add drips as well. Create a new layer and drag it beneath the black outline layer in the layers palette.

Adding color

1 | Click on the foreground color swatch in the toolbox and choose a pink color from the picker. Reduce your brush diameter slightly in the brushes palette. Begin to paint some strokes within areas defined by black outlines on the new layer.

2 | Paint like you did previously, using a very low flow setting and numerous strokes of varying speed and thickness. Now select a purple color from the picker and continue to paint some purple strokes within the same regions of the artwork on the current layer.

3 | Use this method to add a variety of different colors into the shape areas on the current layer, defined by the black outline layer. Remember to vary flow settings, brush diameter and the speed at which you paint your strokes to achieve the authentic spray paint effect.

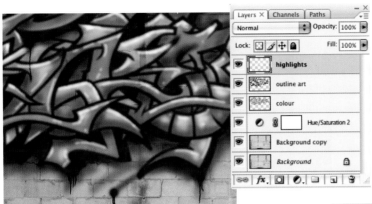

13 | Create a new layer and drag it to the top of the layers palette. With the new layer targeted, and the brush tool still selected, press 'd' on the keyboard to reset the foreground and background colors to their default settings of black and white. Then type 'x' to reverse them. Reduce the master diameter of your brush tip considerably in the brushes palette, and if you've reduced the flow setting, increase it to 30% once again. Use the current brush settings to paint a series of white strokes on this new layer to create highlights on the shapes inside the black outlines.

Opacity and Flow

Rather than always returning to the tool options bar to adjust opacity and flow settings when using the brush tool, a couple of useful keyboard shortcuts will improve your efficiency while working. Pressing a number key on the keyboard will set your brush opacity, using a multiple of ten. Holding down shift while pressing a number key will allow you to adjust the flow instead of the opacity. If you have the airbrush option enabled, things are reversed. When the airbrush is enabled, simply pressing a number key changes the flow. Holding down the shift key while you press a number key changes the opacity, when using the airbrush option.

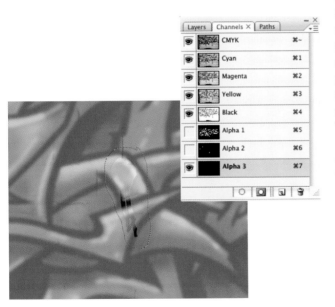

14 | Continue painting until there are deposits of solid white here and there. Also, increase the diameter of the brush and reduce the flow. Then paint some strokes with these brush settings to create a softer, more gradual highlight effect within the shapes. When you're finished painting, return once again to your inverted drips.jpg file. Use the lasso to draw a rough selection around a cluster of drips and copy it. Return to the working file, create another alpha channel and target it in the channels palette. Enable visibility of the composite channel again and then paste into your new alpha channel.

15 | As before, use free-transform to rotate, resize and position the drip. Position it so that it overlaps an area of opaque white and then press return to apply the transformation. Repeat this process to add a few drips to the alpha channel and then generate a selection from it. Target the composite channel and disable the visibility of your new alpha channel. With the current selection active, return to the layers palette. Target the layer with the white highlights painted onto it. Specify a white foreground color and fill the active selection with it. Deactivate the selection.

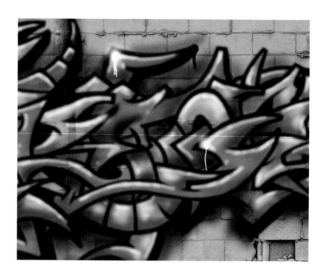

Varying paint colors

Unlike traditional painting, we can change our minds regarding color after the fact when creating graffiti art in Photoshop. Because different colors exist on different layers you can target any individual layer and alter the color via Image>Adjustments>Hue/Saturation. Also, you can target a layer in the layers palette, enable the transparency lock and then fill the targeted layer with any color you choose. This will allow you to instantly change the painted areas of the layer while preserving the transparent areas.

16 | Create a new layer and drag it beneath the white highlight layer in the layers palette. Greatly reduce the size of your brush so the stroke thickness is similar to that of your thin white highlight strokes. Set the flow to 35% and begin to paint some red highlights outside the black outline on the new layer. Be certain to paint over some areas enough times so that there are a few solid red blobs of paint on this layer. Also, increase the brush diameter and reduce the flow setting. With these brush settings, paint some larger, softer strokes here and there on the current layer.

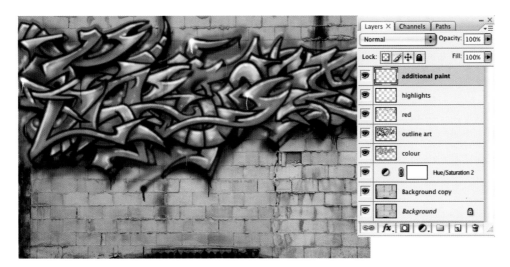

17 | And now for what is becoming a familiar operation, again, return to the drips image file. Paste some selected drips into a new alpha channel. Generate a selection from the channel and fill the selected areas with the same red foreground color on the current layer. Deactivate the selection. Feel free at this point to embellish the image by painting some finer strokes of vibrant color on top of the existing layers on a new layer. Use the now familiar methods you've employed all along to finesse your graffiti art.

Dissecting your graffiti art
Let's recap which methods and techniques are vital when it comes to creating convincing acts of virtual vandalism.

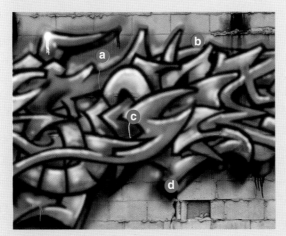

a | Working with the flow setting allowed us to create brush strokes with a paint density that reacted to the speed of the mouse movement. Moving quickly deposited less paint, allowing us to see the detail of the wall through the paint in a number of areas.

b | Even though we imported a perfectly sharp black and white drawing as our outline art, a simple application of the Gaussian Blur filter produced a soft, convincing spray paint effect here.

c | By incorporating paint drips via channel based selections, we were able to force gravity to take its toll on the artwork, adding to the feeling of authenticity. Even while using the airbrush option, no matter how long you hold the mouse button down in Photoshop, the paint simply will not drip as it piles up.

d | By moving the brush quickly, and then holding it in one place with the mouse button pressed, Photoshop allows us to simulate what really happens when you do this with a can of actual spray paint. It is light where the motion was quick, and heavy where the tool was stagnant.

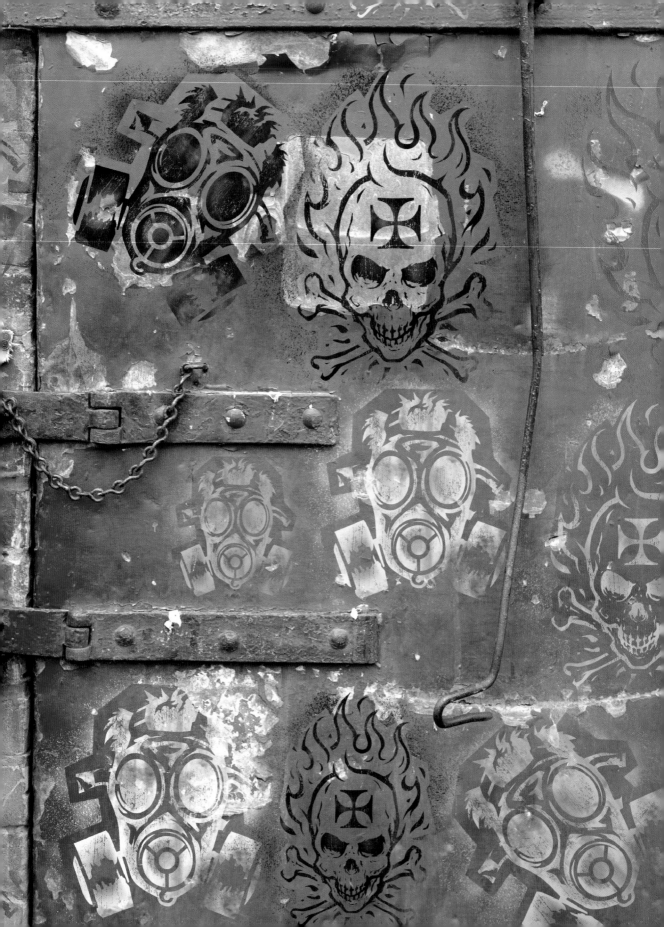

Chapter 4

Creating Stencil Art

Stencil graffiti is a form of urban art that offers quick and easy reproduction. Traditionally, a stencil is made from paper, cardboard or plastic. Usually the stencil is held tight against a wall or another surface and paint is sprayed onto it. Removing the stencil after painting reveals an instant application of the stencil art on the desired surface. Ideally, the paint will only touch the surface in areas where holes in the stencil are present. However, part of the signature appearance of stencil graffiti is the overspray effect that occurs around the edges.

In this chapter, we're going to create a virtual stencil from an existing work of black and white art. The ideal way to do this is to edit the art and then define it as a custom brush preset. However, rather than painting with the new brush preset, like we did in Chapter 1, we'll be using it as a stamp. All that you need to do to add a virtual stencil to an existing scene is choose the custom preset, and click once. Photoshop's custom brush capabilities allow you to put a virtual graffiti stamp on any digitally photographed scene with a single mouse click.

What makes your stencil art effect convincing, is what you do to your artwork before you define it as a brush. You need to distress the brush art, as if it were scratched and affected by the elements. Your overspray needs to look convincing, and for both realistic distress, and convincing overspray, we'll incorporate desktop scans of the real thing. Applying stencil art in Photoshop is indeed as simple as a single click of the mouse, but ensuring that it looks realistic is the direct result of the care you take in preparing your custom brush artwork.

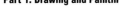

1 | Open up the mask.jpg file. This file provides the subject matter for our initial piece of stencil art. Generally, stencil graffiti art provides social commentary or incorporates an activist theme, so a gas mask is certainly appropriate subject matter here. The first thing we need to do is lighten the density of the black so that even when our brush is eventually used at 100% the resulting stamp is still not entirely opaque. Choose Image>Adjustments>Hue/Saturation from the menu and increase the lightness by about 42.

Project files

All of the files needed to follow along with this chapter and create your own custom stencil brushes are available on the accompanying CD. Files for this chapter can be found in the folder entitled: chapter_04.

2 | Now open up the spatter.jpg file. Select the move tool and then, while holding down the shift key, click anywhere on the canvas and drag the image into your mask. jpg file. This will add the spatter.jpg image to the mask file as a new layer. This layered file will be the working file for your stencil art from this point on. Reduce the opacity of the new layer so that you can see the mask image beneath it. Use the polygonal lasso tool to draw a rough selection that surrounds the gas mask, yet includes a bit of white background as well.

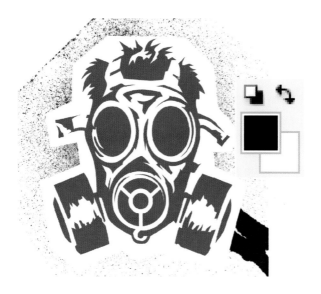

3 I With your spatter layer targeted and your current selection active, choose Layer>Layer Mask>Hide Selection from the menu. After masking, increase the opacity of the layer to 80%. Ensure that the layer's mask is targeted in the layers palette and select the brush tool. Choose a large, soft, round brush preset. Set the foreground color to black by first pressing the 'd' key, and then press the 'x' key. Pressing the 'd' key sets the foreground and background colors to their masking defaults, which is white in the foreground and black in the background. Pressing the 'x' key inverts the colors so that the foreground color is black and the background color is white.

Make your mark

Although there is artwork provided on the CD as the subject matter for your stencil art, you can feel free to create your own. Traditionally, stenciling, as a guerilla art form has been all about expressing yourself and your opinions. So, if you feel that there is something you'd like to say, and you can translate that concept into bold black and white artwork, feel free to use it here instead of the files provided. The process remains the same and will work with a variety of different subjects.

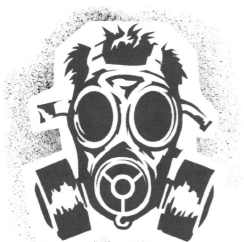

4 I Leave the brush opacity set to 100% and then paint over areas within the mask to hide them. Paint over the dark drips in the lower right, also paint over any sharp edges where the spatter abruptly ends, like the upper left, the upper right and around the edges of the canvas. Now that you've added the spatter layer and masked it accordingly, you can see that the artwork is already beginning to look as if a stencil and a spray can applied it.

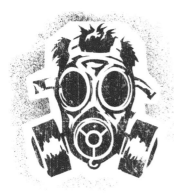

5 | Open up the scratches.jpg file. Again, use the move tool to drag the image into your working file as a new layer. Hold down the shift key as you drag to ensure proper positioning when the scratches file reaches the destination. In the layers palette, change the blending mode of your new scratches layer to lighten. This ensures that only the areas on the current layer that are lighter than areas on the underlying layer appear, creating a scratched paint effect on your black stencil art. Next, target your background layer and select the magic wand tool.

Add light and dark areas

Adding light and dark areas within your stencil art helps to create a genuine weathered look when you apply it to your surface destination.

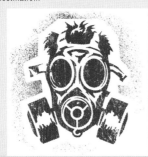

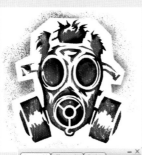

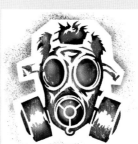

1 | Ensure that the target all layers and contiguous options are disabled in the tool options bar. Leave the tolerance set to 32 and click on a non-white area of the background layer. Click on the create a new layer button in the layers palette.

2 | Drag the layer to the top within the layers palette and select the brush tool. Press 'd' to set the foreground color to black and then paint within the selection here and there on the new layer. Alter brush opacity and diameter as you paint.

3 | Press the 'x' key to switch the foreground color to white. Create a new layer and then paint some faint white areas within the active selection on this layer. Increase the diameter of your brush and use a very low opacity setting.

6 | Open up the rusty.jpg file. This is a grayscale detail photo of a rusted metal surface. It is not the subject matter that is appealing in this case, but rather the contrast and interesting divisions between light and dark. Type control(PC)/command(Mac)-I on the keyboard to invert the image. Then use the move tool to drag it into the working file as a new layer. Hold down the shift key as you drag to ensure correct positioning.

Recognizing potential

This rust texture application is an excellent example of the less than obvious usage of certain images. When you originally look at the digital photo of the rusted box you see an intriguing texture, but it is important to look at it with different blending mode applications and layer stacking options in mind as well. Try to visualize the lighten and darken usage opportunities of basic texture shots. Examine dark and light areas, and think about how they would affect different types of underlying artwork. Experiment with different scans and photos of texture using different blending modes. You're bound to hit upon some interesting effects that would not have been immediately apparent when viewing the images in their normal state.

7 | Change the blending mode of the layer to lighten so that only the light areas of the texture appear against the dark areas of the underlying artwork. To intensify the rusty texture effect, drag the layer onto the create a new layer button at the bottom of the layers palette to duplicate it. Use the move tool to drag the duplicated layer's texture to the right a little, so that it overlaps the texture on the underlying layer. This is a great way to increase the textured effect. Use the same procedure to duplicate your scratches layer and move it too.

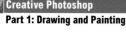

8 | Open up the skull.jpg file. We'll use this image to create a second piece of stencil art that is less of a social comment, and more of a lowbrow urban art icon. To begin, use the same hue/saturation adjustment method you used for your gas mask art to lighten it. Now, ensure that you are working in standard screen mode so that you can view the skull file as well as the gas mask working file at the same time. Use the move tool, while holding down the shift key to drag the first scratches layer from the gas mask file's layer palette onto the skull file's canvas area.

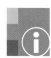

Creating custom brushes

The most important thing to remember when building a file to use as a brush preset is that brush tips operate using the principles of grayscale. Simply put, this means that wherever you have a solid black area, 100% paint will be applied when you use this image as your brush preset. Inversely, areas of white will deposit no paint at all, and areas of grayscale will fall into place in-between, dependant upon the amount of black in those particular areas.

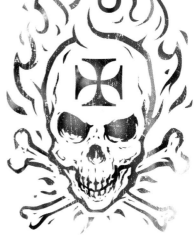

9 | After adding the scratches layer to the skull file, repeat the process of selecting the dark areas of the background layer with the magic wand. Use the same method and tool options that you used earlier in the gas mask file. Then, on a series of layers paint some lighten and darken areas with the brush tool. Again use the same methods, tools and tool options as before. Deactivate your selection and then shift-drag the rust texture layer from the gas mask file into your new file. Reposition the layer as required within the skull file.

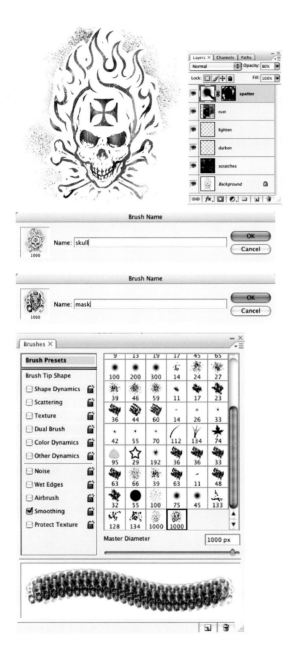

10 | Open up the spatter.jpg file again and shift-drag it into the skull working file with the move tool to add it as a new layer. Reduce the opacity of the new layer to see the art beneath. As you did previously with the gas mask file, use the polygonal lasso to create a rough selection border and then add a layer mask that hides the contents of the selection. Use a large, soft, round brush with a black foreground color to paint over the hard edges on that layer within the mask to remove them. When you're finished editing the mask, target the layer instead of the mask, and change the layer opacity to 80%.

Make it big

Another useful thing to remember when creating a custom brush, is that it is always a good idea to start with an image that is larger than any brush you'll want to use later on. That way, your brush preset is always larger than what you require and you can always reduce your preset size without affecting the sharpness of the tip. However, increasing the size of your brush beyond its original size will result in poor quality and possibly visible pixels when you use your brush as a stamp later on. Photoshop will allow you to define a brush preset as large as 2500 pixels wide by 2500 pixels high.

11 | Next, choose Edit>Define Brush Preset from the menu. When prompted, name your brush 'skull' and click OK. Save and close your skull file. Return to your gas mask file and define this image as a brush preset too, by using the same Edit menu command. Name this preset 'mask' and click OK. Save and close this file as well. Now, go ahead and open up any background image you like, and select the brush tool. If you want to replicate what is being done here, open the background.jpg from the CD. In the brushes palette, choose the new skull or mask option from within the list of available presets.

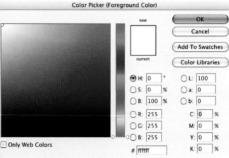

12 | Look for a place within your image that is ideal for an application of this new stencil. Think about the color of spray paint you'd use, and then click on the foreground color swatch to access the picker. Select your desired color from the picker. Because the file we used to define the brush preset was 1000 pixels wide and 1000 pixels high, there is a good chance you'll want to reduce the diameter in the brushes palette. After you've sized your brush accordingly and chosen a foreground color, click once in the desired location within your image to apply the stencil art.

Adjusting the angle

In the brushes palette, there is a small circle and cross hair diagram that allows you to adjust the angle and roundness of your brush tip. Do not alter the roundness as it is not an appropriate adjustment when creating stencil art. However, go ahead and drag the arrow in the diagram to adjust the angle, you can see the result of the adjustments immediately in the stroke preview below. You can also enter a numeric value, however, dragging has a more intuitive feel to it.

13 | Certainly, you can stamp your stencil directly onto your images and the results will be just fine. However, if you want to keep your files editable, it is always a good idea to work on separate layers. So, create a new layer and ensure that it is targeted. Go ahead and apply numerous instances of one brush preset. Alter the angle, color and the size as you see fit.

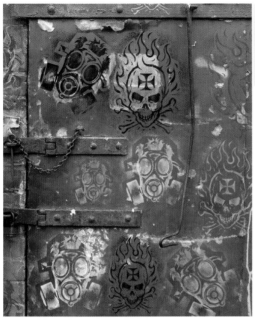

14 I Now, go ahead and add instances of your other brush preset. First, choose a color from the picker each time. Then select your preset in the brushes palette. Adjust the size and angle each time and then simply click once on your new layer to add another instance of your stencil art. Repeat this process until you're satisfied with the result. Once you've added your custom brushes to the list of presets, you can use them in any file you like.

Examine the finished art

Let's take a look at both of our brush presets and note what is effective when it comes to producing convincing stencil art.

a I Overspray can't be avoided in the process of real world stenciling, so it is important that it is included here. Using a scan of the real thing certainly helps to create an authentic appearance.

b I Adding scratches lends authenticity to the results. Untouched and perfectly even paint coverage is rarely evident in real world stencil art, the elements and environmental factors definitely take their toll over time.

c I Rotating your brush tip is a nice option when it comes to simulating realism. Rarely will you see a real world stencil applied to a surface at a perfect right angle. Guerilla artists just don't have time for that sort of thing.

d I Remember, because your stencil art is a brush preset, you can use any color you like. If your background is dark, you can use a light color, or if your background is light, then you can use a dark color. All of the color combinations within the picker are available. This vast range just isn't available when you're working with spray cans in the real world.

Chapter 5

Tracing Photographs

Creating striking illustrations in Photoshop is easy when you use photography as your starting point. You don't really need any traditional drawing skills, you simply need to understand which tools are right for the task at hand, and how to use them to your advantage. All of the details and divisions of color necessary to create a stunning illustration exist in your photography, you just need to recognize the potential within the image and make use of it.

The technique of illustrating over photography revealed in this chapter does involve tracing, but as you define areas with paths, you can simplify, embellish or sharpen the areas of detail as you see fit. For example, take a look at the sky in the background of this illustration. By taking some creative license while creating the outlines of the clouds, I was able to give them a sharp, stylized effect. And it was this effect that dictated the overall style of the finished illustration. In general, the curves are smoother than those in the original photograph, and the detail is minimal in comparison. By using only the necessary details provided by the original image it becomes simpler. The result of this is a much more striking image than the original, especially when viewing it from a distance.

Simplifying and exercising creative license when rendering detail is only a part of what makes this image so striking. This style of illustration owes a lot of its success to color. The colors are bright and the divisions are bold. Highlights and shadows are simplified. And perhaps most important of all, colors are chosen not by what is indicated in the original image, but by what works best within the finished illustration.

So before you begin, try to change your mental framework a little from the norm, this is not an auto trace effect we're creating here, it is an illustration based on a photo. When tracing, do not trace exactly, try to embellish and introduce a nice sharp style to the image. When adding color, make bold decisions. Think about what you'd like to see, rather than what you actually see in the existing photograph. Bearing this in mind as your work will ensure that your finished illustrations surpass any source photos you use.

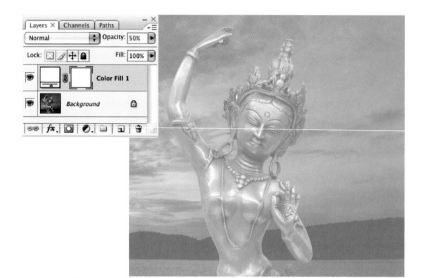

Starter file

The image file needed to follow along with this chapter and create the featured illustration is available on the accompanying CD. This file can be found in the folder entitled: chapter_05.

1 | Open up the starter.jpg file. This is the image we're going to use as the template for our illustration. Generally, it is easier to see what you're doing when tracing, if the image is less intense. Create a new solid color layer by choosing the solid color option from the create new fill or adjustment layer pop-up menu at the bottom of the layers palette. When the picker opens, select white as your color from the picker and reduce opacity of the layer to 50% in the Layers palette.

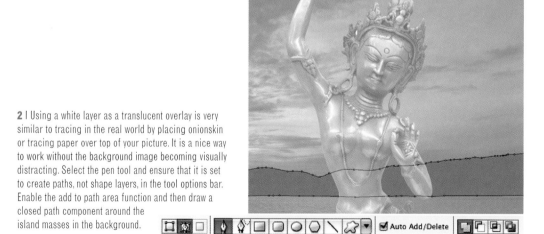

2 | Using a white layer as a translucent overlay is very similar to tracing in the real world by placing onionskin or tracing paper over top of your picture. It is a nice way to work without the background image becoming visually distracting. Select the pen tool and ensure that it is set to create paths, not shape layers, in the tool options bar. Enable the add to path area function and then draw a closed path component around the island masses in the background.

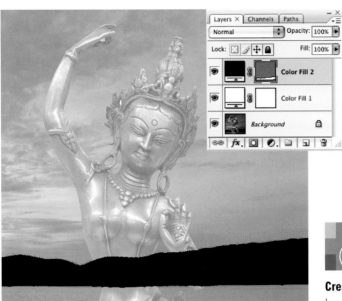

3 | Do not trace every bump that is indicated by the image on the background layer. Create a smooth path that is indicative of the landmasses but simpler. With the path visible, create another solid color layer. Choose black from the picker. Here you can see that by having the path active as we create the solid color layer that the path is converted to a vector mask, which is automatically applied to the solid color layer. After this operation, you'll notice that the pen tool is now set to create shape layers in the tool options bar.

Creating solid color layers

In addition to using the pop-up menu at the bottom of the layers palette to create a solid color layer, you can use the main menu if that is what you prefer. Simply choose Layer>New Fill Layer>Solid Color from the menu. This is just one example of numerous features within Photoshop that can be accessed in more than one place within the workspace.

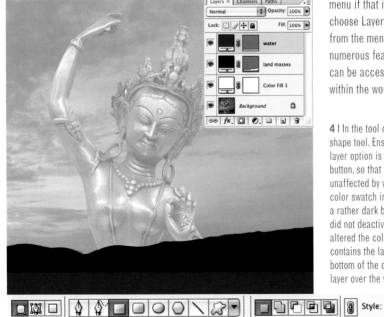

4 | In the tool options bar, select the rectangular shape tool. Ensure that the create new shape layer option is enabled and un-click the link button, so that the existing shape layer is unaffected by what we do next. Next, click on the color swatch in the tool options bar and choose a rather dark blue color from the picker. If you did not deactivate the link button, this would've altered the color of the current layer, which contains the landmasses. Click and drag at the bottom of the canvas to create a blue shape layer over the water area.

5 | Select the pen tool and, once again, ensure that it is set to create paths and not shape layers in the tool options bar. Enable the add to path area function and then take a good look at the sky in the photograph on the background layer. Try to look past all of the rippling cloud details and visually pick out the darkest cloud covered areas of the sky. Use the pen tool to draw a series of path components surrounding these areas. But simplify what you see as you create your paths. Make the components look smooth and stylized. Have some fun with it.

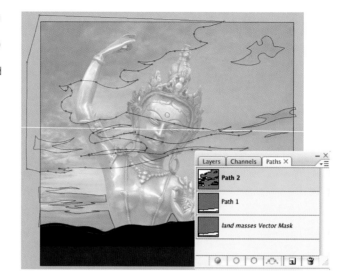

Adding a mask later

You can add a vector mask to any unmasked solid color layer after the fact, you don't necessarily need to create a path before you create your layer. Simply go ahead and create a solid color layer, like we did previously with the white overlay layer. Then create a new path, or target an existing path in the paths palette. With your desired path visible on the canvas, and your solid color layer targeted in the layers palette, choose Layer>Vector Mask> Current Path from the menu.

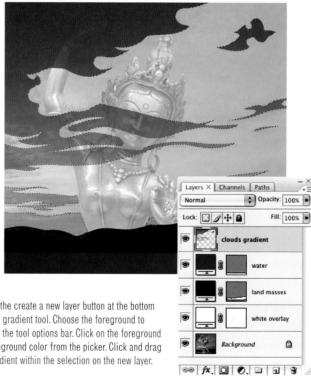

6 | Control(PC)/Command(Mac)-click on the new path thumbnail in the paths palette to load it as a selection. Return to the layers palette and click on the create a new layer button at the bottom of the palette to create a new, empty layer. Select the gradient tool. Choose the foreground to transparent preset and the linear gradient method in the tool options bar. Click on the foreground color swatch in the toolbox to select a dark gray foreground color from the picker. Click and drag from the top of the canvas downward to create a gradient within the selection on the new layer.

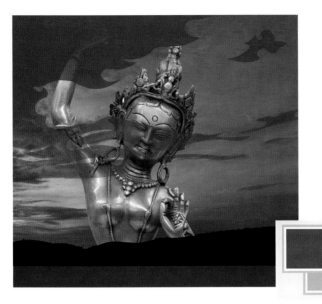

7 | Type Control(PC)/Command(Mac)-d to deactivate the current selection. Temporarily disable the visibility of your white solid color layer by clicking on the eye in the column at the left of the layers palette. Use the eyedropper to click on an area at the lower left of the sky to choose an orange-brown color as the current foreground color. Press the 'x' key to invert the foreground and background colors, sending the new color to the background. Then click on a dark blue-gray region on the canvas to sample it as the current foreground color.

Create a gradient layer

Similar to solid color layers, gradient layers can provide the basis for a simple, graduated sky background.

1 | Choose the gradient option from the fill and adjustment layer menu at the bottom of the layers palette. This will open the gradient fill dialog box. Because the last gradient we created used the foreground to transparent preset that is what is selected.

2 | Click on the arrow button to the right of the gradient preview to open the gradient preset picker. Choose the option from the upper left within the list of presets. This is the Foreground to Background option and makes use of your previously sampled colors.

3 | Now change the angle of the gradient to −90°, flipping it horizontally. You can also enter a numeric value in the angle field or click and drag on the angle control thumbnail to the left of it. Press OK when finished.

8 | Drag the gradient layer down in the layers palette so that it resides directly above the white overlay layer that we created earlier. Select the gradient tool and choose the foreground to transparent gradient preset in the tool options bar. Set your current foreground color to white and ensure that the gradient method is set to radial in the tool options bar. Create a new layer in the layers palette. With your new layer targeted, click and drag to create a white radial gradient where the sun would be on the horizon. Reduce the layer opacity to 65% to soften the effect.

Alter the gradient layer

Although we've chosen colors from the background photo as our starting point, there is no reason why the sky can't be much more intense than the original.

1 | Target the gradient layer in the layers palette. Choose Layer>Layer Content Options from the menu. In the gradient fill dialog box, click on the gradient's thumbnail preview to open the gradient editor. Click on the color stop at the left below the horizontal gradient.

2 | Click on the color swatch in the stops section at the bottom of the gradient editor dialog box. This will launch the picker, allowing you to choose a new color for the gradient stop you selected. Choose a more saturated blue and click OK.

3 | Now select the color stop in the bottom right and follow the same procedure to choose a brighter, more saturated orange. Click OK to close the picker and then drag the midpoint slider under the gradient to the left, until the location reads about 40%.

9 | Click OK when you're finished and take a look at the illustration now. The grey clouds now look a little out of place. To remedy this, first target the layer with the clouds on it and then choose Image>Adjustments>Selective color from the menu. In the selective color options, choose neutrals from the color menu. Use the sliders to increase the amount of cyan and magenta in the neutral components of this layer (which is more or less the entire layer). The ability to adjust image components separately is a fine example of the benefits of building your file as separate layers and using adjustment layers.

Beware of banding

When you are making hue/saturation adjustments that affect underling gradient fill layers, proceed with caution. Extreme adjustments that vastly alter hue and/or saturation will increase the visible banding in the underlying gradient layer. So try to make gentle adjustments and if you want to drastically alter the colors within the gradient, it is best to edit the fill content of the gradient layer itself, rather than using an adjustment layer on top of it.

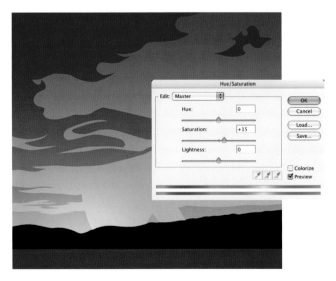

10 | Now, to saturate the colors within the entire background a little more, create a new hue/saturation adjustment layer from the create new fill or adjustment layer menu at the bottom of the layers palette. Simply increase the saturation by 10 and click OK. This little adjustment helps quite a bit without being so drastic that it has adverse effects within the gradient. With your new adjustment layer targeted in the layers palette, shift-click on the gradient layer to target all of the layers that make up the background. Choose>Layer>New>Group from layers from the menu to group them.

11 | Temporarily disable the visibility of your new group and enable the visibility of the white overlay layer once again by clicking in the column to the left of each layer in the layers palette. We'll enable the visibility of the background group again later on, but for now it will simply get in the way of creating the figure. Select the pen tool. In the tool options bar, set it to create paths instead of shape layers, and enable the add to path area option. Use the pen tool to carefully create a large, closed path component that surrounds the figure in the underlying photograph.

Editing layer content

A quick way to edit the content of a solid color, gradient or adjustment layer is to simply double-click on the layer thumbnail in the layers palette. This will open up the layer content options specific to the type of layer you clicked on. For instance, double-clicking on a solid color layer opens the picker, a gradient layer opens the gradient fill options, etc.

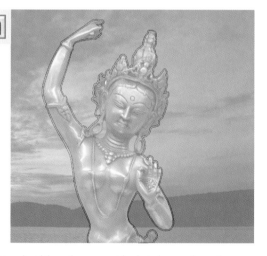

12 | When you have closed the path component, begin to draw another path component on the inside of the first one. The space between these two components will eventually be filled with black to create a black outline to define the figure, keep this in mind as you carefully create your path components. When you've completed the inside component, ensure that it is still selected and then choose the subtract from path area function in the tool options bar. Control(PC)/ Command(Mac)-click on an area of the canvas that contains no path to ensure that no single path component is selected.

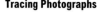

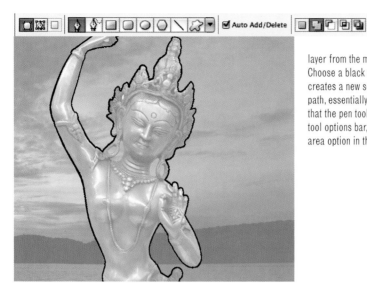

13 I With your path visible (yet no single component selected) on the canvas, create a new, solid color layer from the menu at the bottom of the layers palette. Choose a black color from the picker and click OK. This creates a new solid color layer that is masked by your path, essentially a shape layer. You'll notice, once again, that the pen tool is now set to create shape layers in the tool options bar, leave it like this. Enable the add to shape area option in the tool options bar.

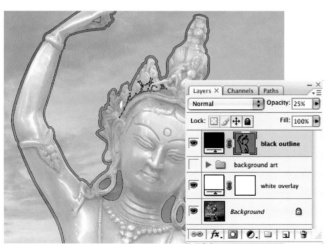

Changing fill color

The quickest method for changing the fill color of a solid color layer begins by targeting it in the layers palette. Once the layer is targeted, you can type alt(PC)/option(Mac)-delete on the keyboard to change the fill color of the layer to your current foreground color. To change it to your current background color, type Control(PC)/Command(Mac)-delete instead.

14 I Reduce the opacity of the layer to 25% in the layers palette. The logic for doing this will reveal itself very soon. Use the pen tool to draw additional closed path components within the solid color layer's vector mask, where you want black to appear. These components will reveal the black of the solid color layer. The reason why the opacity of the layer is reduced is because, as you draw within a vector mask on a layer like this, the components effects become visible as you go, even before they're closed, and it can become visually distracting as you work.

15 I With the pen tool set to add to shape area, continue to carefully draw closed path components that trace all of the dark details of the statue. Remember to simplify and stylize the details as you see fit. Zoom in and out as necessary while you work. Some areas, like her chest, ear holes, and the space between her neck and shoulders will require a two-step process. The first step is to create path components that cover the entire areas. There is a logic to this as well, as we'll be performing a careful subtraction operation next.

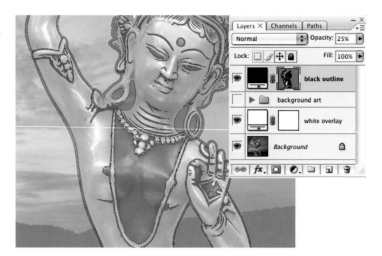

Repairing banding

If you find that banding persists in your gradient fill layer, convert the fill layer to pixels by rasterizing it first. Choose Layer>Rasterize>Fill content from the menu. After you've rasterized the layer, ensure that it is targeted in the layers palette and then add a bit of noise to it. Choose Filter>Noise>Add Noise from the menu. You'll notice that adding noise breaks up the banding. Try to add as little noise as possible or your gradient will start to appear grainy.

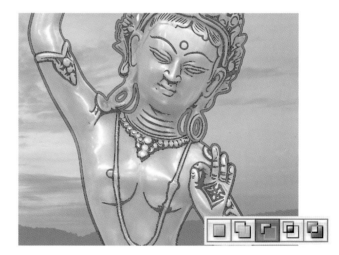

16 I The process is much the same as the one you used to create the outline for the figure, except we're working with shape layers right now instead of path components, so that the results are immediately visible. Ensure that no path component is currently selected and then choose the subtract from shape area function in the tool options bar. With this function enabled, trace the areas inside your black shapes that you want to subtract from the black areas. Remember to create these closed 'subtractive' components at a fair distance inside the larger 'additive' components. So that the result is an outline, similar to your original figure outline.

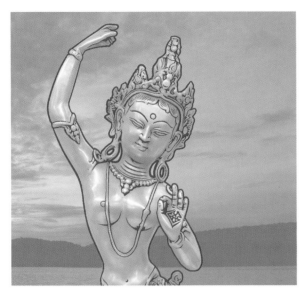

17 | Return the opacity of your layer to 100% now that you've finished creating all of the outline art. Ensure that no single path component is selected, but the paths that make up the vector mask on the canvas are all visible. If you can't see the paths, simply target the vector mask and they will become visible. Control(PC)/Command(Mac)-click on the vector mask thumbnail in the layers palette to load it as a selection. Type Control(PC)/Command(Mac)-shift-I on the keyboard to invert the selection and press the 'q' key on the keyboard to enter quickmask mode. In quickmask mode, areas that lie outside of your selection are indicated by a red overlay.

Hiding the vector mask

If you find that the presence of your vector mask is visually distracting, the quickest way to hide it is to use the keyboard shortcut. Type Control(PC)/Command(Mac)-h on the keyboard to hide the vector mask from view. If you want to show it, just type the same keyboard command. When the mask is hidden, this keyboard command reveals it, and vice-versa.

18 | Select the paint bucket tool and set your foreground color to black. Click in the background area of the image to fill it with red. This masks the area, thus removing it from your selection. Now, click in the areas between her neck and her ears, as well as the holes in her ears and her crown, to fill them with the red overlay, masking them as well. By masking everything except the inside regions of her body, we are ensuring that when we exit quickmask mode, we will have a selection that contains only that. Everything else that is masked, indicated by the red overlay, will fall outside of the selection border.

19 I Press the 'q' key to exit quickmask mode. Your mask is now converted to a selection border that surrounds only the inside areas of the figure. Choose Select>Modify>Expand from the menu to expand your currently active selection by only one or two pixels. Do not expand the selection too much or it will stray beyond the outline. Now, with the currently modified selection active, create a new solid color fill layer in the layers palette. Choose a bright yellow color from the picker and then drag your new, masked, solid color layer beneath the black outline layer in the layers palette.

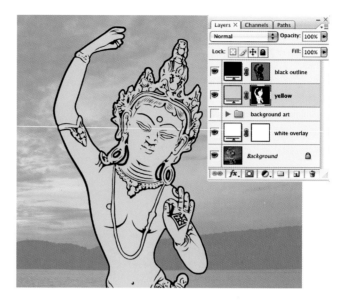

Expanding selections

The reason why selections are expanded before using them to create masked solid color layers is to safeguard against thin, hairline spaces between colors. Think of expanding your selections as a form of trapping, by creating an area of slight overlap, there is no risk of the background showing through in-between colors.

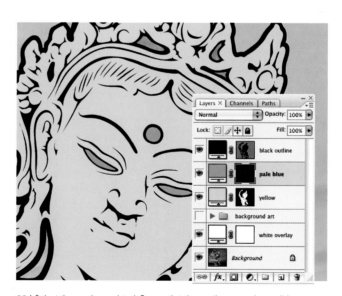

20 I Select the magic wand tool. Ensure that the contiguous and use all layers options are enabled in the tool options bar. Click on the yellow area inside her eye outline to select it. Shift-click on the same area in her other eye and the inside of the circle on her forehead too, adding these areas to the active selection. Expand the selection like you did previously and then, with the current selection active, create a new solid color layer. Choose a pale blue color from the picker.

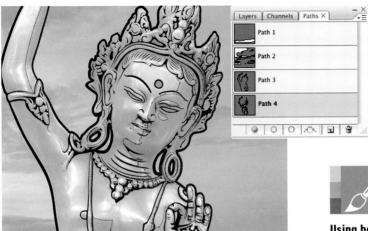

21 | Temporarily disable the visibility of your yellow solid color layer. We need to get it out of the way to define different areas of shading which are visible in the underlying statue image. Using the regions on the photograph as a starting point, we're going to create the effect of lights with different colored gels. Select the pen tool. Ensure that it is set to create paths and that the add to path area function is enabled. Create a series of path components that trace some of the shaded regions on the right of the statue.

Using both masks

In addition to your vector masks, you can add layer masks to your fill layers as well. Simply target a fill layer that already has a vector mask applied to it and click on the add layer mask button at the bottom of the layers palette. This will add a layer mask to your layer as well. Using a layer mask will allow you to use paint tools to mask your layer, creating gradual and soft blending effects that can't be achieved via vector masks.

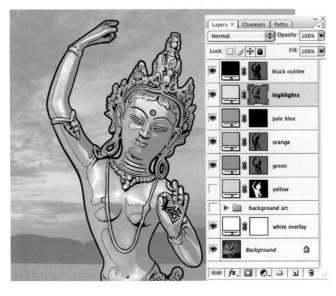

22 | Ensure that no single path component is selected, yet the path is still visible on the canvas. Create a new solid color layer and choose a green color from the picker. Drag this layer beneath the blue layer that fills her eyes and forehead circle with color. Switch the pen mode to create paths in the tool options bar, because it will have automatically switched to shape layers mode. Now draw a series of similar path components that trace similar areas on the left side. Again, with no single component selected, create a new solid color layer. This time choose an orange color.

23 | Disable the visibility of all of your solid color layers except for the black outline layer. Again, set the pen tool to create paths and enable the add to path area option. This time, use the underlying photo as a guide for creating another series of closed paths that trace the very bright specular highlights on the surface of the statue. Ensure that no single path component is selected and then create a new solid color layer. This time, choose a very light yellow color from the picker. Drag this layer up in the layers palette, so that it resides directly beneath the black outlines layer.

Rasterizing vector masks

In the event that you want to do something paint tool related to your vector mask, you can rasterize it, converting it to a regular layer mask. Simply target the layer in the layers palette and then choose Layer> Rasterize>Vector Mask from the menu. Once the mask is converted, you can target it and use any paint tools to edit it, allowing you to achieve effects that simply cannot be performed within a vector mask, like softly blending or blurring the contents of the mask.

24 | Drag your white overlay into the trash in the layers palette to delete it. It is no longer required. Enable the visibility of any fill color layers that weren't visible and take a good look at your illustration now. It is almost complete, but it needs some interesting shading to finish it off. Again, set the pen tool to create paths and ensure that the add to path area function is enabled. Take a good look at the green areas of the figure and try to visualize where some darker green shades would help to add a sense of depth.

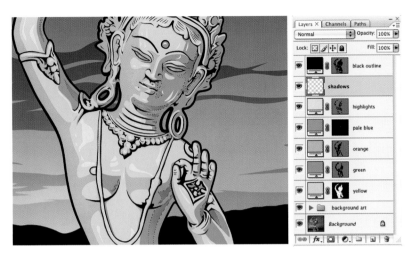

25 | Use the pen tool to create a series of closed path components where you want your shaded areas to go. Load the path as a selection and create a new layer in the layers palette. Select the gradient tool. Choose the foreground to transparent gradient preset and select the radial method in the tool options bar. Select a darker green foreground color from the picker. With the current selection active and the new layer targeted, create a series of gradients by clicking and dragging. If things are looking too dark, reduce the opacity of the gradient in the tool options bar.

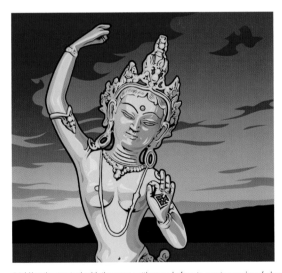

26 | Use the pen tool, with the same settings as before, to create a series of closed path components to indicate the areas of shadow within the orange areas on the statue's other side. Load the entire path as a selection and choose a dark orange foreground color from the picker. Use the gradient tool now, with the same settings as before, to complete your illustration by adding a series of gradients within the selection on the current layer. Use the same logic and procedure as you did while creating your dark green shaded areas. Feel free to edit any vector or layer masks, tweak colors and add or remove any path components as you see fit, embellishing the illustration further.

Vary the color scheme

When you've completed the illustration, nothing is carved in stone. Have a look at the layers palette and you'll see that the file is built in a methodically separated, highly editable way. Go ahead and double-click some of the fill layers. Change the solid colors and alter the gradient layer. Layers that are actual pixels will require direct edits via the Image>Adjustments menu. But have some fun and try different color combinations. You may even hit upon something you like better than the original.

Original model photos: Orlando Marques Hair and makeup stylist: Carla Marques Model: Josie Lyn

When you are photographing subjects for the purpose of illustrating over later, it is important to think differently than you would if you were shooting for traditional purposes. You need to light the scene, adjust the aperture and pose your model in a way that allows you to see differentiation between regions of highlight and shadow, as well as keep as much of the subject in sharp focus as possible. The resulting images do not have to be technically perfect with regards to photography, as long as the aforementioned criteria are met.

Below and on the opposite page, you can see how the above images were used as the basis for illustrations. Both incorporate the techniques explained in this chapter. As you can see in these illustrations, you aren't limited to this particular style only. These pieces combine a variety of different styles and methods, while using the techniques described in this chapter to illustrate the main visual element within each composition.

Chapter 6

Illustrating from Sketches

In the previous chapter, you learned how to create stunning illustrations from existing photography. That is an excellent method to create bold and sharp works of art when you have the appropriate materials to trace from. However, what do you do when you lack photographic resources, and all that you possess is an idea of what you wish to create? The answer to this question can be found at the end of any pencil: start with a sketch. Quickly sketching onto paper is a tried and true method for recording visual ideas, and an integral starting point when it comes to illustrating. However, as much as sketching is an integral part of the illustrating process, it is what you create from that sketch within Photoshop that will transform your basic idea into a professional piece of finished art.

As with tracing photography, we'll be using the Pen tool to create the regions and define the outer edges of our artwork. However, when working from a sketch, it is necessary to refine the artwork as you go. You'll need to not only trace the art, but also create smooth line work of a uniform thickness, add sharp areas of detail, and define regions of varying color. Whereas, when tracing photography, the idea is to simplify, reduce detail, and use what is already there in a stylized manner. Also, when working from sketches rather than photography, your subject matter is not limited to your available photographs, you're only limited by your imagination.

When working with a sketch, always remember that it is merely a starting point. Photoshop provides all of the tools necessary to improve upon and embellish the artwork along the way. Using Photoshop to create artwork from sketches allows you to create finished art that is true to your original idea in terms of concept, but vastly superior when it comes to execution.

1 | Begin by opening up the sketch.psd file. This is the scanned drawing we're going to use as the basis for creating the illustration on the opposite page. As you can see here, the basic idea exists within the sketch. However, when you look at the finished art on the opposing page, you can see that a lot of refinement and embellishments were made to transform the sketch into a finished piece. The first step in the transformation is to carefully define the outer shape of the figure. Select the Pen tool.

Starter file

The sketch needed to follow along with this chapter and create the featured illustration is available on the accompanying CD. This file can be found in the folder entitled: chapter_06.

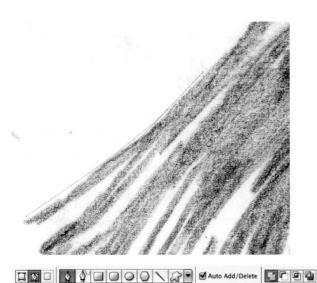

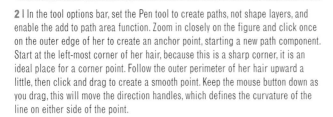

2 | In the tool options bar, set the Pen tool to create paths, not shape layers, and enable the add to path area function. Zoom in closely on the figure and click once on the outer edge of her to create an anchor point, starting a new path component. Start at the left-most corner of her hair, because this is a sharp corner, it is an ideal place for a corner point. Follow the outer perimeter of her hair upward a little, then click and drag to create a smooth point. Keep the mouse button down as you drag, this will move the direction handles, which defines the curvature of the line on either side of the point.

Embellish as you go

Your path doesn't have to follow the sketch exactly, remember the idea here is to improve upon the drawing. Use the sketch as a guide, but create your paths however you think they work best. Don't worry about tracing the sketch exactly, you'll get a much better result if you focus on creating clean line work and smooth curves.

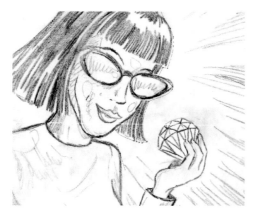

3 | Release the mouse button and move upwards, further along the outer edge of her hair. Click and drag to create another direction point, when you are happy with the approximate curve of the new line segment, release the mouse button. Use this method to work your way around her hair, creating a curved path component. When you get to a sharp corner, simply click and then move on to the next point, creating a corner point instead of a smooth point. Work your way around the entire perimeter until you get to the place where her chest meets the bottom of the canvas.

Screen modes for panning

In order to work beyond the edge of the canvas, you'll need to be working with a screen mode that allows you to see the area beyond. Selecting either Full Screen Mode with Menu Bar or Full Screen Mode from the options available at the bottom of the toolbar are your best options. Although Maximized Screen Mode will allow you to see and work with the areas beyond the edge of the canvas when you're zoomed out far enough, you cannot move the canvas around with the pan tool when you're zoomed out that far. You can toggle through screen modes quickly by simply pressing the 'f' key on the keyboard.

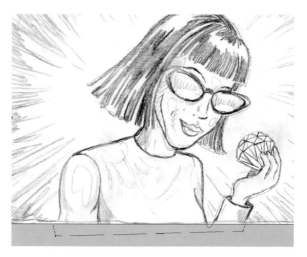

4 | Hold down the space bar to temporarily access the Pan tool. Drag upwards so that you can see the area below the bottom edge of the canvas. Continue to draw your path so that it dips below the bottom of the canvas and then rises back up to trace the contour of her hand. Do not trace the outer edge of the diamond just yet. When you've traced the contour of her hand and find yourself at the bottom edge of the canvas again, create a point below the canvas and then another point below the canvas at the far left.

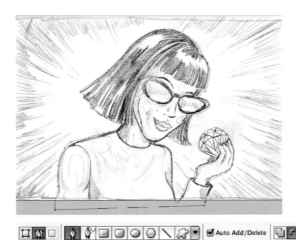

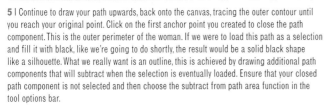

5 | Continue to draw your path upwards, back onto the canvas, tracing the outer contour until you reach your original point. Click on the first anchor point you created to close the path component. This is the outer perimeter of the woman. If we were to load this path as a selection and fill it with black, like we're going to do shortly, the result would be a solid black shape like a silhouette. What we really want is an outline, this is achieved by drawing additional path components that will subtract when the selection is eventually loaded. Ensure that your closed path component is not selected and then choose the subtract from path area function in the tool options bar.

6 | With the subtract from path area option enabled, carefully trace the inside areas of the woman, creating numerous, closed path components that will subtract from the outer path when we load it as a selection. Use the sketch as your guide to trace all of the white regions that exist inside the black outline of the sketch and within the outer perimeter defined by your first path component. Trace her skin, the fabric of her shirt, hair highlights, the inside of her glasses, etc. And remember, if you accidentally create a path component using the wrong path area operation, simply select it with the path selection tool and change the path area function in the tool options bar.

Editing paths

Use the direct selection tool to select individual points of your path components and edit them. You can move anchor points by clicking on them and then dragging. When you click on a smooth anchor point, the direction lines will appear. Clicking and dragging on a direction handle at the end of a direction line allows you reshape the curves on either side of the direction point.

Converting points

You can access the convert point tool within the expanded pen tool button in the tool bar, or by holding down the alt(PC)/option(Mac) key when using the pen tool. To convert a corner point to a smooth point, simply click and drag on it using the convert point tool. Direction lines will appear, curving the line segments on either side of the point as you drag. To convert a smooth point to corner point, click on it once with the convert point tool and the direction lines will disappear, removing the direction lines and the curvature from the line segments.

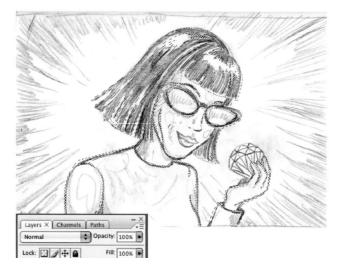

7 | When you close your last path component, there should be no single component currently selected within your path. If for some reason, you have a single component selected, use the path selection tool or the direct selection tool to click on an area of the canvas that contains no path. This will deselect any selected path component(s). Ensure that your new path is targeted in the paths palette, then click on the Load Path as a Selection button at the bottom of the palette. With the selection active, return to the layers palette and click on the create a new layer button at the bottom of the palette.

Auto add/delete

When using the Pen tool, by default, the auto add/delete option is enabled. When this option is enabled, points are added to, or removed from any selected path depending upon where you click. If you click on an existing point, it will be removed. If you click on a line segment, a point will be added.

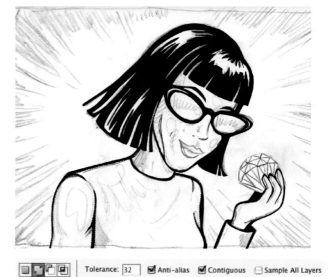

8 | Press the 'd' key to set the foreground color to black if it isn't already. Ensure that your new layer is targeted and your current selection is active. Type alt(PC)/option(Mac)-delete to fill the active selection with the current foreground color on the new layer. Type Control(PC)/Command(Mac)-d to deactivate the selection. Select the magic wand tool. In the tool options bar, ensure that the contiguous option is enabled, sample all layers is disabled, and that the tolerance is left at its default setting of 32. Click on her shirt area contained within the black outlines to load it as a selection.

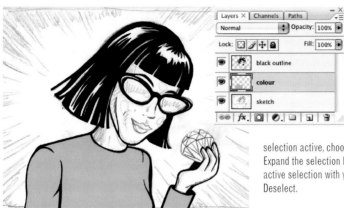

9 | Hold down the shift key and click on her sleeve area as well, adding it to the currently active selection. Click on the foreground color swatch in the toolbar to open the picker. Select a bright orange color from the picker and click OK to specify it as the current foreground color. Create a new layer in the layers palette and drag it beneath the black outline layer. With the selection active, choose Select>Modify>Expand from the menu. Expand the selection by a single pixel or two and then fill the active selection with your new foreground color on the new layer. Deselect.

Fill the remaining areas

Repeat this same method to add a variety of colors to different outlined regions of the artwork.

1 | Target your outline layer in the layers palette and use the magic wand to select her face, neck, and hand regions that are surrounded by black outlines. Leave the selection active and then target the underlying layer. Expand the selection by one or two pixels.

2 | Select a yellow foreground color and fill the active selection with it. Deselect and target the black layer again. Use the magic wand to select her hair highlights. Return to the underlying layer and expand the selection. Select a blue foreground color from the picker.

3 | Fill the active selection with your new foreground color. Repeat this method to add some purple into the highlight areas of her glasses frames. Finally, repeat the process again to add some gray into the lenses of her glasses. Keep this selection active.

10 | Select the gradient tool. Choose the foreground to transparent preset and enable the radial method in the tool options bar. Set the foreground color to white and set the opacity of the gradient tool to 75%. Click and drag once, starting at the top edge of each lens selection border and dragging outwards slightly, to create white highlights at the top of each lens. Next, switch the foreground color to green and add larger gradients into each lens near the bottom. Finally, choose a very light yellow foreground color and create two smaller gradients over top of the green ones you just created.

Mode: Normal Opacity: 75%

Create an action

When repeating the same task over and over again, like expanding a selection, create an action to save you time in the long run. To begin, ensure that you have a selection active. Then, in the actions palette, click on the Create New Action button. Name your action, assign a function key, and click Record. Expand your selection and then click the stop recording button in the Actions palette. The next time you want to expand a selection, all you need to do is click on the assigned function key to play the action, which will automatically expand your selection.

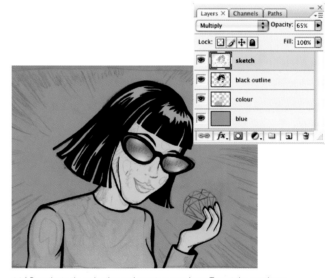

11 | Deactivate the selection and create a new layer. Target the new layer and choose a new, light blue foreground color from the picker. Type alt(PC)/option(Mac)-delete to fill the entire new layer with the foreground color. Drag the layer to the bottom of the stack in the layers palette. Then drag the sketch layer to the top of the stack. From now on, we'll enable and disable the visibility of the sketch layer as required, making it visible only when it is needed as a guide. Change the blending mode of the sketch layer to multiply and reduce the opacity to 65%.

12 I Select the pen tool and ensure that the add to path area option is enabled. Draw a closed path component around the perimeter of her lips, using the same method you used to draw your first path component around the entire woman. Now examine the details of her face that are indicated by the sketch. Create a few thin, closed path components that will add lines of detail to her face. Next, select the subtract from path area option and create two closed path components, surrounding her lips, inside the outer lips path component. Load the entire path as a selection.

Breaking a curve

When you click and drag on a direction handle with the direct selection tool, it moves the direction lines on either side of the direction point, altering the curves of both line segments. However, if you click on a direction handle with the convert point tool, it will convert your smooth point to a corner point with independent direction lines. This means that the direction lines do not affect the line segment curve on the other side of the point when moved, only the curve on the same side of the point is affected.

13 I Target the layer that contains your black outline art in the layers palette, and fill the new selection with black on that layer. Deactivate the selection and select the magic wand tool. Using the same settings as before, use the magic wand to target both empty areas inside the lip outlines. Expand the selection slightly using the Select>Modify>Expand menu option and target the layer that contains your other solid colors in the layers palette. Fill the active selection with red on this layer and deselect. Select the Pen tool and ensure that the add to path area option is enabled.

14 | Use the Pen tool to draw a closed path component that surrounds the outer perimeter of the diamond shape. Next, enable the subtract from path area function and create a closed path component for each facet on the inside of the diamond shape. Ensure that no single path component is selected and then load the entire path as a selection. Create a new layer and place it above the solid blue layer. Select a purple foreground color from the picker and fill the active selection with it on the new layer. Disable the visibility of the sketch layer to see the illustration clearly.

Refine edge

CS3 offers another method for expanding selections, amid a plethora of other features in the new Refine Edge option. When you have a selection active, click on the Refine Edge button in the tool Options bar. Drag the Contract/Expand slider to the right to enlarge the selection boundary, expanding the selection. Or, instead of dragging the slider, you can enter a numeric value in the field.

15 | Use the magic wand tool to select all of the inner facet areas of the diamond. Expand the selection as you've been doing previously and create a new layer. Drag the new layer beneath the diamond outline layer and fill it with a very light purple color. Deactivate the selection and create another new layer. Drag this layer up within the layers palette, until it resides directly below your black outline layer. Choose an orange foreground color. Use the gradient tool, with the same settings as before, to create a series of gradients over areas of her face that require shading.

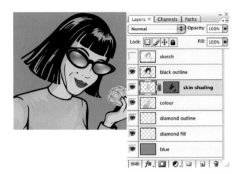

16 I Worry not, all unwanted areas of gradient will be hidden in a moment. Right now, continue to add orange gradients over areas of her neck and hand that will require shading as well. When finished, select the Pen tool and enable the add to path area option. Draw a series of closed path components around only the regions of her skin where you want the orange gradients to be visible. Ensure that no single path component is selected and then choose Layer>Vector Mask>Current Path. This will constrain the visibility of your gradients to the areas within the vector mask's path components.

Create a series of masked gradient layers

Use the same method of creating gradients and applying vector masks to add highlights and shadows to different parts of the illustration across multiple layers.

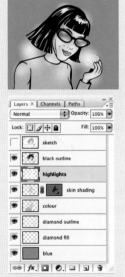

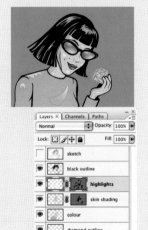

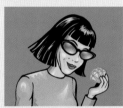

1 I Create a new layer beneath the black outline layer. Target it and create some new radial, white to transparent gradients on this layer, in areas where you'd like to add highlights. For a less drastic result, reduce the gradient opacity in places.

2 I Select the pen tool. With the add to path area function enabled, create a series of closed path components to contain your highlight gradients within specific regions on the canvas. Ensure that no single path component is selected and choose Layer>Vector Mask>Current Path from the menu.

3 I Use this method to create new, vector-masked layers with different colored gradients on them, indicating the different shades within her shirt and the diamond. Also add some darker shading to her face and neck, using the same procedure once again.

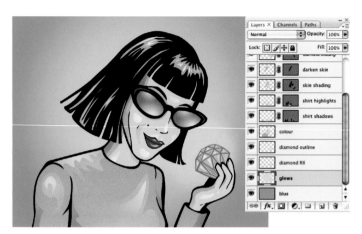

17 I Create a new layer and place it directly above the solid blue layer in the layers palette. Select the gradient tool. Leave the options set as they were, except increase the gradient opacity to 100%. Choose a very light blue foreground color from the picker, then click and drag to create a large, light blue to transparent gradient in behind the woman's head on the new layer. Repeat this process a couple of times to intensify the gradient. Then choose a light purple foreground color and repeat the same process to add a glow behind the diamond.

Continuing to edit masked layers

Once you've created your gradients and added a vector mask to a layer, it doesn't mean that your layer contents have to remain that way. Remember, in areas where you added shading within a vector mask, you can edit the layer contents whenever you like. Simply target the layer, not the mask, in the layers palette and edit the layer using any paint tool. You can paint with a brush or add different colored gradients to alter the colors. Paint anywhere on the layer you like, but bear in mind that only areas that aren't clipped by the layer mask will be visible.

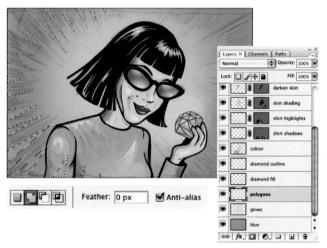

18 I Create a new layer and select the polygonal lasso tool. Enable the visibility of your sketch layer once again. However, ensure that your new layer is presently targeted in the layers palette. Enable the add to selection option in the tool options bar and draw a series of polygons on the left side of the canvas, based on what is indicated by the sketch layer. Select the gradient tool and choose a green foreground color from the picker. Set the gradient opacity to 50%. Click and drag repeatedly, from the edges of the canvas inwards, to create a series of gradients within the polygons around the left edges of the canvas.

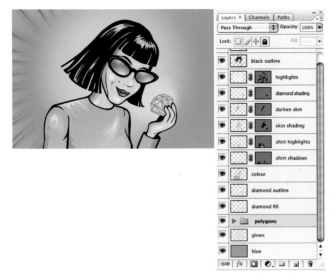

19 | Deselect and create a new layer. Disable the visibility of the sketch layer. Target the new layer and again, draw a series of polygonal shaped selections. This time, make them thinner than before, and try to create them in-between the larger polygons that you created previously. Use a dark blue foreground color and the gradient tool to create numerous gradients within this selection on the new layer. Deactivate the selection when you're finished. In the layers palette, click on the layer below while holding down the shift key to target it too. Choose Layer>New>Group From Layers from the menu.

Zooming

When creating and editing paths, I often find myself zooming in close to edit individual points, and then zooming out to view the results of these edits within the entire path. Rather than always having to switch back and forth between the zoom tool and any path creation or editing tool, you should familiarize yourself with the keyboard shortcuts for zooming. Type Control(PC)/Command(Mac) '+' to zoom in, or type Control(PC)/Command(Mac) '−' to zoom out.

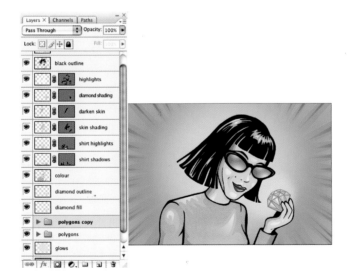

20 | Click on the group in the layers palette and hold down the alt(PC)/option(Mac) key. Drag upwards until you see a very dark horizontal line appear directly above the group in the layers palette and release the mouse button. This creates a copy of the group directly above the original. Target your newly copied group and then choose Edit>Transform>Flip Horizontal from the menu. Select the move tool. Click and drag to the right, while holding down the shift key, until your flipped polygons are moved to the right edge of the canvas.

Just take a look at these examples and you can see the flexibility inherent within the method of working. Feel free to incorporate type layers, repeating patterns, color divisions, or anything else you can think of to add interest and diversity to your illustrated work.

When you choose sketches over photography as your raw resource material, there are no limits when it comes to subject matter. Proven here by the contents of this page, your illustration subjects can be as wild as your imagination.

Chapter 7

Retro Art Effects

There is a certain quality to vintage pop art that usually makes me smile. I am not sure whether it is the perpetually happy and whimsical figures, the coarse halftone patterns and inferior printing, or the gaudy combinations of color. But there is something about that 1950s drive-in style, 'everything-is-wonderful' advertising art that is genuinely unique and strangely optimistic.

From a Photoshop artist's perspective, perhaps a major part of the appeal is just how different it is than most contemporary digital art. As far as execution goes, printed retro art was generally done on the cheap. Registration didn't always match up so well, colors overlapped, and halftone screens were overly large. Age is almost certainly another contributing factor to the appeal. Whether the artwork was part of a sign that has spent forty odd years outdoors, or on an old cardboard box that has been sitting in a mothball-ridden attic, the signs of age are always evident. Areas of color become worn, and printed inks will eventually display numerous scrapes and scratches.

Photoshop is a tool that allows us to achieve absolute perfection in almost anything we set out to do. However, in this chapter, I really want to draw your attention to the fact that Photoshop is an extremely useful tool when it comes to methodically reproducing imperfection. Retro art's simplicity of design, rough and imperfect execution, and whimsical nature, is a breath of fresh air for those of us who could use a break from the seriousness and perfection of working digitally day to day.

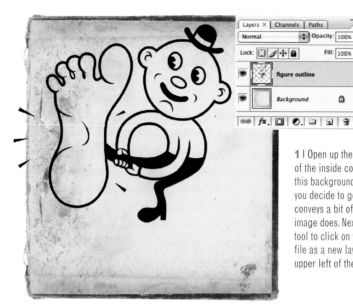

1 | Open up the background.jpg file. This is a desktop scan of the inside cover of an old library book. You can substitute this background image with one of your own if you like. If you decide to go this route, try and choose something that conveys a bit of age, distress, and imperfection like this image does. Next, open up the figure.psd file. Use the move tool to click on your figure and drag it into the background file as a new layer. Drag the contents of the new layer to the upper left of the book cover on the canvas.

CD files

The files needed to follow along with this chapter and create the featured illustration are available on the accompanying CD. These files can be found in the folder entitled: chapter_07. However, do not feel restricted to using these files only. Feel free to follow along and incorporate background imagery and textures of your own as you work through the chapter. Also, rather than using the supplied outline art files, you can create your own outline art using the methods described earlier in either Chapter 5 or Chapter 6.

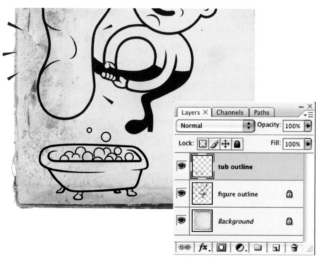

2 | Click on the foreground color swatch in the toolbar to open the picker. Choose a dark blue color from the picker and click OK. With your newest layer targeted, enable the lock transparent pixels option in the layers palette. Type alt(PC)/option(Mac)-delete to fill the solid pixels on the current layer with your new foreground color. Change the blending mode of the layer to multiply. Next, open up the tub.psd file. Again, use the move tool to drag it into your working file as a new layer. Position it beneath the figure on the canvas.

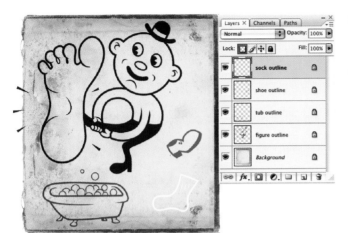

3 I Lock the transparency of the tub layer and then fill it with a slightly lighter blue foreground color. Change the blending mode of the layer to multiply and reduce the opacity a little. Open the shoe.psd file and drag it into your working file as a new layer. Position it to the right of the figure, lock the transparency, and fill the layer with a very light blue foreground color. Repeat this same process one more time to add the sock.psd art to the file as a new layer. Fill the sock with a very light, off-white color.

Create a texture channel

Use a desktop scan of an ordinary slate tile to create a new alpha channel that will assist in ageing your outline art.

1 I Open up the slate.jpg file. Choose Image >Mode>Grayscale from the menu to remove the color information from the file. After converting to grayscale mode, choose Image>Adjustments>Levels and perform a very drastic input levels adjustment, like the one shown here.

2 I Choose Select>All and then Edit> Copy from the menu. Return to your working file. In the channels palette, click on the Create New Channel button. Target the new channel and choose Edit>Paste from the menu. Feel free to use the move tool to reposition the pasted contents.

3 I Click the load channel as a selection button at the bottom of the channels palette. Target all of your outline art layers and type Control(PC)/ Command(Mac)-g to group them. With the current selection active, click on the add layer mask button to mask the group.

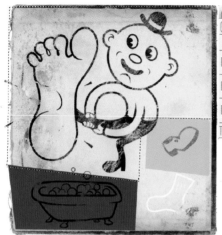

4 | Type Control(PC)/Command(Mac)-shift-n on the keyboard to create a new layer. Drag the layer beneath the group in the layers palette and select the polygonal lasso tool. Use the polygonal lasso to draw a shape that surrounds the bath tub on your new layer. Select a deep red foreground color from the picker and fill the selection with it. Repeat the same procedure to create a green polygonal shape on this layer that surrounds the shoe. Now use the polygonal lasso tool to draw an irregular shaped selection that surrounds the top portion of the background.

Editing masks

You can reintroduce any masked areas by adding white into those areas when your layer mask is targeted in the layers palette. If too much of your group is masked by your channel-based mask, go ahead and paint white over those areas with a soft paintbrush and a white foreground color to make them visible again. You can also reduce the areas affected by your hue/saturation layer masks by targeting the mask and then filling a selected area with black, hiding the effect in that area.

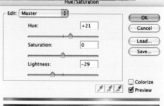

5 | With the current selection active, create a new hue/saturation adjustment layer by choosing hue/saturation from the list of options in the create new fill or adjustment layer menu at the bottom of the layers palette. Adjust the hue to +111, and reduce the saturation by 76. This creates a hue/saturation adjustment layer with a mask based upon your selection border. Now use the polygonal lasso tool to draw a selection border around the sock area. Again, create a new hue/saturation adjustment layer. Set the hue to +21, and reduce the lightness to −29.

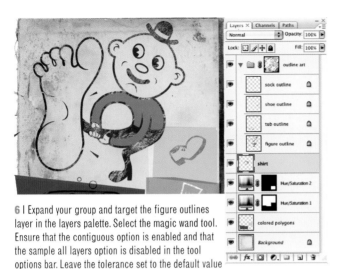

6 | Expand your group and target the figure outlines layer in the layers palette. Select the magic wand tool. Ensure that the contiguous option is enabled and that the sample all layers option is disabled in the tool options bar. Leave the tolerance set to the default value of 32 and click in the figure's empty shirt area that is surrounded by outline art. With your new selection active, create a new layer and drag it beneath the expanded group in the layers palette. Fill the active selection with a lighter red foreground color and deselect.

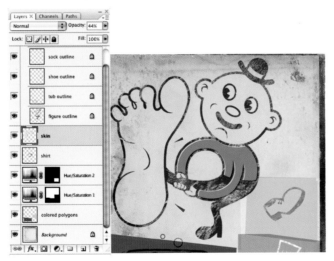

7 | Use the move tool to click and drag a little, offsetting the registration so that the fill color of his shirt doesn't match up with the outline. Again, target the figure outline layer and this time, click in the face area to select it. Then hold down the shift key and click inside the other areas of skin like his foot, hands, etc. This will add all of these areas to your selection. Create another new layer beneath your group in the layers palette. Fill the active selection with a flesh colored foreground color and deselect. Reduce the opacity of the layer to 44%.

Nudging

You can use the move tool to reposition the contents of any layer on the canvas, however, sometimes you may only want to adjust the positioning of something by a few pixels. When you just want to give the contents of your targeted layer a gentle nudge in a certain direction, first select the move tool. Then try using the arrow keys on the keyboard instead of clicking and dragging the move tool. The arrow keys make performing very subtle movements an effortless procedure.

8 | Duplicate the layer by dragging it onto the create a new layer button at the bottom of the layers palette. Increase the opacity of the duplicate layer to 100% and use the move tool to offset the position slightly on the canvas so that the color appears to be out of register. Repeat this method of selecting areas with the magic wand, filling the selections with different colors on new layers, and offsetting the registration, filling all of the outline art. Fill the remaining areas of the figure outline layer and also fill the outlined areas indicated by the other outline art layers.

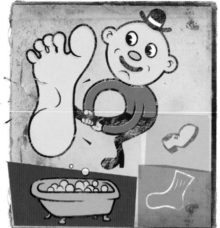

Hide a mask

When you mask a layer or group while a selection is active you'll immediate see the results, as all areas that lie outside of your currently active selection border are masked. Sometimes you may feel that the result is too drastic, and perhaps you want to unmask some currently masked areas to reveal layer contents hidden by the mask. Often, it can be difficult to visualize which areas you want to reveal because they are masked and therefore not visible. However, you can temporarily hide a layer mask by holding down the shift key and clicking on it in the layers palette. The mask thumbnail will be covered with a red 'x'. This will allow you to see your unmasked layer so you can decide which regions need to be revealed. Then, shift-click on the mask thumbnail to make it visible again and edit the mask's contents.

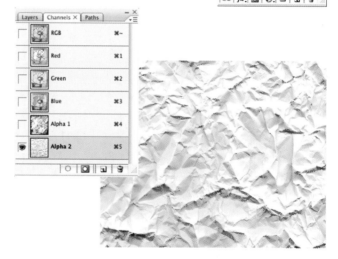

9 | Target all of the individual layers that you created, which fill the outlined areas of your artwork, and add them to a new group in the layers palette. Open up the crumpled.jpg file. Type Control(PC)/Command(Mac)-a to select all and then type Control(PC)/Command(Mac)-c to copy. Once you've copied the crumpled paper image, return to your working file. Create a new alpha channel in the channels palette. Target the channel and then type Control(PC)/Command(Mac)-v to paste the crumpled paper image into the new channel. Load the new channel as a selection.

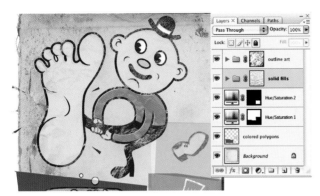

10 I Target the new group containing your filled area layers in the Layers palette. With the current, channel-based selection active, click on the add layer mask button at the bottom of the layers palette to mask the group. Masking this group while the crumpled paper based selection is active will add a nice, subtle distress effect to all of the filled area layers within the group.

Create a halftone screen pattern

Clever use of the Color Halftone filter within a new alpha channel allows us to create and store a dot pattern, which can then be loaded as a selection border.

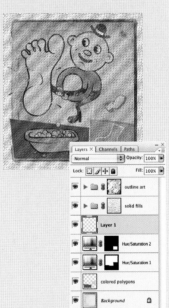

1 I Create a new alpha channel in the channels palette. With this new channel targeted, click on the foreground color swatch in the toolbar and select a light gray foreground color from the picker. Then type alt(PC)/option(Mac)-delete to fill the entire channel with it.

2 I Choose Filter>Pixelate>Color Halftone from the menu. Enter a maximum radius of 9 pixels and set the screen angles of all four channels to 45°. This will convert the gray contents of your alpha channel to a black and white dot pattern.

3 I Load the alpha channel as a selection and return to the layers palette. With your current selection active, create a new layer and place it beneath both of your groups, yet above the adjustment layers, in the layers palette.

11 I With your new layer targeted and the current selection active, select the polygonal lasso tool. In the tool options bar, click on the intersect with selection button. Draw a very rough polygonal selection that overlaps the red background behind the bathtub on the canvas. When you close your polygonal selection, you'll immediately see the results of using the intersect option. Only areas where your two selection borders overlap remain selected. Fill the resulting selection with a light red color and deactivate the selection. Reduce the opacity of the layer slightly.

Create halftone backgrounds

Use the halftone channel alongside the polygonal lasso's intersect function, to create and fill a series dotted of backgrounds for your line art.

1 I Load the channel as a selection again and use the polygonal lasso to create a selection border behind the shoe that intersects with the channel-based selection. Fill the area with green on a new layer. Repeat this process to add a light blue pattern behind the lower portion of the figure.

2 I Load the halftone channel as a selection again and this time, choose Select>Inverse from the menu. Again, use the polygonal lasso to draw a selection border intersecting the area behind the upper portion of the figure. Fill the selection with gold on a new layer.

3 I Use this same method to load the channel as a selection, invert it, and draw a polygonal selection that intersects the selected area behind the sock. Fill the resulting selection with green on a new layer. Deactivate the selection.

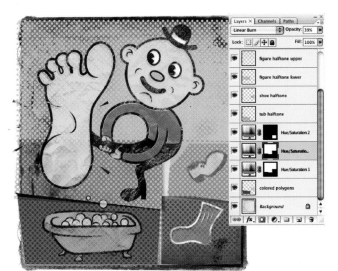

12 | Now that the composition is beginning to take shape. Let's take a moment and look at things that require a bit of refining to enhance color and contrast overall. Because this file is built as separate layers, performing alterations is easy. First, change the blending mode of the hue/saturation layer that affects the area behind the sock to multiply. Next, change the blending mode of the halftone layer behind the lower portion of the figure to multiply and reduce the opacity. Finally, duplicate the other hue/saturation adjustment layer, change the blending mode to linear burn, and reduce the opacity considerably.

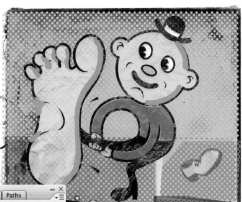

13 | Target all of the halftone layers, adjustment layers, and areas that contain solid colored polygons. Add all of these background-affecting layers to a new group within the layers palette. After you do this, create a new layer and drag it to the top of stack within the layers palette. Select the brush tool and choose a hard, round brush preset from the brush preset picker in the tool options bar. Choose a dark flesh foreground color from the picker and paint some shading onto the figure's skin on your new layer.

Halftone density

When creating halftone patterns within channels, screen density depends upon the value of the grayscale shade you're converting. Here, a light gray converted to a halftone produces a dot pattern in which the dots do not touch and are surrounded by white space. If you were converting a very dark gray, there would be light colored dots, surrounded by areas of black. Try to envision the density of dot pattern you want to create before you fill your channel with a grayscale value, this will help you choose the right shade of gray and ultimately ensure that you get the selection you want from it.

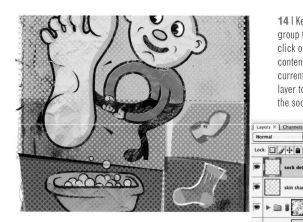

14 | Keep this layer targeted in the layers palette and expand the group that contains your outline art. Control(PC)/Command(Mac)-click on the figure outlines layer to generate a selection from its contents. Press the delete key to remove these areas from your currently targeted layer and deselect. Reduce the opacity of the layer to 61%. Use this same method to paint some details into the sock area on a new layer. Then load the sock outline layer as a selection and delete any painted contents of the selected area on your sock detail layer. Deselect and collapse the expanded group.

Viewing layer masks

Although the layer mask thumbnail in the layers palette provides you with a small preview of the mask's content, it is very small and you can't always see the subtle paint effects that reside within your mask. If you hold down the alt(PC)/option(Mac) key while you click on your layer mask thumbnail it will become visible on the canvas, exactly like you'd see it if you made it visible while hiding the composite channel in the channels palette. This is a quick method to have a look back at how you've edited your masks. Alt(PC)/option(Mac)-clicking on the mask thumbnail again hides the mask and returns the canvas to normal.

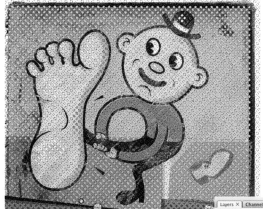

15 | Return to the channels palette and load your halftone channel as a selection once again. Invert the selection and create a new layer at the top of the stack in the layers palette. Choose a darker flesh foreground color than the one you used previously. Paint over shaded areas of his skin within the active selection on the new layer to add darker, halftone shading effects. Next, switch the foreground color to an extremely light flesh color, almost white. Paint within the selection to add highlight areas onto this skin, nose, and hat.

16 | Use a variety of different colors to paint over various areas of this layer to add shading and highlights within the active selection. Increase and decrease the brush diameter as necessary. Also, try reducing the opacity of your brush and painting over areas of the background to introduce different colors into already existing dot patterns. When you're finished, invert the selection and continue to paint on the current layer until you're satisfied with the results and deselect.

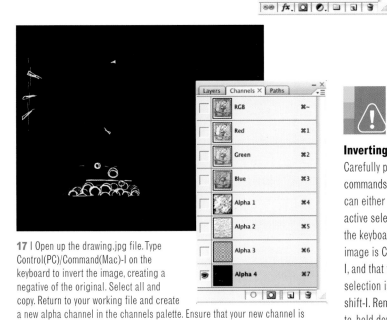

17 | Open up the drawing.jpg file. Type Control(PC)/Command(Mac)-I on the keyboard to invert the image, creating a negative of the original. Select all and copy. Return to your working file and create a new alpha channel in the channels palette. Ensure that your new channel is targeted and paste the copied, inverted image into your alpha channel. Load the channel as a selection.

Inverting keyboard commands

Carefully pay attention to the keyboard commands you use when inverting. You can either invert an image or invert an active selection. Always remember that the keyboard shortcut for inverting an image is Control(PC)/Command(Mac)-I, and that the shortcut for inverting a selection is Control(PC)/Command(Mac)-shift-I. Remembering when, and when not to, hold down the shift key while using these keyboard shortcuts is essential to performing the correct operation each time.

18 | Create a new layer at the top of the stack in the layers palette. Set your foreground color to white and fill the active selection with white on the current layer. Deactivate the selection and use the move tool to position the contents of the layer so that the drawn bubbles nicely overlap the bubbles on the tub outline layer below. Target the top four layers that provide the painted, drawn, and halftone details, and add them to a new group in the layers palette.

The secrets of successful retro art
Let's take a final look at some of the essential techniques required to produce convincing vintage artwork.

a | Starting with an appropriate background image is always helpful. Here an old library book was used, but it can be anything that has a nostalgic feel to it. A background image or texture with an authentic feel will prove much more successful than a flat, solid colored canvas.

b | Using alpha channels as the basis for selections, which are in turn used to mask groups, is an excellent way to create convincing wear and distress. Using appropriate imagery within your channels is very important. Try to choose images containing random patterns and textures, as realistic wear and tear is never orderly.

c | Moving layers that contain fill colors offsets the registration between outlines and solid color fills. This poor registration is a telltale sign of quick and dirty printing, resulting in a distinct look that is about as far away from digital technology as you can get.

d | The halftone screen effect tends to dominate the overall composition in terms of stylistic methods used. It really adds an authentic feel to the finished art, reminiscent of vintage printing methods.

e | Incorporating scanned ballpoint pen art into the composition adds a scratchy, hand drawn feeling, which contributes to the non-digital overall feel of the illustration.

As shown by the examples on this page, working within the framework described in this chapter allows you to create convincing retro art effects time and time again. As you can see, even when sticking to the formula described here, there is room for improvisation within each illustration, making each one stylistically similar, yet unique at the same time.

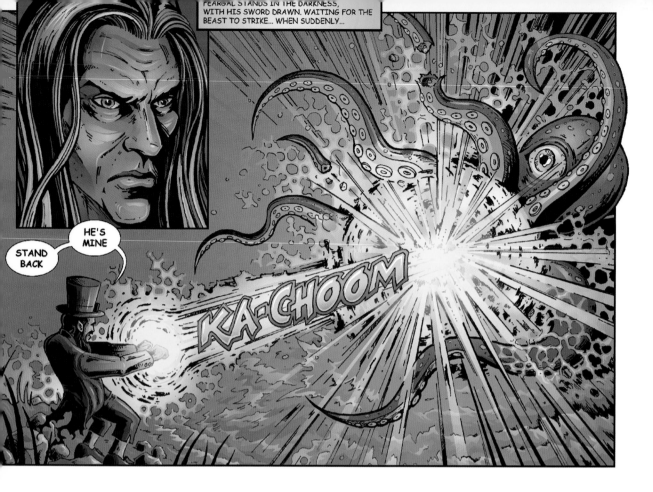

FEARGAL STANDS IN THE DARKNESS, WITH HIS SWORD DRAWN, WAITING FOR THE BEAST TO STRIKE... WHEN SUDDENLY...

HE'S MINE

STAND BACK

KA-CHOOM

Chapter 8

Coloring Comic Art

Not only does Photoshop provide the tools necessary to create stunning images from beginning to end, but it also provides the necessary tools for individuals performing a specific task as part of a larger creative process. In this chapter, we'll be donning the hat of the comic book colorist. A colorist contributes more to the process of comic art creation than merely filling in spaces between the lines. In addition to obviously adding color, the colorist is responsible for refining the light and shadow within the existing ink drawings, as well as creating the mood within each panel via color.

As you shall soon find out, the task facing the colorist is not as effortless as it may appear. Ideally, each region of different color would be surrounded by black outlines in the ink drawing. That way, automatically generated selections could be filled on underlying layers. However, there is no sense in sacrificing the quality of the ink drawing by placing such a rigid restriction on the black and white artist. By taking a creative approach, a capable colorist can work colorful magic within any piece of supplied art. An innovative combination of tools, methods and patience, is the key to bringing any black and white drawing to life via color in Photoshop.

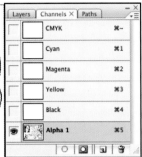

1 | Open up the ink.jpg file. Choose Select>All and then Edit>Copy from the menu. Close the file and then choose File>New from the menu. In the New options, the height, width and resolution will match that of your copied art. Choose CMYK mode, a white background and click OK to create a new working file. In the channels palette, click on the Create New Channel button at the bottom of the palette. With the new channel targeted, choose Edit>Paste from the menu to paste your copied art into the new channel. Click on the Load Channel as a Selection button at the bottom of the Channels palette.

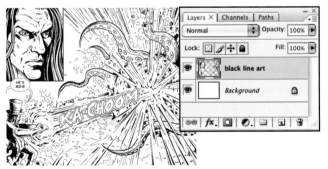

2 | Click on the CMYK composite channel instead of the alpha channel in the Channels palette and return to the Layers palette. Choose Select>Inverse from the menu to invert the selection and then click on the Create A New Layer button at the bottom of the layers palette. Press the 'd' key on the keyboard to set the current foreground color to black. Target your new layer in the layers palette and then type alt(PC)/option(Mac)-delete to fill the currently active selection with black on the new layer. Choose Select>Deselect from the menu to deactivate the selection and target the Background layer in the Layers palette.

Starter file

The ink drawing needed to follow along with this chapter and create the featured illustration is available on the accompanying cd. This file can be found in the folder entitled chapter_08.

Check your channel options

When working with alpha channels, by default, selected areas are white, and color indicates masked areas. The instructions here assume that you are working with the default Channel Options settings. However, the default settings can be changed at any point. If you find that your selections are inverted compared to those discussed within this chapter, you need to change your Channel Options. Simply double-click on your alpha channel thumbnail in the Channels palette to access the Channel Options. In the Channel Options, ensure that color indicates masked areas and not selected areas.

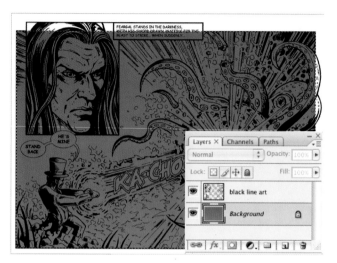

Kuler

Color can make or break any illustration. And when it comes to choosing colors for your comic art, you may find a little assistance in developing your color scheme helpful. Kuler is Adobe's web application that allows you to create, research and even share your color schemes online. Scheme's can be shared with the rest of the world, and downloaded as Adobe Swatch Exchange files. It is worth checking out, even just to see what other artists have come up with.
http://kuler.adobe.com/

3 I Use the rectangular marquee tool to draw a rectangular selection border that surrounds the background of the main panel, but does not stray beyond the black border. Click on the foreground color swatch in the toolbar and choose a teal color from the picker. Next, click on the background color swatch and choose a green background color from the picker. Select the gradient tool. In the tool options bar, choose the foreground to background preset and enable the linear method. Drag from the top of the selection to the bottom while holding down the shift key.

4 I Create a new layer and then select a much lighter blue foreground color from the picker. Switch the gradient method to radial and choose the foreground to transparent gradient preset in the tool options bar. Click and drag from the center of the explosion on the ink drawing outwards, creating a new radial gradient within the selection on the new layer. Choose a muted green foreground color from the picker and change the gradient method to linear. Click and drag from the bottom left corner of the selection inwards a little to change the color of that area. Deselect.

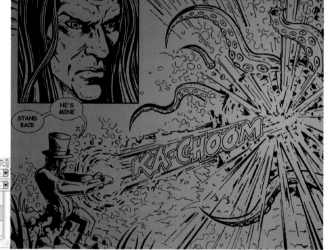

5 | Select the magic wand and target the black line work layer in the layers palette. Enable the contiguous option and disable the sample all layers option in the tool options bar. Leave the tolerance set at 32. Click inside a '*KA-CHOOM*' letter to select that area. Then hold down the shift key and click inside each remaining letter, adding those areas to the selection. Create a new layer and drag it beneath the current layer. Select a bright yellow foreground color and fill the selection with it on the new layer. Repeat the procedure again to select and fill the area surrounding the letters with orange.

Manually filling areas with color

To create more areas of solid color, we'll need to use the brush tool and the eraser together, as there are no more closed black boundaries.

1 | Deselect and choose the brush tool. Choose one of the hard, round, brush presets from the brushes preset picker in the tool options bar. Specify a diameter of around 10 pixels and choose a bright green foreground color.

2 | Set the opacity and flow to 100% in the tool options bar. Use the brush to paint color into areas of the leprechaun's clothing on the current layer. Increase or decrease the diameter as required. Feel free to stray outside of the lines.

3 | Use this method to paint different colors into remaining areas of the leprechaun as well as the rocks. Select the eraser tool. Set up the tip and options like your brush, and erase any painted areas that extend beyond the outlines. Increase or decrease the diameter as required.

6 | Use this method to paint color into areas of the monster as well. Increasing or decreasing brush diameter as required to carefully paint his skin, eye, the underside of his tentacles, suction cups and his spots. Don't be too fussy when painting around the edges because, as you already know, you can erase any unwanted paint. Take extra care when painting in areas where two colors meet. Use very small brushes, and paint one color over the other wherever required. To achieve the soft blending effect around the center of the explosion, erase the sharp painted edges using a very large, soft brush tip and a low opacity setting.

Create shaded areas

Use the gradient tool within path-based selections to add highlights, and shadows to the artwork.

1 | Enable the lock transparency function for this layer in the layers palette. Select the pen tool. Set it to create paths and enable the add to path area function in the tool options bar. Draw a series of path components to indicate highlight regions on the leprechaun's clothing. It is fine if the path components extend beyond the edge of the leprechaun's color fill.

2 | Click the load path as a selection button in the paths palette and select the gradient tool. Select the foreground to transparent preset and the radial option. Choose a light green foreground color then click and drag within the selected areas to add graduated highlights to the leprechaun's clothing.

3 | Because the lock transparency option is enabled, only painted pixels are affected, ensuring that the new highlights don't stray beyond the figure's edge. Use this method to add highlight and shadow areas all over the leprechaun. Vary the gradient colors and also create smaller, bright yellow highlights, within existing highlights.

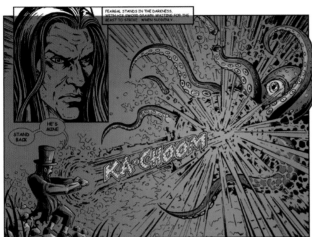

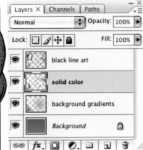

7 | Repeat this method over and over again to add highlights and shadows onto the monster and the rocks underneath the leprechaun on the current layer. Remember that your paths can stray beyond the edges, because the lock transparency option will ensure that you do not affect transparent pixels. Select the magic wand tool. Ensure that the contiguous, and sample all layers options are disabled in the tool options bar. Click on a yellow region inside the lettering to select all regions of this color on the current layer. Choose select>Modify>Contract from the menu and contract the selection by a few pixels.

Envision light sources

Take a good look at the ink drawing before you begin adding any shadows or highlights on separate layers. In this drawing, the explosion areas will provide the brightest light. Therefore, for example, the leprechaun should have all his highlight areas based upon which side of him is facing the light source. That means his front is brightly lit and as a result of this, the shadow areas need to be created on his backside. It is very important that you examine the art, and make a mental note of the lighting situation before you proceed with shading, otherwise the results will be unsatisfactory.

8 | Select the gradient tool and enable the linear method. Choose a red foreground color and drag from the bottom of the selection upwards to create a red to transparent gradient inside the letters. Next, use the magic wand to select the orange outline color and then add a similar gradient into that area. Finally, use the pen tool to draw a series of path components indicating small sharp highlights within the letters. Load the path as a selection and fill it with white. Deselect, and then use the pen tool to create a series of path components within the water, defining regions of shadow.

9 | Load the path as a selection and select the gradient tool. Choose the radial method and use the gradient tool to add large, teal and green, foreground to transparent gradients into the selection on the current layer. Reduce the gradient opacity if you find that the results appear too strong. Now, use the pen tool to define regions of highlight within the water. Load the path as a selection and then use the gradient tool to introduce some gradients into the active selection, using very light foreground colors and varying gradient opacity.

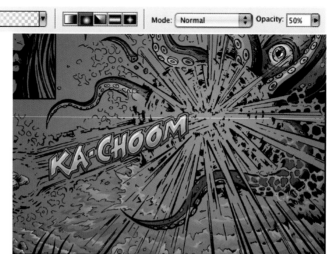

Create a hand-painted selection

In Quick Mask mode you can create a complicated selection border by painting with the brush tool. This creates a temporary channel, which loads as a selection when you exit.

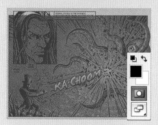

1 | Create a small selection in the explosion area using the lasso tool. Click on the Quick Mask mode button in the toolbar. Immediately, you'll see that the surrounding areas are covered with a red overlay. This indicates masked areas. Removing the red overlay from certain areas creates selections.

2 | Select the brush tool and choose a hard, round, brush preset. Set the opacity and flow to 100 and select the background color, which is white. Carefully paint with white to create selected areas of the explosion and crackle effect. Increase and decrease the size of the brush as required.

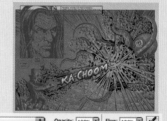

3 | You'll likely end up removing the overlay in certain areas accidentally. To remedy this, simply paint over those areas using black, to mask them once again. You'll find yourself unmasking and masking, back and forth, until your temporary Quick Mask is complete, looking something like this.

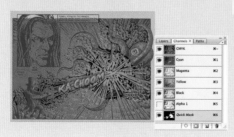

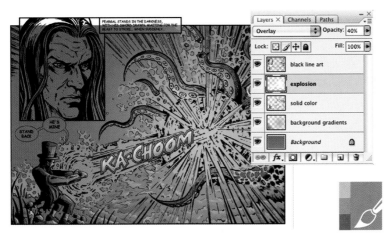

10 | Take your time and exercise care when creating your selection area within the mask. Be careful to ensure that the letters are completely masked even though they're surrounded by the area you wish to select. When you have finished editing your temporary mask, press the Quick Mask button once again to exit Quick Mask mode. When you exit Quick Mask mode, your mask is converted to a selection border. With the new selection active, create a new layer. Fill the active selection with white and change the layer blending mode to overlay. Reduce the layer opacity to 40% and deselect.

Do not be alarmed

It may seem illogical that in step 11, we're including the letters within our selection that you meticulously masked previously to ensure that they would not be included. But do not fret. All of that work was not a waste of time. We'll be using the fruits of your Quick Mask labors shortly to mask a group of layers, revealing the words once again and staying true to the spirit of what you created within your mask.

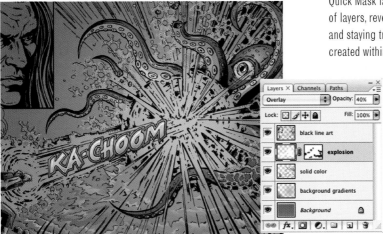

11 | Click the add layer mask button in the Layers palette to mask the new layer. Select the gradient tool and a black foreground color. Within the mask, create a series of radial, black to transparent gradients to soften any hard edges you wish to blend into the background. Control(PC)/Command(Mac)-click on the layer's thumbnail (not the mask), to load a selection from the layer's contents. Use the lasso tool to circle the word area while holding down the shift key so that the new selection includes the words too. Choose Select>Modify>Contract from the menu and shrink your selection just like you did earlier with the lettering.

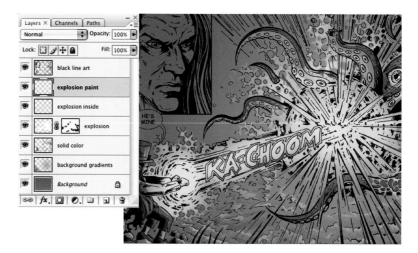

Selecting path components

Generally, when loading selections from paths, I recommend that no single path component be selected so that the resulting selection is based upon all of the path components. However, when adding gradients into selections, especially when working with more than a single gradient, you may wish to generate a selection from only select components within a path and not all of them. Use the path selection tool to select the components you'd like to load as a selection. With your components selected, then load the path as a selection. The resulting selection will be based upon the selected components only.

12 I Create a new layer and ensure that it is targeted in the Layers palette. Select the gradient tool and use it to create numerous radial, foreground to transparent gradients within the active selection on the new layer. Use a variety of yellow and very light yellow foreground colors. Change the blending mode of the layer to overlay, deselect and create a new layer. Select the brush tool. Choose a large, round, soft brush preset. Paint light yellow into the area at the center of the explosion and into the area surrounding the leprechaun's hands on your new layer.

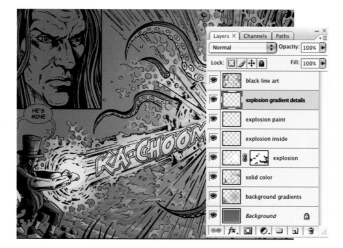

13 I By now you've become very good at creating path components. So go ahead and draw some path components inside the explosion area that add detail, and also create horizontal streaks going across the lettering. Load the path components as selection borders and fill them with radial, foreground to transparent gradients on another new layer. Use an orange foreground color for some areas, and use gold and yellow for others. Also don't be afraid to add smaller, different colored gradients on top of existing ones. Deactivate the selection when finished.

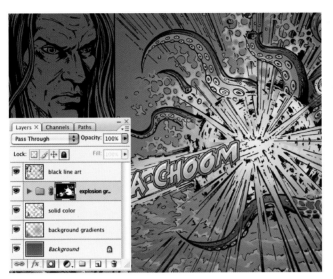

14 | With your current layer targeted in the layers palette, hold down the shift key and click on the lowest explosion layer. This targets both layers as well as all layers between, effectively targeting all of your explosion layers. Type Control(PC)/Command(Mac)-g to group them. Expand the group and Control(PC)/Command(Mac)-click the bottom layer to load a selection from the layer's contents. Target the group and then click on the add layer mask button at the bottom of the Layers palette. Once again, your words that were originally masked, as well as the leprechaun's arms, become clearly visible. Collapse the group.

Embellish the explosion

Continue to work on your explosion outside of the masked group, adding bursts of light and hot centers.

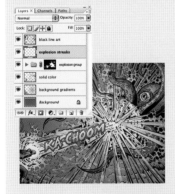

1 | Use the pen tool to draw a series of path components to represent streaks of light emanating from the large explosion's center. Load the path as a selection and add radial, light yellow to transparent gradients into the selection on a new layer.

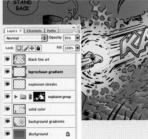

2 | Deactivate the selection and create another new layer. Use the gradient tool, with the current options and foreground color, to create a small radial gradient over top of the leprechaun's hands on the new layer. Reduce the opacity of the layer slightly.

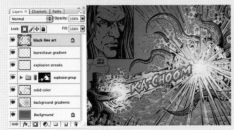

3 | Target the black outline layer and enable the lock transparency option. Select the Brush tool. Use a soft, round brush preset to paint over areas on this layer that are at the center of both explosions. Use red and orange foreground colors as you paint.

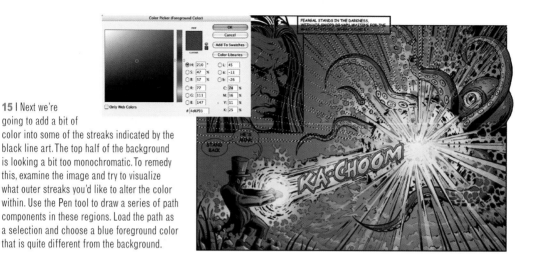

15 | Next we're going to add a bit of color into some of the streaks indicated by the black line art. The top half of the background is looking a bit too monochromatic. To remedy this, examine the image and try to visualize what outer streaks you'd like to alter the color within. Use the Pen tool to draw a series of path components in these regions. Load the path as a selection and choose a blue foreground color that is quite different from the background.

Add streaks of color

Use the gradient tool to add different colored streaks into the background, then mask your layer to avoid covering any main elements and to soften the effect.

1 | Create a new layer and drag it below the black line art layer. Set the blending mode of this layer to color and then use the gradient tool to add large, radial, foreground to transparent gradients into the active selection on this layer. Deselect.

2 | Keep the current layer targeted, and Control(PC)/Command(Mac)-click on the solid color layer thumbnail to load a selection from the contents. From the menu choose. Layer>Layer Mask>Hide Selection so that the streaks do not overlap the monster.

3 | Target the new layer mask in the layers palette. Select the gradient tool and set the foreground color to black. Create black to transparent, radial, gradients within the mask, to gently blend the layer contents into the background in the image center.

16 | Drag the lock on the background layer into the trash within the Layers palette, converting it to a normal layer. Target all of the layers, except the black line art layer, and add them to a new group. Now, use the methods employed so far to create a number of new layers containing the artwork for the inset, text box and speech bubbles. Fill selections with color and gradients. Paint and erase to fill specific areas with solid colors. Fill path-based selections with gradients to add highlights and shadows. When you're finished, add all of these layers to a second group.

Adding and adjusting

Although this file is built on a series of separate layers, do not feel limited to embellishing or altering just those layers. You can add more details or different regions of color on additional layers. Also, feel free to create adjustment layers to alter regions of color on underlying layers. Once you've created an adjustment layer, move it up or down within the layer hierarchy and examine the results. It is though this type of experimentation that results, which may have never occurred to you, can be achieved.

17 | Now that your comic book art is complete, it does not mean that you cannot make further adjustments. Simply expand either group to access individual layers and masks. I added a mask to the layer that contained the explosion streaks, and used it to soften the effect in areas where they overlapped the tentacles. However, this is just one example of what can be done. Take a good look at the illustration and feel free to edit and embellish however you like.

PART 2
Unconventional Methods

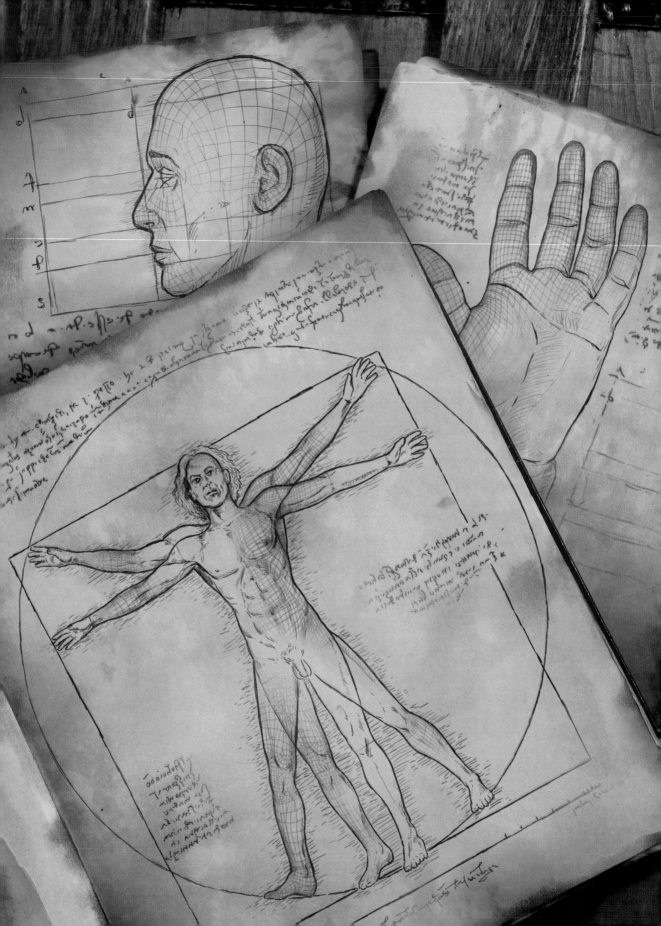

Chapter 9

Antique Effects

hen you look at this image, the last thing you're likely to think of is a hair dryer. I imagine that proves true with a thermal fax machine as well. However, as weird as it may sound, those two very things are essential ingredients in creating the antique sketch effect you see here. Alongside Photoshop, unlikely and technologically inferior tools can prove quite useful when you're trying to create an authentic antique effect.

When you think about very old works of art like the sketches of Leonardo DaVinci, it isn't just the beauty of the drawings and subject matter that captures your attention. Equally beautiful is the process of age itself. Paper turns color over the years. It becomes stained by moisture. It is affected by environmental factors, and edges become darkened from centuries of handling. There is a certain beauty in the randomness of these tactile signs of age, and it is randomness that is often overlooked in the all-too-perfect world of digital art.

I honestly can't tell you what made me to do it. But one day I just tried using a hair dryer on some blank thermal fax paper. The heat forced it to darken around the edges and bleed inward on the page. The first thing that came to my mind was the darkened edges of very old documents and drawings. I looked at it longer and began to ponder the usefulness of the black and white burn effect before me. I immediately began thinking of alpha channels and how they translate grayscale data into selection borders. And just like that the idea was born.

In this chapter, I'll reveal everything you need to know to get your thermal fax machine and hair dryer working for you as creative tools. You'll learn to use these tools to produce the random and tactile raw materials essential to the antique effects you see here. By the end of it, you'll master the art of using real world black and white art as the content of alpha channels. You'll make selections from those channels, and you'll make fantastic multi-layered Photoshop masterpieces from those selections.

A good illustration is a direct result of the materials you begin with. That is why hours and hours were spent creating these initial sketches. Although the thermal fax/hair dryer effects will dictate the overall feel, these sketches provide the subject matter. They were based upon original sketches by Leonardo DaVinci, however, polygons and wire mesh have been included to convey the subtle fact that we're working digitally as well.

1 I The first step is to print out all of the original sketches. Then, take the printed sketches to a thermal fax machine. One at a time, insert each sketch into the thermal fax machine and press the copy button. This will make an exact copy of your original sketch on thermal paper. In addition to copying your sketches, make a few copies of a blank piece of paper, simply to get a couple of blank thermal pages as well.

Project files

All of the files needed to follow along with this chapter and create the featured image are available on the accompanying CD. Files for this chapter can be found in the folder entitled: chapter_09. The initial sketch files can be found there. For those of you who don't have access to a thermal fax machine, hair dryer, or simply want to focus on the Photoshop work, all the scanned thermal pages are included in this folder.

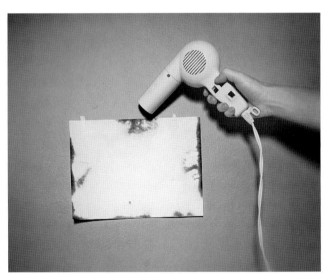

2 I Tape one of your blank pages to a wall or another flat surface. Plug in your hair dryer and ensure that it is set to the hottest setting. Activate the hair dryer and move it close to the paper. Immediately you'll begin to see the paper darken when the hot air hits it. Use this technique to darken the blank sheets of thermal paper around the edges only. These will be used later to create a dark edge effect on the pages within the illustration.

3 | Now tape your thermal copies of the sketches to the wall or another flat surface. When using the hair dryer on these, concentrate on burning the centers of each page. Try moving the hair dryer back and forth quickly. It is fine if the image becomes obscured by the burn effect. You'll notice that the paper will ripple slightly and the high points of the ripples will be darkest.

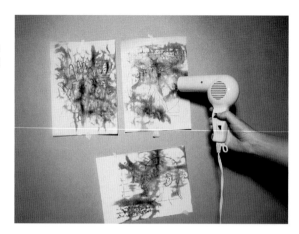

Fax quality

Most fax machines, even old thermal ones, will have a number of quality settings to choose from. For what we're doing here, the best quality is not necessarily what is required. When you are copying your sketches to thermal paper, experiment with a variety of different settings. What you're after is something that, although it may omit lighter details from the sketches, copies the majority of the artwork so that it is dark and legible. The scans included on this CD were copied on an old fax machine using the medium-quality setting, which provided the clearest result.

4 | Open up the background.jpg file. This shot was carefully set up on an antique wooden trunk to lend a sense of authenticity to the final result. The pages you see here are already looking a bit aged. The corners are rounded slightly, and the pages are a bit darker around the edges. Notice how the empty pages are set up to overlap each other. Each page will provide the background for one of the sketches and have an antique effect applied to it.

5 |.If you've done your own thermal effects using the hair dryer and copies of the illustrations, the next step is to scan each piece of paper. Envision the destination of each sketch within the background and actually rotate your pages on the scanner to approximate the angle before you scan them. You can rotate them in Photoshop later if necessary, so don't worry about being too accurate. Also, scan your blank pages with the thermal effects applied to them.

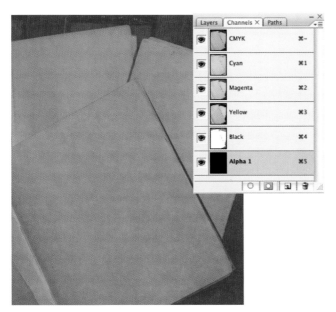

Scanning and tonal adjustments
If you're scanning your own burned thermal fax pages, ensure that they are scanned and saved in grayscale mode. This isn't absolutely necessary, but it is helpful as the scans are destined for alpha channels. Also, it would be ideal if you could adjust your scanner driver preferences, so that an automatic tonal adjustment is performed ensuring that the white backgrounds within your files contain 0% black. If you don't have this option, simply perform a very quick tonal adjustment via the Brightness/contrast option in the Image>Adjustments menu

6 | Open up the man.jpg file. Choose Select>All and Edit>Copy from the menu. Return to the background.jpg file, your working file. In the channels palette, click on the create new channels button to create a new alpha channel. With the new alpha channel targeted in the channels palette, click in the column to the left of the CMYK composite channel to enable the visibility of all channels. Your alpha channel will be visible as a red overlay, similar to traditional rubylith.

7 | With your new channel targeted in the channels palette, choose Channel Options from the channels palette menu. In the channel options, you'll notice that the default setting is for color to indicate masked areas. Change this so that the color indicates selected areas instead. When you click OK, you'll immediately notice that the red overlay disappears from the image window as the background of your alpha channel becomes white instead of black.

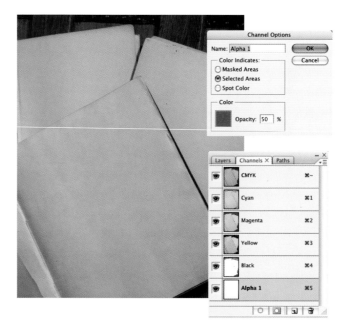

Select, copy, and paste

As you add sketches and scanned thermal effects into each channel you'll be doing a lot of copying and pasting. Therefore it is beneficial to familiarize with some keyboard shortcuts:

- Control(PC)/Command(Mac)-a is 'select all'
- Control(PC)/Command(Mac)-c is 'copy'
- Control(PC)/Command(Mac)-v is 'paste'

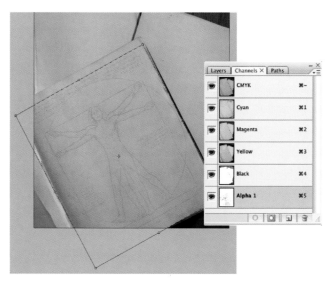

8 | With your alpha channel targeted, choose Edit>Paste from the menu. You'll notice the coloured areas within the pasted sketch appear as a red overlay in the image window. Choose Edit>Free Transform from the menu. Hold down the shift key while you drag a corner point inward to reduce the size of the pasted art proportionately. Move the mouse pointer to the outside of the bounding box until it changes to indicate rotation. Click and drag to rotate the contents to the same angle as the large page. Click in the center of the box and drag it onto the main page to position it.

9 | When you're satisfied, press the enter key to apply the transformation. Although viewing the new channel against the rest of the image is handy for positioning, disable the visibility of the CMYK composite channel by clicking on the eye in the left column. This will allow you to view the channel by itself. Click the load channel as a selection button at the bottom of the channels palette. You'll notice that because you changed color to indicate selected areas, the black regions of the channel are selected rather than the white regions.

Sampling color
When you click on a color with the eyedropper tool. The foreground color is automatically replaced with the new color. However, if you hold down the alt(PC)/ option(Mac) key and click on a color within the image, the background color will be replaced instead of the foreground color.

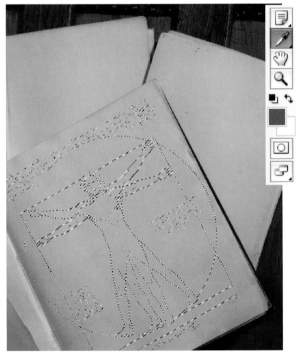

10 | Return to the layers palette and click on the create a new layer button at the bottom of the layers palette. As soon as you create a new layer, the CMYK composite channel will become visible once again, and your alpha channel's visibility will be automatically disabled. This is a handy way to return to the regular workspace. With the current selection active, target your new layer. Select the eyedropper tool and click on a brown area of the background to sample it. The foreground color will automatically change to your newly sampled color.

11 | Ensure that your new layer is targeted and choose Edit>Fill from the menu. In the fill dialog box, use your current foreground color, a blending mode of normal, and 100% opacity. Pay attention to these settings as you'll use them over and over again while filling selections throughout this chapter. Type control(PC)/Command(Mac)-d to deactivate the current selection and change the blending mode of the layer to multiply. Click the add layer mask button at the bottom of the layers palette to add a mask to the layer.

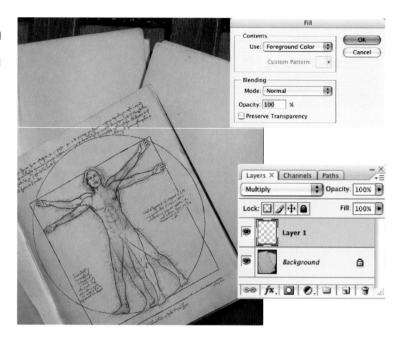

About filling

When you choose Edit>Fill from the menu, you have a number of choices as to how to go about filling. You can choose a color, a blending mode, and an opacity setting. However, throughout this chapter, we'll be using the default settings, which are the current foreground color, a normal blending mode, and an opacity setting of 100%. If you use the keyboard command alt(PC)/option(Mac)-delete, your current layer or active selection is automatically filled, using these settings.

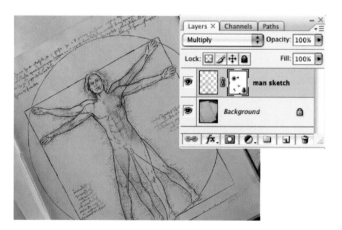

12 | Target the layer mask in the layers palette and select the gradient tool. In the tool options bar, choose the radial method and the foreground to transparent gradient preset. When you target the mask, your foreground color automatically switches to black because you have changed what color indicates in the Channel Options earlier. This is perfect for masking. Click and drag with the gradient tool to draw small, black to transparent, radial gradients within the mask in areas that you wish to gently fade from view. For a more subtle masking effect, try using the gradient tool with a lower opacity setting.

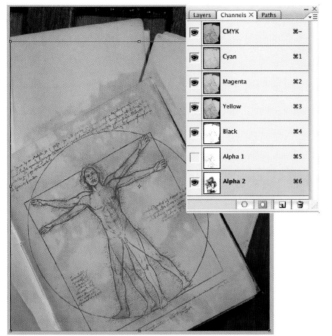

13 | Open up man-thermal.jpg file or a scan of your own version of this thermal-affected sketch. Select all and copy. Return to the working file and create a new alpha channel in the channels palette. Paste your copied image into the new channel and then enable the visibility of the composite channel within the channels palette. Choose Edit>Free Transform from the menu. Use the visible CMYK image as your guide to resize, rotate, and reposition the image you pasted into the channel. Do your best to get it to match up nicely with the sketch on the main page within the image.

Color opacity

In the channel options dialog box you'll notice that at the bottom, there is an area where you can change the opacity of the red overlay. When you are displaying the CMYK composite channel at the same time as your alpha channel, there may be instances where you find that the red is too faint to really see what you're doing. Increasing the opacity in the channel options will help with channel visibility. The downside, however, is that the more you increase the opacity, the less transparent the overlay becomes. Ideally you'll address this on an as-needed basis depending upon your existing channel preview circumstances.

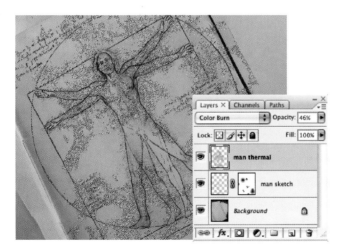

14 | Load your new channel as a selection. In the layers palette, create a new layer. Ensure that your selection is active and that the new layer is targeted. Use the eyedropper to sample a beige color from the image and then fill the active selection with the new foreground color on the new layer. Change the layer blending mode to color burn and reduce the opacity of the layer to 46%.

15 | With the current selection still active, create a new hue/saturation adjustment layer from the menu at the bottom of the layers palette. Increase the saturation by 61 and reduce the lightness by 9. When you create an adjustment layer, your active selection is used to create a mask and then becomes deactivated. Right-click(PC)/control-click(Mac) on the adjustment layer's mask thumbnail and then choose the Add Layer Mask To Selection option from the pop-up menu that appears. This will reload your selection. With the new selection active, create a new layer and ensure that it is targeted in the layers palette.

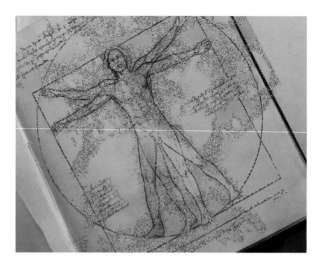

Individual channel options

Earlier on, we changed what color indicates in your channels by accessing the channel options via the channels palette menu. When you do it this way, every subsequent channel you create uses the same options. However, you can edit the options for individual channels after the fact. To do this, simply double-click on any alpha channel in the channels palette. The channel options dialog box opens up, allowing you to alter the options for that specific channel only.

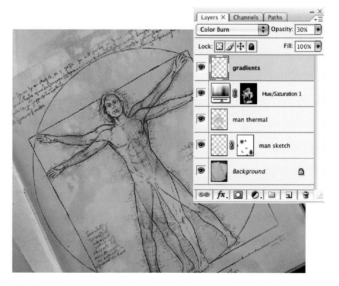

16 | Change the blending mode of the new layer to color burn and reduce the opacity to 30%. Use the eyedropper to sample a slightly darker brown color from within the image and then select the gradient tool. Ensure that the foreground to transparent gradient preset is selected and that the radial method is enabled in the tool options bar. Click and drag to create a few gradients within the selection on the current layer. This will add a darkening effect in these areas. Add as many as you think are needed and then type Control(PC)/Command(Mac)-d to deactivate the selection.

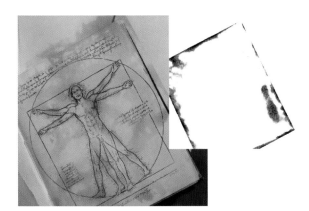

17 I Drag the current layer onto the create new layer button in the layers palette to duplicate it. Change the blending mode to multiply to darken the effect further and then choose filter>Blur> Gaussian Blur from the menu. Ender a radius value sufficient enough to considerably soften the contents of the duplicated layer. Now that the overall page is looking good, it is time to begin darkening the edges. Open up the edge1.jpg file or a desktop scan of your own. Select all and copy.

Begin darkening the edges of the page

Now the blank thermal page scans, that were burned around the edges only, will be put to good use.

1 I Create a new channel in your working file and paste the copied image into it. Enable the visibility of the composite channel and position it over the appropriate area. This included scan was already rotated on the scanner, however, you may need to rotate your own.

2 I Load the channel as a selection and create a new layer. Target the layer and fill the active selection with a newly sampled, dark brown foreground color. Change the layer blending mode to color burn and reduce the opacity to 15%. Deselect.

3 I Duplicate this layer and change the blending mode to multiply to darken the effect. Add a layer mask and then use the gradient tool to add radial, black to transparent gradients into the mask to soften any areas on this layer that appear too dark.

18 | Open up the edge2.jpg file or use another of your own scans. Again, select all and copy. Return to your working file and paste it into a new alpha channel. Enable the visibility of the CMYK composite to aid you in positioning the contents of the channel on the page. The included file was rotated on the scanner, however, especially if you're using your own file, you may need to use free-transform to resize and rotate the channel contents. Load the channel as a selection and then create a new layer in the layers palette.

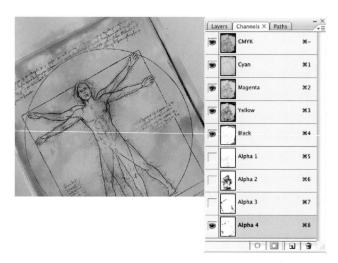

Channel color

Sometimes, when previewing an alpha channel against the CMYK composite channel, red simply isn't going to be as visible as another color would be. You can alter the color overlay of your channel by clicking on the color swatch in the channel options. This launches the picker, allowing you to change the display color of your channel to another color that will be more visible against the CMYK composite channel. Your display color can vary from channel to channel, they don't all have to be the same.

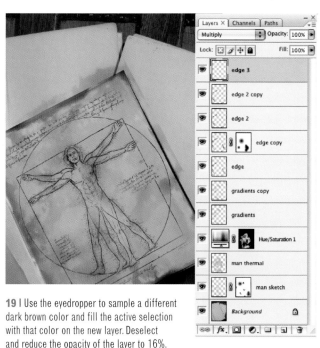

19 | Use the eyedropper to sample a different dark brown color and fill the active selection with that color on the new layer. Deselect and reduce the opacity of the layer to 16%. Duplicate the layer, change the blending mode to color burn and increase the opacity to 24%. Open up the edge4.jpg. Again, copy the image and paste it into a new channel within your working file. Position it using the CMYK composite channel as your guide. Load it as a selection and fill the selection with dark brown on a new layer. Change the blending mode to multiply and deselect.

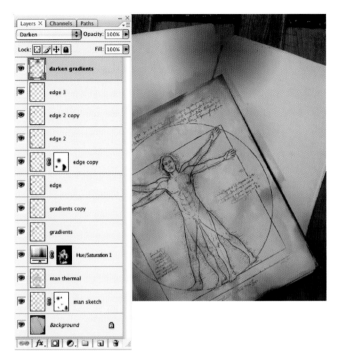

20 | Create a new layer and select the gradient tool. Ensure that the gradient is still set to radial and that the foreground to transparent preset is selected in the tool options bar. Set the blending mode of the layer to darken and ensure that you have a dark brown foreground color specified. Click and drag on this layer, creating gradients in various sizes, using varying opacity settings, to darken the areas of the page on the underlying layers with smooth blends of color.

Cleaning up channels

When you are working with a file like this, it doesn't take long for the channels palette to fill up and for file size to swell. Go ahead and delete any alpha channels you wish from the palette after they've been used. You don't need to hang onto them as storage areas for your selections once you've filled a selection with color on a layer. You can load a selection from the layer at any point by Control(PC)/Command(Mac)-clicking on its thumbnail in the layers palette.

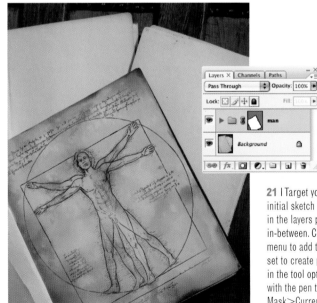

21 | Target your top layer, hold down the shift key and click on the initial sketch layer, which sits directly above the background layer in the layers palette. This will target both layers, and all layers in-between. Choose Layer>New>Group From Layers from the menu to add them to a group. Select the Pen tool, ensure that it is set to create paths, and that the add to path area option is enabled in the tool options bar. Carefully trace the outer edge of the page with the pen tool, drawing a closed path. Choose Layer>Vector Mask>Current Path from the menu to clip the group.

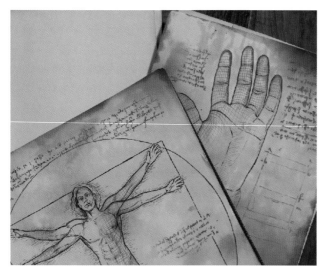

22 | Now repeat what you've done with different resource materials. Follow the same process that you used to create the antique man illustration, using different resource files and a different position on the canvas. Use the hand.jpg and hand-thermal.jpg files for your first two channels and subsequent layers. Then follow the process employed previously to build up layers with varying colors, masks, and blending modes to create the antique effect. To build up the edge effect on a series of layers, use the edge4.jpg file as your resource. When finished, add the layers to a group and clip it with a vector mask.

Examining the hand group

Although the contents of your group will likely differ, this is exactly how I achieved the effect.

a | The channel-based hand-sketch selection is filled with brown on this layer. The blending mode is set to multiply and a mask is used to soften the areas that are too strong.

b | The channel-based thermal hand selection is filled with a lighter brown on this layer. The blending mode is set to color burn and the layer opacity is reduced to 77%.

c | Brown to transparent, radial gradients reside on this layer. The layer blending mode is set to multiply, thus darkening the underlying layers.

d | The channel-based edge selection is filled with brown on this layer. The layer blending mode is set to color burn and the opacity setting is 28%. The layer is duplicated and the blending mode of the duplicate layer is set to multiply. The opacity is increased to 51% and both layers are masked. Gradients are used within each mask to hide the areas which are too prominent.

e | All of these layers are added to a group and a path is drawn around the edge of the page. The path is used as the basis for a vector mask which clips the group and ensures that no artwork extends beyond the edge of the page.

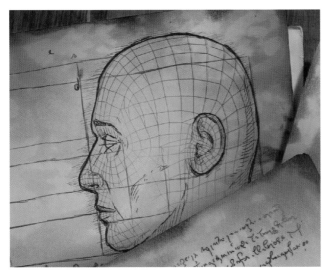

23 | Now it is time to repeat the entire procedure for a third time. This time, use the head.jpg file, the head-thermal.jpg file, the edge5.jpg file, and the edge6.jpg file to create the same effect on the remaining page. Use the now familiar method of creating channel-based selections and building up the antique effect on a stack of layers. Experiment with different colored fills, various blending modes, layer masks and opacity settings. When you're finished, add all of these layers to a group as well. Then clip the group with a vector mask, so that the drawing and the age effect do not stray beyond the edge of the page.

Where to go from here
The methods used to create this effect lend themselves nicely to repetition and experimentation.

a | Use sections of some of your resource files to generate selections and a new stack of layers, adding an antique effect to the page that is partially visible at the lower left of the image. When finished, clip it with a vector mask.

b | Use this same method to add the antique effect to all of the little bits of pages that are sticking out beneath the main pages. This will ensure that all pages, wholly visible or partially visible, will have the same antique effect applied to them. Carefully clip the desired areas with a vector mask.

c | Because this file is built as a series of layer groups, you can edit any layer at any time. If you feel that an effect needs to be made stronger or weaker, alter the blending modes and opacity settings of the layers necessary to make it so. Have some fun experimenting here.

d | If you're not entirely satisfied with the accuracy of your vector masks, never be afraid to zoom in closely and edit the vector mask's individual points and line segments with the direct selection tool.

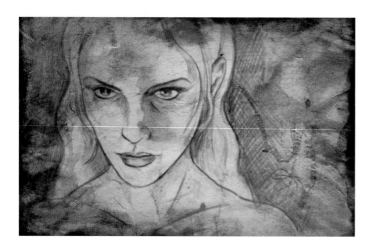

To create this image, the exact same thermal fax technique was used, but instead of copying sketches and then burning them with the hair dryer, only blank sheets of thermal paper were used. Thus providing the ability to focus only on the edges when creating multi-layered burn effects, leaving the actual sketch unaffected.

Another method for ageing paper is to stain it before you scan it. The two scanned pages at the left are simple unbleached paper samples purchased at a Japanese paper shop. The edges were torn off and then a pot of tea was brewed.

The wet tea bags were removed from the teapot and then rubbed along the edges of the paper, allowing it to bleed into the paper from the edges inward. Then a brush was used to paint the tea over the entire paper area. Once the pages had dried, they were scanned. As you can see here, the tea stain method produces a convincing antique paper background effect, without the aid of alpha channels or layer stacks.

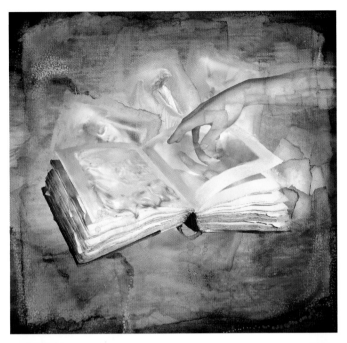

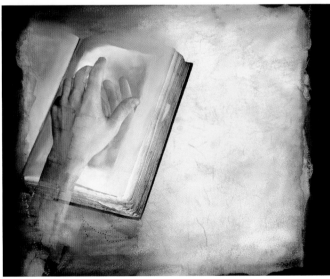

These two images are excellent examples of the tea-stained papers in use. Although the effect is quite different than the thermal fax paper effect, the antique and aged feeling is certainly there.

sonic unyon presents

THE NEIN LIVE

at the legendary Horseshoe Tavern

THE NEIN

**SATURDAY
NOV 19th
DOORS - 8 PM**

**WITH
SPECIAL GUESTS**

**TICKETS
$10.00
at the door**

Chapter 10

Photocopier Meets Photoshop

Photoshop, to many, represents perfection. But while we strive to achieve perfection, let us not overlook the beauty of imperfection. If you're an urban dweller, pay attention to what is surrounding you as you wander the streets. You'll notice photocopied flyers and posters plastered all over the place. You'd be hard pressed to find a better example of imperfect, yet beautiful, artwork. This is the art of the underground scene. Local bands and underground artists do what they can with what they have. There is an evident do-it-yourself esthetic inherent in the majority of urban poster art.

This low fidelity appearance is more a result of available tools and monetary resources rather than a conscious attempt at style. Regardless of intent, a certain style prevails. Poor registration, inferior image quality, and cut-and-paste typography all contribute to the urban underground look. However, the most prominent element is the look achieved by using a poor quality photocopier to put it all together. Generally these collages are photocopied on machines in desperate need of servicing or even dangerously low on toner. Not the sort of thing found at a professional copy shop, but rather like something you'll find in a local convenience store.

Remember, just because Photoshop has an arsenal of tools that lend themselves to achieving perfection, it doesn't mean that you cannot turn the tables and create convincing imperfection. The limit to what you can achieve with Photoshop's tools and functions is dictated by your own willingness to explore less-than-obvious methods.

To create tactile and distressed underground poster art effects, all you need is access to a good old-fashioned photocopier, an enthusiasm for Photoshop, and a willingness to experiment.

Project files

All of the files needed to follow along with this chapter and create the featured image are available on the accompanying CD. Files for this chapter can be found in the folder entitled: chapter_10. You can follow along from the beginning, creating and printing out your own grayscale files. Or, if you don't want to seek out a photocopier on your own, you can access the already photocopied and scanned files in the same folder. These supplied files will be referred to by name throughout the tutorial. Feel free to use them or substitute files of your own as you work.

1 | Open up the neinphoto.jpg file. This is a press photo used by an American band known as The Nein. The Nein will act as the subject for the urban poster art you'll be creating here. To simulate the appearance of cutting with scissors, use the polygonal lasso tool to draw a very rough polygonal selection around the outside of a single band member in the image. Now, create a new file. Specify a white background and grayscale color mode. Set the canvas size to something that is similar in size to the paper you'll be printing everything out on.

Editing text

When you have a type layer targeted in the layers palette and the type tool selected, you can edit any of the type options in the tool options bar. This will affect the entire contents of the type layer. However, if you click on an area of type on the canvas, which activates the type layer, it becomes necessary to select type in order to edit it. Either click and drag to select a portion of the text, or double-click to select it. Once your text is selected, it can then be edited.

Nein press photo courtesy of Casey Burns/The Nein

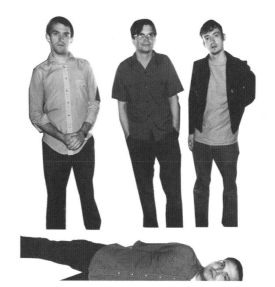

2 | Return to the neinphoto.jpg file. Hold down the Control(PC)/Command(Mac) key. Click inside the selection border and drag the contents of the selection into your new grayscale file as a new layer. Continue to hold down the Control(PC)/Command(Mac) key and position the layer on the canvas to allow space for the band members. Use this method to add each band member to the grayscale file. To fit them on the canvas, you'll likely have to rotate one band member. To do so, target the appropriate layer in the layers palette and then choose a 90° rotation option from the Edit>Transform menu.

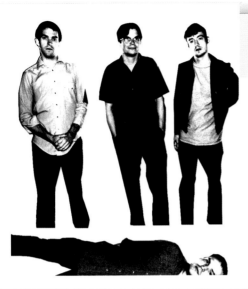

3 | Next, choose Layer>Flatten Image from the menu to flatten the layers. Choose Image>Adjustments>Brightness/Contrast from the menu. Enable the use legacy option offered in the brightness/contrast dialog box so that you are removing shadow and highlight detail when adjusting. Adjust the brightness and contrast sliders to increase the contrast and decrease the range of grays within the image. This is the first step in image deterioration that is necessary to produce a convincing effect. When you've completed the adjustment, print the image in black and white on an ink jet or laser printer.

Creating text

Very simple typography set against black, white, or gray backgrounds will help to lend a sense of authenticity to your design.

1 | Create a new grayscale file identical to your previous file. Select the horizontal type tool. Click on the canvas to add a type insertion point. Enter some text and press the Enter key to create a new, editable type layer.

2 | While the type tool is selected, you can alter the font, size, color, and other attributes of your type layer in the tool options bar. Choose an appropriate font like American typewriter. Now, create another type insertion point and add some different text using a different font.

3 | Target your background layer and use the rectangular marquee to create a selection beneath a line of type. Use Edit>Fill from the menu to fill the selection. Then target the overlaying type layer, ensure that you've selected the type tool and change the color of the type to white.

4 | Use the aforementioned techniques to add all of the necessary text to your page on a series of layers. Try different shades of gray, as well as black, behind white text. Try duplicating type layers by dragging them onto the create new layer button at the bottom of the layers palette. Move the duplicated type around the canvas with the move tool. In addition to experimenting with different grays in the background, try changing some of your black type to gray as well. Fill your page with options until you're satisfied, and then flatten the image. Print this page in black and white as well.

Create some basic shapes
Again, simplicity is the key to a design like this, especially when creating backgrounds and borders.

1 | Create another new grayscale file. Select the rectangular marquee tool. Hold down the shift key while clicking and dragging to draw a square selection. Press 'd' to set the foreground color to black, and type alt(PC)/option(Mac)-delete to fill the selection with it.

2 | Click inside the selection border with the marquee tool and drag the active selection border down on the canvas beneath the square. Choose Edit>Stroke from the menu. Select inside as the location and black as the color. Enter a width value and click OK.

3 | Use the polygonal lasso tool to create a primitive starburst shaped selection on an empty area of the canvas. Use the same methods you used previously with the first square to fill your starburst with black. Print this file in black and white as well.

5 | Open up the computers.jpg file from the CD. This grayscale file has already had the computer images placed in it and has been flattened. All that you need to do here is snap up the contrast a little. Choose Image>Adjustments>Brightness/ contrast from the menu. Again, enable the legacy option to deteriorate the image and adjust the sliders to increase the contrast overall. Print this final file in black and white and then gather up all of your printouts

Making copies
The best way to get that rough, photocopied look, is to gather up your printouts and find a neglected copier.

1 | Convenience stores are the best places to find copiers that are rarely maintained. The lack of maintenance often results in a grittier result, which is exactly what we're after. Get out your printouts and make at least one photocopy of each.

2 | Try copying the copies a few times. With each generation, the quality deteriorates and the signature look of the copier becomes more apparent. Crumple some copies, flatten them, and then copy them again. Incorporating this crumple technique will distress your copies even more.

3 | When you're finished, gather up the copies and head home. There is a good chance that you'll have a lot to choose from. Lay everything out on the floor to have a good look. Choose the best of the bunch and scan them.

6 | Again, all of the photocopied and scanned files that were used to create this poster are included on the CD. They will be referred to by name for the rest of this chapter. However, feel free to substitute photocopies of your own if you like. To begin creating the poster, open up the paper.jpg file from the CD. This desktop scan of a folded piece of paper will act as the background in the multi-layered file you'll create. Something as simple as starting with an authentic background can be very powerful in helping to achieve a convincing result. Every little bit helps.

Choosing fonts

For your poster art to look authentic it should definitely look like a computer was not involved in its creation whatsoever. This especially rings true when it comes to choosing fonts. American Typewriter and Stencil are both fonts that are available when typesetting with traditional tools. As a result of this, it is entirely believable that the typesetting on the poster could've been accomplished by traditional means. Adding the photocopied look to a slick modern font will display the technique we're describing, but at the same time it will ruin the authenticity of the final poster design by displaying something that is clearly impossible.

7 | Choose Layer>New Fill Layer>Solid Color from the menu. When the New Layer dialog box opens, set the blending mode to multiply and click OK. When the picker opens, choose a dark pink color and click OK to create your new solid pink layer. Next, click on the create a new layer button at the bottom of the layers palette. With the new layer targeted, use the rectangular marquee tool to draw a square selection. Press the 'd' key to set the current background color to white. Type Control(PC)/Command(Mac)-delete on the keyboard to fill the new selection with white.

8 | Type Control(PC)/Command(Mac)-d on the keyboard to deactivate the current selection. Open up the shapes.jpg file and use the rectangular marquee tool to draw a selection around the square that has the stroke around it. Hold down the Control(PC)/Command(Mac) key, click inside the selection border and, while holding the mouse button down, drag the contents of the selection into your working file as a new layer. Change the layer blending mode to multiply and then choose Edit>Free Transform from the menu. Hold down the shift key while dragging a corner handle outwards to increase the size proportionately.

Lighten then darken

Almost every photocopier has a setting that allows you to lighten or darken the copied image. When you're copying the original, try using a very light setting so that a lot of the detail and tonal range disappear. Then, try copying this initial copy with a darker setting, enhancing the contrast while copying the image of reduced detail and tonal range.

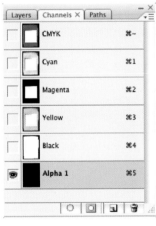

9 | Click and drag within the bounding box to position the layer contents. When it frames the white box on the layer below, press the enter key to apply the transformation. Return to the shapes.jpg file and deactivate the selection. Choose Image>Adjustments>Invert from the menu to invert the color of the shapes image. Now, use the rectangular marquee tool to draw a selection around the inverted square shape. Choose Edit>Copy from the menu. Return to your working file. In the channels palette, click on the create new channel button at the bottom of the palette to create a new alpha channel.

10 | Click in the column to the left of the CMYK composite channel in the channels palette to make it visible at the same time as your alpha channel. Your alpha channel will preview against the background as a red overlay. Ensure that the alpha channel is targeted in the channels palette and then choose Edit>Paste from the menu to paste the copied rectangle into the channel. Use Free-Transform to increase the size and position the square so that it overlaps the large white square, exactly like you did with the outlined square earlier. Press Enter to apply the transformation.

The Nein

I often listen to music when I spend countless hours in my studio and every once in a while I come across a band like The Nein that sparks an idea. I thought this band was the ideal subject to display such an anti-technology technique. They hail from the USA and their album 'wrath of circuits' has an inherent fear of technology about it. They are currently signed to Sonic Unyon Records in Canada. If you'd like to hear their music you can find audio samples at: http://www.sonicunyon.com

11 | Control(PC)/Command(Mac)-click on the alpha channel thumbnail to generate a selection from its contents. In the layers palette, with the current selection active, click the create a new layer button. Target your new layer at the top of the layers palette and select the gradient tool. In the tool options bar, choose the linear gradient method and then click on the gradient preset thumbnail to edit the gradient. Choose any two-color gradient preset as a starting point, then click on the color stop at the left, below the gradient. Click on the color swatch to launch the picker and select a light blue color.

12 | Use this same method to change the color stop beneath the gradient at the right to a different, darker blue. Drag the gradient midpoint to the right slightly and click OK. Your new gradient will be selected as the preset when you exit the gradient editor. Click and drag, from the bottom up, within the current selection on your new layer. This will add your new gradient into the selection. Deactivate the selection and change the blending mode of the layer to multiply.

Adding a figure
Follow this process to create a figure, complete with a giant laptop on his head.

1 | Open up the band.jpg file and use the polygonal lasso tool to draw a polygonal selection around one of the band members. Control(PC)/ Command(Mac)-click inside the selection and drag the contents into your working file as a new layer.

2 | With the new layer targeted, choose Edit>Free-Transform from the menu. To rotate, move the mouse pointer outside the bounding box, then click and drag. Shift-drag the corner of the box to increase the size proportionately. Press the enter key to apply the transformation.

3 | Open the computers.jpg file. Select a laptop with the polygonal lasso and drag it into your working file as a new layer. Use the free-transform function to rotate, resize, and position the laptop so that it overlaps the figure's head.

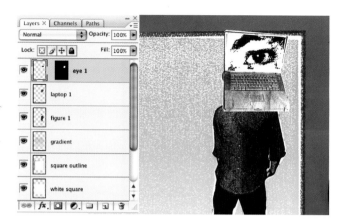

Linking the unlinked

When you have a selection active and you choose the Paste Into option from the Edit menu, your copied artwork is pasted into the file as a new layer. This layer is automatically masked and the active selection determines which areas of the new layer will remain visible. When you create a masked layer this way, the mask and the layer are not linked in the layers palette. If you want to move both the layer and mask together it is necessary to link them by clicking in the space between the two thumbnails in the layers palette. You'll see a link icon appear in this area. Masks are linked to layers here because if the groups containing the layers are moved, we want the masks to move with them.

13 | Use the polygonal lasso tool to draw a selection that surrounds only the screen of the laptop in your working file. Open the eyes.jpg file. In the eyes.jpg file, draw a polygonal selection around one of the eyes in the image. Copy the selected area and return to your working file. With your current selection active, choose Edit>Paste Into from the menu to paste the eye into the image as a masked layer. Target the new layer thumbnail in the layers palette (not the mask) and use free-transform to resize and position the eye.

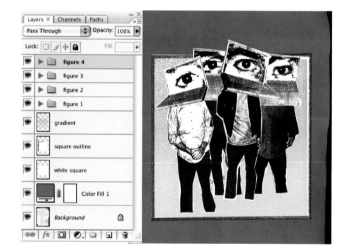

14 | Click in the area between your new layer thumbnail and the mask thumbnail in the layers palette to link them. Now, target the current layer and then Control(PC)/Command(Mac)-click on the laptop layer and the figure layer in the layers palette so that all three layers are targeted. Choose Layer>New>Group From Layers from the menu to add these layers to a group. Now, repeat this procedure three times to add the three remaining figures, add laptops on their heads, put eyes on the laptop screens, link any unlinked masks, resize and rotate as required, and then add each set of layers to a group until you have a separate group for each figure.

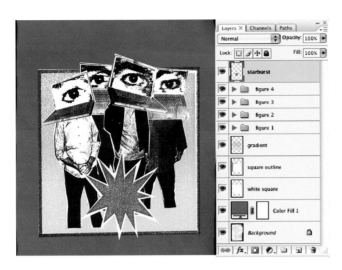

15 | Return to your shapes.jpg file. If you left the file open, chances are it is still inverted. Choose File>Revert from the menu to revert it back to the original positive state. If it isn't currently open, reopen the shapes.jpg file. Use the polygonal lasso tool to draw a selection border around the starburst shape. Hold down the Control(PC)/Command(Mac) key, then click inside the selection border and drag it into your working file as a new layer. Use Free-Transform to increase the size and position the layer on the canvas as shown here.

Another duplication method

When you are using the polygonal lasso tool, try right-clicking(PC)/control-clicking(Mac) on the contents of your layer on the canvas. You will see a pop-up menu appear offering you several functions to choose from. Included on the list is the option to duplicate the layer. Try using this method, you may find it even quicker than dragging layers onto the create new layer button at the bottom of the layers palette. This method works with any selection tool.

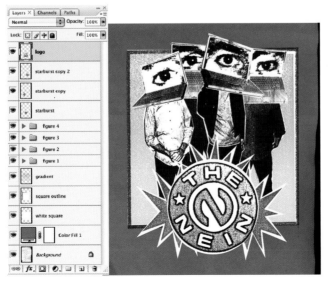

16 | Drag your starburst layer onto the create a new layer button at the bottom of the layers palette to duplicate it. Use the move tool to drag it over to the left and then down slightly on the canvas. Duplicate this layer too, and then move it to the right. Open the logos.jpg file. Click and drag with the elliptical marquee tool to select the logo at the upper right. Hold down the shift key to create a circular selection as you drag. Control(PC)/Command(Mac)-drag the selected logo into the working file as a new layer. Use free-transform to adjust the size and position.

17 | Return to your logo.jpg file. This time use the elliptical marquee tool to draw a selection around the black logo at the lower right of the canvas. Copy it and return to your working file. Click on the create new channel button at the bottom of the channels palette to create an alpha channel. Double click the new channel thumbnail and when the Channel Options appear choose selected areas in the Color Indicates options and click OK. Paste the copied art into your new channel and then enable the visibility of the CMYK composite channel by clicking in the column to the left of it in the channels palette.

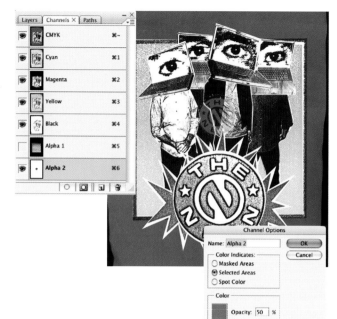

Constrained rotations

When you are rotating the contents of a layer or selection with free-transform, try holding down the shift key while you click and drag outside of the bounding box. When you do this, your rotations will be constrained to 45° increments.

18 | Use free-transform to increase the size of your pasted selection and position it within the channel so that it overlaps the logo in the composite channel. Press Enter to apply the transformation and then open up the type.jpg file. Use the polygonal lasso tool to draw a selection around the 'sonic unyon presents' that is set against a dark background. Copy it and return to your working file. Paste it into your targeted alpha channel and then use free-transform to adjust the size and position it at the upper left within the channel. Load the channel as a selection.

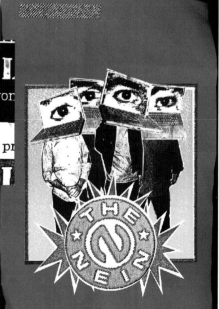

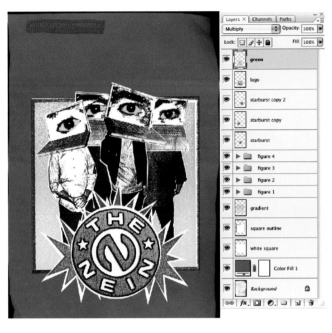

19 | With the new channel-based selection active, return to the layers palette and create a new layer. Click on the foreground color swatch to choose a light green foreground color from the picker. Type alt(PC)/option(Mac)-delete to fill the active selection with the foreground color on the new layer and then deselect. Set the blending mode of the layer to multiply in the layers palette and select the polygonal lasso tool. Use the polygonal lasso to draw selections that cover each large eye. Then fill these selections with the same color on the current layer. Deselect.

Lighten via blending

If you double-click a layer thumbnail in the layers palette you will access the Layer Style box which, in addition to a plethora of other options, allows you to control the blending of the layer. In this case, simply direct your attention to the top slider in the 'blend if' section. Drag the left slider underneath the 'this layer' bar to the right. This will lighten all of the shadow areas on the layer. This is a handy way to lighten all of the black components of your photocopied art on a layer. The advantage of doing this versus a color adjustment is that you can always go back to this dialog box and edit or reset your adjustment.

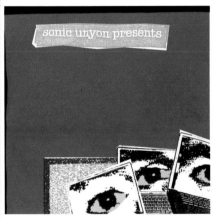

20 | Create a new layer and drag it below the top layer in the layers palette. Use the polygonal lasso to draw a shape that roughly surrounds the 'sonic unyon presents' box on the top layer. Ensure that the new layer is targeted and then press 'd' on the keyboard to set the background color to white. Type Control(PC)/Command(Mac)-delete to fill the selection with the background color and then deselect. Return to the type. jpg file, reopen it if necessary.

21 I Use the rectangular marquee to draw a selection around the black against white 'sonic unyon presents' type. Copy it, return to your working file, and paste it in as a new layer. Drag the layer to the top of the layers palette and change the blending mode to multiply. Use free transform to adjust the size and angle of the layer contents as well as position it over the other 'sonic unyon presents' artwork on the canvas. Repeat this method to add the 'live at the horseshoe' text on a new layer. Drag the new layer beneath the figure groups in the layers palette.

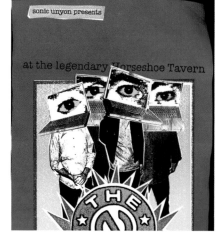

Distorting

Each piece of photocopied text that is brought into this image as a new layer is resized and rotated by using the free-transform function. However, if you look at the word 'live' you'll notice that it has been distorted. To distort, rather than scale, while using free-transform, hold down the Control(PC)/Command(Mac) key while you drag a corner handle of the bounding box.

22 I Now, return to the type.jpg file. Use the polygonal lasso to select a section of type, copy it and then paste it into the working file as a new layer. Use free-transform to size, rotate, and position it. Repeat this method over and over again until you've added all of the necessary text elements to the poster. Leave the blending modes for all of these new layers set to normal as you add them. Move the layers up and down within the palette as you see fit.

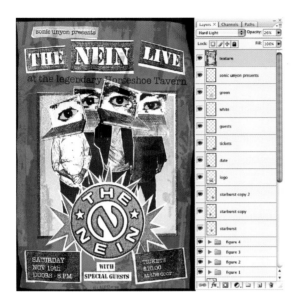

23 | The poster design is complete, but it doesn't look weathered or distressed enough on the surface. To remedy this, we'll incorporate a photo of the real thing. Open up the texture.jpg file. This is a photo of extremely weather-beaten poster art. Select all and copy. Paste it into your working file as a new layer and drag the new layer to the top of the stack in the layers palette. Change the blending mode of the layer to hard light and reduce the opacity to 26%. Save and close your poster file with all of the channels and layers intact.

Put your poster up on the wall

Add your poster to a background image as an editable smart object, carefully tracing it with the pen tool.

1 | Open up the wall.jpg file. Then, choose File>Place from the menu. Navigate to your layered poster file on your hard drive and open it. This will place your poster file into the wall image file as a smart object.

2 | The smart object is placed into your file surrounded by a free-transform bounding box. Resize and rotate the smart object while placing it to the left of the canvas. Press the enter key to commit the transformation.

3 | Use the pen tool to draw a closed path around the pink edge of the rotated poster. The smart object's black background should lie outside of your finished path. Ensure that the pen tool is set to create paths and the add to path area option is enabled.

24 I With your new path selected and your smart object targeted in the layers palette, choose Layer>Vector mask>Current Path from the menu to clip your smart object with the path. You will see a vector mask added to your smart object in the layers palette. If you wish to edit your poster at any point, all that you need to do is double-click on the smart object in the layers palette. This will open a new document containing a layered version of the poster. You can make any changes you like to the poster file. Once you save the changes the smart object will automatically update within this file, reflecting the changes you made.

Examining the poster you've created

A successful urban poster art effect is the culmination of a number of essential ingredients.

a I Converting your images to grayscale and then enhancing the contrast is an excellent way to get started. It allows you to create simple, high contrast images that lend themselves nicely to real-world photocopier degradation without losing any essential detail.

b I Scanning the photocopied results and then using the polygonal lasso tool allows you to create an imperfect and choppy composition. Because most real-world underground posters are put together by manually cutting and pasting, a choppy Photoshop selection technique is necessary to ensure an authentic look.

c I Creating areas of color that overlap the imagery on a layer with a multiply blending mode simulates authentic silkscreen printing effects. Usually, urban posters that are silk-screened are hastily created with poor registration and as a result, colors overlap and tend to look sloppy.

d I Now, even though we started with a folded piece of paper in the background, the results were still a little too crisp looking. Adding a photo of actual torn up posters on the top layer helps to provide a gritty, textured effect.

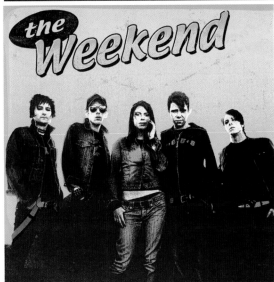

Because this style of urban artwork is comprised of flat, solid colors, it lends itself nicely to hue/saturation adjustments. As is evident in these poster designs for The Weekend, a hue adjustment, after all is said and done, can open the door to a plethora of new color combinations. Sometimes you'll be taken by surprise to see how well a color combination that you'd never think to try will work out.

Original Weekend press photo courtesy of Teenage USA Recordings.

Chapter 11

Urban Lowbrow Art

here is evidence of a reckless approach inherent in the majority of urban art. This, along with pop-culture subject matter, is what some argue sets it apart from the world of mainstream art, giving it the derogatory sounding tag of being 'lowbrow'. However, with a lack of mainstream acceptance comes a sense of freedom. Not only is no subject too taboo, but the techniques of execution are less limited than within mainstream art. Paint is thrown around with abandon, new elements are added on top of old, and the visual result has an incredibly loose feel to it. This is something that is rarely achieved or even addressed in the world of digital art. Things are often very contrived and the feeling of abandon is rarely even attempted. The recklessness and abandon that the paint slingers take for granted is something that we Photoshop artists must carefully plan and calculate. In order to achieve similar results, it is up to the digital artist to devise a process that mimics the techniques of the real world approach. That process is outlined step-by-step within this chapter.

As you work your way through the following pages, you'll notice the inclusion of many real world resources. When a dripping paint effect is required, I'll opt for an actual photo of just the thing. An appropriate paper scan is used to create an authentic unbleached parchment background, and all of the primary elements are converted drawings or photos. The results are helped by the fact that no single element is entirely computer generated, however, it is the conversion process used here that gives the finished image its signature appearance.

All of the main elements in this composition are converted to high contrast, black and white imagery, before becoming part of the composition. Using bitmap mode is very effective because, as you'll discover shortly. When you choose the threshold method, a pixel can either be black, or it can be white. There are no shades in-between. Another method for achieving high contrast is to use a couple of native filters that reside within Photoshop. The stamp and photocopy sketch filters can prove very useful when it comes to converting color and grayscale images, and will help preserve a little detail where the bitmap conversion method will not.

When it comes to adding black and white components to the composition, we'd be nowhere if it weren't for alpha channels. They provide unparalleled control and flexibility when it comes to creating custom selections from black and white data, as you'll see for yourself soon enough. So lower you chair, lean back, and let's create an urban lowbrow masterpiece.

1 | To get started, open up the bkd.jpg file from the CD. This will act as the background layer in our new working file. Next, open up the black and white heart.jpg file. Type Control(PC)/Command(Mac)-a to select all of the image contents and then type Control(PC)/Command(Mac)-c to copy the contents of the selection. In the bkd.jpg file, click on the Create New Channel button at the bottom of the Channels palette. With your new alpha channel targeted, type Control(PC)/Command(Mac)-v to paste the copied black and white image into your alpha channel. Click on the Load Channel as a Selection button at the bottom of the palette.

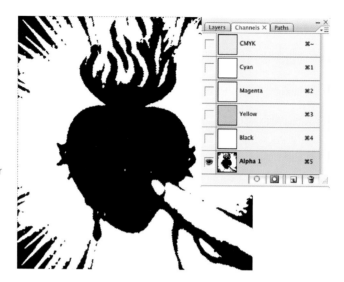

CD files

The files needed to follow along with this chapter and create the featured illustration are available on the accompanying CD. These files can be found in the folder entitled: chapter_11. However, do not feel restricted to using these files only. Feel free to follow along and incorporate background imagery and textures of your own as you work through the chapter. Also, rather than using the supplied outline art files, you can create your own outline art using the methods described earlier in either Chapter 5 or Chapter 6.

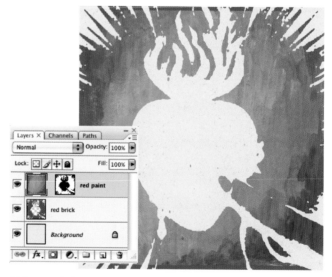

2 | Return to the Layers palette and click on the Create a New Layer button at the bottom of the palette. Target your new layer and click on the foreground color swatch in the toolbar to access the picker. Choose a color similar to red brick and click OK. Type alt(PC)/option(Mac)-delete to fill the active selection with the new foreground color. Leave the selection active and open up the redpaint.jpg file. Select the contents of the redpaint file and copy. Return to the working file with the active selection and choose Edit>Paste Into from the menu.

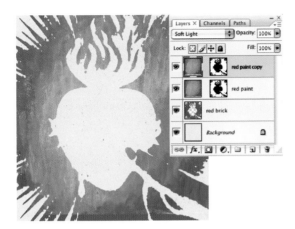

3 I Use the move tool to drag the layer up to the top of the canvas area within the mask. Because the mask isn't linked, it will remain in position as you move the layer contents. Change the layer blending mode to hard light and then duplicate the layer by dragging it onto the Create a New Layer button. Change the blending mode of your duplicate layer to soft light. With your current layer targeted, shift click on the layer directly above the background layer, targeting the top three layers. Type Control(PC)/Command(Mac)-g to add the targeted layers to a new group.

Mask your group

Punch a hole in your paint effects by using the contents of a new channel as the basis for a mask.

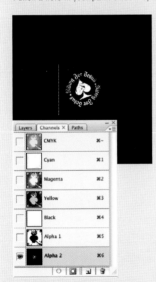

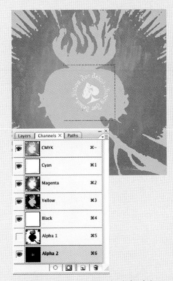

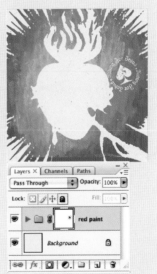

1 I Open up the ace.jpg file. Select the contents of the file and copy them. Return to your working file and create a new alpha channel in the channels palette. With your new channel targeted, paste the copied contents from the other file.

2 I Click in the column to the left of the CMYK composite channel to enable its visibility. You will now see your alpha channel appear as a red overlay on top of the image. This will aid you in repositioning your pasted art.

3 I Position the pasted art within the paint area to the right. Load the channel as a selection and then target your group in the layers palette. Choose Layer>Layer Mask>Hide Selection from the menu to mask this area of the entire group.

4 | Open up the dice.jpg file. We're going to use the photocopy filter here as it will produce a high contrast result with a halo around the perimeter of the dice. The Photocopy filter uses the current foreground and background colors to produce its results, so in order to create a black and white effect, we need to set the foreground and background colors to their default black and white state. Press the 'd' key on the keyboard to set the foreground and background colors to their default state. Choose Filter>Sketch>Photocopy from the menu. Adjust the detail and darkness settings until your dice look something like this. Apply the filter.

Incorporate the dice

Place your converted dice into another channel and use the resulting selection to punch another hole in the paint.

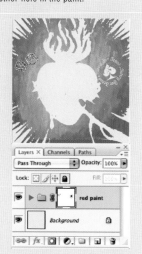

1 | Choose Image>Mode>Grayscale from the menu. Then, choose Image>Mode>Bitmap to access the bitmap conversion options. Choose 50% threshold as the method and leave the output set at the current resolution. This will vary depending upon the resolution you're working at.

2 | Click OK to convert your image. Then select the contents of the image and copy them. Return to your working file, create a new alpha channel and invert it by Typing Control(PC)/Command(Mac)-i. Paste your copied dice into the new, inverted channel.

3 | Enable the visibility of the composite channel. Position your selection contents to the left and then load the channel as a selection. Invert the selection by typing Control(PC)/Command(Mac)-shift-i. Target the group's mask in the Layers palette and fill the selection with black.

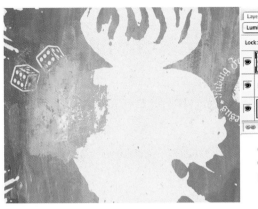

5 I Deactivate the dice selection. Open up the bluepaint.jpg file and use the magic wand to select a range of blue color from within the image. Hold down the Control(PC)/Command(Mac) key and drag the selected paint into the working file as a new layer. Choose Edit> Free-Transform from the menu. Click and drag within the center of the bounding box to reposition the contents, then shift-click and drag a corner point to resize the contents of the bounding box proportionately. Press the Enter key to apply the transformation. Reduce the opacity of the layer and change the blending mode to luminosity.

Finish the blue paint effect

Repeat the process of dragging selected regions of blue into the image and then add a solid blue background on an underlying layer.

1 I Return to the bluepaint.jpg file and use the magic wand to select another, different range of color. Again, hold down the Control(PC)/Command(Mac) key and drag it into the working file. Use Free-Transform to resize and position it, change the mode to luminosity and reduce the opacity.

2 I Use this method to add a couple more layers from the same bluepaint.jpg file. Control(PC)/Command(Mac)-click on the thumbnail of one of these layers to generate a selection from the contents. Then Control(PC)/Command(Mac)-shift click on the remaining blue paint layer thumbnails to add them to the selection.

3 I Create a new layer and drag it below all of these new layers in the layers palette. Choose a light blue foreground color from the picker and use it to fill the active selection on your new layer. Deactivate the selection.

6 | Target all of the blue paint layers and group them in the Layers palette. Open up the figure.jpg file. This file, like the original heart.jpg file, has been prepared ahead of time. Both images were converted to grayscale and then converted to bitmap mode, as you did previously to convert the dice after the photocopy filter was applied. Use the move tool to click anywhere on the image and drag it into the working file as a new layer. Reposition the layer contents toward the upper left of the canvas. Drag the new layer to the top of the stack in the Layers palette.

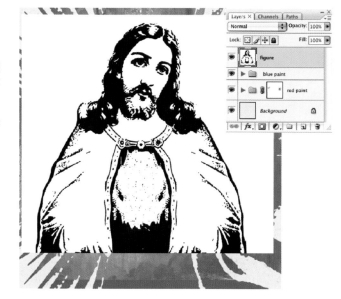

The conversion process

In order to convert an image to bitmap mode, it must be converted to grayscale first. After you convert your image to grayscale, it is a good idea to examine the overall contrast within the image. Perform any tonal adjustments you think will be necessary for a successful conversion while you're working in grayscale. Once you've got things looking the way you want them, then go ahead and convert the image to bitmap mode. Once the image is in bitmap mode you cannot perform any tonal adjustments, so you must remember to make any adjustments while you are in grayscale mode.

7 | Now open up the edges.jpg file. This is another prepared image that was created by converting poor quality scans of photocopied pages to bitmap mode. If you like this sort of look, be sure to read Chapter 10 where

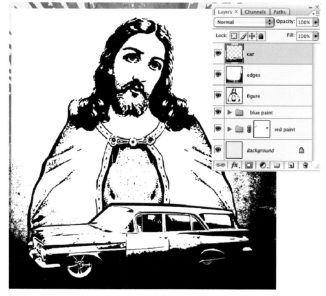

photocopy effects are explained in greater detail. Use the move tool to drag the edges.jpg image into the working file as a new layer. Position the layer so that it touches the top of the canvas and change the blending mode to multiply. Open up the car.psd file and drag it into the working file as a new layer too. Position the car layer at the bottom of the canvas.

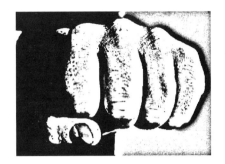

8 | Open up the righthand.jpg file. Duplicate the background layer and ensure that the foreground and background colors are set to black and white. Target the bottom layer and then choose Filter>Sketch>Stamp from the menu. Adjust the sliders, so that there is good balance between contrast and detail. Click OK to apply the filter and then target the top layer that is hiding the effect. Now choose Filter>Sketch>Photocopy. Apply a fairly dark photocopy effect and then change the blending mode of this layer to multiply. Choose Layer>Flatten from the menu to flatten the image.

Incorporate hands into the design

Add the selected hand to your working file, then repeat this entire process to alter and then add the other hand as well.

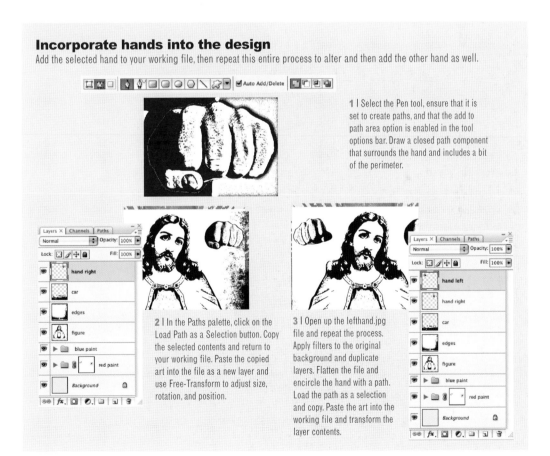

1 | Select the Pen tool, ensure that it is set to create paths, and that the add to path area option is enabled in the tool options bar. Draw a closed path component that surrounds the hand and includes a bit of the perimeter.

2 | In the Paths palette, click on the Load Path as a Selection button. Copy the selected contents and return to your working file. Paste the copied art into the file as a new layer and use Free-Transform to adjust size, rotation, and position.

3 | Open up the lefthand.jpg file and repeat the process. Apply filters to the original background and duplicate layers. Flatten the file and encircle the hand with a path. Load the path as a selection and copy. Paste the art into the working file and transform the layer contents.

9 | Target all of these black and white layers and add them to a new group within the Layers palette. Ensure that the new group is targeted in the Layers palette, and set the blending mode of the group itself to multiply. Now you can see your entire composition clearly, select the magic wand tool. Disable the contiguous option, and then enable the sample all layers option in the tool options bar. Leave the tolerance set at the default value of 32 and click on a black area of the canvas. This will select all visible areas of the same black color.

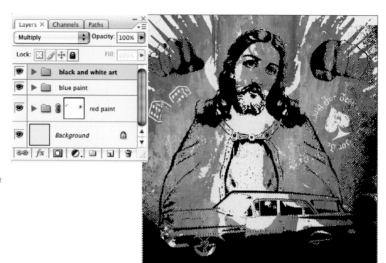

Gathering resource materials

When collecting resource materials to use within your urban art illustrations, primarily main image components, bear in mind the conversion process. The image of Jesus is a photograph I took of a mural painted onto the side of a religious supply store. I knew it was an ideal candidate for conversion because, although the original was in color, there was enough contrast between the outline and fill colors to indicate that conversion to black and white would be successful. And although the low-rider car is a photo of an actual car, I examined the image and found the same qualities were present. It is important to look for areas of pre-existing contrast in your photographs or scans to ensure that the image contains detail and is properly represented when you convert to bitmap mode.

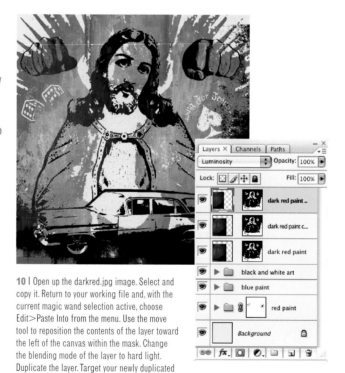

10 | Open up the darkred.jpg image. Select and copy it. Return to your working file and, with the current magic wand selection active, choose Edit>Paste Into from the menu. Use the move tool to reposition the contents of the layer toward the left of the canvas within the mask. Change the blending mode of the layer to hard light. Duplicate the layer. Target your newly duplicated layer and now duplicate it too. Target the second duplicate layer and use the move tool to move the layer contents upward and to the left a little more. Change the blending mode of the layer to luminosity.

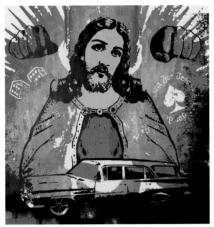

11 | Target all of the dark red paint layers in the Layers palette and group them. Use the pen tool to create path components outlining areas like the car windows and the front of his gown. Generate a selection from the path and fill the active selection with brown on a new layer. Drag the layer down beneath the group that contains the black and white artwork in the Layers palette. Reduce the layer opacity slightly, revealing some of the painterly texture beneath. Use this same method again to add color into his skin and hair on other layers beneath the group containing the black and white art.

Add the heart

A scanned drawing, converted to bitmap mode, provides the basis for the heart-shaped selection within a new alpha channel.

1 | Open up the sacredheart.jpg file. Choose Image>Mode>Bitmap from the menu. Use the 50% threshold method and then invert the image. Copy the inverted bitmap and create a new alpha channel in your working file. Paste the copied art into the channel.

2 | Load a selection from the channel and then create a new layer in the Layers palette. Drag your new layer to the top of the stack in the Layers palette. Fill the active selection with a light beige foreground color on the new layer.

3 | Deactivate the selection and then use the move tool to reposition the contents of the layer, so that the heart is sitting directly on top of his chest area. Keep the foreground color set to the same beige and select the Horizontal Type Tool.

12 | Click on the hand at the right to add a text insertion point in that area of the canvas. Type the word 'hate' and press the Enter key. Try to select an appropriate font from the available fonts in your system that are listed in the tool options bar. Also enter a sufficient size to cover the hand as shown here. Choose Edit> Free-Transform from the menu. Click and drag outside of the bounding box to rotate it and then place the type directly over the knuckles. Press Enter to apply the transformation and then use the same method to add the word 'love' across the knuckles of his other hand on another type layer.

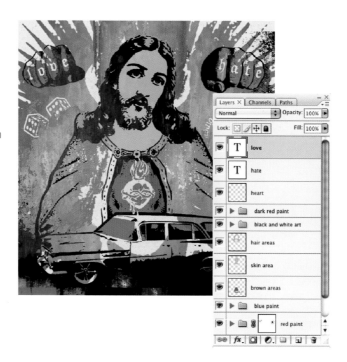

No fonts, no problem

You may find that you're lacking an appropriate font on your system for the love and hate knuckle tattoos in your illustration. If this is the case, worry not, there are plenty of appropriate fonts out there on the web. Simply do a search for gothic free fonts like I did here, and you'll find numerous hits offering a vast number of appropriate fonts, available for free personal use.

13 | Open the spraypaint.jpg file. Use the lasso tool to draw a rough selection containing some of the dripping paint and copy it. Create a new alpha channel in the working file and paste your copied paint into it. Generate a selection from the channel and create a new layer in the Layers palette. Fill the active selection with a new, bright orange foreground color. Deactivate the selection and use free-transform to resize the contents of the new paint layer. Position it over the hand at the left and drag the layer beneath the group that contains the black and white art.

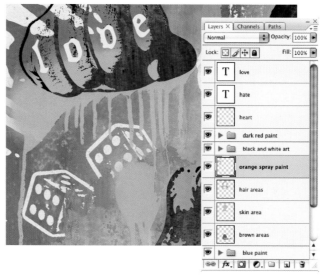

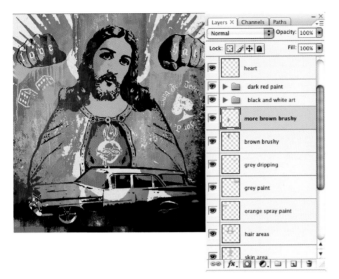

14 I Use this method to add dripping paint clusters on a variety of layers in different colors. Explore different positions on the canvas as well as within the Layers palette hierarchy. Repeat this entire procedure, using the brushy.jpg file and the overspray.jpg file as the resources for new alpha channel based selections. Load the channels as selections and fill the selected regions with color to produce similar effects in different colors on a variety of layers. Vary the position of your layers, but ensure that they remain below the black artwork group in the Layers palette.

Don't stop there

Take a good look at your file. It contains numerous layers and alpha channels. You do not have to limit yourself to stopping because the Illustration is complete. There are endless opportunities when you consider the resources available within the file. For instance, I duplicated one of the blue paint layers, changed the blending mode to overlay, and increased the opacity to 100%. After that, I dragged it out of the group and closer to the top of the stack within the Layers palette. Finally, I moved it down to the bottom of the canvas. This is just one very simple example of what can be done. Have some fun and experiment with what else you can do within the file.

15 I Now, use the splatters.jpg as the resource for an alpha channel based selection. Again, fill the selection with a variety of colors on different layers. Move them up or down within the palette, transform and reposition the layer contents as necessary. Feel free to duplicate and perform transform operations on your new layers as well as existing paint layers.

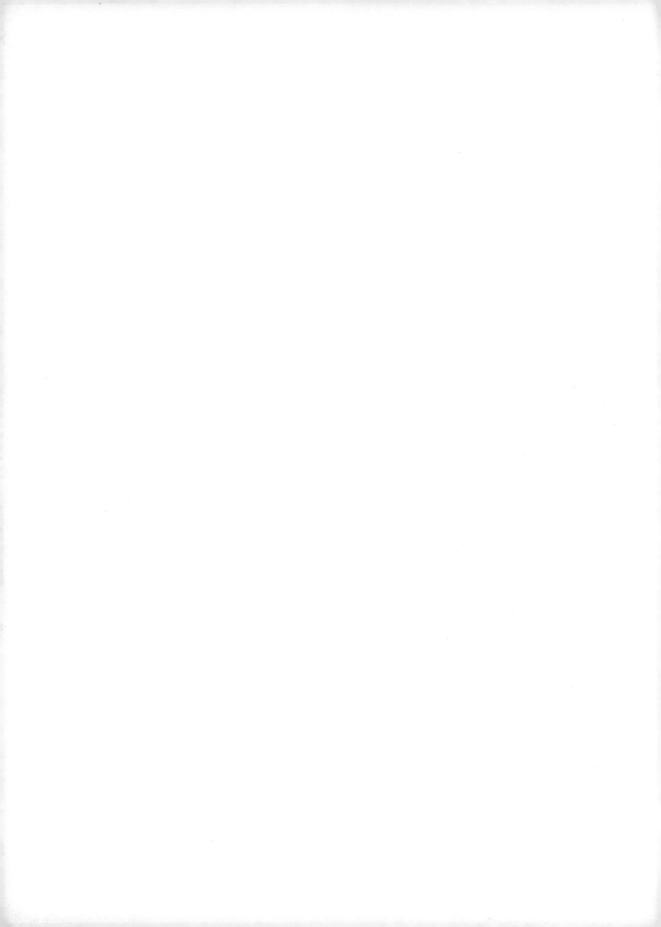

PART 3

Illustrative
Photography

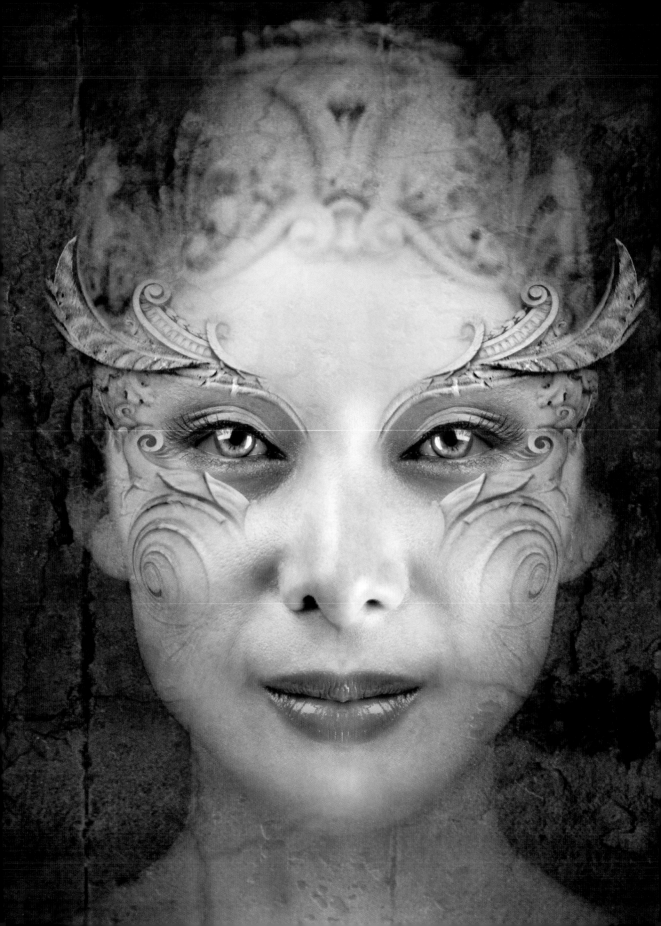

Chapter 12

Creature Architecture

Looking at this beautiful creature before you, it is difficult to imagine that it is nothing more than a simple model shot combined with various photographs of stone textures and architectural details. In a composition like this, the images provide the raw materials, but it is the Photoshop process that allows you to dissolve the boundary between photographic collage and stunning illustration. Things as basic as blending modes, layer masks, and layer groups are much more powerful than they seem. When features are used together as a means to an end rather than on their own, the resulting imagery is always much more than the sum of its parts.

As is often the case in Photoshop, something vast and complicated in appearance is merely the result of repeating an integral procedure over and over again. In this chapter you'll learn how to stack up duplicate layers, alter the blending modes of each, and place them in masked groups. Also, it is very important to remember that groups, like layers, can be duplicated as well. Duplicated groups, like individual layers, can be horizontally flipped and this will allow you to duplicate portions of the image, so that you can create both sides of the face with mirror-like precision. And, although in this chapter I'll explain in detail, numerous ways to finesse your imagery as well as work with color and texture, layer stacking, and duplication is essentially the nuts and bolts of what we're doing here.

The process of creating an image like this may seem daunting at first, but once you get started, the logic reveals itself and you will find yourself perfecting this stacking technique until it comes naturally. Here, I've decided to make a beautiful stone alien by adding snapshots of architectural details to her face. However, as is evident in the showcase images at the end of this chapter, this illustrative effect can be achieved with anything, it doesn't have to be stone details, it can be leaves, or whatever you like.

When you look at this group of photographs, you may find it difficult to envision the results. But rest assured, the stunning image at the beginning of this chapter is nothing more than the product of very basic photographs. Be warned however, as you read through the following pages and develop an understanding of the process, it may change the way you view the world surrounding you. One hazardous side effect of producing photographic illustrations is that you'll tend to always be scanning everything you see, trying to find something useful for your next composition. So proceed at your own risk, and don't say I didn't warn you first.

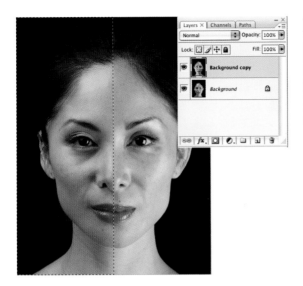

1 | The first thing you need to do is to open up the face.jpg file. This file provides the basic starting point for the photographic illustration. In the layers palette, click on the background layer and drag it onto the create a new layer button at the bottom of the palette to duplicate it. Target the duplicate layer in the layers palette and then choose Edit>Transform>Flip Horizontal from the menu to flip the contents of the duplicate layer. Use the rectangular marquee tool to draw a selection around the left half of her face on this layer.

Project files

All of the files needed to follow along with this chapter and create the featured image are available on the accompanying CD. Files for this chapter can be found in the folder entitled chapter_12.

Duplicating Layers

There is more than one way to duplicate a layer in Photoshop. You already know that you can drag a layer onto the create a new layer button at the bottom of the palette, but there are a few other ways to do it. With your layer targeted, simply choose the Duplicate Layer option from either the layers palette menu or the Layer menu in the menu bar. Another method is to hold down the control key(Mac), or right-click(PC) on your targeted layer in the layers palette. A pop-up menu will appear that offers up the Duplicate Layer command here as well.

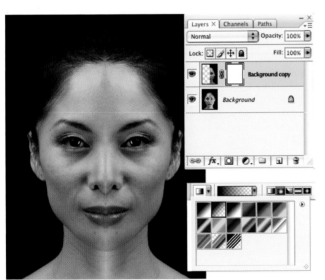

2 | Press the delete key to remove the selected area from the duplicate layer. Already, things are beginning to appear a little strange as a result of reflecting half of her face. Deactivate the current selection and then click on the add layer mask button at the bottom of the layers palette to add a mask to the duplicate layer. Select the gradient tool, and in the tool options bar, choose the radial gradient option. From the list of gradient presets, choose the foreground to transparent gradient preset. Click on your layer mask in the layers palette to ensure that it is targeted.

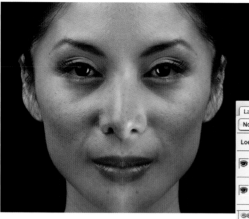

3 | Set the current foreground color to black, then click and drag on the canvas to add a gradient within the layer mask. Start with the nose area, you'll immediately see the hard line disappear as you introduce a gradient overtop of it. Also, as you introduce gradients into the mask, you'll see them appear on the layer mask thumbnail in the layers palette.

Using the gradient tool within your new layer mask
You need to think beyond a single gradient when it comes to creating a gentle mask effect for an image like this.

1 | If you find that you have masked out areas by accident because you have created a gradient that is too large within your mask, worry not, there is a way to remedy this. First, set the foreground color to white.

2 | Now, using white, click and drag to unmask areas of the layer, blending them back into visibility. The key to successful masking is to add and remove as needed, drawing gradients and switching back and forth between black and white as required.

3 | Create large and small gradients as required, masking and unmasking, until you've removed the hard line dividing the two halves of her face. Also, for gentle results, try reducing the opacity of the gradient in the tool options bar as you use it.

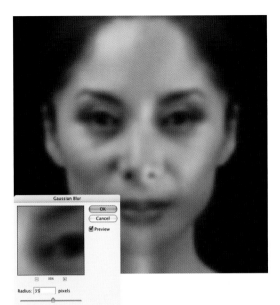

4 | When you're happy with the results of the mask, choose Layer>Flatten Image from the menu to merge the layers. Now we're going to add a blur effect around the edges. Duplicate the newly merged background layer in the layers palette using the layer duplication method of your choice. With the duplicate layer targeted in the layers palette, choose Filter>Blur>Gaussian Blur from the menu. Enter a radius value that has a significant impact. This will vary depending upon the resolution you're working at. Click OK to apply the blur effect to your duplicate layer.

Setting and swapping colors

When editing the content of a layer mask you'll generally want to use either black or white, if your foreground and background colors are showing up as shades of gray you can quickly set them to their default black and white state by pressing the 'd' key on your keyboard. By default, white is the foreground color and black is the background color when a mask is active. However, if you want to switch them quickly, just press the 'x' key on your keyboard. You can swap the foreground and background colors as often as you like by simply hitting the 'x' key.

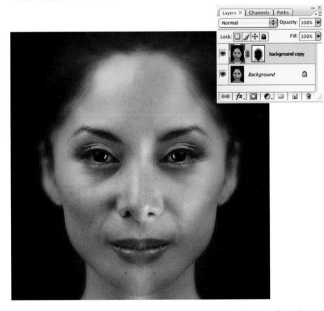

5 | Add a layer mask to your blurred layer and select the gradient tool. If you haven't altered any of the tool settings, they will remain the same way you left them. With the foreground color set to black, the gradient preset set to foreground to transparent, and the radial option enabled, click and drag from the center of her face outward to reveal the image underneath the layer that remains in focus. Add gradients to the mask, in black and white as required, masking and unmasking the contents of the layer, until her face is in focus and the surrounding areas are not.

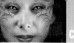

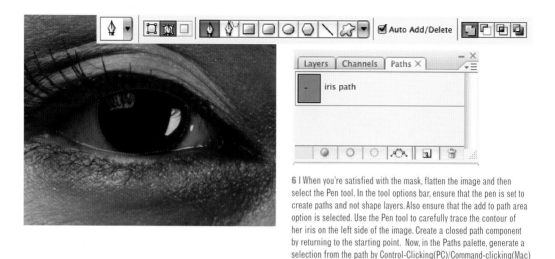

6 | When you're satisfied with the mask, flatten the image and then select the Pen tool. In the tool options bar, ensure that the pen is set to create paths and not shape layers. Also ensure that the add to path area option is selected. Use the Pen tool to carefully trace the contour of her iris on the left side of the image. Create a closed path component by returning to the starting point. Now, in the Paths palette, generate a selection from the path by Control-Clicking(PC)/Command-clicking(Mac) on the Path thumbnail.

Building up luminous eye effects

Use a series of different layers to begin stacking up the luminous eye effect that give our alien her other-worldly stare.

1 | Choose Layer>New>Layer Via Copy from the menu to create a new layer containing the selection contents. Choose Image>Adjustments>Levels from the menu and drag the center input slider to the left to lighten the iris midtones. Drag the left slider toward the right a little.

2 | Control(PC)/Command(Mac)-click your layer thumbnail to generate a selection from it. Then create a new hue/saturation adjustment layer. Enable the colorize option and then manipulate the sliders to give the iris a bright blue hue. Select the magic wand tool when finished.

3 | Click on a blue area of the iris to generate a selection from it. Create a new layer and then add a white to transparent radial gradient inside the active selection on your new layer. Change the layer blending mode to overlay.

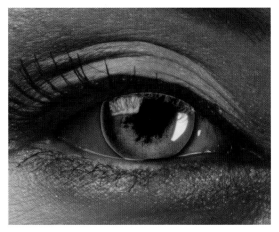

7 | Duplicate the top layer and change the blending mode to screen, this adds some white into the iris. Reduce the opacity of the top layer to 40% or so. Now, go ahead and add layer masks to the top two layers and use the aforementioned gradient methods to blend any hard edges or mask out any unwanted areas from the individual layers. Target the top layer and then, while holding down the shift key, click on the iris layer that sits just above the background layer. This targets both layers as well as all layers in-between within the layers palette.

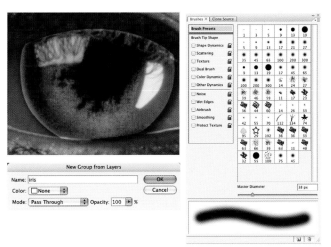

8 | With multiple layers targeted in the layers palette, choose Layer>New>Group From Layers from the menu. This creates a new group containing all of the layers. Go ahead and name it 'iris'. Deselect any currently active selections and click the add layer mask button in the layers palette to add a mask to your group. Select the brush tool. In the brushes palette, choose a soft, round, brush tip preset. Disable all of the brush dynamics from the column at the left with the exception of smoothing. Zoom in close on the iris.

Smoothing

Leaving the smoothing option enabled in the brushes palette will allow you to produce smother curves while you paint. It is very useful to those of you who are painting quickly with a stylus instead of a mouse, but if you are painting very quickly you may notice a slight delay while your finished strokes are rendered on the screen.

9 | Adjust the master diameter of your brush in the brushes palette, so that it is about half as wide as her pupil. Target the iris group mask in the layers palette and then, while using a black foreground color, paint over all of the hard edges around the perimeter of the iris. Next, in the tool options bar, reduce the opacity of the brush considerably, and paint over areas of the iris within the layer mask that you want to soften. Try working with a variety of opacity settings to get the best results.

Duplicating groups

Duplicating a group is done exactly the same way as duplicating a layer. You still have a number of options when it comes to exactly how you create your duplicate. You already know that you can drag the group onto the create a new layer button in the layers palette, but the other duplication methods will work as well. You can target your group and then choose Duplicate Group from the Layer menu in the main menu or from the Layers palette menu. Also, you can control-click(Mac)/right-click(PC) on the layer in the Layers palette and then choose the duplicate group option from the resulting pop-up menu. In every case, the procedure is exactly the same as duplicating a single layer, except for the fact that Duplicate Layer is replaced with Duplicate Group within any menu you decide to use.

10 | In the layers palette, drag the iris group onto the create a new layer button to duplicate the entire group. With the duplicate group targeted, Choose Edit>Transform>Flip Horizontal from the menu to flip the duplicated iris group. Select the move tool. While holding down the shift key, use the move tool to drag the duplicate group across the canvas so that it rests perfectly on top of the other eye.

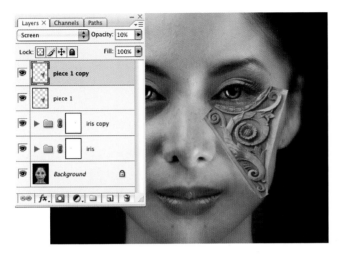

11 | Now that you've completed the iris effects, we'll begin to add some of the stone details to her face. Start by opening up the piece1.psd file. Use the move tool to click on the stone detail and drag it into your working file as a new layer. Position the contents of the new layer on the canvas, so that the stone detail overlaps her cheek at the right. Next, duplicate the layer, change the blending mode of the duplicate layer to screen, and reduce the opacity to 10%.

Precise dragging

When you are dragging layers from one file to another, it is likely that you'll need to reposition the layer on the canvas once it is in your destination file. However, if your source and destination files have the exact same pixel dimensions, try holding down the shift key while dragging your layer from file to file. This will place the layer in your destination file, in the exact same position on the canvas area as it was in your source file.

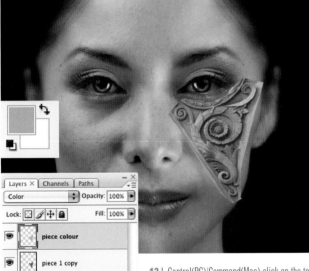

12 | Control(PC)/Command(Mac)-click on the top layer's thumbnail to generate a selection from the contents of the layer. Now, with the new selection active, select the eyedropper tool and click on an area of her skin to sample it. This will set the foreground color to the new sampled color. Create a new layer and then fill the contents of the selection on the new layer by choosing Edit>Fill from the menu. And finally, change the blending mode of this new layer to color and deactivate the current selection.

Dragging multiple layers

You can drag more than one layer at a time from file to file. First, simply target more than one layer in the layers palette. Next, click on any one of the targeted layers and drag it into the image window of any other open file. The layer you dragged will be added to the destination file, as well as all of the additional layers that were targeted in the layers palette of the source file.

13 | At the moment, your top layer should be targeted in the layers palette. Hold down the Control(PC)/Command(Mac) key and then click on the two layers beneath it that contain the stone detail, to target them as well. Now that the top three layers are targeted, choose Layer> New>Group From Layers from the menu to add them to a group. Once they are grouped, add a layer mask to the group and ensure that the mask remains targeted in the layers palette.

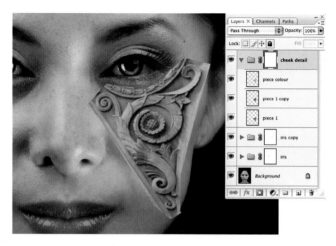

Merging groups

As is true with many Photoshop functions, you can access the merge group function in a number of different places. First, target your group in the layers palette, and then you can either choose Merge Group from the Layer menu or from the Layers palette menu. In addition to these methods, you can always right-click(PC)/ control-click(Mac) on the group itself within the Layers palette. A pop-up menu will appear and you can choose the Merge Group option from the list. However, the quickest method, and the one you should familiarize yourself with, is the keyboard shortcut. Simply target your group in the layers palette and then type Control(PC)/ Command(Mac)-E on the keyboard.

14 | Use the lasso tool to draw a rough selection on the layer mask that traces the contour of the stone detail. Then invert the selection by choosing Select>Inverse from the menu. Fill the inverted selection on the targeted layer mask with black and then deactivate the selection. This will remove the straight edges contained within the original file. Next, with your group targeted in the layers palette, choose Layer>Merge Group from the menu to merge the entire group into a single masked layer. Now, drag your layer mask into the trash in the layers palette to remove it. When prompted, click the apply button.

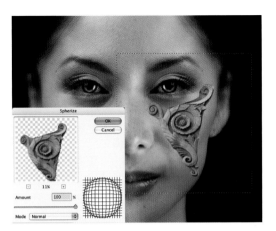

15 I Next, select the rectangular marquee tool and draw a rectangular marquee that contains the stone detail as well as a fair amount of the background image within the selection border. You need an ample amount of space between the stone detail and the selection border for this effect to work out properly. Once you've made your selection, ensure that your newly merged layer is targeted in the layers palette. Then choose Filter>Distort>Spherize from the menu. Increase the amount considerably to add the necessary contour to the stone detail and then click OK.

Completing the spherize effect

Before moving onto masking or another piece of stone detail, this piece still needs a little bit of finesse to make it work.

1 I Deactivate the selection and then choose Edit>Free-Transform from the menu. Hold down the Control(PC)/Command(Mac) key while dragging the corner points of the bounding box to freely distort the contents of the layer, making it fit her cheek area better.

2 I Press Enter on your keyboard to apply your transformation. Draw another rectangular selection around your stone detail like you did before using the Spherize filter earlier. Next, just choose Filter> Spherize from the menu to repeat the previous spherize effect.

3 I Deselect and again, use the same Free-Transform method while holding down the Control(PC)/ Command(Mac) key to adjust the shape, making it fit her face better. Sometimes a bit of repetition is necessary to get the effect you're after. Press Enter and add a layer mask.

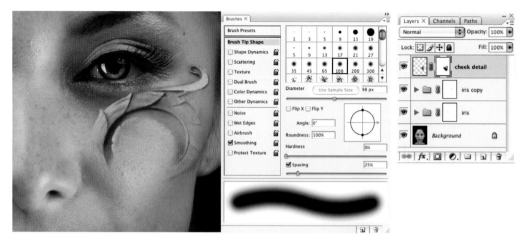

16 | Target your layer mask in the Layers palette and then select the brush tool. Choose a soft, round brush tip preset and disable any brush dynamics in the Brushes palette. Use the brush, with a foreground color of black, to paint within the mask. Vary the brush diameter in the Brushes palette as well as the opacity in the tool options bar. Varying the size and opacity will allow you perform large, gentle mask effects, as well as more drastic, smaller, and precise effects. Continue masking until the stone detail begins to look like what you see here.

Choosing details

The process described here will definitely have you producing impressive results when it comes to blending different photographic elements into people. However, one of the most important, and often overlooked, parts of the process is selecting just what to use. I took over 70 photos of various architectural details with this image in mind. Before I began the process of compositing within Photoshop, I spent a lot of time looking at all of the detail photos. Rotating them, flipping them, assessing which particular detail was appropriate for which portion of her face, etc. It is necessary to spend the time planning what to use ahead of time so that you don't spend hours adding various elements into your image, only to find that at the end of it all they don't work. Whether you're adding architectural details or something else entirely, a little forethought goes a long way in the end.

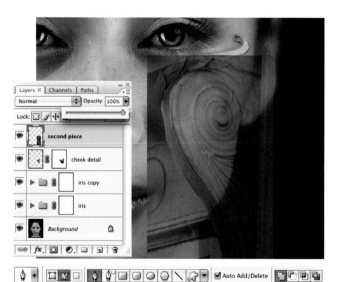

17 | Now, to add a different stone detail to the same area of her face, open up the piece2.jpg file. Use the move tool to drag the image into your working file as a new layer. Reduce the opacity of your layer in the layers palette so that you can see the underlying image and position it so that it fits nicely within the composition, overlapping her existing cheek detail. Next, return the layer to full opacity and select the Pen tool. Ensure that the paths option and the add to path area option are both enabled in the tool options bar.

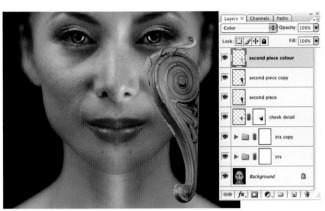

18 | Draw a closed path that surrounds the piece of detail. Generate a selection from the new path in the paths palette using the same methods as you did previously with the iris path. Choose Select>Inverse from the menu and then press the delete key to remove the unwanted portions from this layer. Duplicate the layer. Change the duplicate layer's blending mode to screen to lighten the detail. Control(PC)/Command(Mac)-click on the layer thumbnail to load a selection from the contents of your new duplicate layer. With the new selection active, create a new layer and fill the active selection with a color sampled from her skin via the eyedropper. Change the blending mode of the layer to color.

Reshaping the stone detail

You'll notice this fundamental process begin to repeat itself as we use free-transform and spherize to customize this piece of detail too.

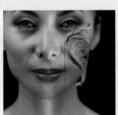

1 | Deselect, then target all three layers that make up this new piece of detail and merge them by choosing Layer>Merge Layers from the menu. Select Edit>Free-Transform from the menu. Hold down the Control(PC)/Command(Mac) key while dragging the corner points of the box to reshape the detail.

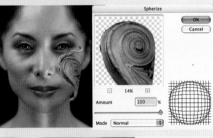

2 | Press Enter to apply the transformation and then use the rectangular marquee tool to draw a generous selection around it that includes sufficient space all around. Choose Filter>Distort>Spherize from the menu and again, use the filter to add curvature to the detail.

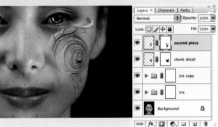

3 | After you apply the filter, like last time, you'll need to tweak the detail by transforming and possibly spherizing again. When you're happy with the results add a layer mask. Again, use a soft brush, with varying size and opacity, to paint within the mask, gently blending the detail.

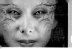

19 | Target the two layers that contain stone details in the layers palette and merge them into one. Target the new, merged layer, and repeat the process of spherizing within a large rectangular selection border to add some curvature to the newly merged details together. Next, add a layer mask and use the paintbrush method employed previously to gently fade areas of this layer into the background, by painting within the mask using various opacity and size settings.

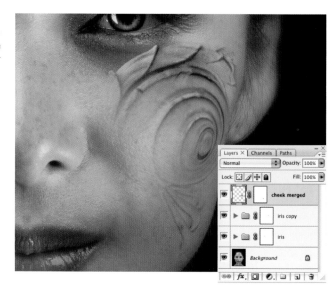

Why screen?

You've probably noticed by now that when I want to lighten a layer by placing a duplicate of that layer on top of it, the blending mode I reach for is screen. People often think literally when it comes to lightening one layer with another and tend to reach for the lighten blending mode instead. That is fine if your top layer contains lighter colors. However, if it is an exact duplicate, like we're using here, there will be no visible effect. Choosing the screen blending mode is excellent for this because it multiplies the inverse of the blended colors, resulting in a bleach effect, lightening the base layer with an exact duplicate on an overlaying layer.

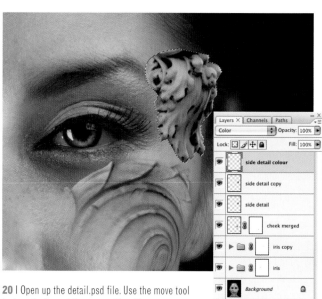

20 | Open up the detail.psd file. Use the move tool to drag the layer into your working file as a new layer. Use Free-Transform to resize, reshape, and position the new detail to the side of her face by her eyebrow. Duplicate the layer and change the blending mode of the layer to screen. Generate a selection from the contents of this layer. Now, create a new layer and fill the selection with a pink color sampled from her skin. Change the layer blending mode to color.

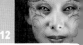

21 I As you've done previously in this chapter, create a new group containing the three newest layers. Add a mask to the group and select the brush tool. Paint with varying opacity settings and a soft round tip, to gently fade the layers within the group into the background by painting black into the mask. Remember to vary the size of the brush tip as required. Don't bother with the top of the detail or the right-hand side. Open up the detail1.psd file.

Layer destinations

When you drag the detail1.psd file into the working file you'll probably notice that it goes into your existing layer group in the layers palette. This is because the layer group was targeted in your working file when you dragged the layer from the detail1.psd file into it. Obviously you don't want this layer to reside within the existing group, so to move it out, begin by clicking on your layer in the layers palette and dragging it upward. Drag it above the current group until you see a dark horizontal line appear just above the set in the layers palette. When you see this line, let go of the mouse button and your layer will be placed above the group, outside of it, in the layers palette.

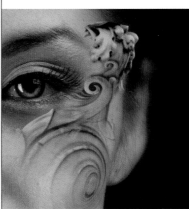

22 I Use the move tool to drag the layer from the detail1.psd file into your working file as a new layer. This stone detail is light enough that we don't require a duplicate layer with a different mode to lighten it. This time, simply generate a selection from the contents of the layer and then create a new layer. As you've done previously, fill the selection with skin color on the new layer and change the layer blending mode to color. Add both layers to a group. Mask the group and then edit the mask like you've done previously with the brush tool.

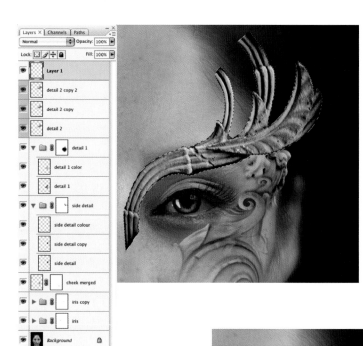

23 | Open up the detail2.psd file and drag the image into the working file as a new layer. Move the layer out of any groups it may have fallen into and drag it to the top of the layers palette. Use Free-Transform to resize and place it just above her eye. Duplicate the layer, change the mode to screen, and reduce the opacity to 56%. Duplicate this layer and then change the blending mode to soft light, adding contrast. Reduce the opacity of this layer a little more. Generate a selection from the layer and create a new layer while the selection is active.

Group advantages

When you've created a stack of layers, grouping the layers is always a much better option than merging if at all possible. By keeping layers separated within the groups you can edit things at any point later on. You can increase or decrease layer opacity, alter a blending mode, or even add and edit individual layer masks. So by keeping things separate, you are affording yourself the luxury of changing your mind layer on. Now, in some cases, like when you want to add a spherize effect to a stack of layers, you'll need to merge the layers first. But whenever possible, you should try to keep everything within your file as separate as you can for further editing.

24 | Again, as you've done previously with the other detail layer stacks, fill the selection on the current layer with skin color and change the blending mode to color. Deselect and then create a new group that contains all of the detail 2 layers. Add a mask to the group and then edit the mask with the brush tool, painting with black, like you've done previously to blend the detail into the underlying face. Vary the brush size and opacity as required and even use the gradient tool to create larger, sweeping blend effects.

25 | It is safe to assume that at this point that you can't ignore the repeating pattern that is emerging here. Every time you add a new element you place it as a layer in the image, resize and position it exactly where you want it. Then you duplicate it, alter the blending mode to enhance it, and repeat if necessary. Finally, you generate a selection from your layer contents, fill the selection with skin color on a new layer, and change the blending mode of the new layer to color. Open up the detail3.psd and detail4.psd files.

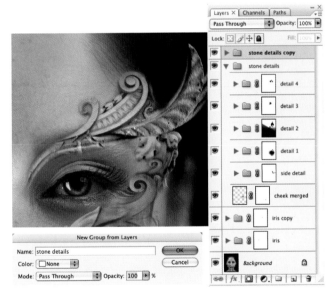

Groups within groups

At this point you're well aware of the advantages of grouping layers. However, it is important that you don't forget that you can group groups as well. This adds another level of organization to your files. Again, grouping rather than merging affords you the luxury of editing individual groups later on. In addition to this, grouping a number of groups allows you move, duplicate, and transform large numbers of layers together at the same time. In this particular case, all of the stone detail groups are now neatly contained within a single group, making it easy to duplicate and flip them to the other side of the face, preserving all blending operations as well as their special relationships to each other within the image.

26 | Use all the methods we've used so far to introduce each element into the image. Bring them in as layers, use duplication, blending modes, color fills, and masked sets. It is unlikely that you aren't familiar with the process at this point as we've gone through it a few times already. Position each of these new detail groups above the large eyebrow detail. Collapse all of your groups in the layers palette to conserve space. Target every group except the two iris groups and the background layer. Choose Layer>New>Group From Layers from the menu. Then choose Layer>Duplicate Group from the menu to copy the new group.

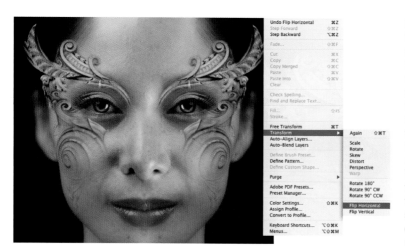

27 | With the duplicate group targeted in the layers palette, choose Edit>Transform> Flip Horizontal from the menu. It may take a moment to perform this operation as Photoshop has a lot to think about here, but just like that, you'll see the duplicate detail flip over and position itself on the other side of her face. You can move it a little with the move tool, just be certain that you're holding down the shift key while you click and drag sideways to avoid any unwanted vertical movements.

Further Masking

Now that you have the face details separated into two groups, you may notice visible layer artifacts here and there that you don't want to see in your image. To remedy this, go ahead and add a mask to either or both of your stone detail groups. Use the Brush tool or a series of gradients to gently mask out any areas you don't want to be visible. Try editing the masks of the two halves a little differently here and there, so that they don't look exactly the same as each other. You still want a mirror image effect across her face, but mask editing allows you to introduce a little bit of subtle individuality to each side.

28 | Open up the column.psd file. Use the move tool to drag the layer into your working file as a new layer and position it at the top of the canvas. In the layers palette, drag the new layer down so that it sits above the background, but underneath all of the other layers and groups. Use the Gaussian Blur filter to add a slight blur to the contents of the layer. Duplicate the new layer and change the blending mode of the duplicate layer to screen. Then, duplicate the duplicate layer and change the blending mode to soft light.

29 | Generate a selection from the contents of your newest duplicate layer and, with the selection active, create a new layer on top of it in the layers palette. Fill the active selection on the new layer with skin color, change the layer blending mode to color, and deselect. Add a new group containing all of your column layers and add a mask to it. Edit the mask with the brush and gradient tools to gently blend the column group of layers into her forehead.

Adding lighter areas

Now that the details are in place, it is time to begin smoothing out her skin with some lighter colors.

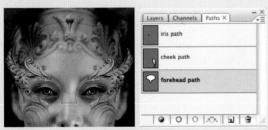

1 | Create a new layer that sits above your column group in the layers palette. With this layer targeted, use the Pen tool to draw a closed path that surrounds her forehead. Ensure that the path overlaps, but does not extend below, her eyebrow details.

2 | Generate a selection from the path and then change the layer blending mode to lighten. Use the radial gradient tool, set at foreground to transparent, to create gradients within the selection at varying opacities. Sampling various skin colors as you go.

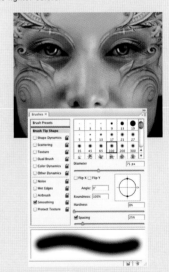

3 | Deselect and use the brush tool, with varying opacity settings and a soft round tip, to paint over dark blemishes and unwanted areas on this layer with colors sampled from neighboring areas. Hold down alt(PC)/option(Mac) while using the brush to sample colors as you work.

30 | Next, create another new layer, ensure that it sits above the previous 'lighten' layer you were just working on in the layers palette. Change the blending mode of this layer to multiply and then select the gradient tool. This time, select the linear gradient method but leave the preset set at foreground to transparent. Sample a dark background color from the image and then draw a gradient from each corner inward slightly to darken the edges of the image.

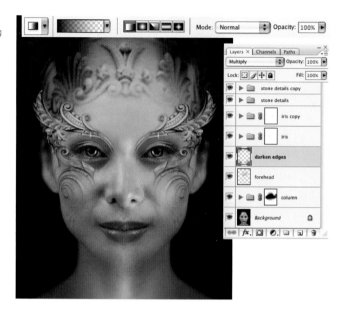

Multiply versus darken

In order to add the burn or darkening effect around the edges, I created a number of dark colored gradients, extending from the corners inward, on a layer with the blending mode set to multiply. Because the desired effect is to darken, you might wonder why I did not use the Darken blending mode instead. The Darken blending mode looks at the color on the active layer and the color on the underlying layers and displays whichever is darkest. However, Multiply blending mode does not compare colors, it simply multiplies the underlying color by the color on the layer, resulting in a much darker color than the color on either layer. Because of this, the multiply blending mode gives a more drastic darken effect than the darken blending mode.

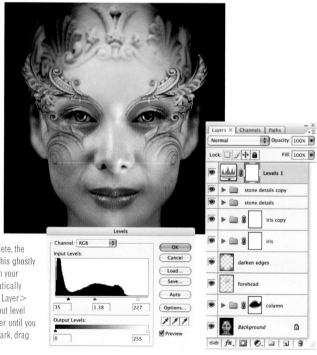

31 | Now that the illustrative portion of the image is complete, the next stage is to alter the color. The first step in achieving this ghostly gray look is to increase the contrast. Target the top layer in your layers palette, so that any new layers we create will automatically reside above all of the others in the layers palette. Choose Layer> New Adjustment Layer>Levels from the menu. Drag the input level sliders from the left- and right-hand sides toward the center until you see the overall contrast increase. If the midtones get too dark, drag the center input level slider to the left until they improve.

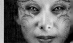

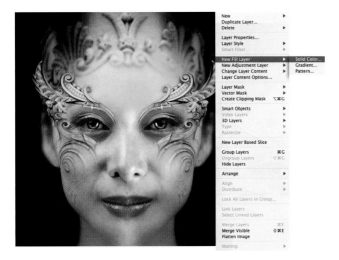

32 | Choose Layer>New Adjustment Layer>Hue/Saturation from the menu. Adjust the hue to 211, and decrease the saturation to almost nothing. This will remove a great deal of color from the image. Change the blending mode of the Hue/Saturation layer to color and reduce the opacity considerably in the layers palette. She still needs a bit of color in her complexion to work with. Now, we want to make things appear a little more blue, so choose Layer>New Fill Color>Solid Color from the menu.

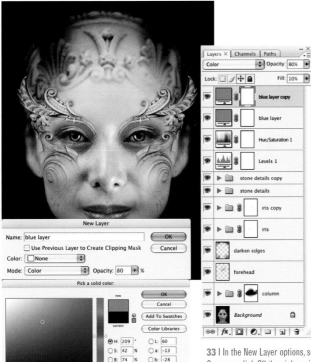

Undoing adjustments

When you add an adjustment or fill layer, you'll notice that the underlying image is effected in its entirety. However, you may notice specific details in the image, like her iris and lip areas in this case, that you want to remain unaffected by one or all of the adjustment layers. If this is what you're after, simply target an adjustment or fill layer's mask in the layers palette. You can edit an adjustment or fill layer mask exactly like you edit any other layer mask. Adding black to the mask will hide the effect of the layer in that area, so if you want her iris areas to be unaffected by one of your adjustment or fill layer, simply paint over that area within the specific layer's mask.

33 | In the New Layer options, set the blending mode to color and reduce the opacity to 80%. Once you click OK the picker will appear. Select a nice, bright blue color from the picker and click OK. You'll immediately notice that the effect is much too strong. To remedy this, drag the Fill slider down to 10% in the layers palette. Now you'll notice the effect is a little too soft. Remedy this by simply duplicating the solid color fill layer.

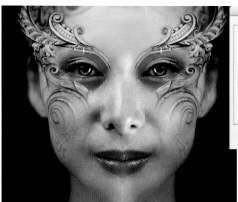

34 I The effect is almost complete. However, achieving a very desaturated color cast can be tricky. Sometimes your images can look too warm or too cool. In this case, it looks a touch too warm. In order to remedy this, choose Layer> New Adjustment Layer> Selective Color from the menu. Choose neutrals from the color menu. Increase the amount of cyan slightly, while equally reducing the amount of yellow. The result will be subtle, but it helps cool the image overall.

Adding surface texture

Now that the color adjustments are complete, the final stage is to add a textured effect.

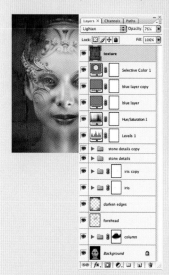

1 I Open the texture.psd file. Use the move tool to drag it, while holding down the shift key, into the working file as a new layer at the top of the layers palette. Change the blending mode to lighten and reduce the opacity to 76%.

2 I Duplicate the layer and change the blending mode of the duplicate to soft light. Add both of these layers to a new group and then add a layer mask to the group. Select the gradient tool and target the group's mask in the layers palette.

3 I Choose the radial gradient method and the foreground to transparent preset in the tool options bar. Using a black foreground color, click and drag within the mask to create a variety of gradients, masking the texture overlapping the center of her face.

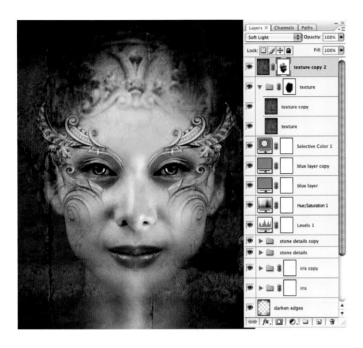

35 | Now, duplicate the top-most texture layer within the group. Click on it and drag it out of the group within the layers palette. Ensure that it is on top of the group and at the top of the entire layer stack within the layers palette. Increase the opacity of the layer to 100% and ensure that the blending mode is set to soft light. Add a mask to this layer. Use the gradient tool, set up exactly the way it is, with varying opacity settings to edit the layer mask, adding gradients to reveal the underlying face.

Final inspection

Let's take one last look at the image, and examine which techniques will prove useful later on, when you're creating other images on your own.

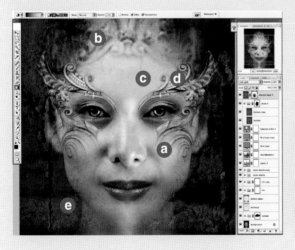

a | This cheek detail was made perfect by transforming and spherizing, then repeating the process. It is important to be willing to repeat a process as many times as it takes until things look just right.

b | Adding a blur effect to not only this crown, but also to the outer edges of her face and neck, adds a nice depth of field effect, while removing amateurish hard edges.

c | Painting and adding gradients on a layer with a lighten blending mode allows you to smooth out her forehead nicely. It also preserves any highlights underneath that are lighter than the colors on your layer.

d | Creating details on half of her face and then duplicating them not only provides a sense of surrealistic symmetry, but it also saves a massive amount of time.

e | Adding a rough surface texture to the entire image not only helps to bring it all together, but it also creates an illustrated feeling that helps the image to transcend that of basic photographic collage.

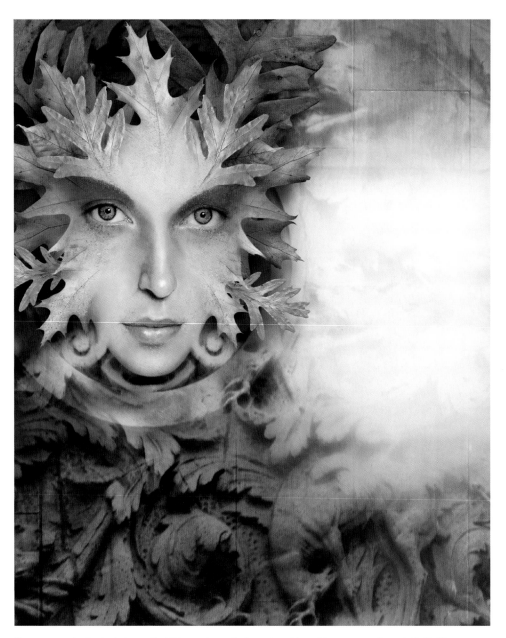

Once you master the technique of building up layer stacks and working with groups, you're only limited by your imagination. This image was created using the same techniques, but instead of stone details, I decided to create a mythical green woman by incorporating desktop scans of leaves.

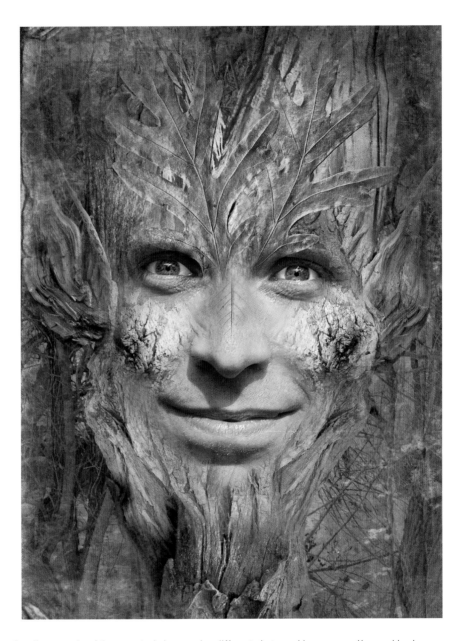

Again, here is another fine example of the same techniques, using different photographic resources. You can blend almost anything into a human face and make the result look convincing if you abide by the methods explained previously in this chapter.

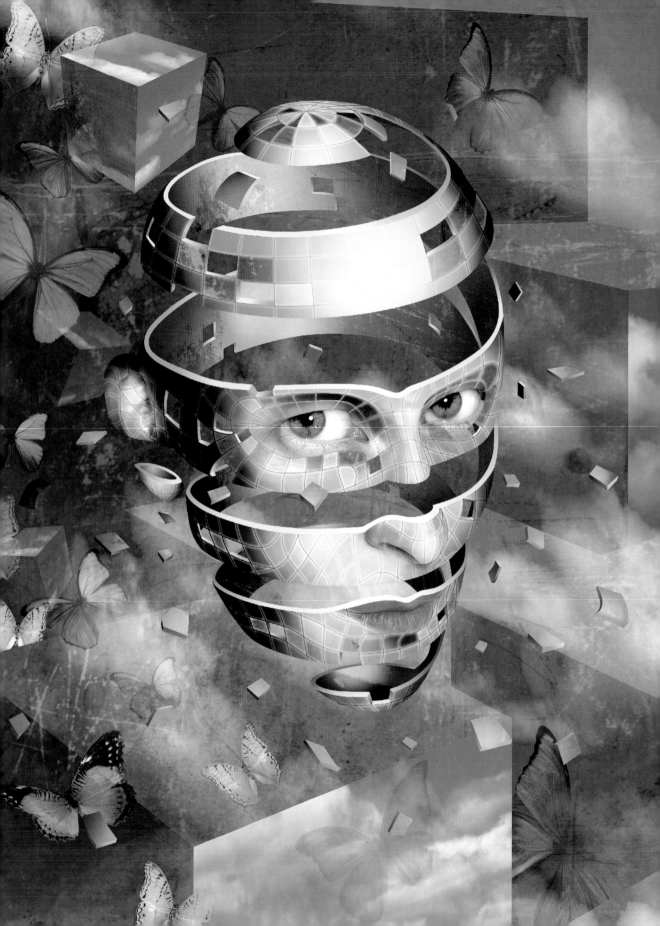

Chapter 13

The Third Dimension

As an artist who works digitally, when I hear the words 3D I think of software. Programs like Maya, SoftImage, and Cinema 4D come to mind. I think of building objects in 3D space, adding light, texture, and rendering. The right software package can certainly assist in creating amazing works of 3D art, however, those who are accustomed to working in 2D may find the steep learning curve a little daunting. As someone who grew up drawing and painting, I have found that working in a 3D program is just never as intuitive as working on a flat canvas. For years I have been working with a variety of 3D programs, but I always find myself struggling against the software at some stage in the process. I have the idea in my head or on paper, and it generally seems to be a battle to get it the way I want it within the software. In short, nothing was ever as effortless or intuitive as working within Photoshop.

It was the work of traditional artists, especially M.C. Escher, that got me thinking of just illustrating my 3D effects the old fashioned way. These artists never had any 3D software, they just sat in their studios and drew or painted what was in their heads. I finally decided that there was no reason why I, as an illustrator armed with Photoshop, couldn't do the same thing digitally, and the image you see here is my most successful attempt so far. As you work through the process of recreating this image on the following pages, you see that although we're using Photoshop instead of a pencil or paintbrush, the fundamental process of creating 3D effects is quite similar to traditional methods of drawing or painting in perspective.

Admittedly, a program like Photoshop places us at a distinct advantage as far as tools are concerned. M.C. Escher never had the opportunity to work with layer masks, or enjoy the freedom of multiple undos. However, even though we've got an arsenal of excellent tools at our disposal, you'll notice that as soon as you begin to create the peeling head effect you see here, you're pondering many of the same things Escher himself must've pondered. No matter how advanced your tools are, you still need to use your brain. In order to create something impressive, you always need to visualize what you want first.

1 I Open up the face.psd file from the CD. Initially you'll notice that this image appears a little soft, so the first thing we need to do is sharpen it. Choose Filter>Sharpen>Smart Sharpen from the menu. Basic mode is fine for this simple task. Increase the amount to around 100 and set the pixel radius to 1. Leave the remove option set to Gaussian Blur. Although we're going to drastically alter this image before it's finished, a little sharpening will help in areas that will remain largely untouched, like his eyes.

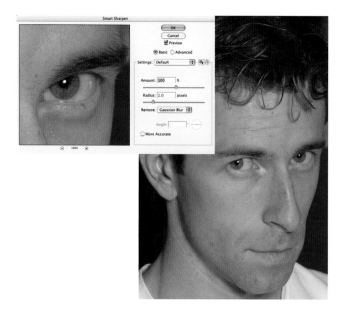

Project files

All of the files needed to follow along with this chapter and create the featured image are available on the accompanying CD. Files for this chapter can be found in the folder entitled: chapter_13.

Feathering selections

In this instance, I created a selection and then feathered it to soften the edges after the fact. However, when you choose a selection tool like the lasso or a marquee tool, take a look in the tool options bar and you'll see a feather function there. You can enter a pixel radius and then every time you create a selection with that tool your selection will be feathered instantly. This value remains set until you change it, even when switching back and forth between tools.

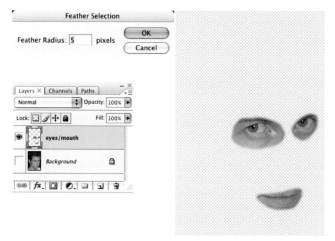

2 I Select the lasso tool and draw a rough selection that surrounds one of his eyes. Then, while holding down the shift key, draw another rough selection that surrounds his other eye, and then draw another that surrounds his lips. With both eyes and his lips surrounded by selections, choose Select>Modify>Feather from the menu. Here I decided to use a radius of 5 pixels to create a gentle soft edge, however, depending upon the resolution you're working at, this number may vary. With the feathered selection active, choose Layer>New>Layer Via Copy from the menu. Temporarily disable the visibility of the background layer to view the new layer you've created from the selected contents.

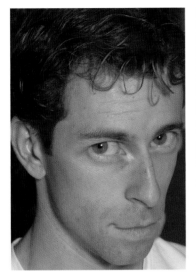

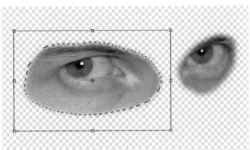

3 I With your new layer targeted, use the lasso tool to draw a selection that completely surrounds one of the eyes. Once selected, choose Edit>Free-Transform from the menu. Use the corners and midpoint handles of the bounding box to increase the eye in size and alter the proportion so that it is larger and wider than the original. Press Enter on the keyboard and then repeat the process with the other eye and the lips, until all elements on this layer have been edited individually with the free-transform tool. Enable the visibility of the background layer when finished.

4 I With your top layer targeted in the layers palette, hold down the shift key and then click on the background layer. This will allow you to target both of your layers at the same time. Now, with both layers targeted, choose Layer>Smart Objects> Convert to Smart Object. This converts your layers into an editable smart object. With the smart object targeted in the layers palette, choose Filter>Blur>Gaussian Blur from the menu. Enter a substantial radius value to blur the smart object considerably and click OK.

Checking position

When you alter the eyes and mouth on the new layer you may find it difficult to visualize how they will appear against the face in the background because at this stage the background layer's visibility is disabled. The best way to see if things are working out is to enable the background layer visibility after each free-transform operation. Then you can see how the transformed facial feature fits within the face on the underlying layer. If you don't like the result you can always undo the transformation and try it again, bearing in mind what not to do the second time around.

5 | When you apply a filter to a smart object it shows up in the Layers palette as a smart filter, complete with a mask. A smart filter mask works just like a layer mask, except that it allows you to mask filter effects instead of layer contents. Target the smart filter mask and select the gradient tool. In the tool options bar, choose the radial method and the foreground to transparent gradient preset. Set your foreground color to black. Use the gradient tool to click and drag within the smart filter mask. Create a series of gradients, both large and small, that mask the blur effect in key areas of his face.

Smart filters

Smart filters and the ability to mask smart filters are functions that are new to Photoshop CS3. In order to recreate this same effect in Photoshop CS2, you'll need to do things a little differently. Start by duplicating your smart object. Then you need to rasterize the duplicated smart object, converting it to a traditional layer. This rasterized object layer can then be blurred using the Gaussian Blur filter and the effect can be masked via the use of an ordinary layer mask. Essentially, you're creating a duplicate layer with a masked blur effect that sits on top of your original smart object.

6 | Create a new hue/saturation adjustment layer by selecting the hue/saturation option from the create new fill or adjustment layer menu within the button at the bottom of the layers palette. Adjust the hue to 24 and decrease the saturation by 14. This removes a bit of pink from his skin. Now create a new Curves adjustment layer from the same menu at the bottom of the layers palette. Adjust the curve of all the CMYK channels to increase the contrast and then adjust the magenta curve only to reduce a bit more of the pinkish hue.

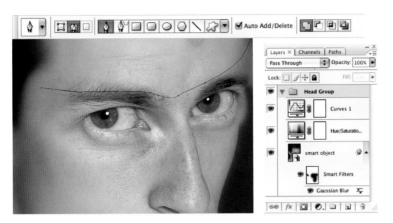

7 | Target all of the contents of the layers palette and then Choose Layer>New> Group from Layers from the menu. We are adding the layers and the smart object to a group so that everything can be masked together with a single vector mask. Select the pen tool and in the tool options bar, ensure that the pen tool is set to create paths and not shape layers. Click the Add to Path Area option and then begin to draw a horizontal line that follows the contour of his face.

The ribbon effect
Visualize, draw path components, and create a vector mask to create the 3D spiral effect.

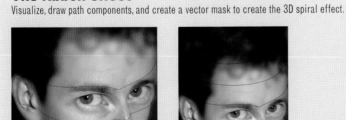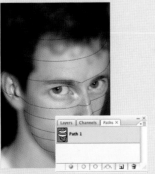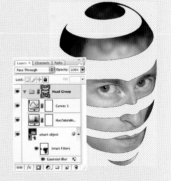

1 | Give some thought to your viewing angle and how the face would look as a spiral ribbon. Continue your line and use it as the basis for a closed path component that looks like a strip across his eyes and his ear.

2 | Draw more closed path components across his face, paying attention to the contour of his features. Feel free to alter the sides as you see fit, including background into the shape, or removing skin, to get the head shape you're after.

3 | When you're finished, ensure that your new path is targeted in the paths palette and return to the layers palette. Target your group and choose Layer> Vector Mask>Current Path from the menu. This masks areas that lie outside of your path components.

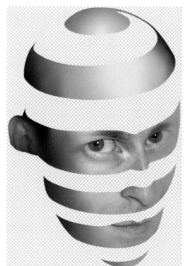

8 | To add to the surreal feel, we'll remove his hair and smooth his complexion, so create a new layer. Because you have the group targeted, it will automatically be added to the group at the top of the stack. Select the gradient tool. Leave the gradient tool options set as they were previously and begin to click and drag, creating different colored gradients on the new layer. Hold down alt(PC)/option(Mac) to sample colors from the underlying layers for your new gradients. Shown here is the gradient layer by itself, yours should look something like this when you're finished.

Editing your vector mask

Should you decide at any point, that you're not happy with shape of the bands you've created across the face, you can fix them by editing the vector mask. As soon as you click on your group, the path components that make up the vector mask will become visible on the canvas. The visible paths can be edited by using the direct selection tool. Simply click and drag any of the anchor points, line segments, or Bezier handles to edit the path. When you edit a path you'll instantly see the results of altering your vector mask.

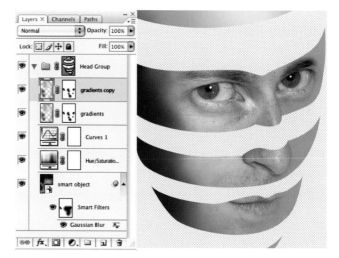

9 | Add dark gradients in areas of shadow and light gradients where there should be highlights. If some of your gradients accidentally cover features and details like his eyes or his inner ear, worry not, we'll remedy this now. Add a layer mask to the layer by clicking on the add a layer mask button at the bottom of the layers palette. Then, with the layer mask targeted, use black to create gradients within the mask to mask the stray gradients. Duplicate the layer by dragging it onto the create a new layer button in the layers palette to strengthen the overall gradient effect.

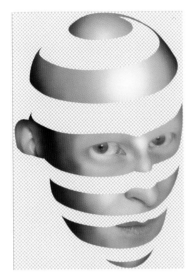

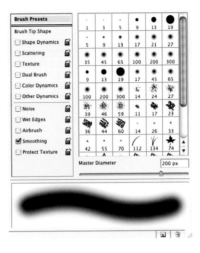

10 | Create a new layer at the top of the stack in your group. Target the new layer and select the brush tool. In the brushes palette, choose a large, soft, round brush tip, and disable all brush dynamics except for smoothing. Choose a diameter that is large in relation to your image. Set the brush opacity to about 25%, then alt(PC)/option(Mac)-click on an area of skin to sample the color. Gently paint with this color over areas of similar color that require a smoother blended appearance. Use this method to blend areas of color together on the new layer, sampling different colors as you go.

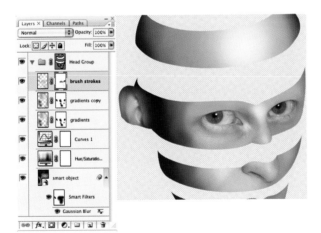

11 | Continue to paint in this manner, vary color, brush tip size, and opacity as you go. Keep painting until you've created a nice, soft fell overall. It is fine to stray over areas like his eyes because again, we can mask unwanted areas from this layer. Add a layer mask, ensure that it is targeted and set the foreground color to black. Use your brush to paint over brush stroke areas within the mask that you want to hide, specifically going over his eye areas so that there is no skin color straying into the whites of his eyes.

Keeping things separate

You'll notice here that I've instructed you to create another new layer to use before you paint. You may wonder what the point of this is, as the new layer and the underlying layer both have a normal blending mode and an opacity setting of 100. The main reason, apart from the fact that the previous layer is already masked, is to keep things separate for flexibility. Often when painting on a layer, I find that I want to decrease the opacity of the layer later on, to lessen the effect. This usually happens a number of steps later, and if I had painted on the same layer that the gradients were on, I wouldn't be able to reduce the brush stroke opacity without affecting the gradients. Ensuring that the brush strokes are on their own layer also allows me to mask them separately from the gradients.

201

12 | Use the pen tool to draw a closed path in the shape of his lips. Ensure that the add to path area option is selected in the tool options bar. This is your chance to alter the shape of his lips, so feel free to deviate from the original photo. Generate a selection from your new path by Control(PC)/ Command(Mac)-clicking on it in the paths palette. With the selection active, return to the layers palette and create a new layer at the top of the layer stack within the group.

Painting within selections

The method of painting within a path-based selection can be used for things other than reshaping lips. As you've noticed by now, creating gradients and soft brush strokes on a series of layers can tend to hide sharp details contained in the original image underneath. By carefully creating closed paths and generating selections from them, like we've done here with the lips, you can paint within sharp-edged selection borders. In areas like the side of his nose, you can introduce slightly darker colors into the selection right next to the edge, creating sharp contrast with adjacent pixels that are on the other side of the selection border, making certain features like his nose stand out better.

13 | Use the eyedropper to sample a pink color from his lips and then paint over any areas within the selection on the new layer that need to be pink. Ensure that you paint over any areas of visible skin within the selection, hiding them with the pink lips color. This will help to define the edge of his lips. When you're finished choose Select>Inverse from the menu to invert the selection. Paint over any areas that should be skin colored within the inverted selection using colors sampled from his skin. When you have achieved a nice defined lip shape choose Select>Deselect to deactivate the selection.

14 | Create a new brightness/contrast adjustment layer from the list at the bottom of the layers palette. Now that we're finished painting, it is time to bump up the color and contrast on the underlying layers a little. Increase the brightness slightly, but greatly increase the contrast. After clicking OK, create a new Levels adjustment layer. Select the black channel and drag the left input levels slider to the right to darken the shadows. Then drag the middle input levels slider to the right too, to darken the midtones. Finally, create a new hue/saturation adjustment layer and increase the saturation by 16.

Changing his eye color

Build a set of virtual contact lenses by combining path-based selection with adjustment layers.

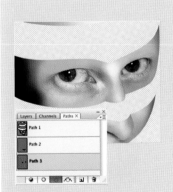 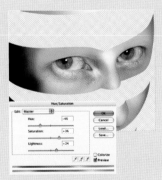 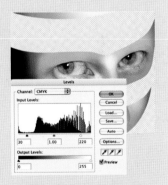

1 | Use the pen tool to draw two closed path components in the image, one surrounding each iris. Ensure that the add to path area function is enabled when you do this. Generate a selection from your new path in the paths palette.

2 | With the selection active, create a new hue/saturation adjustment layer. The active selection will automatically mask the new layer. Move the hue slider until the blue changes to a greener blue. Increase the saturation and the lightness and click OK.

3 | Generate a selection from the same path one more time. With the selection active, create a new levels adjustment layer. Drag the left and right sliders for the CMYK input levels towards the center of the histogram to increase the overall contrast.

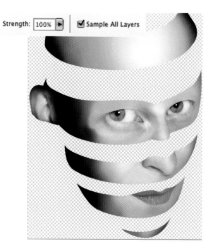

15 | Create a new layer. Ensure that this new layer is targeted in the layers palette and select the blur tool. Choose a soft round brush tip preset and enable the sample all layers function in the tool options bar. Set the strength to 100 and begin to paint over areas that need softening. Specifically areas like the edges of his iris, which are looking rather sharp from the previous adjustments. Increase and decrease the strength and size of the brush tip as required to soften the underlying imagery to your liking.

Disabled dynamics

Often, when choosing a brush tip preset, you'll notice that the shape dynamics option is enabled in the brushes palette. Stylus users will frequently find this set to pen pressure and as a result, when they paint, the thickness of the stroke will vary depending upon pressure. Because the painting methods used here require a predictable and uniform stroke thickness, you are instructed to disable brush dynamics. When using the blur tool, stroke variation is not as apparent as when painting, so disabling shape dynamics isn't that crucial. However, if you decide you want uniform stroke thickness when blurring, by all means, go ahead and disable shape dynamics when using the blur tool too.

16 | Alright, one more adjustment layer and then we'll get onto the intricate line work and square divisions across his face. Create a new curves adjustment layer. Alter the CMYK curve so that the shaded areas are enhanced and the highlight areas are lightened. Have a look at the curve I've created here and use it as a guide for this adjustment. When you're happy with the result, click OK and then select the pen tool.

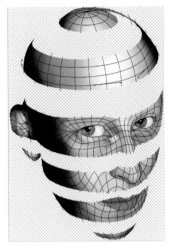

17 | Now it is time to draw all of the individual lines that break up the face into small, cubic planes. Look carefully at the face and use the existing contours as your guide to plan where each line will go. Use the pen tool to draw a single curved line. When it is finished hold down the Control(PC)/Command(Mac)-key and click anywhere on the canvas. By doing this, the next time you click, you'll begin a new line, rather than continuing the existing one. Use this method over and over to create all of the lines. This aspect is very time consuming, but equally rewarding in the end.

Creating the facial grid
The intricate grid across his face begins as a series of open paths, and is then combined with paint tools and layers.

1 | Your grid can overlap the edges of the face because the group vector mask will hide anything that strays beyond the edges. Select the brush tool, choose a hard, round brush tip preset in the brushes palette.

2 | Specify a small diameter in the brushes palette, this will dictate the thickness of your visible lines and will vary depending upon your image resolution. Use the eyedropper to sample a dark brown color from the image and create a new layer.

3 | Target your new layer and target your path in the paths palette. Ensure that no single path component is selected. Choose Stroke Path from the path palette menu. Choose the brush option. The grid will be stroked with your brush and current foreground color on the new layer.

18 | Change the blending mode of your new layer to color burn and reduce to opacity to 59%. This layer containing your painted grid, will be one that you return to later to generate various selections from. Name it something memorable. And giving the layer thumbnail a color to make it stand out is a good idea. I have named my layer 'grid' and specified a yellow color for the layer thumbnail. Duplicate the grid layer and choose Filter>Blur>Gaussian Blur from the menu. Add a slight blur, just enough to soften the grid without making it disappear.

Layer properties

You can add color to your layer thumbnails as well as change the name by accessing the layer properties. Target a layer and choose layer properties from either the layer menu or the layers palette menu. You can also right-click(PC)/control-click(Mac) on a layer thumbnail and then select layer properties from the pop-up menu.

Deselecting path components

A path can be made up of many path components. In the case of the facial grid path, each line is a path component within the path. When you stroke a path with the brush tool like I've done here, it is very important that you do not have a single path component selected. If you stroke the path with one component selected, only that path component will be affected and the others will remain untouched. To deselect a path component simply hold down the Control(PC)/Command(Mac)-key while using the pen tool and click on an area of the canvas that contains no path components.

19 | Enable the transparency lock for the duplicate grid layer in the layers palette and then choose Edit> Fill from the menu. Fill the layer with 100% white. Change the blending mode of the layer to normal and increase the opacity to 100%. Keep the current layer targeted, and Control(PC)/Command(Mac)-click on the grid layer beneath it to generate a selection from the original grid layer's contents. Now, with your grid copy layer targeted, press the delete key. Deselect. This removes the white from the grid itself, leaving behind a white outer glow around the entire grid on the current layer. Duplicate the grid copy layer a number of times to intensify the effect.

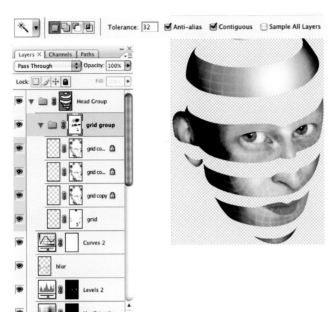

20 I Add a layer mask to the original grid layer. Create radial, black to transparent gradients within the mask to hide areas of the grid with soft transitions. Use this same method to mask one of your grid copy layers. Then, while holding down the alt(PC)/option(Mac) key, click on the mask and drag it onto another grid copy layer in the layers palette to add an identical mask to that layer. Repeat this process with the remaining unmasked grid layer. Add the grid layers to a new group. Add a mask to the group and then use the same methods to edit the group's mask. Select the magic wand tool and deactivate the sample all layers function.

Path editing

Because this facial grid is constructed of path components it is entirely editable. You can use the direct selection tool to select and edit any point, line segment, or Bezier handle. You can fiddle until your heart's content. However, be certain that you're happy with the appearance of your grid before you go ahead and stroke the path with a brush. Once you do this, the pixels on your targeted layer are painted with the brush and editing the path from this point on won't do you any good. So be certain you're satisfied before you select the stroke option.

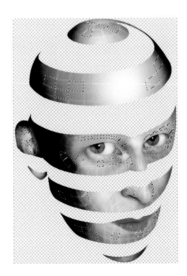

21 I Ensure that the contiguous and anti-alias options are enabled and leave the tolerance set to the default value of 32. Target your original grid layer in the layers palette. Use the magic wand tool to click on an area that is enclosed on all sides by grid lines. Hold down the shift key and click on other enclosed areas on this layer to add them to the selection. Be careful not to click on areas that are not completely contained within grid lines or you'll end up selecting the entire background.

22 | Open up the texture.jpg file. Choose Select>All and then Edit>Copy from the menu. Return to your working file and, with the new selection active, choose Edit>Paste Into from the menu. This will paste the copied image into your file as a new, masked layer. The mask is dictated by the active selection. Drag the new texture layer out, and on top of, your grid group in the layers palette. However, ensure that your layer remains within the main group. Change the layer blending mode to luminosity and reduce opacity to 76%. Duplicate this layer and change the blending mode to overlay.

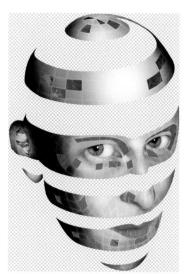

Altering the grid

Now that you know how to select squares from the grid, there's much more you can do to embellish the face.

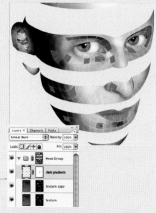

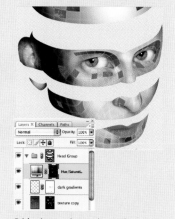

1 | As you did previously, use the magic wand to select a number of different square areas that are contained within the grid. Create a new layer, drag it to the top within the group, and on that layer, use the gradient tool to create a number of brown to transparent radial gradients within the selection.

2 | Deselect and add a layer mask. Use the gradient tool to edit the mask, softening the effect, as you've done previously. Change the layer blending mode to linear burn and then use the wand to select some different squares from the grid layer.

3 | Again, use the magic wand to select a number of random squares from the grid layer. Target the top layer in the group and then create a new hue/saturation adjustment layer. Adjust the hue and saturation, altering the color of the selected areas.

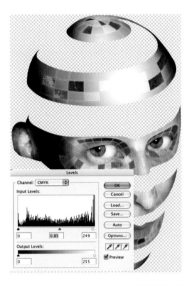

23 | Repeat the process of randomly selecting squares from the grid layer, then, while the selection is active, create another hue/saturation layer and alter the colors within those areas. Repeat this process again, but this time use a brightness/contrast adjustment layer to create some bright areas. And finally, create a levels adjustment layer while there is no current selection active. Use the CMYK input levels sliders to lighten the midtones and highlights of the underlying layers. To accentuate the line work, select your grid group in the layers palette and drag it above all of the other layers within the main group.

Masking the group

In addition to the existing vector mask, there are other ways to control what parts of the group are hidden and what parts are visible.

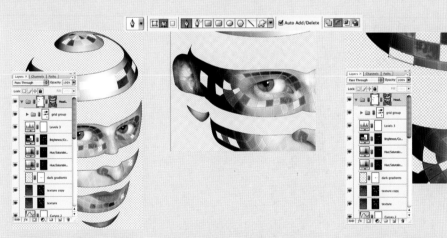

1 | Return to your original grid layer one final time. Again use the wand tool to select a number of square areas from that layer. With the selection active, target the main group in the layers palette and choose Layer>Layer mask>Hide Selection from the menu.

2 | As you can see, it is possible to use a layer mask and a vector mask at the same time. Select the pen tool. This time, enable the subtract from path area option in the tool options bar. Zoom in close on the image.

3 | Target the group's vector mask and, using the grid as a visual guide, trace over sections along the edges of the ribbons. Because the pen is set to subtract, as you create closed shapes with the vector mask targeted, they'll be removed from visibility.

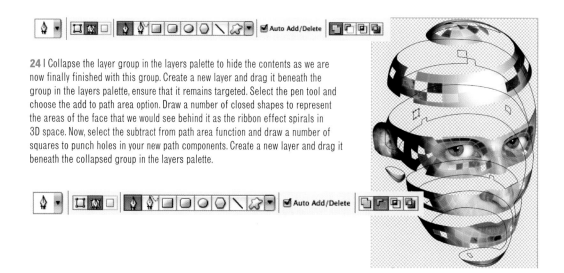

24 | Collapse the layer group in the layers palette to hide the contents as we are now finally finished with this group. Create a new layer and drag it beneath the group in the layers palette, ensure that it remains targeted. Select the pen tool and choose the add to path area option. Draw a number of closed shapes to represent the areas of the face that we would see behind it as the ribbon effect spirals in 3D space. Now, select the subtract from path area function and draw a number of squares to punch holes in your new path components. Create a new layer and drag it beneath the collapsed group in the layers palette.

Creating the inside

Now we'll use a number of familiar methods to add depth and texture to the inside of the spiral.

1 | Generate a selection from your new path. Use the eyedropper to sample a brownish gray color from the image and then fill the active selection with it on your new layer. Keep the selection active and open the texture.jpg file.

2 | Copy the texture image and then return to your working file. With the selection active, choose Edit>Paste Into from the menu to add it as a masked layer. Change the layer blending mode to multiply and reduce the opacity to 35%.

3 | Duplicate the layer, change the mode to overlay and increase the opacity to 100%. Use this same paste into method to add the contents of the texture1.psd file into your file as a masked layer. Change the mode to soft light, duplicate the layer, and change the duplicate layer mode to pin light.

25 | Generate a selection from your newest path again and create a new layer. With this layer targeted, select the radial gradient tool. Use the foreground to transparent method with a black foreground color to add gradients into the active selection on the current layer. Focus on the outer edges to add shadow. Change the blending mode of the layer to multiply and reduce the opacity to 68%. With the selection still active, create another new layer, this time add some white gradients into the selection on the new layer. Create them just left of the center, near his forehead, to add highlights. Deselect and reduce the layer opacity slightly.

The illusion of thickness
Again, the same methods are used, but this time to add some depth to the spiraling ribbon that makes up his face.

1 | By now you're familiar with the process of creating paths. Use the pen tool to draw a series of path components indicate the thickness of our spiraling ribbon. Also, add path components to create thickness within the holes in the front areas of the face.

2 | Generate a selection from the entire path and create a new layer. Fill the active selection on the new layer with a pink color sampled via the eyedropper tool from his skin. Deselect and enable the transparency lock for this layer.

3 | Use the radial gradient tool with previous settings to create some brown to transparent gradients around the edges on this layer. Use the polygonal lasso to create sharp edged selections over the areas where thickness was added to each square hole. This allows you to add gradients within each selection, creating the illusion of inner walls on the edges of each hole, adding depth via shading.

26 | Now that you've created the illusion of thickness for the spiraling ribbon and the holes in the front of the face, it is time to also add some thickness to the holes in the back areas. Use the pen tool to draw a series of path components to form the outline for the hole thicknesses. Ensure that the add to path area option is enabled as you work and then generate a selection from the entire path. With the selection active, create a new layer and drag it beneath all of the other layers in the layers palette. Fill the active selection with skin color on the new layer. Deselect, and enable the transparency lock for this layer.

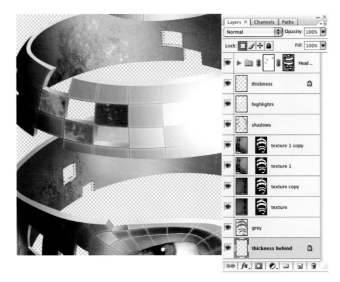

Selections, paths, and components

To generate a selection from an entire path, meaning all of the separate path components within that path, you must ensure that no components are selected. If a component, or multiple components are selected, the selection you generate will be based upon the selected components only, disregarding all other path components. If you have a path component selected, you can deselect it by clicking on an area of the canvas that has no path component with either the path selection tool or the direct selection tool.

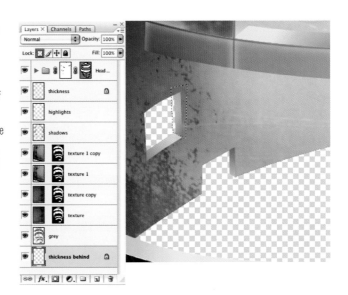

27 | Again, as you did previously with the areas in the front of the face, use the polygonal lasso to create sharp edged selections for each new inner wall. One by one, draw a selection in the appropriate area, add a brown to transparent gradient, deselect, and then move on to the next area. Continue in this manner until all areas of thickness have some shading on them and all the corners of interior holes are clearly indicated by shading within sharp-edged selections.

28 | Open up the background.psd file. This file contains a background image similar to the textures we've been using so far, and it also contains a layer named 'lines'. This layer is included within the file to act as a template. One of the things that makes the work of Escher so powerful is his ability to create optical illusions. Here we're going to create a bit of an optical illusion of our own by creating shaded and textured planes that don't match the perspective of the imagery. Things will look normal at first glance, but upon further inspection, the viewer will notice that this is an impossibility.

Creating paths

When you draw a path component with the pen tool, a path is automatically created in the paths palette. Any components you draw while this path is targeted will be added to that path. By clicking in the empty space in the paths palette, you are ensuring that no path is targeted. When no path is targeted, a new path is automatically created as soon as you begin to draw with the pen tool. Another way to create a new path is to simply click on the create new path button at the bottom of the paths palette. This will create an empty path and target it, then any components you create with the pen tool will be added to that path.

29 | Select the pen tool. Ensure that the add to path area option is enabled. Using the lines layer as your guide, you're going to create three separate paths in the paths palette. Because the shapes you need to create have no curves, this should go quick. First, trace all of the top planes that are indicated by the lines layer. Draw as many closed path components as required. Name this path 'tops'. Create a new path, trace all of the left facing planes and name it 'lefts'. Then do the same for the right facing planes until you have three separate paths.

30 | Open up the sky.jpg file. Use the move tool to drag the sky into your working file as a new layer. Hold down the shift key while you drag to ensure accurate positioning. Change the blending mode of the layer to hard light and reduce the opacity to 70%. Generate a selection from the 'lefts' path in the paths palette. With your sky layer targeted and the current selection active, choose Layer>Layer Mask>Hide Selection from the menu. Next, load the 'tops' path as a selection. With your layer mask targeted, choose Edit>Fill from the menu to fill the selected area on the mask with black. Deselect.

Repeat the process

Continue to use your paths as the basis for selections, which will mask your layers as you add sky imagery to the other background planes.

1 | Disable the visibility of the 'lines' layer, you don't need it anymore. Shift-drag the sky.jpg file into your working file as a new layer again. Generate a selection from your 'rights' path and then click the add layer mask button in the layers palette.

2 | Reduce the opacity of the layer to 70% and generate a selection from the 'rights' path again. Create a new selective color adjustment layer while the selection is active. Select cyan from the colors menu and use the sliders to alter the cyans within the selection.

3 | Again, drag the sky image into the file as a new layer. Click on the 'lefts' path to load it as a selection. With your new layer targeted, click on the add layer mask button in the layers palette. Change the blending mode to color burn and reduce the opacity to 73%.

31 I At the moment in Photoshop, you have two files open. There is the head file and the background file you just created. For the moment, we're going to need to create another temporary file. Create a new file in RGB mode that is approximately 3 inches high and 3 inches wide, using the same resolution as your other two files. Create a new layer in this file and with that layer targeted choose Filter>Vanishing Point from the menu.

Create a cube shape
The vanishing point filter proves useful for create shapes in perfect perspective.

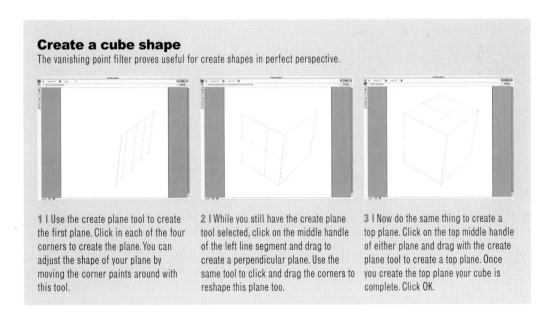

1 I Use the create plane tool to create the first plane. Click in each of the four corners to create the plane. You can adjust the shape of your plane by moving the corner paints around with this tool.

2 I While you still have the create plane tool selected, click on the middle handle of the left line segment and drag to create a perpendicular plane. Use the same tool to click and drag the corners to reshape this plane too.

3 I Now do the same thing to create a top plane. Click on the top middle handle of either plane and drag with the create plane tool to create a top plane. Once you create the top plane your cube is complete. Click OK.

32 | When you exit the vanishing point filter and return to your empty file you'll notice nothing. That is because we just created the planes within the vanishing point filter, not any sort of artwork. We're now going to return to that filter a number of times to add an image to each plane that matches the perspective of the cube we just created. Open the top.jpg file, select all and copy. Return to your empty file and then launch the vanishing point filter again.

Adding texture to cube
Add texture by pasting a different image onto each plane within the vanishing point filter.

1 | Inside the vanishing point filter you'll see the planes you just created. Type Control(PC)/Command(Mac)-v to paste the copied image. Use the marquee tool to click on your selected image and drag it onto the top of the cube.

2 | You'll see a thick blue line appear around the plane to indicate your image will be placed there. Choose the transform tool and resize the image by dragging the corner points of the selection. Click OK and witness the results on your previously empty layer.

3 | Open the left.jpg file and use the same method to copy, launch vanishing point, and then paste onto the left plane. Exit vanishing point and then repeat the entire process with the right.jpg file. Paste it onto the right plane.

33 | Use the move tool to drag your cube layer from this file into your background image file as a new layer. Duplicate the layer a number of times and use the move tool to scatter the cube layers around the background. Use varying opacity settings from layer to layer, making some less prominent than others. Also try varying the layer blending modes of a few cube layers. Blending modes like pin light, hard light, and linear light produce interesting yet understated blending effects and work well with the colors in this image. Target a single cube layer and choose Edit>Free Transform from the menu.

Vanishing point mode

You may be wondering why we went to the trouble of creating a new file for the cube only. Although it would have been less effort to simply create a cube on a new layer in the background file, this wasn't an option and I'll tell you why. You have probably noticed by now that for this chapter we've been working in CMYK mode for both the head file as well as the background file. Vanishing point only works in RGB mode. So in order to create the cube using vanishing point, we had to do it in a separate file using RGB mode. Once the layer is dragged from the RGB file to the CMYK file, the colors are automatically Converted to CMYK.

34 | Hold down the shift key and drag the corner handle in or out, depending upon whether you wish to increase or decrease the size of the cube. To rotate, move the mouse pointer slightly outside of the box until it changes to indicate rotation. When this happens, click and drag to rotate. When your are finished rotating and/or scaling, press the enter key. You can also alter the perspective of any cube by targeting the layer and then choosing Edit>Transform>Perspective from the menu. After doing this, dragging the corner points will allow you to alter the perspective of the targeted cube. Again, pressing the enter key will apply the transformation.

35 | Open the three butterfly images included on your CD. Use the move tool to drag them into the background working file as individual layers. Scatter them around on the canvas and use the free-transform methods you've used previously to alter the size and rotation of different butterflies on different layers. Feel free to duplicate butterfly layers and move them around until you think there are enough of them within the scene. Go ahead and add layer masks to some of the butterfly layers. And as you've done numerous times by now, use the gradient tool to add black to transparent gradients within individual layer masks, blending some of the butterflies into the background.

Stacking up butterflies

Create duplicate butterfly layers, alter layer blending modes and opacity, then edit individual layer masks to gently blend your butterflies into the background.

1 | Target one of your butterfly layers and convert the blending mode to luminosity, then duplicate this layer and change the blending mode to overlay. Add a mask to one of the layers and use the gradient tool to edit the mask.

2 | Use this method to duplicate other butterfly layers, building up stacks with differing blending modes and mask the layers. Remember, you can also group the layers and edit the group's mask to affect all layers within the group.

3 | Use this method to add interest to a number of the butterflies within the scene. In some instances, try simply changing the blending mode and not duplicating the layer. Vary opacity settings and blending modes as you see fit. Have a bit of fun experimenting here.

36 | Open up the clouds.jpg file, select all and copy. Return to your background file. In the channels palette, click the Create New Channel button to create a new alpha channel. With this channel targeted, choose Edit>Paste from the menu to paste the copied clouds image into your new channel. Ensure that your new channel remains targeted in the palette and click on the Load channel as a selection button to generate a selection from the white areas of the pasted image within the channel.

Black sky?

When you open up the clouds.jpg image you will notice that it is a very dark sky with a few white clouds within it. Not exactly what you expect to see when you open up a sky image. This image was carefully prepared ahead of time and yes, it did originally start out as a nice blue sky with fluffy white clouds. Because it was destined for an alpha channel, it was altered ahead of time so that the resulting selection could be controlled before pasting into the channel. Drastic tonal adjustments were performed to ensure that the only white areas visible would remain within the cloud areas, not within the sky. Doing this ensures that when the channel is converted to a selection, the entire background will lie outside of the selection border because it is 100% black.

37 | With your new alpha channel based selection active, return to the layers palette. Create a new layer and drag it to the top of the layer stack. Choose Edit> Fill from the menu to fill the active selection with white on the new layer. Deselect. Create a number of duplicates of this layer and use the move tool to move the layers around the canvas, scattering clouds across the image. Use the free-transform tool to increase or decrease the contents of individual layers as you see fit. If you wish to increase the intensity of a certain layer, simply duplicate it and leave it in the same place on the canvas.

38 | Return to the file that contains the head you were working on previously. Target all of the contents in the layers palette: the groups and the all layers. Make sure that you've got everything. Choose Layer>Smart Objects> Convert to Smart Object from the menu. This will create a smart object that contains everything within the file. Now, use the move tool to drag your smart object into the background file you've been working on. Move it to the top of the stack in the layers palette and use the move tool to position it just left of the center on the canvas.

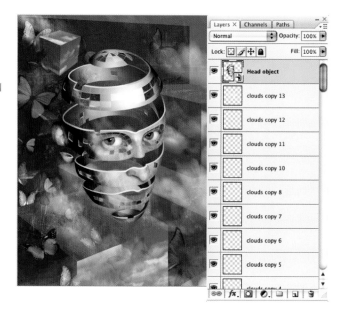

Add the floating bits
Some floating pieces of the face are all that is required to complete this scene.

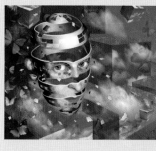

1 | Select the pen tool and ensure that the add to path area function is enabled in the tool options bar. Use the Pen tool to carefully draw a number of path components that resemble rectangles and curved rectangles. Vary the angle from component to component.

2 | Create a new layer at the stop of the layer stack. Generate a selection from the path and fill it with skin color. Use the radial gradient tool, with the foreground to transparent preset, to add shading to individual pieces in a variety of colors.

3 | With your current selection active, open up the texture.jpg file again and copy it. Use Edit>Paste Into to paste it into your active selection. Change the layer blending mode to Linear Burn and reduce the opacity 29%. Duplicate this layer and change the mode to overlay.

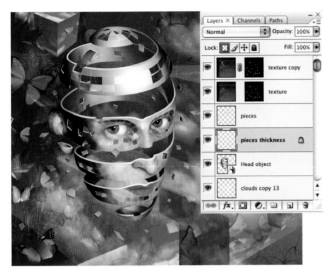

39 | Create one final new layer and place it just above your smart object in the layers palette so that it is directly beneath the layer that contains all of the new floating pieces. Use the pen tool to draw a number of closed path components to add thickness to your floating pieces. Generate a selection from the path and then fill it with a sampled skin color on your new layer. Enable the transparency lock for this layer and then add some shading to the thickness you've just created, Use the exact same methods of introducing gradients into polygonal selections that you used previously to add shading to each piece. You are now essentially finished. However, feel free to use everything you've learned so far to embellish the image further.

Head Examination

Now that the composition is complete, let's take a final look at the tricks and techniques used to give the head a spiral 3D appearance.

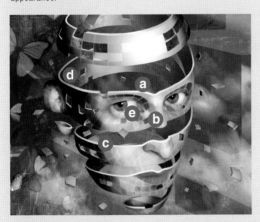

a | By working within a group that had a vector mask applied to it, we were able to concentrate on making the head itself look good, knowing that layers and paint effects weren't going to stray beyond the dictated shape and onto the background.

b | Adding line work via stroked paths allowed us to give the face a 3D wire mesh look. By dividing the face into sections, we were able to remove sections via mask editing to create the illusion of holes.

c | Drawing the thickness of the spiral may be a little time consuming at first, but once you fill it with color and add shading with gradients it looks quite convincing.

d | Building up texture on the inside of spiral helps to make things look less flat. This sense of depth is aided again by adding gradients to simulate areas of highlight and shadow.

e | Because his iris areas have been altered by using adjustment layers, the colors can be changed at any point by simply editing the adjustment layers. Double-click any adjustment layer to edit it.

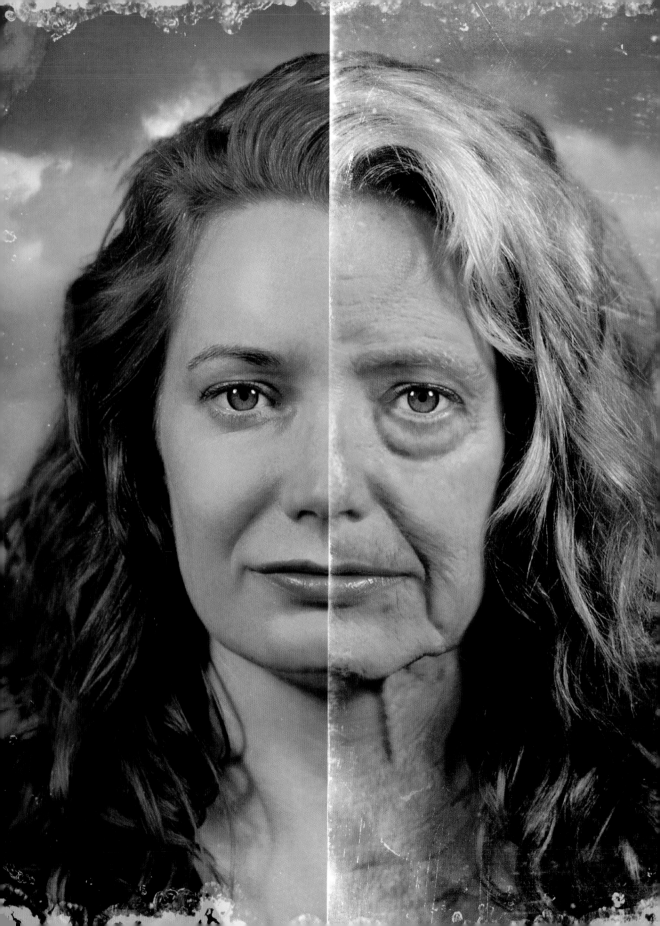

Ageing Effects

There is no way around it, our culture is obsessed with age and beauty. We are bombarded with advertisements and television commercials filled with young, beautiful people, and are trained to think that age is unattractive. However, if you can snap yourself out of this media-influenced tunnel vision and objectively look at the face of an older person there is a certain majestic beauty to it. Wrinkles accentuate features, hair turns gray, and a sense of wisdom tends to come across. There is a certain beauty in the ageing process that far too many people ignore.

Any photographer who has worked in advertising or magazine publishing is no stranger to battling age. When an image ends up in Photoshop, skin is often smoothed, and pores and wrinkles are removed alongside any evident gray hairs. In general, the ageing process is reversed. However, it was after I received a commission from a Canadian women's magazine that I was asked to create the exact opposite as well. They wanted to show a woman both young and old. Granted, the left side of her face has all of the retouching and perfecting the western world has come to expect, but the right side is something else entirely. It shows the same woman, but many years older.

The challenge when creating something like this is authenticity, it's got to look real and the best way to achieve that is to start with the real thing. So not only did I photograph the beautiful young model you see here, but I also photographed the elderly, adjusting the lighting to accentuate every wrinkle and porous area of the skin. A method was developed for introducing sections of the aged face into the beautiful model's face, and as you can see here, the results are rather convincing.

In addition to the Photoshop face effects, the overall image needs to convey the juxtaposition between young and old. That is why one half of the background is in full color, while the other half is desaturated, gray, and contains distressed, aged surface texture effects. As a result of this, the concept is evident at a glance, and after you follow along with this chapter's step-by-step instructions, the process of creating an ageing effect will become just as evident.

1 I Before we get started with the face or any
ageing techniques, we first need to create a
background for the image, giving our model an
environment to reside within. Open up the
sky.jpg file. Select the gradient tool. In the tool
options bar, select the foreground to transparent
option from the list of presets in the gradient
picker. Select the linear gradient method and
then press the 'd' key on your keyboard to set the
foreground color to black.

Project files
All of the files needed to follow along with
this chapter and create the featured image
are available on the accompanying CD.
Files for this chapter can be found in the
folder entitled: chapter_14.

Constraining gradients
Holding down the shift key while you
create a linear gradient will constrain the
resulting gradient to either 90°, 180°, or
45°. This means that it will be straight up
and down, perfectly straight from left to
right, or perfectly diagonal.

2 I Choose Layer>New>Layer from the menu to create a new layer. Change the
blending mode of the layer to multiply in the layers palette. Reduce the gradient
opacity to 25% and then, while holding down the shift key, click and drag from the
top of the canvas down a little. Do this from the bottom up, and then in from the left
and right sides so that the sky is surrounded by dark gradients.

3 | Click the add layer mask button at the bottom of the layers palette to mask the layer. Target the mask, then switch the gradient to the radial method and increase the opacity to 100% in the tool options bar. Click and drag from the center of the mask outwards. Do this as many times as required to mask the gradient layer until only the corners appear quite dark. This gives the sky image the signature look as if it were photographed with a toy camera like a Holga or Lomo.

Add gradient effects

A series of gradients on different layers help to transform this ordinary sky image background.

1 | Switch the gradient back to the linear method and create a new layer. Select a light brown foreground color from the picker by clicking the foreground color swatch. On a new layer, draw a gradient about half way up from the bottom.

2 | Change the blending mode of the layer to color and then create another one. On this layer, use an orange foreground color to create another gradient from bottom to about half way up. Change the blending mode of the layer to color and reduce the opacity.

3 | Create a new layer and draw a black gradient from the bottom about a third of the way up. Add a layer mask to the layer and use a radial gradient within the mask to edit the layer mask like you did with your first gradient layer.

4 | Open up the model.jpg file. Use the move tool to drag the image into your working file as a new layer. Position the new layer to the left edge of the canvas. Duplicate the layer by dragging it onto the create new layer button at the bottom of the layers palette. Change the blending mode of the duplicate layer to screen and reduce the opacity to 11%. With the duplicate layer targeted choose Select> All and then Edit>Copy from the menu. Next, Control(PC)/Command(Mac)-click on the layer thumbnail in the layers palette to generate a selection from the contents of the layer.

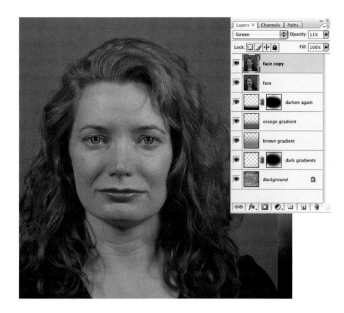

Pasting with precision

When you want to paste the contents of a layer into a channel in an identical position it is very important that you follow this process exactly. Select all and then copy the contents of the layer. Then generate a selection from the layer contents and with that selection active, paste into an alpha channel. Skipping any part of this process will result in your image being pasted into the channel in the wrong position.

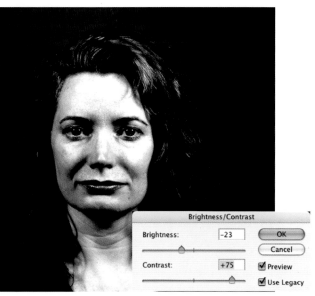

5 | In the channels palette, click on the create new channel button. With the new channel targeted and the current selection active, choose Edit>Paste from the menu. This will paste the copied image into your selection. Choose Select>Deselect and then choose Image >Adjustments>Brightness/Contrast from the menu. Enable the legacy option and then perform a drastic adjustment until the image in your channel looks like what you see here. Click the load channel as a selection button at the bottom of the palette and then return to the layers palette. With the new selection active, target the top layer.

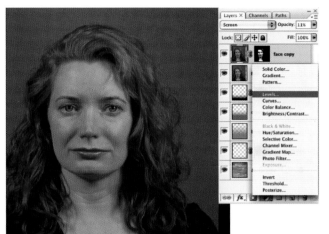

6 | With your current selection active and the top layer targeted, click on the add layer mask button at the bottom of the layers palette. This will mask all areas outside of the selection, resulting in this screen layer brightening the lighter areas of her face, adding a bit of subtle contrast. Deselect and create a new Levels adjustment layer from the menu at the bottom of the layers palette.

Tonal and color adjustments

It is time to alter her complexion a little. Don't worry if the background is affected, we'll remedy that next.

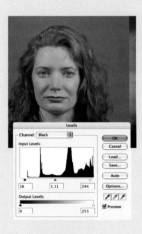

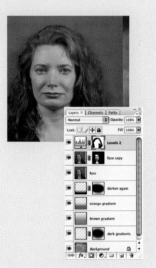

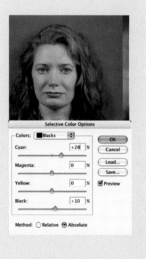

1 | Leave the channel set to CMYK and drag the left and right input level sliders closer to the center of the histogram. Then select the black channel and perform a similar adjustment. Click OK and target the adjustment layer's mask in the layers palette.

2 | Select the brush tool. Choose a large, soft, round brush tip from the preset picker in the tool options bar. Use black to paint over areas around the edge of her hair within the layer mask, masking the Levels adjustment here.

3 | Create a new Hue/Saturation adjustment layer and reduce the saturation slightly. Next, create a selective color adjustment layer. Select black from the color menu and increase the amount of cyan and black in the black component. Enable the absolute method.

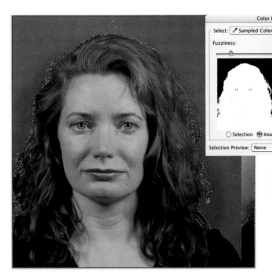

7 | Choose Select>Color Range from the menu. In the image window, use the eyedropper to click on the background. Immediately in the preview you'll see the background appear black in areas of similar color. Increase the fuzziness to add more colors to this range. If some background colors still aren't included, hold down the shift key and then click on them in the image window to add them to the desired range. Feel free to reduce the fuzziness if necessary. When you're satisfied with the targeted color range in the preview, enable the invert option and then click OK.

Removing ranges

When working with the color range tool, you can shift-click on colors in the image window to add that range of color to the selected range. However, if you wish to remove a range of color from the specified range within the color range tool, simply alt(PC)/option(Mac)-click on the color in the image window. You'll immediately see the range of color removed from the targeted range in the color range preview.

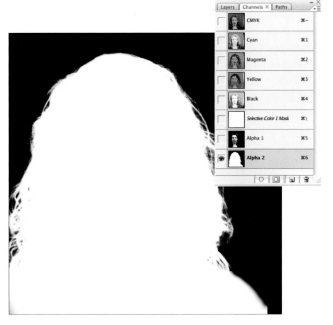

8 | With your new selection active, click on the save channel as a selection button in the channels palette. Target the new alpha channel that is created and then deactivate the selection. Ideally you want all of the model, including her hair, to be white, and all of the background to be pure black. Begin with a brightness/contrast adjustment like you did in the previous channel, but less drastic. Then, select the brush tool. Use a hard round brush tip preset to paint white over unwanted black areas and black to paint over unwanted white areas. Alter brush diameter as required.

9 | Load the new alpha channel as a selection and return to the layers palette. Target the three adjustment layers and the two model image layers, then choose Layer>New>Group from Layers from the menu. Ensure that the current selection is active and that the new group is targeted in the layers palette, then click on the add layer mask button at the bottom of the layers palette. Immediately you'll see the fruits of your labor as the original model photo background disappears. Duplicate your new group and then, with the duplicate group targeted, choose Layer>Smart Objects>Convert to Smart Object.

Adding soft focus effects

Using smart filters and smart filter masks allows us to add a blur effect around her hairline, hiding any imperfections that remain.

1 | With your new smart object targeted, choose Filter>Blur> Gaussian Blur from the menu. Specify a generous radius, mainly to soften the edges of the hair. Click OK and drag the smart object below the group in the layers palette. Target the smart filter mask.

2 | Use the gradient tool to create a black to transparent linear gradient within the mask from the top down, masking the top of the blur filter. Duplicate the smart object like you would any layer and drag it to the top of the layer stack.

3 | Target the duplicated smart object mask and select the brush tool. Use a large soft brush to paint within the targeted mask. Paint with black to mask the blur effect from her face. Then paint around the edges of her hair with white to reveal the blur effect there.

10 | Use the rectangular marquee tool to draw a very quick selection that surrounds her two eyes only. With this selection active, choose Select>Color Range from the menu. By using a selection, you will only target ranges of color that reside within the selection border. Use the eyedropper to click on the whites of her eyes in the image window. Adjust the fuzziness, then add and remove colors from the targeted range until only the whites of her eyes are targeted. If there is a slight overlap into other areas, that is fine. Sometimes it is very difficult targeting a range without including a few unwanted areas.

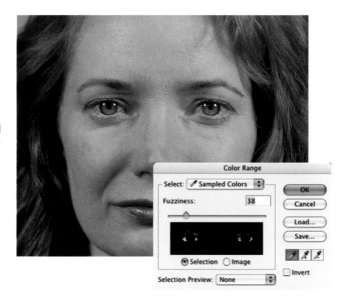

Selection previews

When you are generating a selection from a range of color while using the color range function, a preview of what you're going to get is absolutely essential. The preview window offers an excellent alpha channel style preview, however, if you're after something more, you need to direct your attention to the Selection preview menu at the bottom of the color range interface. Here you can choose from a number of preview options that will allow you to see your selection previewed against the full sized image in the background.

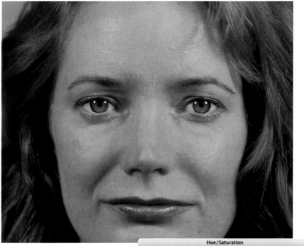

11 | With the current selection active, create a new hue/saturation adjustment layer via the menu at the bottom of the layers palette. Leave the hue as it is. Reduce the saturation considerably and increase the lightness. This will lighten the whites of the eyes nicely. If the edges of your adjustment are too sharp, target the adjustment layer's mask in the layers palette and then choose Filter>Blur >Gaussian Blur from the menu. Increase the radius until the edges appear soft enough. If you have unwanted areas of adjustment as a result of your color range generated selection, paint over them within the mask.

12 | Choose View>Show rulers from the menu. Click on the ruler at the left and drag a new guide onto the canvas, release the mouse button when you reach the center of her nose. This guide is the reference line for the division between the young and old halves of her face. Go ahead and hide the rulers in the View menu once you've created the guide. Now, create a new layer at the top of the stack in the layers palette. Select the brush tool and choose a soft, round, brush tip preset.

Painting advice

When you are smoothing skin in this manner it is very important that you paint with a very low opacity setting and build up strokes. If you decide to save time and paint using a higher opacity, the effect won't look realistic. It is also very important to frequently sample different skin colors. Hold down alt(PC)/option(Mac) to temporarily access the eyedropper tool as you go. Also remember that you can mask your layer at any point later on and gently fade things that appear too strong, introducing gradients and brush strokes into the mask.

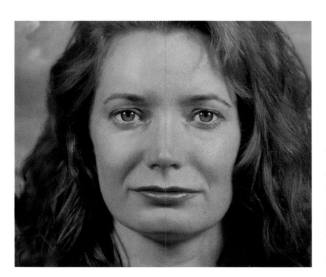

13 | Set the opacity of the brush to something very low, like 15–20%. Zoom in close on the left half of her face and sample a skin color via the eyedropper tool. Use this skin color to paint a few strokes over a porous or blemished area until it disappears. Use this method to soften the appearance of the skin on the left side of her face. Adjust brush opacity and size as required. Also, don't be afraid to frequently sample skin colors depending upon the area you're painting. Take your time and continue on in this manner until her skin appears very smooth.

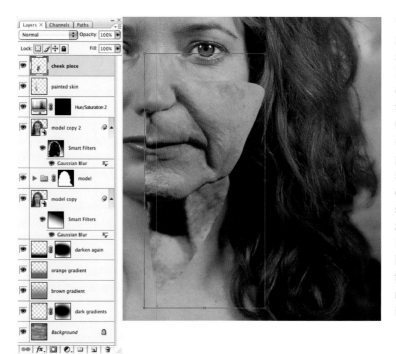

14 | Open up the man.jpg file and use the pen tool to draw a closed path that surrounds his right cheek, including quite a bit of his neck and the area under his nose. Control(PC)/Command(Mac)-click the path thumbnail in the paths palette to load it as a selection. Use the move tool to drag the contents of your new selection into the working file as a new layer. Choose Edit> Free Transform from the menu. Drag the corner handles of the bounding box to resize the new layer as required to make it fit nicely within her face.

Enhance the jowl effect

Layer masking and duplication are essential ingredients when it comes to jowl enhancements.

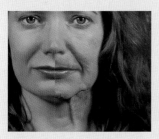

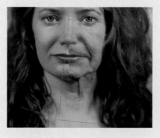

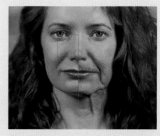

1 | Use the rectangular marquee to draw a box on the left side of the guide and then choose Layer>Layer mask>Hide Selection from the menu. Use the brush tool, with a soft tip to paint black within the mask, masking the hard edges.

2 | Duplicate the layer and again choose Edit>Free-Transform. Move the contents of the box down a little and move the mouse pointer outside the box until it changes to indicate rotation. Rotate the contents a little to the right and press the Enter key.

3 | Use the brush tool to paint over any unwanted areas within the mask. Draw a rectangular marquee over top of any layer content that strayed onto the left side of the guide. Fill the selection with black on the layer mask and deselect.

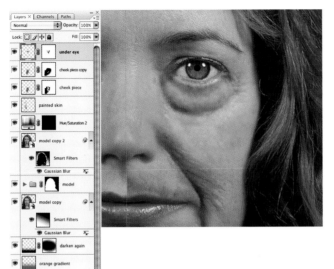

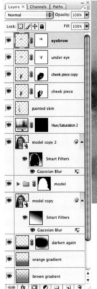

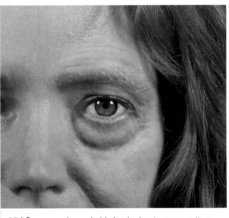

15 | Return to the man.jpg file and this time use the pen tool to draw a closed path around the area underneath his eye. Load the path as a selection and use the move tool to drag the selection contents into the working file as a new layer. Again, use free-transform to resize and position it so that it looks as if it belongs. Press Enter to apply the transformation and click on the add layer mask button at the bottom of the layers palette to add a mask to this layer. Use the same methods you used previously to edit the layer mask with a soft brush, varying diameter and opacity, blending the layer seamlessly into the background.

Positioning tip

When you drag a portion of the man's face into your working file as a new layer, the first thing you'll want to do is alter the size and position it properly. In some instances you may find it helpful to see underlying layers at the same time as you're doing this. To do this, simply reduce the opacity of your new layer until you can see both the new layer and the underlying imagery. Then perform your free-transform operation. Once finished, you can return the layer to full opacity. You cannot adjust layer opacity at the same time as performing a free-transform operation.

16 | By now you're probably beginning to see a pattern emerge. Basically, you need to select an area of the man's face that is aged looking and bring it into your working file as a new layer. Use free-transform to position and resize the portion of his face until it fits nicely into the destination location in the working file. Add a mask to the layer and edit the mask with a soft brush, painting black within the mask at various opacity settings, to soften the edges and blend the layer into the background. Use this method to add the man's eyebrow to her face.

233

17 | Return to the man's face image. Focus on areas of wrinkled or porous skin as opposed to prominent features. Bring these sections into your working file as new layers, then resize and position them. However, this time, change the blending mode of these layers to darken so that only the dark areas of his wrinkles and pores show through. Mask your layers to blend them into her face. To darken areas even more, like the added forehead wrinkles, use the color range tool to target only the recessed areas of the wrinkles.

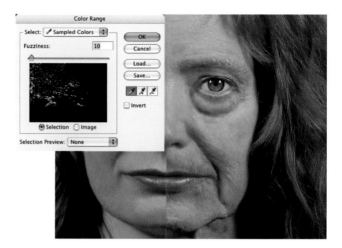

Use the appropriate tool

Using paths to trace certain areas of the man's face is very helpful because paths allow you to create very precise selection borders. Paths are especially useful for areas that contain prominent features, however, areas like pores and wrinkles require less precision. In areas like this you can work faster if you use the lasso tool to draw very quick and rough selection borders. The ragged edges won't really matter because you're going to mask your layers anyway.

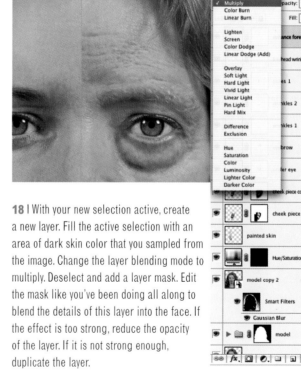

18 | With your new selection active, create a new layer. Fill the active selection with an area of dark skin color that you sampled from the image. Change the layer blending mode to multiply. Deselect and add a layer mask. Edit the mask like you've been doing all along to blend the details of this layer into the face. If the effect is too strong, reduce the opacity of the layer. If it is not strong enough, duplicate the layer.

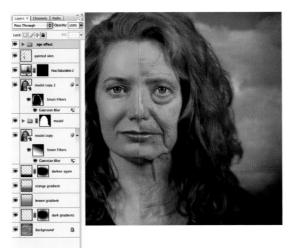

19 | Use these methods repeatedly to finish adding details and signs of age to the right side of her face. Work on the nose area, and add more pores and wrinkles. Build up masked layers and remember to use color range, multiply, and the darken blending mode for certain layers to accentuate wrinkles. Open the neck.jpg file and drag in selected portions of the neck as new layers. Again, resize and position the contents of these layers, masking them as required. When you're finished, target all of the layers that contribute to the ageing effect and add them to a single group.

Create a channel based selection

By using a pasted smart object, you can create an alpha channel that will ensure the accurate selection of her hair.

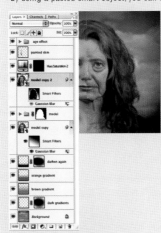

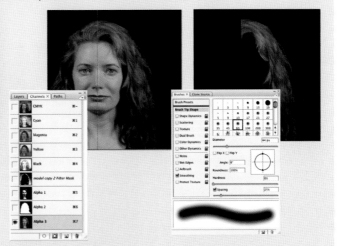

1 | Target one of the smart objects in the layers palette. Disable the smart object's Gaussian Blur smart filter by clicking the visibility icon. Select all and copy. Control(PC)/Command(Mac)-click on the smart object in the layers palette to generate a selection from it.

2 | Re-enable the visibility of the smart filter and with the selection active, create a new channel in the channels palette. Paste the copied contents into the new channel. Use the rectangular marquee to draw a selection that covers the area left of the guide.

3 | Fill the active selection with black and deselect. Use the brush tool to carefully paint black over everything white in the channel that is not hair. Take your time and fluctuate between hard and soft brush tips. Vary the size as required.

20 | Use Image>Adjustments>Brightness/
Contrast to increase the contrast within the
channel. Load the channel as a selection and
create a new layer in the layers palette. Drag
the layer to the top of the stack if it isn't there
already, and then fill the active selection on the
new layer with white. Deselect and duplicate
the layer. Change the blending mode of the
duplicate layer to color. You'll immediately notice
the graying effect this has on her hair. Duplicate
the newest layer with the color blending mode to
enhance the graying effect.

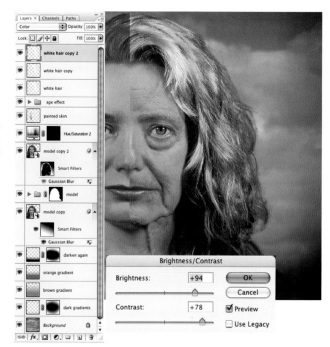

Channel previews

When you are working within an alpha channel
performing tonal adjustments, like in this
case, adjusting the brightness and contrast, it
can feel like a bit of a guessing game. As you
increase the contrast of her hair in the channel,
darker gray bits will disappear, and lighter gray
areas will become lighter. But how do you know
when enough is enough? One handy way to
see what you're doing is to enable the visibility
of the color composite channel at the top of
the palette. When you do this you'll see your
channel previewed against the image, similar
to a traditional red rubylith overlay. Previewing
your channel against your image will aid you in
realizing when your adjustment has gone too far.

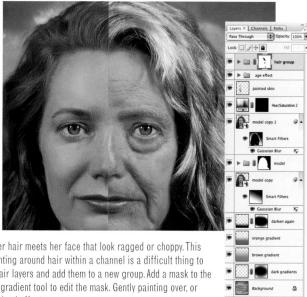

21 | Chances are there will be some areas where her hair meets her face that look ragged or choppy. This
is understandable regardless of your skill level. Painting around hair within a channel is a difficult thing to
pull off perfectly. To remedy this, target your three hair layers and add them to a new group. Add a mask to the
group and then use the brush tool and/or the radial gradient tool to edit the mask. Gently painting over, or
adding gradients over, areas that require a smooth blend effect.

22 | Open up the scratches1.jpg file. Select the entire image and copy it. In your working file, create a new alpha channel and then paste the copied scratches into it. Use the move tool, while holding down the shift key, to drag the selection contents to the right. Move it to the right until the left side of the selection border is touching the guide. Load the new channel as a selection.

Hide/show guides

While you are working your way through creating this image, there will be times when you want to view the guide that you created, and also times when you want it out of the way. You can view or show the guide via the View>Show>Guide menu option. However, it is advantageous to learn the keyboard command for a speedier process. Hold down the Control(PC)/Command(Mac) key and then press the ';' key on your keyboard to show or hide any guides.

23 | Create a new layer in the layers palette. Ensure that your new layer sits above all of the other layers and then fill the active selection with white. Deselect and add a layer mask. Use the gradient tool to mask out areas of the layer that are too strong by creating black to transparent gradients within the mask as needed. Now repeat this same process again with the scratches2.jpg. Paste it into a new channel, fill the selection on a new layer and then mask the layer. Duplicate your second scratches layer and reduce the opacity a little, making these scratches more pronounced.

24 | Open up the edges.jpg file. Copy the entire contents of the image and, you guessed it, paste it into a new alpha channel in your working file. Generate a selection from the channel and then create a new layer at the top of the stack in the layers palette. On the new layer, fill the currently active selection with white as you've done previously with the scratches. Deselect and reduce the opacity of the layer to 73%. Add a mask to the layer and then use radial gradients, from black to transparent, within the mask to remove unwanted areas.

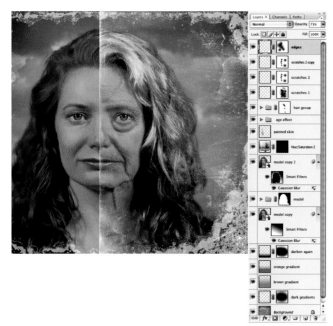

Realistic textures

Sometimes, in order for things to look genuine you simply need to use the real thing. There are loads of filters out there that claim to produce scratches and the like, but it never looks entirely real. Bearing in mind that the scratches were going to be used in an alpha channel, I printed out a solid black page on my laser printer. Then I took some very course sandpaper to the printout and scuffed it up. I scanned the scratched page, and just like that, I had a perfect scratches texture ideally suited for use in an alpha channel.

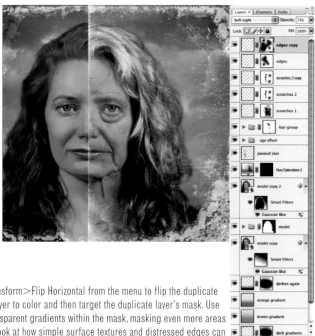

25 | Duplicate the layer and then choose Edit>Transform>Flip Horizontal from the menu to flip the duplicate layer. Change the blending mode of the duplicate layer to color and then target the duplicate layer's mask. Use the radial gradient tool to create more black to transparent gradients within the mask, masking even more areas on this layer. Stand back for a moment and have a look at how simple surface textures and distressed edges can change the overall feel of the image.

26 | Use the rectangular marquee tool to draw a rectangular selection over the right half of her face, including the background. With the selection active, choose solid color from the list under the create new fill or adjustment layer menu at the bottom of the layers palette. Choose a gray color from the picker and click OK. Change the layer blending mode to color and then target the layer's mask. Use the gradient tool to create black to transparent radial gradients within the mask, to mask the gray areas of this layer that cover her face.

Now examine what you've done
The accelerated ageing method used here is quite successful, let's take a closer look at some of the things that make it work so well.

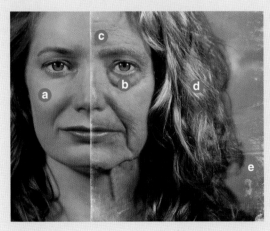

a | Although this model is young and beautiful, painting over any pores on the left side creates even more contrast between the young smooth side of her face and the old, wrinkled, porous side of her face, making the result that much more dramatic.

b | Placing separate pieces of the aged face onto the woman allows for more flexibility and a much better result than trying fit an entire half of the old man's face in the image as a single piece.

c | Some sections of the image are helped by combining selections generated from portions of the placed imagery with various layer blending modes. In the case of her forehead, a selection was generated from the deep areas of her wrinkles. Then, that selection was filled with color on a layer using a multiply blending mode, making the wrinkles appear even deeper.

d | Using a section of the actual image in an alpha channel can be the perfect basis for a selection, as is evident in the gray hair effect you see here.

e | Something as simple as a gray color layer and some surface scratches lend a sense of aged atmosphere to the right side of the image.

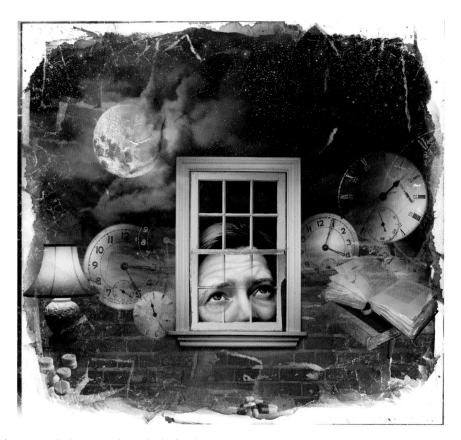

Here, the same methods were used to make the face in the window look sleep deprived. As a matter of fact, this is the same female model and the same elderly gentlemen who were used earlier in this chapter.

In this image, again, the same ageing techniques were used. However, there were three models used for this one, one of them being the same elderly gentleman again. He certainly is a good sport.

Again, the same two models were used. The face of the woman was aged extensively and then a different shot of her face was perfected and placed in her hand. The art director wanted the final result to look as if she were about to put on a mask of her former youth and beauty.

Chapter 15

Realistic Surrealism

When you glance at an image like this, it becomes immediately apparent that it has a story to tell. The first thing you see is the large figure in the center being reborn. A new self-bursts forth from the old self and smaller elements on the perimeter of the image add to the narrative. The face looking through the magnifying glass represents self-analysis. The painting at the right represents a lack of focus, and feelings of fragmentation. The figure with the hole in his chest represents emptiness. This image was autobiographical and all of the secondary elements represented my feelings at the time. I was due for a change and had made the decision to seriously pursue art. The figure in the center represents the cathartic relief I felt, and continue to feel to this day as a result of my decision.

Apart from the subject matter, this image also meant change for me in terms of technique. It was the first time I decided to use photography as a resource to be heavily manipulated within an illustration. Manipulated that is, to the point where it appears to be more painting than photography. As you follow along you'll notice that there is no state of the art photography involved here at all. I simply shot it all quickly on 35 mm film, paying attention to gesture, light, and shadow, not focus, exposure, or anything resembling photographic perfection. As you work your way through this chapter the logic reveals itself through the methods used herein. You'll learn a number of techniques that are not only useful for replicating the image you see here, but can also be applied to your own work regardless of the quality of your own photographic resources.

1 | Open up the background.psd file. This painting will provide the background and you'll build up the finished image on a series of layers within this file. Choose Filter>Render> Lighting Effects from the menu. In the preview window, rotate the existing spotlight so that it is shining down. Decrease the intensity and the ambience until the preview is fairly dark. Drag a second light onto the preview. Make this an omni light with a relatively low intensity and ambience value.

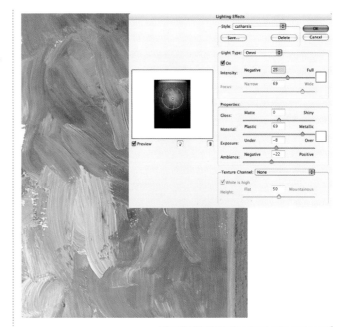

Project files

All of the files needed to follow along with this chapter and create the featured image are available on the accompanying CD. Files for this chapter can be found in the folder entitled: chapter_15.

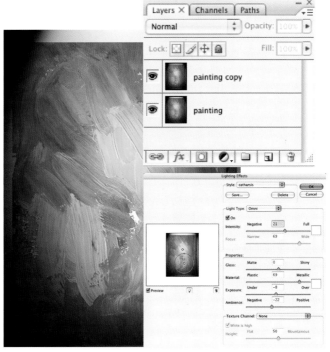

2 | Alt(PC)/option(Mac)-drag the omni light within the preview to copy it. Move it beneath the other two lights and reduce the intensity. Adjust the size and position of your lights as you see fit within the preview window. When you're happy with the result, click OK to apply the lighting effect to your painting. In the layers palette, duplicate your layer by dragging it onto the create new layer button. Change the blending mode of the duplicate layer to overlay and reduce the opacity to 30%.

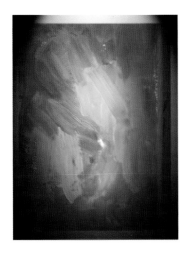

3 | Target both layers in the layers palette and then right-click(PC)/control-click(Mac) on one of the targeted layers. Choose Convert to Smart Object from the pop-up menu. With your smart object targeted, choose Filter>Blur>Gaussian Blur from the menu. Enter a radius value that will noticeably blur the smart object. Click OK, target the smart filter mask in the layers palette and then select the gradient tool. Set the foreground color to black. Use the radial gradient option and the foreground to transparent preset to create numerous black to transparent gradients within the smart filter's mask, removing the blur effect from these regions.

Setting the mood

Adjustment layers and a desktop scan help to enhance the overall mood created by this dimly lit background.

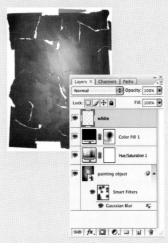

1 | Create a new hue/saturation adjustment layer. Adjust the hue to −5 and decrease the saturation by 31. Next, create a new solid color layer. Choose black and then set the blending mode of the layer to multiply. Reduce the opacity to 47%.

2 | Target the mask of the solid color layer and add some black to transparent radial gradients into the mask, to hide some dark areas created by this layer. Vary the gradient opacity as necessary. Open up the torn.jpg file.

3 | Copy the image. Return to your working file. Create a new alpha channel and paste the copied image into it. Load the channel as a selection and then create a new layer. Use Edit>Fill to fill the selection on the new layer with white.

4 | Change the blending mode of the current layer to
overlay. With the current selection active, create a new
layer. Change the blending mode of the layer to linear
burn and reduce the layer opacity to 24%. Sample a
brown color from the background by clicking on it with
the eyedropper tool. Type alt(PC)/option(Mac)-delete
to fill the selection with the new foreground color on
your new layer. Type control(PC)/command(Mac)-d to
deactivate the selection and then use the move tool to
drag the layer to the lower right slightly. Add a layer
mask.

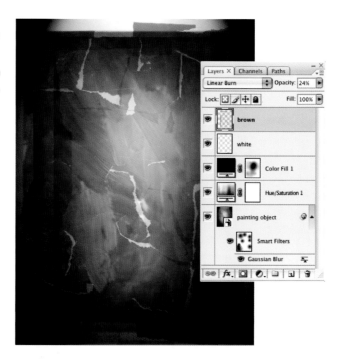

Refine edge

When you have a selection active, direct your
attention to the refine edge button that appears
in the tool options bar. This new feature has a
number of sliders that allow you to feather your
selection, as well as perform a variety of other
operations to modify your selection borders.
One particularly useful feature when feathering
is the variety of preview options. There are a
number of different image window previews
similar to those included within the Select>
Color Range command.

5 | Use the gradient tool to create black to
transparent gradients within the mask. Create
linear gradients at the top and left, to mask the
hard edges of the layer. Create radial gradients
within the mask to hide areas that you feel are
too visible. When you're finished editing the mask,
select the rectangular marquee tool. Create a
rectangular selection that lies within the white
border of the original painting. Right-click(PC)/
Control-click(Mac) on the canvas while the
selection is active and choose the feather option
from the pop-up menu that appears. Enter a radius
value that will significantly soften the edge.

6 I Type control(PC)/command(Mac)-shift-i on the keyboard to invert the active selection. Now, with the inverted selection active, create a new solid color adjustment layer from the menu at the bottom of the layers palette. Areas that fall outside of the selection border will be automatically masked. Choose a black color from the picker and click OK.

Adding the central figure

Place the main figure in the scene, using a vector mask to remove unwanted portions of the layer.

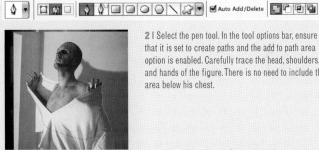

2 I Select the pen tool. In the tool options bar, ensure that it is set to create paths and the add to path area option is enabled. Carefully trace the head, shoulders, and hands of the figure. There is no need to include the area below his chest.

3 I Once you've closed the path, ensure that the top layer is targeted and then choose Layer> Vector Mask>Current Path from the menu. The resulting mask will clip the contents of your layer. Use the direct selection tool to tweak the vector mask if necessary.

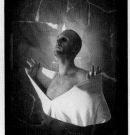

1 I Open the middle.jpg file. Use the move tool to drag the image into your working file as a new layer. Choose Edit>Free Transform from the menu and shift-drag the corners of the bounding box to increase the size proportionately. Press Enter to apply the transformation.

247

7 | Right-click(PC)/control-click(Mac) to the right of the layer thumbnail and layer mask thumbnail in the layers palette. A pop-up menu will appear, choose the Duplicate layer option from the pop-up menu. When prompted, specify the current document as the destination and click OK. Change the blending mode of the duplicate layer to screen and reduce the opacity to 51%. Duplicate this layer and then change the blending mode to overlay. Stacking up layers like this with varying blending modes really helps to enhance the overall contrast of the figure. Don't worry too much about overly saturated colors at this point, we'll address that next, this stacking method is to boost contrast while preserving image detail.

Where to click

When you right-click(PC)/control-click(Mac) on a layer in the layers palette, a pop-up menu will appear. However, the options within the menu will be different depending upon exactly where it is that you click. For instance, the duplicate layer option is only available when you click to the right of the layer and layer mask thumbnails. Clicking on a layer thumbnail or a layer mask thumbnail will result in different menu options relative to that particular layer component.

8 | Hold down the control(PC)/command(Mac) key and click on the vector mask thumbnail of your top layer in the layers palette. This loads the vector mask as a selection. With the selection active, create a new hue/saturation adjustment layer. Reduce the saturation by 100% and click OK. Now, hold down the control(PC)/command(Mac) key and click on the adjustment layer's mask in the layers palette to load it as a selection. With this selection active, create a new selective color adjustment layer via the menu at the bottom of the layers palette. Choose neutrals from the color menu and alter the individual color components as seen here.

9 | Open up the left.jpg file. You'll find a path included in the paths palette. Control(PC)/command(Mac)-click on the path thumbnail in the paths palette to load it as a selection. Copy the contents of the selection and paste them into the working file as a new layer. Use free-transform to adjust the size and rotation of the layer contents. Holding down the control(PC)/command(Mac) key while you drag a corner point will allow you to freely distort the contents of the bounding box. Press enter to apply the transformation when you're satisfied with the results.

Using bits and pieces

Revise the shape of the left figure by floating bits and pieces of his skin on a series of new layers.

1 | Use the lasso to draw a very rough selection around an area of his chest on this layer. Feather the selection so that edges are soft via the select menu, the tool options bar, or the refine edge command.

2 | Choose Layer>New>Layer Via Copy from the menu to copy the selected area to a new layer. Move the new layer over to the right to widen his chest. Use this method to widen his neck as well.

3 | Target all of the layers that make up the left side and then choose Merge layers from the layers palette menu to merge them into a single layer. These layers are merged, so that we can apply the liquify filter to his entire left side.

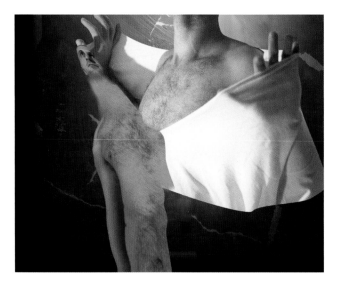

10 I With your merged layer targeted, choose Filter>Liquify from the menu. Use the forward warp tool to gently push pixels around. The idea here is to reshape the left side so that it looks like it is being stretched or pushed. You'll want to warp his face so that it looks as if his hand is pushing through it. Also, remember to use the reconstruct tool to undo anything that gets pushed too far and looks out of place. Take your time with this and press OK to apply the filter when you're satisfied.

Looking into the liquify effect

Here are some helpful hints for creating a convincing stretch effect within the liquefy filter.

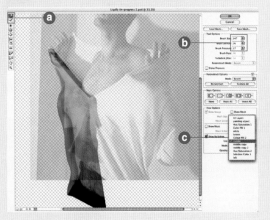

a I You don't need to use any bloat or twirl functions to achieve a convincing effect. The forward warp tool is simple, yet it allows you a fair amount of control when pushing the pixels around, so that you can get things looking exactly the way you want them to. The reconstruct tool is there to remove anything you do that appears too drastic. A good method of working is to toggle back and forth between these tools as you go.

b I Less is often more when it comes to liquefying. Try using a large brush size combined with a low density and pressure setting. When you set up the tool like this it is possible to slowly build up the effect. You'll have to paint areas over and over before things go too far and the effects look unrealistic.

c I Because we want the final result to look as if it belongs in the scene, it is useful to enable the show backdrop option. You can choose which layers to display and how opaque to make them. Try choosing one of the main figure layers as a background, rather than showing all layers, to reduce the onscreen clutter as you work.

11 | Reduce the opacity of your layer so that you can see the background through it. Select the pen tool and then draw a path that will define the edge of the left side. Having the background partially visible as you work will aid you in making the shape of his left side look as if it belongs within the scene. When your path is closed, choose Layer>Vector Mask>Current Path from the menu to clip the layer with your path.

Why Merge?

Ideally, the best way to combine layers is to convert them to a smart object. That way, everything remains editable. Although you can apply smart filters like Gaussian Blur to smart object, the liquefy filter cannot be applied to smart object. That is why, in this instance, we've merged all of the layers that make up the left side before the liquefy filter was used. If you're worried about making a mistake, duplicate your layer before using the filter. Keep the duplicate in the layers palette with the visibility disabled. That way, if you want to revert the layer to its original state at any point, you have a backup copy.

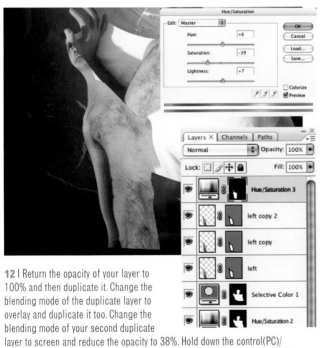

12 | Return the opacity of your layer to 100% and then duplicate it. Change the blending mode of the duplicate layer to overlay and duplicate it too. Change the blending mode of your second duplicate layer to screen and reduce the opacity to 38%. Hold down the control(PC)/command(Mac) key and click on the layer's vector mask to load it as a selection. With this selection active, create a new hue/saturation adjustment layer. Set the hue to +6, the saturation to −39, and increase the lightness to 7.

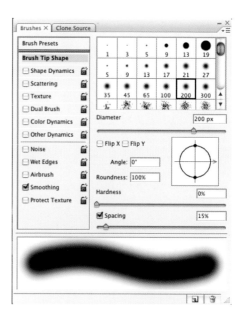

13 | Generate a selection, from one of the vector masks attached to any layer that is used to make up his left side. Create a new layer at the top of the layers palette. Select the brush tool. In the brushes palette, choose a large, soft, round, brush tip preset. Disable all dynamic functions except the smoothness option. Sample a light skin color from an underlying layer and then paint, using a low-opacity setting of around 15%, on this layer to smooth out the skin on the underlying layers. It is beneficial to have the appearance of smooth skin when combining two halves of the body.

Use your discretion

No matter how closely you follow along, remember that things rarely look identical each time the same image is created. You'll need to follow along closely here, but you'll also need a willingness to improvise. For instance, on this page, it is unlikely that after transforming the right half of his body that it will be identical to what you see here. That is fine, just tailor the instructions to fit what is happening on your screen. Every transformation and hand drawn selection border will differ slightly.

14 | Open up the right.jpg file. In the paths palette, load the existing path as a selection and then copy the contents of the selection. Return to your working file and paste the copied selection contents in as a new layer. Use free-transform to resize, reshape, and position the right half of his body where it belongs. Now, his chest looks good, but other parts of the layer do not. To remedy this, use the lasso to draw a rough selection around his head. Hold down the shift key and draw another selection around the right side of his arm.

15 | Choose Layer>Layer Mask>Hide Selection from the menu. Now, although these parts of the layer are masked and no longer visible, they are still there. Target the layer instead of the mask in the layers palette. Use the lasso tool to draw a selection around the head and neck on this layer. Then choose Layer>New> layer Via Copy from the menu to create a new layer that contains the contents of the selection.

Use free-transform to reshape and reposition the contents of the new layer. Add a layer mask and then use a soft brush or a series of gradients within the layer mask to hide any hard edges.

Here we go again

To construct the right side of his body, you simply need to repeat a few familiar procedures over and over again.

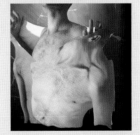

1 | Use previous method of making a selection, creating a new layer via copy, and then transforming and masking to build up a series of layers for the right side of his body. Use sections of his arm and chest as you see fit.

2 | Target all of the layers that make up his right side in the layers palette and then choose Merge Layers from the layers palette menu to merge them into a single layer. With the new merged layer targeted, launch the liquify filter.

3 | As you did with the other side, use the forward warp tool to gently move the pixels around. Enable the show backdrop option to ensure that what you're doing will work within the scene. Press OK to apply the filter.

253

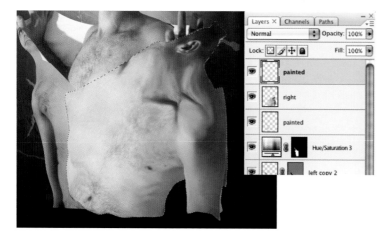

16 | Create a new layer at the top of the layers palette. Select the brush tool. And then, as you did with the left side, use a soft round brush tip with a low opacity setting to paint over areas of his skin. Use the eyedropper tool to sample light areas of the skin on the underlying layer and then paint it onto this area using a very low-opacity setting. When you're finished painting, control(PC)/ command(Mac)-click on the merged layer underneath the new paint layer in the layers palette to generate a selection from it.

Seeing through layers

When you are creating one side of his body from a number of copied components on a series of layers, it is good practice to get used to temporarily reducing the opacity of various layers as you work. This will allow you to see through certain layers and know how you're positioning is working in relation to underlying layers. Reduce the opacity of the layer you're working with, transform it, position it, and then when you're satisfied that it works with the underlying layers, return it to full opacity. This method is very effective, use it often.

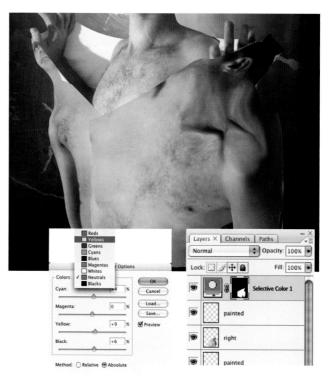

17 | With the current selection active, create a new Selective color adjustment layer. From the colors menu, one at a time, choose the reds, yellows, neutrals, and blacks. Each time you choose a color, edit the cyan, magenta, yellow, and black sliders to make that particular color component match the left side. You can return to previous colors as you go. This is a very visual and intuitive adjustment so be certain to pay attention to what is happening in the image window as you go.

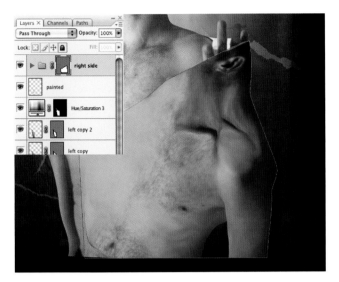

18 | Target all of the layers that comprise his right side: the liquefied layer, the painted layer, and the adjustment layer. Add them to a new group. Target the new group in the layers palette. Choose the pen tool and draw a closed path that will define the area of his right side. When you've closed the path, choose Layer> Vector Mask>Current Path from the menu to convert your path to a vector mask that clips the contents of the group.

Hiding vector masks

If you wish to edit a vector mask, you can do so at any point by using the direct selection tool. However, there will be times when editing a vector mask, that it would be beneficial to see what layer content lies hidden outside the boundaries of the mask. To hide the effects of a vector mask, shift-click on it in the layers palette. A red 'x' will appear over the mask thumbnail and it will be disabled in the image window. To reactivate the mask, shift-click on it again.

19 | The vector mask does a good job of clipping the contents of the group, however, the area at the left where the right side meets the left side needs something smoother. Click the create layer mask button at the bottom of the layers palette to add a layer mask to the group in addition to the existing vector mask. Select the gradient tool. Use a black foreground color, the radial option, and the foreground to transparent preset to create a series of gradients within the new mask. Soften the area where the two sides of his chest overlap.

20 I Target all of the layers that make up his left side and add them to a new group as well. This will help to keep things in a logical order within the layers palette. Control(PC)/command(Mac)-click on an adjustment layer mask or vector mask thumbnail attached to any of your middle figure layers in the layers palette. This will generate a selection from the contents of the mask. Create a new layer and move it below the left and right side groups in the layers palette. Choose lighten from the list of blending modes in the Layer palette's blending mode pop-up menu.

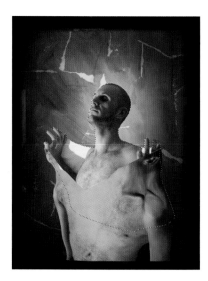

Hiding selection borders

When painting over dark areas like this, working within a selection border is essential in ensuring that you don't stray onto the background. However, staring at the marching ants while you work can get distracting. Typing control(PC)/command(Mac)-h will hide your selection border. When the selection border is hidden the same keyboard command will reveal it again.

21 I Select the brush tool. Choose a large, soft, round brush tip preset. Disable any dynamic functions, but be certain to leave the smoothness option enabled. Set the opacity very low to around 15–20%. With the new layer targeted, sample a light color from the middle figure's skin by holding down the alt(PC)/option(Mac) key to temporarily access the eyedropper, and then clicking. Let go of the key and begin to paint over a darker area within the selection. Use this method to sample a variety of light colors and paint over dark regions, primarily the head and right arm, within the selection. Vary brush size and opacity as needed.

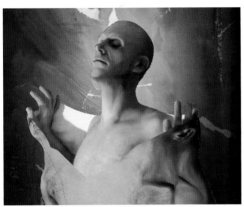

22 | Create a new layer and select the blur tool. Ensure that the new layer is targeted and set the strength of the blur tool to 100%. In the tool options bar, enable the sample all layers option. Use a soft, round, brush tip preset and paint over areas within the currently active selection on the new layer that, although already smoothed somewhat by paint on the underlying layer, still shows some of the grain from the original photograph. Now switch to the smudge tool, set the strength to around 25% and enable the sample all layers option. Use a similar brush tip preset to gently smudge areas within the active selection. Use numerous small strokes to resemble oil painting techniques.

Smudge painting

When you are painting over areas of his face, neck, and shoulders with the smudge tool, you must be willing to vary the tool options as you go. Reduce the size of your brush in areas like those around his eyes, so that you don't paint over areas that provide essential details. Also, if things are looking too fluid, try reducing the strength of the tool. You want to gently build up the effect by using multiple, gentle strokes. Working in this manner is what will allow you to simulate the blended quality of oil painting.

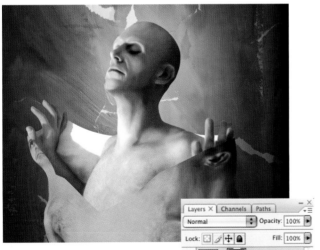

23 | With the current selection active, create a new levels adjustment layer from the menu at the bottom of the layers palette. Leave the channel set to RGB and then drag the left and right input levels sliders toward the center of the histogram to increase the contrast. Now target the adjustment layer's mask and use the radial gradient tool to draw black to transparent gradients within the mask to soften the effect in areas where the contrast is too drastic. Duplicate the layer to intensify the adjustment, and continue to mask even more areas of this adjustment layer with similar gradients.

24 | Open up the sky.jpg file, select all, and copy. Paste the copied sky image into your working file as a new layer. Position the sky layer on the canvas, so that it overlaps his head and shoulders entirely. Reduce the opacity of the layer to 40% and change the blending mode to overlay. Duplicate the layer, return the blending mode to normal and reduce the opacity of the duplicate layer to 11%. Now duplicate this layer, and then change the blending mode to luminosity. Again, duplicate this layer and then change the blending mode to soft light, increase the layer opacity to 40%.

Duplicating and altering

As you create the effect of the sky overlapping his head and shoulders it may seem like an awful lot of duplicate layers. However, working in this manner is a very intuitive and artistic way to get the results you're after. It really is as simple as trying different modes and opacity settings, one at a time, until you've found the combination of layers that works best. Also, remember that by keeping all of the layers separate, you can tweak individual layers at any point later on.

25 | This may seem like a lot of duplication, but you'll certainly see the results take shape as you follow along. Finally, duplicate the top sky layer one last time. Change the blending mode to color and reduce the opacity to 27%. Feel free to add masks to individual sky layers and edit them as you've edited previous layer masks using the gradient tool to remove areas that are too prominent. Create a new layer with a color blending mode and sample a light yellow color from within the image. Create a series of radial, foreground to transparent gradients, overlapping his chest area.

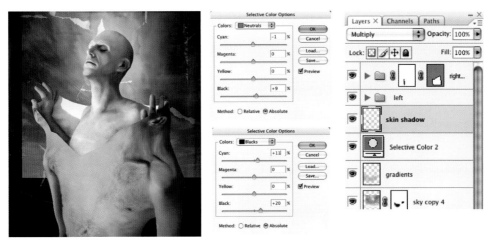

26 | Create a new selective color adjustment layer. Increase the amount of cyan and black in both the neutral and black color components. Create a new layer and change the blending mode to multiply. Use the brush tool to paint a soft black brush stroke on this layer in the area where his stretched skin overlaps his chest, creating a shadow effect. Use an extremely low-opacity setting so that the result is very slight. If your shadow still appears too prominent, reduce the layer opacity.

Add some internal texture

Use the first source image as your resource to make the inside of his skin look at home within this highly textured scene.

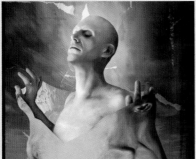

1 | Use the pen tool, set to create paths, with the add to path area option enabled, to create a series of closed path components within a single path. Carefully trace all of the areas where you can see the inside of his skin.

2 | Load the path as a selection and then open the background.psd file again. Use the rectangular marquee to select a section of the painting and copy it. Return to your working file and choose Edit>Paste into to paste it into your selection.

3 | Change your layer blending mode to darken and reduce the opacity to 30%. Duplicate the layer and change the blending mode to color. Increase the opacity to 35% and control(PC)/ command(Mac)-click the layer mask thumbnail to generate a selection from the mask contents.

259

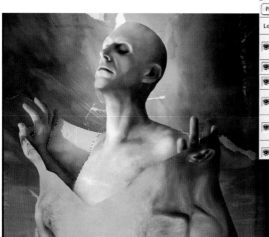

27 I With your current selection active, create a new layer. Target this layer, set the foreground color to black and select the brush tool. Paint some very faint black shadows inside of the selection border where it needs to be darker to look realistic. Use a similar brush tip preset and opacity setting as you did when you created the previous shadow against his chest. With your current layer targeted, hold down the shift key and also target the bottom sky layer. This also targets all of the layers in-between. Choose Layer>New>Group From Layers from the menu.

Grouping layers

When you have a number of layers targeted within the layers palette, a quick way to add them to a group is to type control(PC)/command(Mac)-g on the keyboard.

28 I Hold down the control(PC)/command(Mac) key and click on an adjustment layer mask or vector mask thumbnail belonging to any of the middle figure layers in the layers palette. This will generate a selection from the contents of the mask. With the current selection active, target your new group in the layers palette and then click on the create layer mask button at the bottom of the layers palette. This will mask the group so that nothing extends onto the background. Target this group as well as all of the other groups and layers that work together to create the main figure.

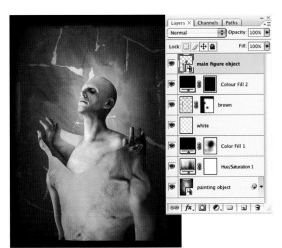

29 | When you've targeted the layers and groups within the layers palette, right-click(PC)/control-click(Mac) on the area to the right of any targeted layer's thumbnails. A pop-up menu will appear. Choose convert to smart object from the pop-up menu. Ensure that you are not clicking on a layer thumbnail or a layer mask thumbnail, or you will access a different pop-up menu that does not offer this function.

Adding texture

Paste imagery into alpha channels and channel-based selections to build up textured areas within the background of the image.

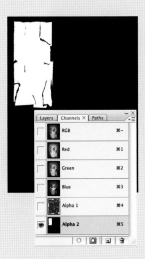

1 | Open up the torn1.jpg file. Copy the contents of the file and then create a new alpha channel in the channels palette of your working file. Paste the copied image into your new channel and load it as a selection.

2 | Keep this selection active and then open the texture.jpg file. Copy the contents of this file and return to the working file. With the current selection active, choose Paste Into from the Edit menu. Use the move tool to reposition the layer within the mask.

3 | Change the layer blending mode to multiply and drag it beneath the main figure smart object in the layers palette. Duplicate the layer and change the blending mode to overlay. Duplicate this duplicated layer and change the blending mode to color.

30 I Add these three texture layers to a new group. Add a mask to the group and then edit the mask by adding radial, black to transparent gradients into the mask. Create the gradients in the area where the texture falls behind his hand to blend it into the background. Now open up the man.psd file. Use the move tool to drag the layer into your working file as a new layer and place it over your new textured background on the canvas. Position him close to the main figure's hand.

Smart objects

One of the main advantages to using smart objects is that they always remain editable. Right now, there are two smart objects in this file. One is the background object and the other is the main figure object. A quick way to edit either object is to simply double-click on the smart object thumbnail in the layers palette. This will open a new document window containing the layered version of the smart object. Make any changes and then save. Close the file and you'll see the smart object in your working file is updated automatically.

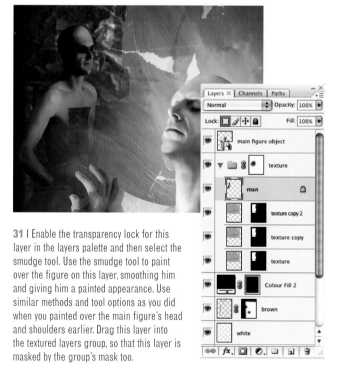

31 I Enable the transparency lock for this layer in the layers palette and then select the smudge tool. Use the smudge tool to paint over the figure on this layer, smoothing him and giving him a painted appearance. Use similar methods and tool options as you did when you painted over the main figure's head and shoulders earlier. Drag this layer into the textured layers group, so that this layer is masked by the group's mask too.

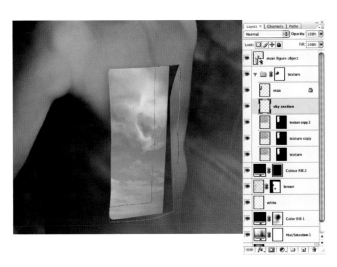

32 | Open up the sky.jpg file, use the rectangular marquee to select a small section of the sky and copy it. Paste the copied section of sky into your working file as a new layer. Drag it into the texture group, beneath the figure layer in the layers palette. Position it so that it shows through the hole in the figure. If there are any areas that extend beyond the edge of the figure, erase them, or select and delete them. Use the pen tool to draw a path that indicates thickness, defining the inner sides of the opening.

Adding dimension

Create visible, inner sides of the opening, giving the figure a sense of thickness and depth.

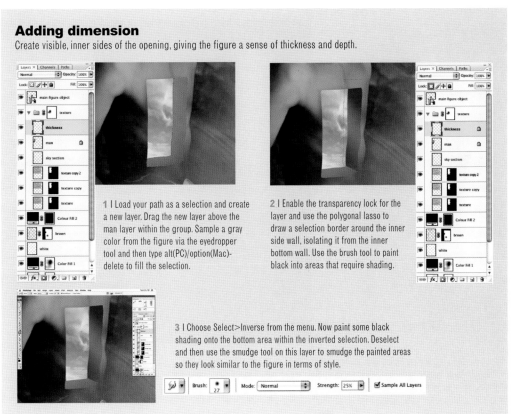

1 | Load your path as a selection and create a new layer. Drag the new layer above the man layer within the group. Sample a gray color from the figure via the eyedropper tool and then type alt(PC)/option(Mac)-delete to fill the selection.

2 | Enable the transparency lock for the layer and use the polygonal lasso to draw a selection border around the inner side wall, isolating it from the inner bottom wall. Use the brush tool to paint black into areas that require shading.

3 | Choose Select>Inverse from the menu. Now paint some black shading onto the bottom area within the inverted selection. Deselect and then use the smudge tool on this layer to smudge the painted areas so they look similar to the figure in terms of style.

33 | Open the rust.psd file. Use the move tool to drag the rusty image into the working file as a new layer. Because the layer currently targeted in your working file is within the texture group, the new layer will be placed on top of it within the group. Position the contents of the layer to the left side of the canvas. Add a mask to the layer and create a series of black to transparent radial gradients within the mask to hide any hard edges.

Unmasking layer content

As you add black to transparent gradients within your layer masks there are bound to be occasions when you mask more of a layer than you want to. A quick way to unmask areas is to press the 'd' key. When a layer mask is targeted this will set the foreground color to white. Click and drag to create white to transparent gradients within the mask to gently reveal masked areas that were accidentally hidden by black to transparent gradients.

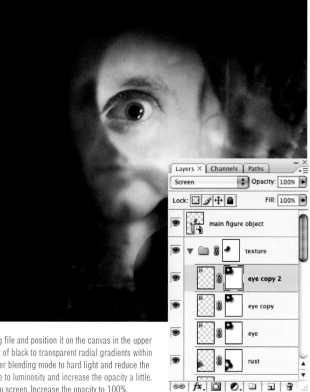

34 | Open up the eye.psd file. Drag the layer into your working file and position it on the canvas in the upper left-hand corner. Add a mask to the layer and create a number of black to transparent radial gradients within the mask to hide the hard edges of the image. Change the layer blending mode to hard light and reduce the opacity to 61%. Duplicate the layer, change the blending mode to luminosity and increase the opacity a little. Duplicate this layer too, and then change the blending mode to screen. Increase the opacity to 100%.

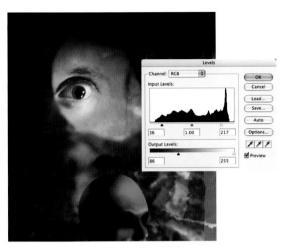

35 I Target the layer's mask in the layers palette and create more black to transparent radial gradients within the mask until the only visible part of the layer is the eye and the area immediately surrounding it. Duplicate this layer and change the blending mode to overlay. Target your new duplicate layer (not the mask) and choose Image> Adjustments>Levels from the menu. Drag the left and right input levels sliders toward the center of the histogram to increase the contrast. Then drag the left (black) output levels slider to the right to lighten the darkest areas.

Paste in a painting

Create a custom alpha channel to use as the basis for a selection, which will mask a previously completed painting.

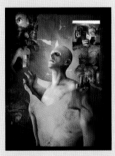

1 I Open the torn2.jpg file. Select and copy the contents of this file, then create a new alpha channel in your working file. Paste the copied image into your channel and then load the channel as a selection. Return to the layers palette.

2 I Open the painting.jpg file, select all, and copy. Return to your working file. Ensure that your selection is still active and then choose Edit>Paste Into from the menu to paste the image into your file as a masked layer.

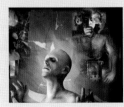

3 I Target your new layer (not the mask) in the layers palette and use the move tool to reposition the layer content within the mask on the canvas area. Target the mask and add gradients, producing a soft blending effect.

36 | In the layers palette, control(PC)/command(Mac)-click on the main figure smart object to generate a selection from its contents. Choose Select>Inverse from the menu and target the aforementioned smart object. Open up the fence.jpg file and copy it. Return to the working file. With the inverted selection still active, and the figure smart object targeted in the layers palette, choose Edit>Paste Into from the menu. After pasting, move the new layer's contents down within the layer mask. Target the new layer's mask in the layers palette and then draw a linear, black to transparent gradient within the mask, from the middle of the canvas downward, to create a soft fade effect.

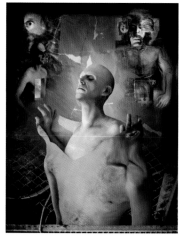

Adding final surface textures
Create an aged and tactile feeling by adding some hand written text alongside scanned, distressed paper texture.

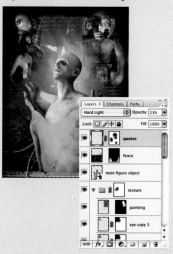

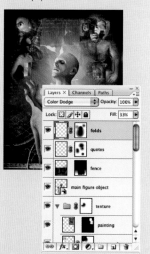

1 | Open up the quotes.jpg file. Select all and copy. Return to your working file. Create a new alpha channel and paste the copied contents into it. Load the new channel as a selection. Create a new layer in the layers palette.

2 | Fill the active selection on your new layer with white. Change the blending mode to hard light and reduce the opacity considerably. Deselect, add a layer mask, and create a number of radial, black to transparent gradients within the mask to fade certain areas.

3 | Open the folds.jpg file and repeat the same process. Paste it into a new channel and load it as a selection. Fill the selection with white on a new layer. Mask it and then edit the mask, to mask out where folds overlap key images. Change the blending mode to color dodge.

37 | Duplicate this layer and change the blending mode of the duplicate layer to hard light. Reduce the opacity of the layer to 33%. Now, navigate down to the bottom layers in the layers palette. Sitting above the bottom smart object, an adjustment layer, and a solid color layer is the white torn paper texture layer you created earlier in this chapter. You previously loaded a channel as a selection and filled it with white on this layer. Duplicate this layer and drag it to the top of the stack in the layers palette. Reduce the opacity of the layer to 33%.

Removing sharp edges

If you find that the edges of your figure look too sharp, there is a way to soften them. Create a new layer above your head layer, but beneath the top four texture layers in the layers palette. Target your new layer and disable the visibility of the four texture layers above it. Use the blur tool, with the sample all layers option enabled, to paint over any sharp areas on your new layer. When you're finished, enable the visibility of the texture layers once again.

38 | Now, add one last element to the image. Open the head.psd file and use the move tool to drag it into your working file as a new layer. Position it over the face of the painting at the upper right and change the blending mode to hard light. Move this head layer below the top four layers in the layers palette, so that the surface texture and quotes reside above it.

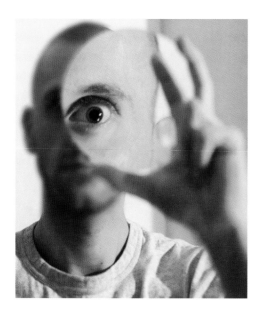 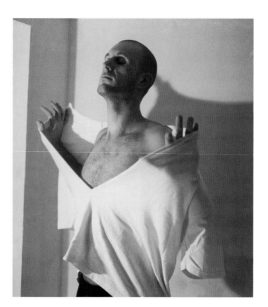

Now that you're finished. Take a moment, and look at some of the photographs that were used. These really are quite amateurish in terms of lighting, exposure, and focus. But what makes them valuable resources is that they provide excellent gesture, overall detail, contrast, and in the case of the fence, texture. As a Photoshop artist you need to be able to see beyond the traditional photographer's approach to capturing things. You need to plan and to be able to spot the potential within your images, bearing in mind that each photo is valuable starting point, rather than an end in itself. Less than perfect images can be excellent resources when used as building blocks for photographic illustrations.

Here are a couple of examples that employ the same techniques explained in this chapter. You can see in the top image, that the head photograph was painted over using the same methods used to smooth the main figure on the previous pages. The raven in the bottom image was pieced together from bits an pieces of different images, using the same techniques we employed to created the tearing skin earlier on.

PART 4
Photoshop and Other Programs

Chapter 16

Bringing Stale 3D to Life

These days, most digital artists recognize the potential within photography, but unfortunately, 3D is often overlooked as a starting point for digital illustration. Which is unfortunate, because it can provide a useful building block that, when combined with what Photoshop has to offer, yields impressive and innovative results. These unique results are a combination of the depth that 3D provides, and the painterly freedom of working in 2D.

The reasons for going this route are numerous. Perhaps you're not a 3D expert, and although you can model objects effectively, you find texture mapping a frustrating experience. Those of you who are proficient in Photoshop, yet not so masterful over a given 3D application, will definitely find this method of applying texture beneficial.

Another reason for choosing this approach is that perhaps you don't want your 3D renderings to look the same as every other artist using the same application. Photoshop provides such a range of tools, that it is easy to map imagery onto your 3D renderings in perspective or follow curved contours, creating convincing and unique results that deviate from the signature look of 3D modeling applications.

In addition to mapping artwork in perspective and wrapping it around contoured objects, you can make use of all of the image composition tools and features that Photoshop has to offer. This will allow you to combine your 3D art with painted images and tactile art components, creating a unique blend of futuristic 3D, and warm, illustrative, traditional art.

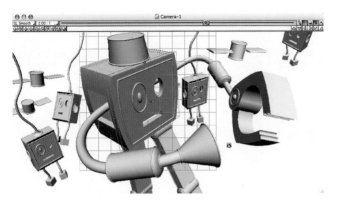

1 | When working in 3D, the first step is to build your scene. You'll need to use the tools within your chosen 3D application to carefully construct each object and component. When you have finished creating all of your 3D objects, then it is time to think about adding lighting and setting up a camera to render your scene. Now, if you were going to work purely in 3D, you'd need to apply textures to your objects. But because we'll be doing that in Photoshop, all objects will be rendered with a neutral gray surface texture applied to them, as shown here in the camera window's preview.

The almighty Jeff Soto

Jeff Soto is one of my favorite living artists. He lives in Riverside, California and paints mind boggling epic scenes with robots and all kinds of organic things in them. I was so inspired by Jeff's 'walkers' that I decided to try something similar by combining 3D and Photoshop. I think the results are pretty good, but if you want to see spectacular paintings and true inner vision, visit www.jeffsoto.com

Project files

All of the files needed to follow along with this chapter and create the featured image are available on the accompanying CD. Files for this chapter can be found in the folder entitled: chapter_16.

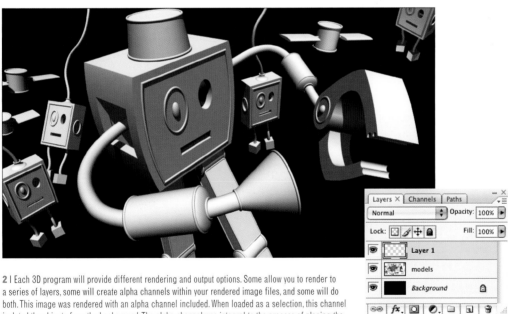

2 | Each 3D program will provide different rendering and output options. Some allow you to render to a series of layers, some will create alpha channels within your rendered image files, and some will do both. This image was rendered with an alpha channel included. When loaded as a selection, this channel isolated the objects from the background. The alpha channel was integral to the process of placing the rendered art on a layer, separate from the background. Go ahead and open up this layered rendering to begin, the file is called render.psd. Click the create a new layer button in the layers palette to create a new, empty layer, and move it to the top of the stack in the layers palette.

3 | Open up the yellow2.psd file. Type Control(PC)/command(Mac)-a to select all and then type Control(PC)/Command(Mac)-c to copy the selected contents. Return to your rendering. psd file. Select the pen tool. In the tool options bar, ensure that it is set to create paths and that the add to path area option is selected. Use the pen tool to draw a closed path component that carefully traces the outline of the left side and top of the main figure's torso.

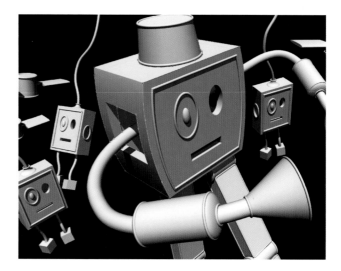

Creating planes

Photoshop's vanishing point filter allows us to create planes that match the perspective of our 3D objects, so that pasted texture will match the object's perspective.

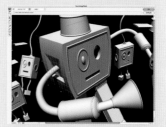

1 | Target your path and click on the Load Path as a Selection button in the Paths palette. With the selection active, target the empty top layer in the layers palette and then choose Filter>Vanishing Point from the menu. The create plane tool will be selected.

2 | Use the create plane tool to click four times, defining the four corners of the side plane. Now, use the create plane tool to click on the top center point of the existing grid and drag to the right. Dragging creates a perpendicular grid across the top.

3 | Use the edit plane tool to click and drag any of the corners of either plane to reshape it. When finished, use the edit plane tool to click on the first plane, the side plane, so that it is targeted.

4 I Type Control(PC)/Command(Mac)-v to paste. You'll see a rectangular marquee appear in the upper left of the vanishing point workspace and the current tool will automatically switch to the marquee tool. Click within the selection border and drag it over to your first perspective plane. Immediately, you'll see the pasted texture appear and conform to the perspective defined by the grid that it is sitting on. Select the transform tool and drag the corner points of the bounding box to resize your pasted texture until it fills the entire side. Note that the pasted texture will not stray beyond the edges of your original selection.

A large enough plane

Ensure that when you create your perspective planes that they cover the sides of the artwork entirely. It is fine if your planes extend beyond the desired areas but make sure that they don't fall short. When you place pasted artwork onto a plane, it can cover the entire plane but it will not extend beyond the edge. So if the end of the plane falls short of the edge of your object, your artwork won't cover the side of your object properly.

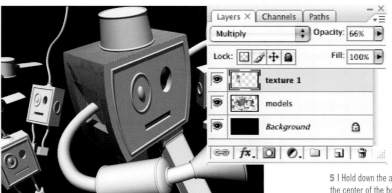

5 I Hold down the alt(PC)/option(Mac) key, then click in the center of the bounding box and drag it up onto the perpendicular plane at the top of the shape. Position it so that it does not run down onto the side plane and use the bounding box corner handles and midpoints to resize it. When you're satisfied, click OK to exit the vanishing point filter and the newly mapped texture will appear on your targeted layer within the currently active selection. Reduce the opacity of the layer to 66% and change the blending mode to multiply.

6 | Duplicate your current layer by dragging it onto the create a new layer button in the layers palette and change the blending mode to overlay. Ensure that your current selection remains active. Create a new layer in the layers palette and then open the stripes.psd file. Select all and copy. Return to the working file. With the new layer targeted and the current selection active, launch the vanishing point filter again. The grids you previously created are still there. Type control/command-v to paste and use the marquee tool to position the stripes on your first plane.

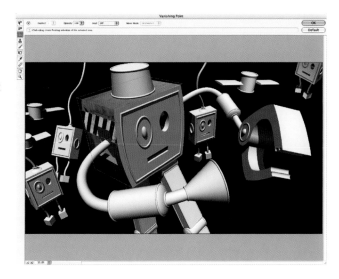

Deselecting in vanishing point

When you paste an image into vanishing point it is very important that you exercise special care when it comes to where you click. If you click anywhere outside the selection marquee, the floating selection becomes deselected and pasted onto the currently targeted layer back in Photoshop. Be especially careful when you're pasting into an area defined by a selection border like we're doing here, because although you'll see the marquee, you won't be able to see the pasted art until you drag it into the selected area defined in the Photoshop workspace.

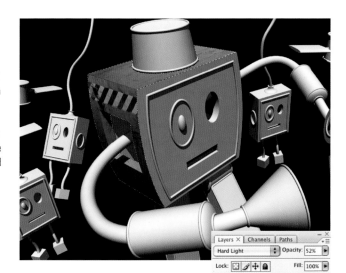

7 | Select the transform tool. Hold down the alt(PC)/option(Mac) key while dragging your corner and mid-point bounding box handles inwards. This allows you to reduce the size while scaling down towards a central point. Press OK to apply and exit the vanishing point filter. Change the layer blending mode to hard light and reduce the opacity to 52%. At this early point you can already see the advantages of using vanishing point to place texture on your objects in perfect perspective. Building up texture layers in this manner allows you to combine them with the luminosity of your original rendering.

8 | Open the rusty2.tif file. Select all and copy. Return to the working file and type Control(PC)/Command(Mac)-d to deactivate the currently active selection. Use the pen tool to carefully draw a path that surrounds the central area of the main torso. Carefully trace the interior of the large frame on the figure's chest, with the add to path area function enabled. When you've completed the closed path component, hold down the Control(PC)/Command(Mac) key to temporarily access the direct selection tool. Use it to tweak any points or line segments as necessary.

Path area functions

You need to proceed logically, and use the correct path area functions to ensure that your path based selections load properly.

1 | Click anywhere on the canvas so that the path component is no longer selected. In the tool options bar, select the subtract from path area function. Now use the pen tool to carefully trace the outside of the circular piping.

2 | Again, hold down the Control(PC)/Command(Mac) key and click anywhere on the canvas area so that your current path component is no longer selected. Choose the add to path area option and then carefully trace the interior of this shape.

3 | Control(PC)/Command(Mac)-click on the canvas to deselect the newest component and then switch the path area operation back to subtract. With the subtract option enabled, trace the inner circle with the pen tool. And finally, ensure that no single path component is selected.

9 | Control(PC)/Command(Mac)-click on the new path's thumbnail in the paths palette to load it as a selection. Target the top layer in the layers palette and then type Control(PC)/Command(Mac)-shift-'v' to paste the copied image into your working file as a new layer that is masked based on the currently active selection. Target the new layer, not the mask, and then choose Edit>Free-Transform from the menu. Hold down the Control(PC)/Command(Mac) key and then move the corner points to freely distort the layer contents within the mask. Adjust the bounding box until the pasted art mimics the proper perspective and press the enter key.

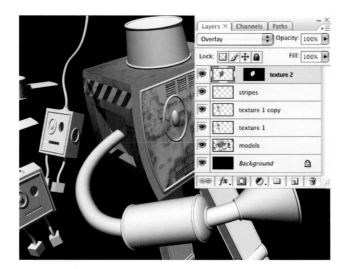

A blue plane

When you create your perspective planes in vanishing point, it is important that the grids appear blue, and not red or yellow. If the grid is any color but blue, it means that the corner points were placed in a manner that will not work, making the perspective plane invalid. You can repair an invalid plane by moving the corner points until the grid appears blue.

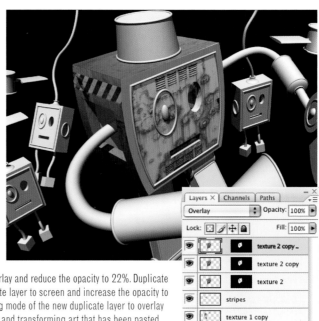

10 | Change the blending mode of the layer to overlay and reduce the opacity to 22%. Duplicate the layer, change the blending mode of the duplicate layer to screen and increase the opacity to 31%. Then duplicate this layer, change the blending mode of the new duplicate layer to overlay and increase the opacity to 100%. Vanishing point, and transforming art that has been pasted into a carefully created selection are effective methods to add texture to flat planes within Photoshop. Incorporating the technique of stacking layers with varying blending modes and opacity settings only helps to improve the effect.

11 I Use the pen tool to trace the inner face area on the front of a smaller figure. Use the methods explained earlier to create a path that consists of several path components. Follow the same procedure to apply different path area functions to the components as you create them so that the eye details remain outside of your selection when you load it. Load the path as a selection and create a new layer. Open up the rusty1.tif file. Copy the rust image and return to your working file. Choose Edit> Paste Into from the menu.

Repeating the process
Applying texture to different image components means repeating the same process again and again.

1 I Target the newly pasted layer and choose Edit>Free Transform from the menu. Again, Control(PC)/Command(Mac)-drag the corners of the bounding box to distort the layer contents to match the object's plane within the new mask. Press enter to apply the transformation.

2 I Change the layer blending mode to screen and reduce the opacity to 27%. Duplicate the layer and change the blending mode to overlay. Increase the opacity to 100%. Now use the pen tool to draw path components on the face of another small figure.

3 I Again, use the appropriate path area functions. Load the path as a selection, paste the copied rust texture into it, and use free-transform to distort it. Stack up duplicate texture layers with varying blending modes and opacity settings to successfully recreate the effect again.

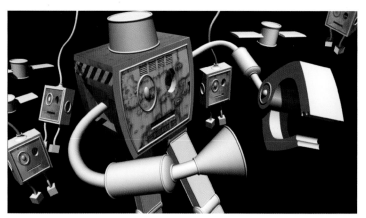

12 | Repeat this process over and over to apply texture to the face of each smaller object. For each you'll need to create a compound path, load it as a selection, paste your copied texture into it, distort the art, alter your layer opacity and blending mode, duplicate the layer, and alter it as well. Necessary blending modes and layer opacity settings may vary from object to object, so experiment in each instance to see what works best. To organize the layers palette, create groups, label them appropriately, and drag the appropriate files into them.

Using groups

Groups are an excellent tool for keeping the layers palette organized. To create an empty group, just click once on the Create a New Group button at the bottom of the layers palette. Or, you can also create a new group by choosing the appropriate option from either the Layer menu in the menu bar, or the Layers palette menu. To add a layer to your group, simply drag it onto the new group in the layers palette. Layers are added to a group from top to bottom, meaning that the first layer you add resides at the top of the stack within the group. Then, the next layer you add is placed beneath that one and so on. Layers can be moved up and down within a group, added to a group, or removed from it, at any point.

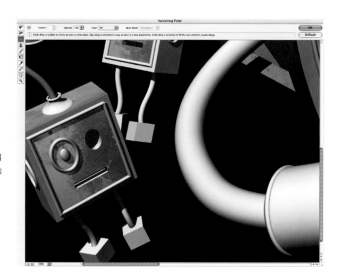

13 | Open up the yellow1.psd file and copy the contents. Return to your working file and then use the pen tool to create a new path, carefully tracing the top area of a smaller object. Load the path as a selection and create a new layer. Drag the layer to the top of the layers palette. With the current selection active and the new layer targeted, launch the vanishing point filter. Delete any existing grids and create a perspective plane across the top of the object. Paste your copied art and drag it onto the new grid.

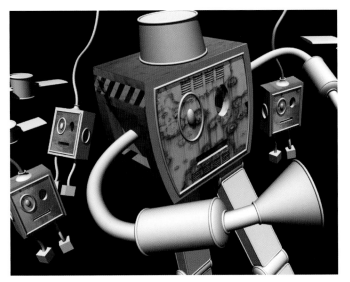

14 | Press OK to exit the vanishing point filter and then deactivate your current selection when you return to the Photoshop workspace. Repeat this process again to add the same copied texture to the top of the small figure at the right of the main figure. This is the only other small figure that has a visible top plane. It is fine to use the same layer for both of these pasted textures. Leave the layer blending mode set to normal in this instance. Deselect and then add this layer to the group that contains your other small figure textures.

Perspective Transform

1 | Open up the rusty2.tif file again and copy it. Return to your working file and use the pen tool to carefully draw a series of path components that surround the side of the claw. Load the path as a selection.

2 | Choose Edit>Paste Into from the menu to paste the copied art into the selection as a masked layer. Target the layer and choose Edit>Free Transform from the menu. Rotate by clicking and dragging outside the box and drag the handles to adjust the size of the pasted art.

3 | Hold down the Control(PC)/ Command(Mac) +alt(PC)/ option(Mac)+shift keys and then drag a corner point. You'll notice that the bounding box now behaves as a perspective plane. Drag the appropriate points in the necessary directions to try to match the perspective of the selected area.

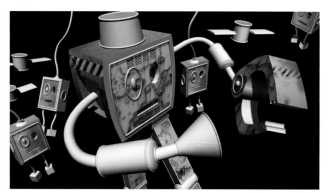

15 | Press enter to apply the transformation and change the blending mode of the layer to hard light. At this point, you've learned everything you need to know to apply texture to flat regions of your 3D renderings in Photoshop. Use the methods explained previously and the texture files included in this chapter's folder on the CD to add texture to other regions of the image on a series of new layers. Add texture to the tops of the cylindrical objects, the legs of the main figure, and the front surface of his claw. Organize your layers into both new and existing groups when you're finished.

How the rest was done

Although you're already familiar with the process at this point, here's some additional detail regarding how the flat texture mapping was completed.

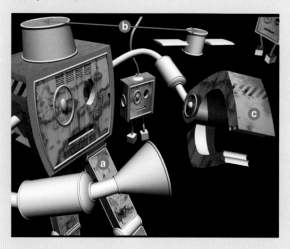

a | For the fronts of the main figure's legs, the concrete.psd file was pasted into path based selections as layers. Each layer was freely distorted by using free-transform and duplicated once. The first layer's blending mode was set to multiply with a reduced opacity setting and the duplicate layer's blending mode was set to overlay. The opacity of the duplicate layer was increased. This same method was used for the sides of the legs as well. However, instead of using the concrete.psd file, the yellow2.psd file was used.

b | Sections of the rust textures were pasted into path based selections on top of each cylinder. The layers were distorted by using the free-transform perspective option and all layer blending modes were left at normal.

c | Vanishing point was used for the surface of the claw. A path based selection was created and a new empty layer was used. A perspective plane was created in vanishing point and the rust texture was pasted onto it. Then in a separate operation, the stripes were pasted onto the same grid and transformed. The layer's blending mode was left set to normal.

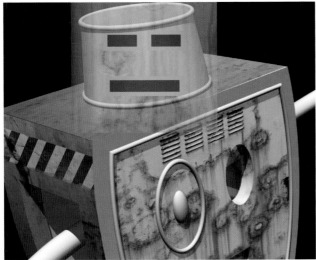

17 I Choose file>Open as Smart Object from the menu and navigate to the face.psd file in this chapter's folder on the CD. Once the file opens as a smart object, use the move tool to click on the canvas and drag the smart object into the working file. Reduce the smart object's opacity in the layers palette so that you can see the underlying layers as well and use the move tool to place it over the main figure's head on the canvas.

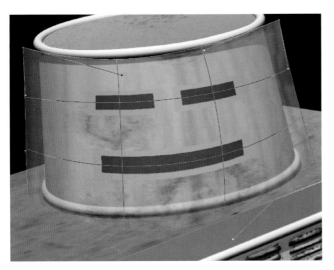

18 I Choose Edit>Transform>Warp from the menu to access the warp function. When the mesh appears, drag each corner point inwards so that the overall mesh shape begins to match up with the underlying face area. Then drag the corner point handles where required, to adjust the curvature of the outer edges of the shape. Click on bounding box segments, areas of mesh, or any areas within the mesh, and then drag to adjust specific areas. When you're happy with the results, press the enter key to apply the warp effect.

Switching transform functions

By now you have discovered that manipulating the handles of the free-transform bounding box while holding down different keys changes the operation. For instance, holding down the Control(PC)/Command(Mac)+alt(PC)/option(Mac)+shift keys allows you to perform a perspective transformation, and holding down the Control(PC)/Command(Mac) key allows you to freely distort. However, another method for switching transformation operations is to right-click(PC)/control-click(Mac) inside the bounding box. This will display a pop-up menu that allows you to choose a transformation operation from the list.

19 | Next, use the pen tool to draw a precise closed path around the face area. Ensure that the add to path area option is enabled in the tool options bar. Next, choose Layer> Vector Mask>Current path from the layers menu to clip the unwanted portions of the smart object instance with a vector mask. Change the blending mode of the object instance to multiply and reduce the opacity to 35%. Duplicate the object instance, change the blending mode to overlay and increase the opacity to 100%.

Vector mask editing

Although you'll take great care in drawing your paths before you use them to create vector masks, they are still editable afterwards. Simply target any layer with a vector mask applied to it in the layers palette and the vector mask will be visible on the canvas. Use the direct selection tool to click on line segments or anchor points and edit the vector mask directly. Any vector changes you make are reflected within the masking operation immediately.

20 | Repeat this method again and again to add a warped instance of the opened smart object over top of each cylindrical shape, so that each cylinder looks as if it has a face mapped onto it. Before you warp further instances of the smart object, you'll need to use free-transform to size them appropriately. Carefully draw a path around each instance of the smart object and use that to create a vector mask that clips unwanted areas extending beyond the cylinder's edge. Use the blending mode and layer duplicate combinations employed previously as a guide, yet feel free to tailor each face individually.

21 | Double-click any of the smart object instances in the layers palette. This will open a file containing your layered face artwork. In the layered face file, target the gray layer and then choose the bevel and emboss option from the list of layer styles available at the bottom of the layers palette.

Adjust the bevel and emboss settings so that there is an obvious bevel effect around the black areas of the eyes. Go ahead and use the settings shown here as your guide, but feel free to embellish further at will. When you're finished, close the file. Save the changes when prompted.

22 | When you return to your working file, you'll notice that all of your smart object instances are updated with the bevel and emboss effect. Open up the cone.psd file and use the move tool to drag it into the working file as a new layer, reduce the opacity to see the underlying layers and position the layer over the cone at the end of the figure's arm. Choose Edit>Transform> Warp from the menu. But before we warp the layer, let's rotate and resize it. To do this, click the Switch Between Free Transform And Warp Modes button in the tool options bar.

Warping and transforming

When you are using the warp transform function to map texture onto a curved or contoured shape, there will often be instances when you need to transform the texture in order to make it match up nicely. Always remember that there is a Switch Between Free Transform And Warp Modes button in the tool options bar. This button allows you to work intuitively, switching between warp and free transform, back and forth as required, until you've achieved the desired results. It also allows you to perform any free-transform operation alongside warp transformations within a single operation, resulting in less image deterioration.

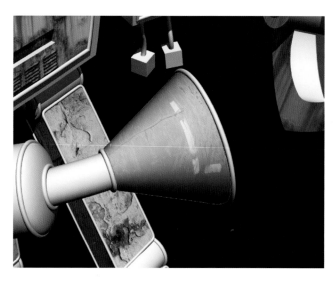

23 | This changes the warp mesh to a free-transform bounding box, allowing you to resize and rotate the layer. When you're finished, click the button again in the tool options bar to switch back to, and edit, the warp mesh. Press enter to apply the warp and free-transform operations. Carefully create a path around the desired area and convert it to a vector mask, clipping the layer. Change the blending mode to linear burn, reduce the opacity to 20% and duplicate the layer. Change the duplicate layer mode to color burn, increase the opacity to 30%.

Stacking logic

Duplicate layers are stacked up with different blending modes not only because it allows you to blend your textures into the underlying layers nicely, but also because it provides flexibility. By having texture built up on separate, duplicate layers, you have the flexibility of returning to any layer and editing the opacity or blending mode to adjust how it blends with the rendering underneath.

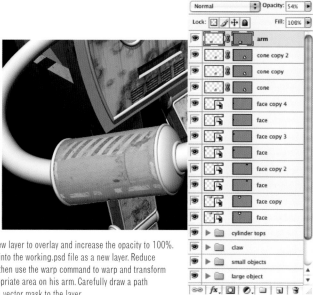

24 | Duplicate the current layer, change the mode of the new layer to overlay and increase the opacity to 100%. Use the move tool to drag the contents of the arm.psd file into the working.psd file as a new layer. Reduce the opacity, position it over the main figure's forearm, and then use the warp command to warp and transform the layer until it looks as if it belongs over top of the appropriate area on his arm. Carefully draw a path surrounding the area with the pen tool and use it to apply a vector mask to the layer.

25 | Change the layer opacity to 73% and the blending mode to multiply. Duplicate the layer, change the mode to overlay, and reduce the opacity to 54%. Use this method again to add the same warped texture to the cylinder on his other arm. Drag the image file in as a new layer. Warp, transform, and clip it with a vector mask. Then alter the layer blending mode and opacity of the layer, as well as alter a duplicate of that layer. Again, the layers palette is getting a little chaotic. Take a moment to organize your new layers and smart object instances into groups.

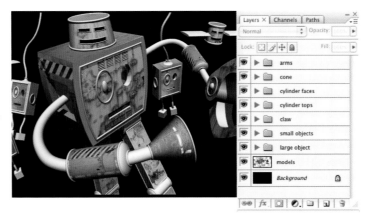

Adding real paint

When you want to build up a painterly feeling, there's nothing quite like scans of the real thing.

1 | Open up the bkd.jpg file and select the move tool. Hold down the shift key and drag the painted image into your working file as a new layer. Move the layer in the layers palette so that it resides directly above the background.

2 | Now open up the red.jpg file. Again, shift-drag with the move tool to add this image to your working file as a new layer. Drag the layer up in the layers palette until it resides directly above your rendered 3D models layer.

3 | Change the blending mode of the current layer to linear burn and then duplicate it. Reduce the opacity of the duplicate to 32% and duplicate it too. Change the blending mode of the current layer to overlay and increase the opacity to 100%.

26 | Now, create a new hue/saturation layer by choosing hue/saturation from the menu beneath the Create new fill or adjustment layer button at the bottom of the Layers palette. Adjust the hue to +180, reduce the saturation by 65, and increase the lightness by 13. This will change the overall feel from deep red to a less intense blue. Now it may appear as if we've altered an alarming

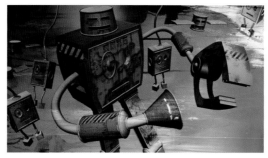

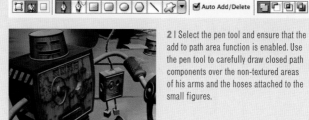

amount of the image by adding the red paint layers and then performing this hue/saturation adjustment. Do not be alarmed, as you'll see below, there is a method that will contain this effect within specified areas.

Containing the blue paint effect

A carefully crafted vector mask is all that you need to contain the group's effect to specified regions of underlying layers.

2 | Select the pen tool and ensure that the add to path area function is enabled. Use the pen tool to carefully draw closed path components over the non-textured areas of his arms and the hoses attached to the small figures.

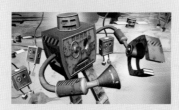

1 | Now that your hue/saturation layer is targeted, shift-click on the bottom red paint layer, this will target these two layers and the duplicate paint layers in-between. Choose Layer>New Group From Layers from the menu to add all of the targeted layers to a new group.

3 | Also, carefully draw closed path components around his knee joints. Control(PC)/Command(Mac)-click on the canvas to ensure no path is selected and then choose Layer>Vector Mask>Current Path from the menu. This will mask the effect of the group in areas not defined by path components.

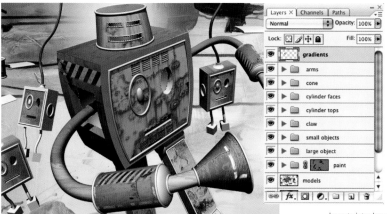

27 I Use the pen tool to carefully create a series of path components surrounding holes in the main robot. Ensure that the add to path area function is enabled. Next, ensure that no single path component is selected and then load the entire path as a selection. Create a new layer, drag it to the top of the layers palette, and select the gradient tool. Select the foreground to transparent gradient preset and choose the radial method in the tool options bar. Click and drag within your active selection on the new layer to introduce a variety of red, orange, and yellow gradients into the selected areas.

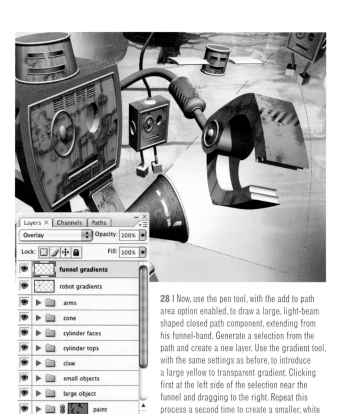

28 I Now, use the pen tool, with the add to path area option enabled, to draw a large, light-beam shaped closed path component, extending from his funnel-hand. Generate a selection from the path and create a new layer. Use the gradient tool, with the same settings as before, to introduce a large yellow to transparent gradient. Clicking first at the left side of the selection near the funnel and dragging to the right. Repeat this process a second time to create a smaller, white to transparent gradient on top of the yellow one. Change the blending mode to overlay.

Making multi-colored gradients

The technique I used here to create multi-colored radial, foreground to transparent gradients, is to first create a large gradient using one color. Then, switch to another color and create a smaller one directly on top of it. The colors blend together nicely using this method, especially when blending colors like red and yellow together. However, you can also add multiple colors directly into a gradient. Click on the gradient thumbnail in the tool options bar to open the Gradient editor. Click below the horizontal gradient preview anywhere to add another stop. Then click on the color swatch to launch the picker, allowing you to choose a different color for this stop. Creating a multi-colored gradient really is that easy.

29 | Deselect and duplicate the layer. Reduce the opacity of the new layer to 33%. Choose Filter>Blur>Gaussian Blur to add a slight blur to the layer. Duplicate the duplicate layer and change the blending mode to screen. Increase the opacity of the new layer to 100%. At this point, you can see that by filling path based selections on a series of layers, we've added a fiery heat inside of the main robot and a bright light emanating from his funnel-hand. Now, use the pen tool to draw a path component surrounding the inside of the main eye on his chest. Ensure that the add to path area function is enabled.

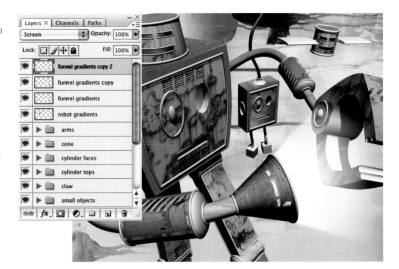

Changing path area operations

As you work your way through this chapter you'll notice that every time you're instructed to create a path component with the pen tool that you need to check or set your path area function first. This ensures that your path components behave the way you want them to when you load your selections. However, in the event that you create a path component with the incorrect path area option assigned to it, you should know that it can be remedied. Simply select the path component in question with the path selection tool. Once the component is selected, choose the correct path area function in the tool options bar.

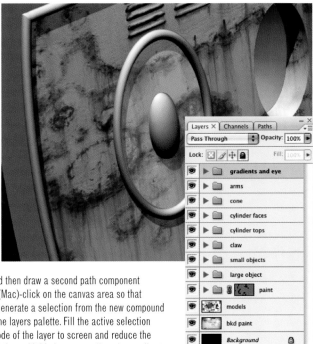

30 | Enable the subtract from path area function and then draw a second path component around the main pupil shape. Control(PC)/Command(Mac)-click on the canvas area so that neither of your path components is selected. Then, generate a selection from the new compound path in the paths palette and create a new layer in the layers palette. Fill the active selection on the new layer with white. Change the blending mode of the layer to screen and reduce the opacity to 24%. Deactivate the current selection and then add this layer, as well as the gradient layers, to a new group.

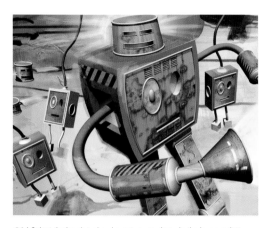

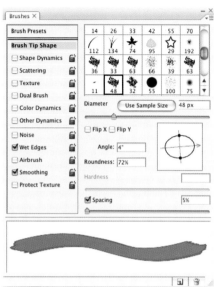

31 I Select the brush tool and create a new layer in the layers palette. Open the brushes palette and scroll through the list of available presets until you begin to see the chalk, oil, and pastel tip presets. Using any of these presets for painting within the image gives it a very natural feel. Select one of the brush presets and enable the wet edges option as well as smoothing. Set the brush opacity to 50% in the tool options bar. Sample colors from the background, and begin to paint brush strokes on the new layer. Alter roundness and angle settings to add some diversity to your brush strokes.

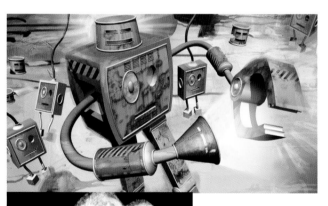

Sampling as you paint

When you are painting with the brush tool, the most efficient way to grab colors from within your image as you go, is to keep one finger near the alt(PC)/option(Mac) key. Pressing this key temporarily switches the brush tool to the eyedropper tool, which allows you to sample a foreground color by clicking on the canvas. Press the key, sample color, paint, press the key, sample a different color, paint, you get the idea. This is a very intuitive method for painting with a number of different colors in Photoshop.

32 I Build up brush strokes in areas where you want them more pronounced. Sample colors from the background often and choose new colors from the picker as necessary. Alter the opacity and size of the brush stroke as you go, for a more natural effect. Painting with the right brush tip definitely adds a tactile feel to your image, and a sense of the tactile is what is often absent from 3D art. However, as you've certainly figured out by now, the best way to add an organic feel is to use something natural. Open up the cloud.jpg file.

33 | Select the contents of the cloud. jpg file and copy it. Return to your working file and, in the channels palette, click on the create new channel button to create an empty alpha channel. Target this channel and paste the copied cloud art into it. Position it at the upper left of the canvas area within the channel and then click on the load channel as selection button to generate a selection from the contents of the channel. Create a new layer in the layers palette and choose a pink foreground color from the picker. Type alt(PC)/option(Mac)-delete to fill the selection on the new layer.

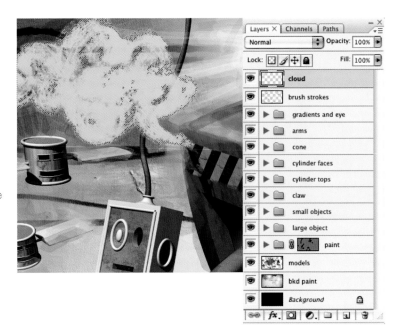

Wet edges

The wet edges option in the brushes palette is a simple, yet excellent way to add a different feel to your brush strokes when painting in Photoshop. The wet edges feature causes paint to build up around the edges of your strokes as you paint them, simulating a watercolor feel within the result.

34 | Deactivate the current selection and open up the sketch.jpg file. Again, select the contents of the file and copy. Return to your working file and create another new alpha channel in the channels palette. Target the alpha channel and paste your copied art into it. Now, because we want this to line up with the cloud art we just created, click in the column to the left of the RGB composite channel to enable its visibility. Your alpha channel is previewed against the composite channel as a red overlay. Position the pasted art, using the visible RGB image as your guide.

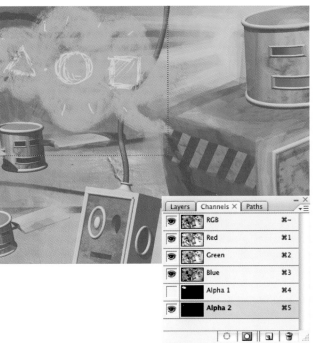

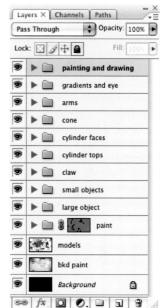

35 | Load the channel as a selection and then create one final new layer in the layers palette. Ensure that your new layer is targeted. Choose a dark green foreground color from the picker and type alt(PC)/option(Mac)-delete to fill the currently active selection on the new layer with your new dark green color. Deactivate the selection and then add the three top layers to a new group in the layers palette to tidy things up a little. Continue to edit and embellish from here as you see fit.

Examine your texture mapping methods

Let's take a final look at the essential tools and methods used to get all of the textures looking like they belong on this 3D model.

a | Building up texture on a series of layers is an excellent way to make it blend with the underlying 3D art. By using the right combination of layer blending modes and opacity settings you can combine the color and detail of the texture with the highlights and shadows of the 3D art.

b | Free-transform allows you to freely distort your pasted textures to any shape you like, allowing you to match the perspective plane of the object you're mapping the texture onto. Also, you can use the perspective transform method to make your manipulations adhere to the rules of 3D space, while you alter the bounding box.

c | Vanishing point is definitely the most precise way to map your textures on numerous planes. When using the vanishing point filter, you can ensure that textures mapped on adjacent planes adhere to proper perspective in relation to each other.

d | Warp transformations allow you to precisely follow almost any curve or contour. Also, don't forget that you can toggle between warp transformations and free-transform functions via the Switch Between Free Transform And Warp Modes button in the tool options bar.

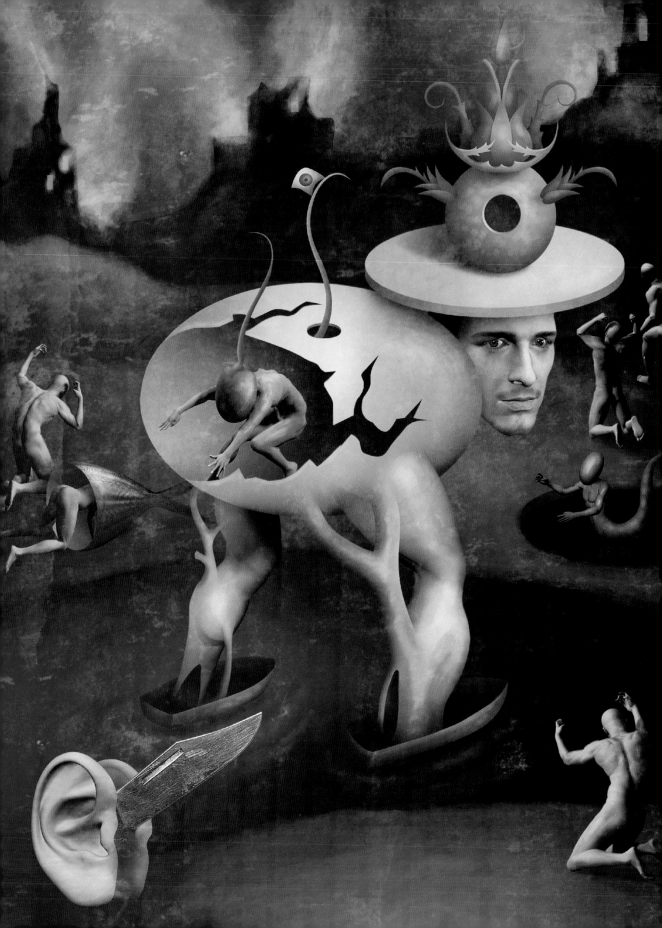

Chapter 17

Poser and Photoshop: Create an Old Master

I n this chapter you'll learn to create a digital old master inspired by the infamous paintings of Hieronymus Bosch. The image you see before you is the result of combining Photoshop with what E Frontier's Poser has to offer. The third panel of Bosch's triptych 'The garden of earthly delights' is our inspiration here. It depicts the hellish results of mankind succumbing to earthy temptations. It is a dark, strange, and ominous piece that shows numerous figures engaged in a rather surreal state of suffering. The fact there are numerous figures involved makes Poser an ideal application to incorporate into the Photoshop workflow this time around.

Poser is a 3D figure creation tool. As its name suggests, it allows you to pose, create, and render human figures. Actually, Poser will allow you do much more than that. You can animate figures, add clothing, and even create impressively realistic hair. However, for this particular style of artwork, we really only need to make use of its most rudimentary features. But I'm certain that you'll agree, it does an excellent job of allowing us to quickly create nude figures and body parts, which have provided the raw materials for the artwork you see before you.

There are many illustrators and digital artists out there who will argue against using Poser. Often they will site the fact that although there are a plethora of options for creating your figures, a signature appearance rears its head time and time again. And it looks like a Poser work of art, rather than being your own work of art. Granted, when you use predefined settings and prefab features within any software package, the results will clearly reveal what you've been doing.

So it is important to remember that Poser is not responsible for a certain look within your art, it is how you use Poser that is the determining factor. By avoiding the use of immediately recognizable Poser components like clothing, hair, and in many cases faces themselves, I have created a series of Poser renderings that are more generic in appearance. The result is that the Poser output is a raw material that is built upon within Photoshop, rather than being the center of attention.

In addition to rendered figures from Poser, other raw materials used here include a couple of simple photographs and a highly textured desktop scan. Basically, each ingredient used to create this illustration is not that impressive on its own. However, it is the method of illustrating and combining these elements within Photoshop that transforms the results from a thrown together collage into a stunning work of ancient looking art.

1 | Open up the working.psd file. This file has a number of paths included within it as well as a green canvas to help get you started. The first thing we need to do is to add some graduated color in the top portion of the background. This will eventually be the sky area. Select the gradient tool. In the tool options bar, select the foreground to transparent gradient preset from the gradient picker, and choose the radial gradient method. Click on the foreground color swatch in the toolbar to access the picker. Select a yellow-ochre color from the picker.

Project files

All of the files needed to follow along with this chapter and create the featured image are available on the accompanying CD. Files for this chapter can be found in the folder entitled: chapter_17.

2 | Click and drag to create small radial gradient at the top of the canvas on the background layer. Repeat this method to create numerous gradients in the top portion of the canvas area. Feel free to alter the opacity of the gradient and use slightly different foreground colors as you see fit. Also, use black as the foreground color to create some gradients around the edges of the canvas. Next, direct your attention to the contents of the paths palette. Hold down the Control(PC)/Command(Mac) key and click on the bldgs path to load it as a selection.

3 | Click on the create a new layer button at the bottom of the layers palette to create a new layer. Press the 'd' key to set the foreground color to black. Ensure that your new layer is targeted in the layers palette and then type alt(PC)/option(Mac)-delete to fill the current selection with black on the new layer. Now, while the current selection remains active, use the gradient tool to create a series of gradients in the lower part of the selected area on the new layer. Use a dark red foreground color and the same gradient tool settings you used previously.

Repeat the process

Use this same procedure repeatedly to create the initial background for our hellish scenario.

1 | Load the hills path in the paths palette as a selection. On a new layer, fill the selection with the current dark red foreground color. Create some faint yellow, and green to transparent gradients within the selection on the new layer.

2 | Now load the grass path as a selection. Fill the selection with a lighter green on a new layer. Use the gradient tool to add radial foreground to transparent gradients, in a variety of colors, into the selected area of your new layer.

3 | Load the water path as a selection. Repeat this entire process to create an area of green water and colored gradients on a new layer. And finally, load the shore path and again, repeat the process using earthy colors within the selection on another new layer.

4 | Use the rectangular marquee tool to draw a rectangular selection to indicate a window within one of the ruined building shapes in the background. Hold down the shift key and draw a series of additional rectangles, adding them to the selection. Use the eyedropper tool to click in the sky, sampling the green as the foreground color. Fill the active selection with the new color on yet another new layer. Select the gradient tool. Add some radial, yellow to transparent gradients into the windows shapes on this layer.

Layer from background

The only way to add a background layer to a group is to convert it to a normal layer. To do this, you can target the layer and choose the appropriate menu command if you like. However, an even quicker way is to double-click on the background layer. This is a shortcut to the new layer options, which allow you to rename and convert the layer. Also, in CS3 you can simply click on the lock icon to the right of your layer thumbnail and drag it into the trash at the bottom of the Layers palette. This will bypass the layer options and immediately convert your layer.

5 | Target the background layer and then choose Layer>New>Layer From Background from the menu. Name the layer and click OK. Hold down the shift key and click on your top layer. This will target all of the layers in the layers palette. Choose Layer>New>Group From Layers from the menu. This will add all of your background layers to a new group, keeping the Layers palette organized. Next, create a new layer and use the elliptical marquee tool to draw a large selection border. Select a pink foreground color from the picker and fill the active selection with it.

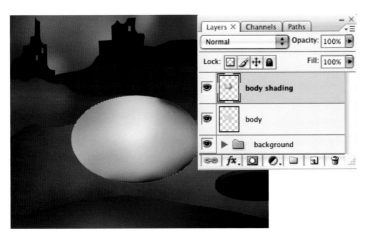

6 I Create a new layer and keep the current selection active. Select the brush tool. Choose a large, soft, round brush preset from the preset picker and specify a low opacity setting in the tool options bar. Use the brush tool to paint a variety of darker flesh colors, adding shading, on the new layer. You can choose colors from the picker, or alt(PC)/option(Mac)-click anywhere on the canvas to sample an existing color. Paint with a low opacity setting, and create darker regions by building up strokes in the same area.

Crack the egg

Create a crack-shaped selection and fill it with dark shades, to create the inside of the hollow egg shape.

1 I Select the pen tool and ensure that it is set to create paths in the tool options bar. With the add to path area option enabled, take your time and carefully draw a closed path that represents a cracked opening in the egg. Load the path as a selection.

2 I With the selection active, create a new layer and ensure that it remains targeted in the layers palette. Set the foreground color to black or a very dark brown. Fill the active selection with your foreground color and select the gradient tool.

3 I Select a light beige color and drag from the left edge of the selection toward the right to create a light, radial, foreground to transparent gradient within the selection. Draw another, smaller gradient using the same method and a lighter color.

7 | Type Control(PC)/ Command(Mac)-d on the keyboard to deactivate the current selection. Use the elliptical marquee tool to draw an elliptical selection to represent another, smaller hole. Sample the dark color from the inside of the egg with the eyedropper tool and fill the new selection with it. Create a new layer and drag it beneath this layer in the layers palette. Use the ellipse tool to carefully draw an elliptical selection border that is a little bit larger than the previous one you created to make the small hole. Click and drag within the selection border until it lines up with the hole like you see here.

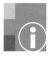

Transforming selections

There will be situations when you are trying to create a very precise selection with a selection marquee tool and no matter how many times you redraw the selection, it still isn't quite right. The large elliptical selection created here, to add dimension to the small hole, is an excellent example of this. In these instances you can resize or reshape your selection border by choosing Select>Transform Selection from the menu. The bounding box works just like a free-transform bounding box, except that rather than transforming your selected contents, it transforms the selection itself.

8 | Choose a light brown color from the picker and fill the active selection with it on the new layer. Now select the gradient tool and leave all of the tool settings as they were previously. Select a darker brown color from the picker and use the gradient tool to click and drag inward, from the left and right to create darker gradient-based shading within the selection. This adds a sense of thickness to the egg shell in this area. Deactivate the selection and select the pen tool.

9 | Use the elliptical marquee tool to draw a large ellipse at the upper right of the egg on the canvas. Create a new layer and drag it to the top of the stack within the layers palette. Fill your active selection on the new layer with a skin color sampled from the egg. Select the gradient tool and create a large, radial, foreground to transparent gradient within the right side of the selection using a lighter color. Duplicate the layer by dragging it onto the create a new layer button at the bottom of the layers palette. Target the original, underlying layer.

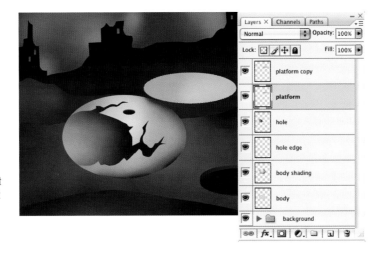

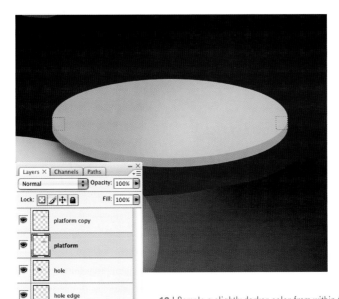

Accessing the move tool

When you have a selection tool currently chosen, like the elliptical or rectangular marquee tool used here, there is a quick way to access the move tool. Simply hold down the Control(PC)/Command(Mac) key and the tool will temporarily switch to the move tool. Releasing the Control(PC)/Command(Mac) key will revert your tool back to the original tool.

10 | Sample a slightly darker color from within the egg and fill the active selection on the currently targeted layer with it. You won't see the effects immediately, because the duplicate layer above it obscures this layer. Deactivate the selection and use the move tool to drag the currently selected layer downward while holding down the shift key. Drag it down until it begins to create an edge indicating the depth of the platform. Now, use the rectangular marquee tool to draw two selection borders that cover the areas at the left and right that aren't filled with color and fill them using the same color used previously.

11 | Control(PC)/Command(Mac)-click on the current layer thumbnail in the layers palette to load a selection from the layer's contents. Choose a darker brown foreground color. Use the gradient tool, with the same settings used previously, to create gradients within the selection. Create one at the left and one at the right to add some depth and shading to the edge of the platform on this layer. Create a new layer and drag it to the top of the stack in the layers palette. Deactivate the selection and choose the Lasso tool. In the tool options bar, set the feather amount to 5 pixels.

Containing the shadow

When you create this shadow on top of the platform it may stray beyond the edge of the platform and onto the background. To remedy this, Control(PC)/Command(Mac)-click on the layer thumbnail of the layer that contains the platform top in the layers palette. This will generate a selection from the contents of the layer. Choose Select>Inverse from the menu to invert the selection. Next, target your first shadow layer and press the delete key. Then target your duplicate shadow layer and press the delete key. This will delete any layer content from your shadow layers that strays beyond the confines of the platform.

12 | Because we'll be placing an object on this platform, we need a shadow to make it look convincing. Use the lasso tool to draw the shape of the shadow from the center of the platform on a diagonal angle upward to the left. Select the gradient tool and use it to create a radial gradient from the bottom right of the selection outward. Use the same tool setting and the same foreground color that you used previously. Change the blending mode of the layer to multiply and then duplicate it to intensify the effect. Deactivate the selection.

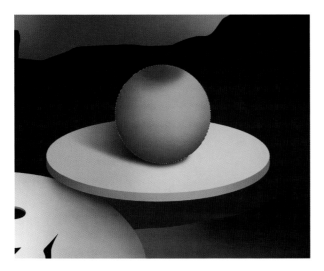

13 | Create a new layer. Ensure that it is targeted and residing at the top of the stack in the layers palette. Hold down the shift key and create a circular selection border on top of the platform with the elliptical marquee tool. Choose a pink foreground color from the picker and fill the active selection with it on the new layer. Select the brush tool and choose a large, soft, round brush preset. Set the opacity fairly low and select a darker pink color from the picker. Paint some shaded areas around the edge, adding a shadow at the top as well.

Creating organic details
Areas are first defined by path-based selections and then filled with color. Painting within the selection border adds shading and depth.

1 | Use the pen tool to draw a closed path component that resembles a thorny twig. Load it as a selection and fill it on a new layer, using a pink color sampled from the ball. Select the Brush tool.

2 | Use a soft, round brush preset to paint the shaded areas into the selection on the layer. Use a low opacity setting and a darker pink color. Use the pen tool to create a closed path component that represents a leaf. Load it as a selection and fill it with pink.

3 | Paint some shading into the selection and then draw another path component. Load it as a selection, fill it, and paint shading into the selection. Repeat this process until you have created numerous overlapping, shaded leaves on your layer.

14 | Use this method of drawing path components, loading selections, filling with color, and painting over the color, to create numerous organic details on the same layer. Focus on creating details for the left side at the moment. When you're finished, deactivate any currently active selections. Duplicate the layer and then choose Edit>Transform> Flip Horizontal from the menu to flip the duplicate layer sideways. Hold down the shift key and drag the layer contents to the right with the move tool.

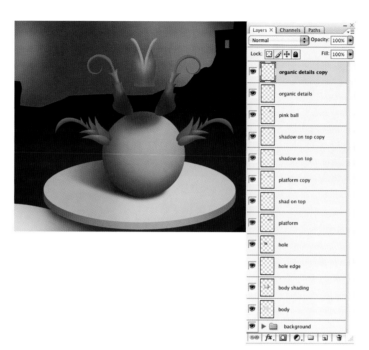

Moving contents within the layer

When you create numerous organic details on a single layer, individual details can be moved without affecting the others on the same layer. If you want to move something within a layer, target the layer and draw a selection around the contents of the layer using the lasso tool or a marquee tool. Be careful not to include any unwanted details within your selection border. Once you've selected your desired detail on the layer, simply hold down the Control(PC)/ Command(Mac) key to temporarily access the move tool. Click and drag within your selection to move the contents within the layer. Go ahead and use this method to edit the contents of your own layers as you see fit.

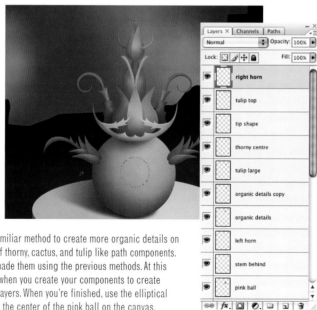

15 | Continue to employ what is now becoming a familiar method to create more organic details on a series of layers. Take your time and create a lot of thorny, cactus, and tulip like path components. Load them as selections, fill them with color, and shade them using the previous methods. At this point, pay special attention to layer stacking order when you create your components to create shapes that are clearly in front of, or behind other layers. When you're finished, use the elliptical marquee tool to draw a circular selection border in the center of the pink ball on the canvas.

16 | Create a new layer and fill the active selection with a dark pink color. Select the gradient tool. Again, leave it set to create radial, foreground to transparent gradients. Choose a light pink foreground color from the picker and then click and drag, starting at the left edge of the selection, outward, to create a gradient in the left side of the selection on the new layer. Draw another, slightly smaller circular selection and position it so that it reveals the left edge of the larger, gradient filled circle on this layer. Fill the new selection with a dark red color.

17 | Add a very subtle gradient inside of the current selection using a slightly lighter red and the linear gradient method this time. Deactivate the selection, target all of the layers that make up your new object and add them to a new group in the layers palette. Use this method of working with paths, selections, filling, and painting to create a flag pole and flag on a new layer. First create the flag pole, then the flag, then create the object on the flag. Carefully create the flag pole path so that the flag looks as if it is rising out of the hole in the egg.

Locking transparency

The reason why we've left our selections active while painting, is to prevent the paint from straying onto transparent portions of the layer. However, if you wish to return to a layer later on, and paint further after the selection has been deactivated, there is another method you can use, rather than reloading the original selection. Simply target your layer and then enable the Lock transparency button in the layers palette. The transparency lock will not allow you to edit any transparent portions of the layer, which allows you to paint with the method we've been using, without the assistance of a selection.

305

18 | As previously done with the egg shape, the platform, the pink organic object, and the flag, use the same methods to create a couple of boats on a new layer. Your path components will obviously differ, as will your fill colors, brush thickness, opacity, and shading colors, but the basic procedure will remain the same. Create path components. Load the path as a selection. Fill it with color on a new layer and paint to indicate depth and add shading. In this case, create the bottoms of the boats first, then the inner sides, then the outer sides and backs.

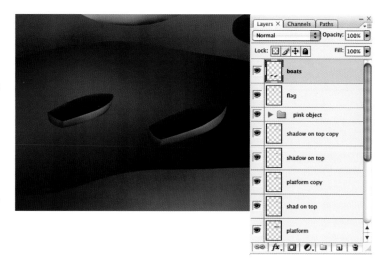

Incorporating photography

Now that you've spent a fair amount of time painting within selection borders, let's incorporate some photographic resources

1 | Open up the knife.psd file. Use the move tool to drag the knife into the working file as a new layer. Position the knife in the lower left of the canvas area where it will eventually be combined with the ears.

2 | Open up the fish.psd file and drag it into your working file as a new layer too. Position it to the lower left of the egg on the canvas. Drag the layer down in the layers palette until it rests directly above the background group.

3 | Create an elliptical selection. Choose Select>Transform Selection from the menu. Click and drag outside the box to rotate the selection and then press Enter. Fill the selection with gray on a new layer. Add black and white, radial, foreground to transparent gradients into the selection.

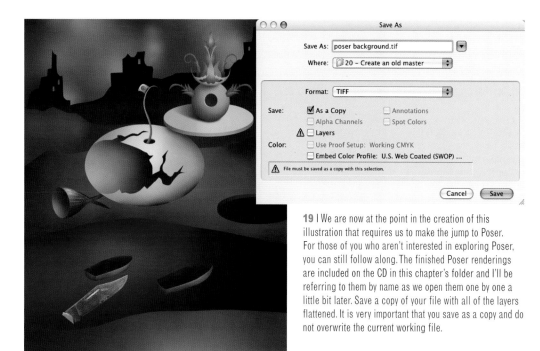

19 | We are now at the point in the creation of this illustration that requires us to make the jump to Poser. For those of you who aren't interested in exploring Poser, you can still follow along. The finished Poser renderings are included on the CD in this chapter's folder and I'll be referring to them by name as we open them one by one a little bit later. Save a copy of your file with all of the layers flattened. It is very important that you save as a copy and do not overwrite the current working file.

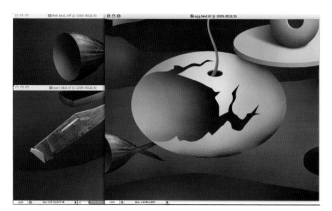

Poser demo and tutorials

For those of you who are curious to try working with Poser, you can download a demo version of the software from the e-frontier website. In addition to downloading a trial version of Poser, you can also peruse the tutorials section of their site to learn everything you need to know to follow along with the process I used here (http://www.e-frontier.com/).

20 | Ideally, you'll make a series of different, smaller background image files from your flattened background picture. You can select portions with the rectangular marquee tool, copy them, paste them into new image files, and then save them as individual flattened background files. Or you could avoid the copy and paste process by making a series of screen captures as you zoom into specific areas. How you generate the backgrounds is really up to you. I created a separate file to accompany each figure I was going to create in Poser.

2 | As you can see here, each specific background picture is helpful when working in Poser. The figure is posed and adjusted so that he looks as if he's crawled into the fish at the proper angle. The image is also used as a reference when adjusting Poser's lighting controls so that the direction of light does not conflict with the background scene. The majority of the figures used in the background are basic figure presets. However, in some instances, deviation from presets is required.

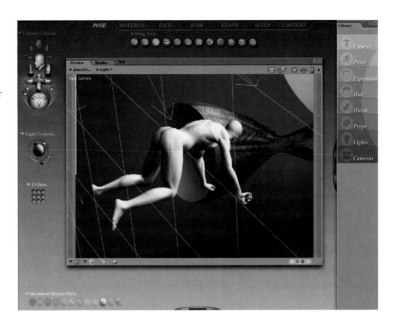

Customizing in poser

To create surreal figures and portions of people within Poser it is necessary to deviate from basic renderings of default figures.

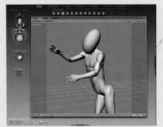

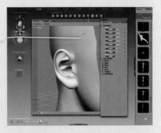

1 | Some figures, like the man trapped inside the main figure, have their heads replaced with props in Poser. The figures and props can be distorted before you render them. Here, the head was stretched vertically and was changed to a blue color.

2 | In the pond creature's case, his skin and head prop were colored gray, and the main figure's legs were distorted greatly before the figure was rendered. Also, once you've adjusted angle, pose, and lighting, you can hide your background image to avoid visual distraction as you work.

3 | For portions of figures, like the ears at the left of the illustration, you can simply use Poser's cameras to zoom in closely on the areas you wish to render. After you render something you can always remove unwanted areas in Photoshop.

22 | Each figure or figure component was carefully created in Poser. Then, each figure or component was rendered as an image file to be placed within the working file in Photoshop. If you have been following along and working in Poser, you can go ahead and quit Poser now. Return to your layered working file in Photoshop. Open up the inside.psd file. Use the move tool to drag the figure into your working file as a new layer. Move the layer above the layer that contains the cracked egg effect in the layers palette. Use free-transform to adjust the figure's size and positioning.

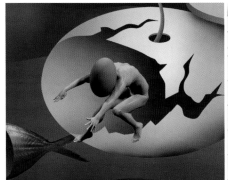

23 | Control(PC)/Command(Mac)-click on the layer thumbnail of the layer that contains the cracked egg art in the layers palette to generate a selection from the contents of that layer. Ensure that your new figure layer is targeted and then, with the current selection active, click on the Add Layer Mask button at the bottom of the layers palette to mask all areas of the layer outside of the selection. Create a new layer and use the methods you used earlier to create a shaded stem rising out of his head, complete with base leaves. Use the exact same approach you used to create the flag and the pink object.

Poser renderings

The Poser files that were rendered for this illustration are included within this chapter's folder on the CD. Poser will include an alpha channel in each rendering, which allows you to easily select the figure. For the files used in this illustration, I used each file's alpha channel to isolate the figure and place it on a layer so that all you need to do is drag each layer into the working file. For figure components like the main head and ears, I removed the unwanted portions of the rendering and again, placed the desired portions on layers to be easily dragged into the working file.

24 | Open the head.psd file and use the move tool to drag it into the working file as a new layer. Drag the layer down, beneath all of the egg body layers in the layers palette. Position the head under the platform to the right of the egg. Control(PC)/Command(Mac)-click on the new head layer thumbnail to generate a selection from its contents. Create a new layer and select the brush tool. Paint some shading within the selection on the new layer using black, a low opacity setting, and a soft, round brush preset. Change the layer blending mode to multiply and deselect.

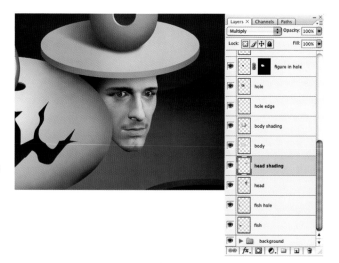

Inside the fish

Now use what are becoming familiar techniques, to place a figure inside of the hollow fish, complete with shading.

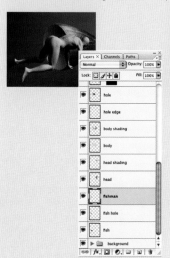

1 | Open up the fishman.psd file. Use the move tool to drag the figure into the working file as a new layer. Position him over the fish like he is crawling into it. Load the layer that contains the hollow fish artwork as a selection.

2 | Choose Select>Inverse from the menu to invert the selection. Then choose Layer>Layer Mask>Reveal All from the menu. Target the mask and use the brush tool to paint with 100% black, over the areas within the selection you wish to hide.

3 | Create a new layer with a multiply blending mode and invert the selection. Ensure that you have a large, soft, round brush selected and paint within the selection using black, to add shading on the new layer. Be sure to use a low brush opacity setting. Deselect.

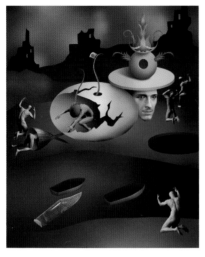

25 | Open the figure1.psd file. Again, drag the figure in as a new layer. This time, drag the layer below the fish layer in the layers palette and position the figure to the left of the fish, slightly behind it. Load a selection from the figure layer contents and create a new layer with a multiply blending mode. Paint black inside the selection, as you did previously, to add some shading near the fish in the selection. Deselect and then drag the rest of the numbered figure layers into the working file. Position them in their appropriate places, using the opening illustration as your guide.

Create a creature

Combine a Poser rendering with a now familiar illustration technique, to create an ominous sea creature, complete with tail.

1 | Open the creature.psd file and drag it into the file as a new layer. Position the creature over the left side of the pond on the canvas. Select the Pen tool and draw a closed path component to outline his tail.

2 | Load the path as a selection and use the brush tool to paint gray within the selection. Use a high opacity setting and a large, round, brush preset. Sample colors from the creature. Reduce the opacity and paint shading around the tail edges using a darker color.

3 | When you're finished painting, deactivate the current selection. Choose Image> Adjustments>Hue/Saturation from the menu. Reduce the lightness and the saturation so that there is less contrast within the creature, making it less prominent within the scene.

26 | Open the ear.psd file. Drag it into the working file as a new layer and position it to the lower left of the canvas so that it overlaps the left side of the knife. Drag the layer up in the layers palette above the knife layer. Then duplicate the layer and drag the duplicate layer down in the layers palette beneath the knife layer. Hold down the shift key and use the move tool to drag the duplicate ear layer to the right a little. Use free-transform to reduce the size of the duplicate ear slightly. Enable the transparency lock for this layer.

Creating new layers

You know by now that there are numerous areas within the Photoshop workspace that allow you to create a new layer. There is the Layer menu, the Layers palette menu, and the button at the bottom of the Layers palette. However, if you want to quickly create layers on the fly, familiarize yourself with the keyboard shortcut for creating a new layer. Type Control(PC)/ Command(Mac)-Shift-N on the keyboard to quickly create a new layer at any point.

27 | Select the brush tool. Choose a large, soft, round, brush preset and a high opacity setting. Paint over the ear on this layer using colors sampled from within the ear. The idea is to gently paint over the detail so that it looks like you're seeing the other side of the ear. Feel free to lower your brush opacity and continue to paint, gently blending the colors together. Target the knife layer and choose Image>Adjustments>Selective Color from the menu. Choose neutrals from the colors menu and reduce the cyan while increasing magenta and yellow to give the blade a tarnished appearance.

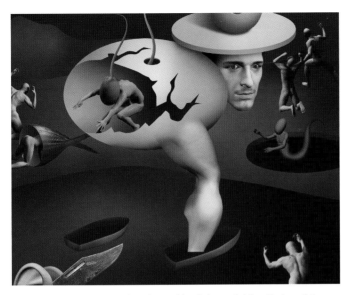

28 | In the layers palette, find your boats layer and drag it down so that it resides beneath the layers that make up the cracked egg body of the main figure. It is very important that you do this or future layers will overlap other layers incorrectly. Open the leg1.psd file and drag it into your working file as a new layer. Position it where the main creature's right leg should go, so that the bottom sits in the boat at the right. Add a layer mask and use the brush tool to paint over the top of the leg, softly blending it into the underlying layers.

Alter the leg shape
Use the same illustration methods you've been using all along to give his leg a tree-like quality.

1 | Use the pen tool to carefully create a closed path component that resembles wooden branches attached to his leg, with a doorway at the bottom. Load the path as a selection and fill it on a new layer, using skin color sampled from his leg.

2 | Use the Brush tool, as you've done previously, to paint shaded areas into the selection, blending it nicely into the leg on the layer below. Sample colors from the leg, use varying opacity settings, and vary the size of your soft, round, brush preset as necessary.

3 | Deselect and add a mask to the layer. Target the mask and use the brush tool to softly paint black over areas of hard edges that you want to blend into his leg on the underlying layer. Concentrate on the top of the branches and the calf area.

313

29 | Open the leg2.psd file and drag it into the working file as a new layer. Position it where his other leg should go on the canvas, with the bottom of the leg resting in the other boat. Drag this layer beneath all of the cracked egg body layers, but above the boats layer in the layers palette. Use the exact same method as described on the previous page to add a shaded, tree-like object to this leg too, on a new layer. Deselect and mask this layer too, editing the mask with a soft brush to blend the tree-like contents of the layer with his leg on the layer below.

Locking image pixels

Another layer lock that you might find useful when creating a multi-layered illustration like this is the one located directly to the right of the Lock Transparency button in the layers palette. This lock is called Lock Image and will lock all of the image pixels of the currently targeted layer. Enabling this lock prevents any alterations to the layer by any of the Photoshop paint tools. This is a good lock to enable when you've finished painting on a layer, to prevent accidental alterations later on.

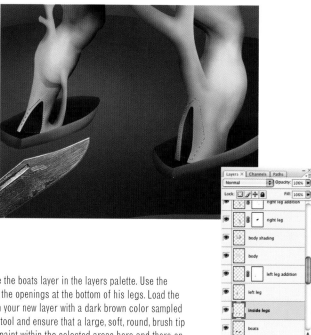

30 | Create a new layer and position it directly above the boats layer in the layers palette. Use the pen tool to draw two closed path components behind the openings at the bottom of his legs. Load the entire path as a selection. Fill the active selection on your new layer with a dark brown color sampled from the inside of one of the boats. Select the brush tool and ensure that a large, soft, round, brush tip preset is selected. Set the opacity very low and then paint within the selected areas here and there on the current layer, using lighter brown colors sampled from the boats.

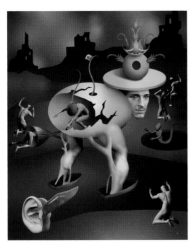

31 | When working like this, it is amazing at how quickly the layers palette begins to look chaotic. Take a few minutes now to logically group layers together within the layers palette. Put all of the main figure layers into a single group, place the ears and knife into a group, etc. Once you've organized the layers palette, create a new layer and place it directly above your original background layer group in the layers palette. This is the background group you created much earlier in this chapter. We'll be painting on the new layer next, so select the brush tool.

Create a painterly effect

Adding numerous small, tactile feeling and semi-transparent brush strokes, will give your illustration a much more authentic and organic look.

1 | In the brushes palette, choose the wet sponge brush tip preset and reduce the diameter. Disable the wet edges option so that the strokes are more solid feeling. Paint a series of small strokes on the layer using colors sampled from the background and low opacity settings.

2 | Create a second layer and paint over the existing brush strokes on the new layer, using even lower opacity settings, to blend the paint effect. Frequently press down the alt/option key to temporarily access the eyedropper tool and sample underlying colors as you go.

3 | Create a new layer at the top of the layers palette. Reduce the brush diameter. Paint brush strokes over different parts of the image, using colors sampled from underlying layers until there are subtle brush strokes all over the surface of the image.

32 I Open the book.psd file. This is a desktop scan of a very old book cover texture. Hold down the shift key and use the move tool to drag the image into your working file as a new layer. Ensure that it is at the top of the stack in the layers palette. Change the layer blending mode to soft light and reduce the opacity to 53%. With your new layer targeted, type Control(PC)/ Command(Mac)-a to select the entire layer and copy it by typing Control(PC)/Command(Mac)-c.

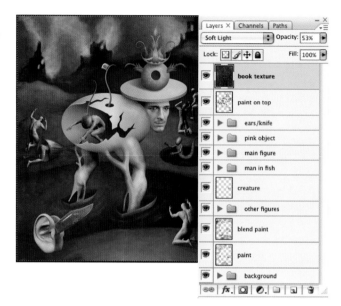

Locking position

If you want to prevent accidentally moving your layers around on the canvas, direct your attention to the Lock Position button in the layers palette. It is directly to the right of the Lock Image button at the top of the layers palette. Enabling this lock will still allow you to edit the content of your layer with paint tools. However, you will not be able to move the layer contents until the lock is disabled.

33 I In the channels palette, click on the create new channel button at the bottom of the palette to create an empty alpha channel. Target the new, empty channel in the channels palette and paste the copied book texture into the channel by typing Control(PC)/Command(Mac)-v on the keyboard. With your new channel still targeted in the channels palette, click the load channel as selection button at the bottom of the palette to generate a selection based upon the white areas within the channel.

34 | Return to the layers palette and create a new layer. Ensure that your new layer is at the top of the stack within the layers palette and that your channel-based selection is active. Choose a very light yellow foreground color from the picker. With your new layer targeted, type alt(PC)/option(Mac)-delete on the keyboard to fill the active selection with the new foreground color on the new layer. Deactivate the selection and change the blending mode of the layer to overlay.

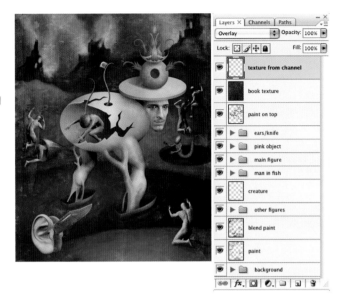

Examine your masterpiece

Lets take a look back at what tools, techniques, and resources were necessary to create this stunning and ancient looking old master.

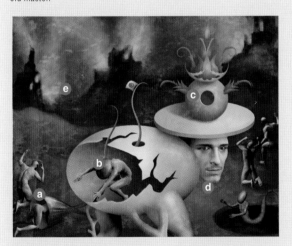

a | By creating backgrounds in Photoshop, and then importing them into Poser, we were able to render figures using appropriate lighting and angles. That way, when the finished Poser renderings were added to the Photoshop file, they didn't look out of place.

b | Although anything can be altered after the fact in Photoshop, we were able to get a head start in Poser by replacing body parts with props, like this figure's head. In the case of the sea creature to the right, body parts were distorted greatly and the surface color was changed to gray before rendering the figure.

c | By filling path-based selections with color on various layers, and then adding highlight and shadow via the brush or gradient tools, we can create anything imaginable within Photoshop. Illustrated works can range from the very simple, like the creature's tail, to the very complicated, like the organic pink object you see here.

d | You don't necessarily have to incorporate entire Poser figures into your composition. By using just a head and a pair of legs, we were able to combine these body parts with Photoshop illustrated elements, to create a strange creature as our main point of interest.

e | Gently building up paint on a series of layers helps to make the composition look more like a real world painting. Incorporating a desktop scan of old texture helps to give the finished piece the appearance of being centuries old, rather than being created in Photoshop CS3.

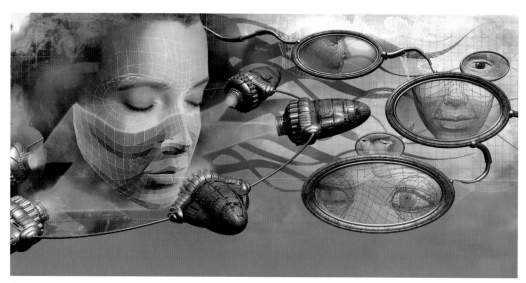

If you're interested in going further exploring the combination of Poser and Photoshop, try rendering your Poser files as single frames of animations. Rendering as an animation frame allows you to use the different display modes within Poser. This means that you can render wire frame or flat shaded images, as is shown in the above image. However, you can do a lot with a wire frame rendering, especially when combining it with photography. The simple inclusion of a single wire frame element can completely change the feel of your composition in Photoshop, as is shown below and on the opposite page.

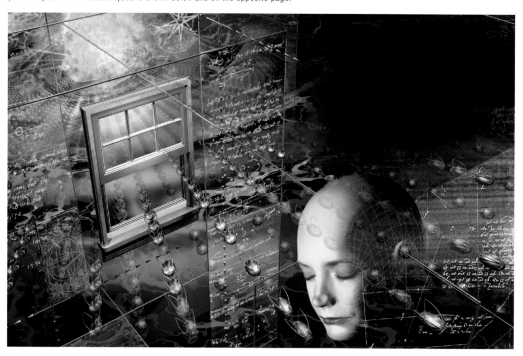

Something as simple as the inclusion of a photographed element can help to draw attention away from the signature appearance of Poser figures within a composition. Here, a photographed hard-hat was placed on each figure within the image. A distinct advantage of adding a hat is that you can cover what is obviously 3D rendered hair.

Another way to remedy the hair issue is to combine carefully photographed real people with your Poser renderings in your Photoshop files. The male figure in this image is an excellent example of real photographs combined with Poser body parts. Also, as is evident in both of these figures, using photographed clothing instead of rendered clothing really helps to add a sense of realism.

Chapter 18

Art Noveau: Pasting Vector Art from Illustrator

There are some excellent vector tools and features within Photoshop itself. But experienced digital artists, illustrators, and designers rarely limit themselves to a single application when it comes to creating artwork. It is no secret that when it comes to drawing with vectors that there is no better choice than Adobe Illustrator. Illustrator has been the industry standard vector art tool for as long as I can remember. I personally have been using it as an integral part of my digital toolset since 1991.

The features and functions within Illustrator are unparalleled indeed, but what do you do when you want all of the superb vector creation possibilities offered within Illustrator, yet you also want the superb paint tool features in Photoshop? The answer is simple: you combine the two applications. And believe it or not, when it comes to creating a stunning Art Noveau masterpiece like you see here, you just need to copy and paste. To put it simply, Photoshop and Illustrator play well together.

In this chapter, we'll explore the advantages of bringing existing vector art from Illustrator into Photoshop and using it as vector building blocks to create the piece you see here. More specifically, we'll be pasting it into Photoshop, creating shape layers and paths as the Illustrator data makes its way into Photoshop. Paths will be used to create selection borders, and shape layers will be duplicated and edited to suit a variety of purposes. Once the vectors are safely in place, we can employ Photoshop's marvelous paint and composition tools, resulting in a nostalgic piece of art that is a combination of both sharp vectors and soft painted elements.

1 | Open up the pattern.ai file in Illustrator. Select the entire contents of the file. This file contains all of the vector objects and compound paths that we'll use as the building blocks to create a background texture in Photoshop. After you have selected everything, choose Edit>Copy from the menu. Leave Illustrator open, but go ahead and close the file. Now launch Photoshop to run both applications simultaneously.

CD files

All of the Illustrator files required to follow along with this chapter are included in the chapter_18 folder on the CD. For those of you who wish to follow along without using Illustrator, there is a file in this folder called working.psd. All of the art pasted from Illustrator throughout this chapter exists within that file. Following along using that file is simply a matter of enabling the visibility of the included shape layers and generating selections from included paths as necessary.

Illustrator preferences

In order to have the full gamut of options available to you when you paste your Illustrator art into Photoshop, it is necessary to that your Illustrator preferences are set up properly before you copy. In the file handling and clipboard preferences, ensure that the PDF and AICB options are enabled. If these options are not enabled, your art will be automatically rasterized when you paste it into Photoshop.

2 | In Photoshop, create a new document that is approximately 18 inches wide and 12 inches high. Set the background contents to white. Select the gradient tool. In the tool options bar, choose the linear gradient method and the foreground to transparent gradient preset. Click on the foreground color swatch in the toolbar to open the picker. Select a purple color from the picker and create a gradient on the background layer by clicking on the left side of the canvas and dragging to the right.

3 | In the tool options bar, switch the gradient method to radial. Leave the gradient preset set to foreground to transparent. Now, select a yellow color from the picker and create a large radial gradient in the upper left of the canvas area. Next, choose a darker purple foreground color and create a new gradient in the lower left. Finally, choose a very light yellow foreground color and create a smaller gradient in the area between the other two.

Creating a pattern

Use a path from Illustrator as the basis for a selection border, to create a gentle, graduated pattern across the entire background.

1 | Choose Edit>Paste from the menu. When you are prompted, choose path from the list of Paste As options. This pastes your copied Illustrator art into your file as path. It becomes immediately visible on the canvas as well as in the Paths palette.

2 | With your new path targeted in the Paths palette, click on the load path as a selection button. Now, with the new selection active, click the create new layer button in the layers palette to create a new, empty layer.

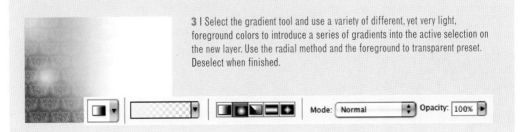

3 | Select the gradient tool and use a variety of different, yet very light, foreground colors to introduce a series of gradients into the active selection on the new layer. Use the radial method and the foreground to transparent preset. Deselect when finished.

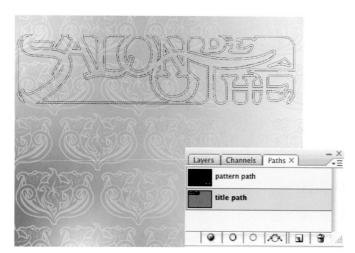

4 | Return to Illustrator and open the title.ai file. Again, select all of the contents of the file and copy. Go ahead and close the file, but again, leave Illustrator open. Return to Photoshop and paste the copied vectors in as a new path. When the path becomes visible on the canvas, type Control(PC)/Command(Mac)-t to access the free-transform path command. Shift-drag a corner handle inwards to reduce the size slightly while preserving proportion. Position the path at the upper left of the canvas and press the Enter key to apply the transformation. Load the path as a selection.

Show Bounding Box

When you are using the path selection tool, you'll notice that there is an option in the tool options bar called Show Bounding Box. When you enable this option, selected path components will automatically be surrounded by a bounding box. This bounding box allows you to perform the same transformation operations as the free-transform path command.

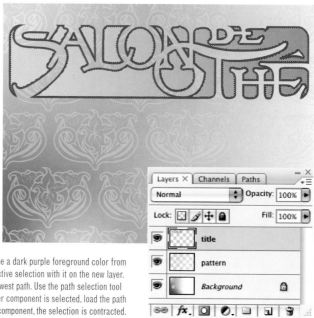

5 | Create a new layer and ensure that it is targeted. Choose a dark purple foreground color from the picker and type alt(PC)/option(Mac)-delete to fill the active selection with it on the new layer. You'll notice that there are two path components in your newest path. Use the path selection tool to select the inner path component and then, while the inner component is selected, load the path as a selection again. Because you selected only the inner component, the selection is contracted. Use the gradient tool, with the same settings as before, to fill the active selection with various light purple gradients.

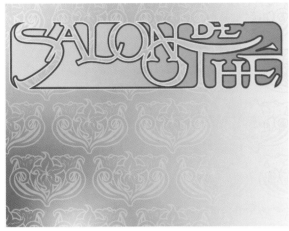

6 | Deactivate the selection by typing Control(PC)/ Command(Mac)-d on the keyboard. Choose Stroke from the list of options in the layer style menu at the bottom of the layers palette. In the stroke options, specify a generous thickness. The thickness will vary depending upon the resolution you're working at. Choose a fleshy color from the picker by clicking on the color swatch. Leave the blend mode set to normal and the opacity set to 100%. Click OK to exit the stroke options and then press the 'd' key on the keyboard to set the current foreground color to black.

Foreground color and shape layers

When you paste artwork from Illustrator into Photoshop as a shape layer, the color of the resulting shape layer is not determined by the fill color applied to the objects in Illustrator. The color of your new shape layer is determined by the current foreground color within Photoshop. That is why on this page, when we paste art from illustrator into Photoshop as a new shape layer, the foreground color is set up prior to pasting. However, you can always change the color of a shape layer after the fact by double-clicking the thumbnail in the layers palette.

7 | Return to Illustrator again, and this time open up the woman.ai file. As you've done previously with the other two illustrator files, select the entire contents of the Illustrator file and then copy. Close the file and then return to Photoshop. Choose Edit>Paste once again from the menu. This time, when you paste, choose the shape layer option instead of the path option. This will paste your copied Illustrator art into your Photoshop working file as a new shape layer. Use the move tool to position the shape layer to the left side of the canvas.

8 | In the layers palette, target your new shape layer. Hold down the alt(PC)/option(Mac) key and then drag downwards in the layers palette until you see a horizontal, thick, black line appear directly beneath the shape layer. Release the mouse button and you'll see that this is an excellent way to not only duplicate a layer, but it also allows you to place your duplicate where you want it within the layers palette. Disable the visibility of your original

layer and then double-click your duplicate layer thumbnail in the layers palette to open the picker. Choose yellow to change the duplicate layer's fill color to yellow.

Exporting paths

At this point, you can clearly see that there are a number of ways to incorporate Illustrator art into your Photoshop files. However, this relationship is a two way street and paths can also be exported from Photoshop to use within Illustrator. To export a path, choose File>Export>Paths to Illustrator. This allows you to create a new Illustrator file containing one of your Photoshop paths. In the Export Paths box, you can name your file and choose which path to export from the write menu. The new file containing your path can then be opened and edited within Illustrator.

9 | Choose the direct selection tool from the toolbar and use it to click on the outside path component of your shape layer while holding down the alt(PC)/option(Mac) key. This will select the entire outer path component, without selecting any of the other path components. Press the delete key and the selected path component will disappear. This alters the behavior of other path components, inverting the effect on the shape layer. The result is a filled hair shape, but it is not perfect. There will be some components inverting that you don't want to. Alt(PC)/option(Mac)-click on any unwanted inverted components, like the areas between strands of her hair, and press the delete key to remove them.

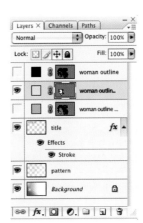

10 | Disable the visibility of your new yellow hair shape layer. Alt(PC)/option(Mac)-drag your hidden black outline shape layer again to create another duplicate shape layer that resides between the original black outline layer and the yellow hair layer in the layers palette. Use the method explained on the previous page to invert the contents of the shape layer by deleting the outer path. Then, systematically delete all shape layer components that are not areas of her skin. Again, use the method explained on the previous page. Double-click the shape layer thumbnail in the layers palette and change the color of the shape layer to a flesh tone.

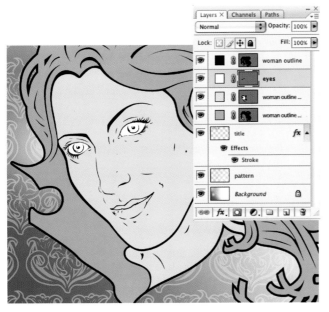

Saving paths as shapes

You can store any path or shape layer's vector mask as a custom shape, to be used again at any point later on. To save a path as a custom shape, first target the path in the Paths palette. Then, choose Edit>Define Custom Shape from the menu. Name your shape and click OK. This will add your shape to the custom shape pop-up palette in the tool options bar, which is only available when you're using the custom shape tool. Simply choose your new custom shape from the available options in the pop-up menu. Then, click and drag to create a new instance of your shape. Holding down the shift key as you drag will ensure that your shape is proportionately accurate.

11 | Enable the visibility of your black outline and yellow hair shape layers in the layers palette. Select the pen tool. Ensure that it is set to create a new shape layer in the tool options bar and set your foreground color to white. Use the pen tool to carefully draw a closed path that outlines her eye, creating a new shape layer. Then choose the add to shape area option in the tool options bar and create a closed path component around her other eye, adding it to the existing shape layer.

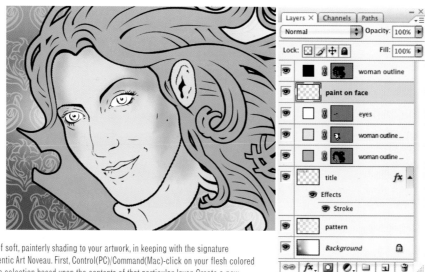

12 | Now add a bit of soft, painterly shading to your artwork, in keeping with the signature appearance of authentic Art Noveau. First, Control(PC)/Command(Mac)-click on your flesh colored shape layer to load a selection based upon the contents of that particular layer. Create a new layer that resides directly above your white eyes shape layer in the layers palette. Select the brush tool and choose a large, soft, round brush tip preset. Set the opacity of your brush around 20% in the tool options bar. Select a darker flesh color from the picker and begin to paint some shaded areas in the selection on the new layer.

Moving layer effects

When you apply a layer effect to a layer, it is not permanently attached to that layer. You can move it to another layer by simply clicking on the layer style and dragging it onto another layer in the layers palette. Or, you can copy your layer style to another layer by clicking on it and then alt(PC)/option(Mac)-dragging it onto another layer.

13 | Continue to paint shaded areas on her face. Choose lighter or darker flesh colors from the picker, and increase or decrease brush opacity as required, until you've painted a sufficient amount of soft shading onto her skin. Next, use the same techniques, with much smaller brush tips and different colors, to paint shading into the whites of her eyes, her iris areas, and her lips. When you're finished, deactivate the selection and select the pen tool. Ensure that the pen tool is set to create paths, not shape layers, in the tool options bar.

14 | Also, make sure that the add to path area option is enabled in the tool options bar. Now take a good look at her hair and try to visualize where darker areas would naturally occur within the yellow areas. Carefully draw numerous closed path components wherever you think her hair should have some darker shading. Keep your shapes simple and use the contours indicated by the black outline layer as your guide. When you've finished creating the path components, generate a selection from the entire path by Control(PC)/ Command(Mac)-clicking on it in the Paths palette. Create a new layer.

Add shadows and highlights

Create highlights and shadows within sharp-edged selection borders, adding depth and shine to the woman's swirling Art Noveau hair.

1 | Target your new layer and select the gradient tool. Choose a brown foreground color from the picker and then click and drag within the active selection to add numerous gradients. Create a variety of different radial, foreground to transparent gradients within the selection.

2 | Deactivate the selection and then select the pen tool. Now use the pen tool to create a series of path components to represent small highlight areas within her hair. Again, use the black outline art as your visual guide.

3 | Load the new path as a selection and create a new layer. Choose a very light yellow foreground color from the picker and fill the active selection with it on the new layer by typing alt(PC)/option(Mac)-delete on the keyboard. Deselect.

15 | Using the methods we used on the previous page, let's add some unnatural mauve details into her hair. First, use the pen tool to draw closed path components within her hair that will accommodate gradients of a different color. Load the entire finished path as a selection, create a new layer, and select the gradient tool. Choose a mauve foreground color from the picker and create a series of radial, foreground to transparent gradients within the selection. Deactivate the selection when complete.

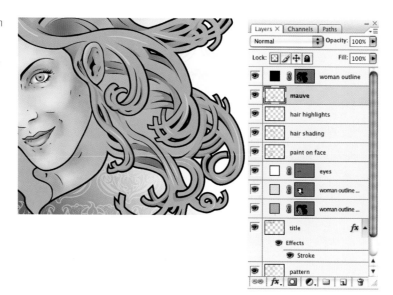

Other paste options

In addition to pasting your Illustrator art into Photoshop as paths and shape layers, there are a couple of other options. You can paste copied artwork from Illustrator into Photoshop as pixels or smart objects. Pasting as pixels will add your artwork to the canvas with a bounding box surrounding it. Similar to free-transform, you can adjust size, angle, or position, and then press the Enter key to apply the transformation. Once the transformation is applied the artwork is rasterized. Smart objects are pasted in with the same bounding box surrounding them. You can edit the source content of your smart object by double-clicking it in the layers palette. We'll explore Illustrator smart objects in detail in the following chapter.

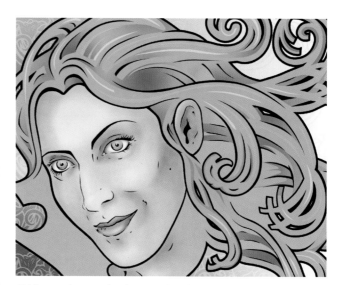

16 | Now use the pen tool to draw a number of closed path components in areas where you want to create some mauve highlights in her hair. Use the same logic and techniques as you used to create the yellow highlight path components. Also, create a closed path component that surrounds the area in her hair to the left of her face. Generate a selection from the entire path and fill the contents of the selection with the current mauve foreground color on the same layer as your mauve gradients. Deactivate the selection.

17 | In the layers palette, target the top shape layer that contains your black outline art. Then, hold down the shift key and click on the yellow hair shape layer. This will target both layers that you clicked on, as well as all of the layers in-between. Type Control(PC)/Command(Mac)-g on the keyboard to add all of these layers that make up the woman to a new group. Now, return to Illustrator once again and open the teacup.ai file. Copy the artwork and return to Photoshop. Set the foreground color to black and paste the copied art into your working file as a shape layer.

Dragging from Illustrator

If you want to add Illustrator art to your Photoshop file as a smart object, there is a quicker method than copying and pasting. Use the standard screen mode option in Illustrator and position your window so that you can see your open Photoshop destination file in the background. Then, simply drag your Illustrator art with the selection tool into your Photoshop file in the background. The dragged artwork will be added to your Photoshop file as a smart object.

18 | Use the move tool to move the teacup outline to the lower left of the canvas and then create a duplicate of the shape layer underneath the original. Disable the visibility of your original layer and target the duplicate in the layers palette. As you did with her hair and face previously, use the direct selection tool to click on a point or line segment of the outer path component in this shape layer. Press the delete key twice to remove the outer path component and invert the shape layer areas. Use this same method to remove unwanted, inverted path components from the layer.

19 | Change the fill color of your duplicated shape layer to a light purple and select the pen tool. In the tool options bar, ensure that the pen tool is set to create shape layers and that the subtract from shape area option is enabled in the tool options bar. Use the pen tool to carefully draw a path component that covers only the steam that is rising from the teacup. Adding this path component to your shape layer hides, but does not permanently remove, the steam area of your shape layer.

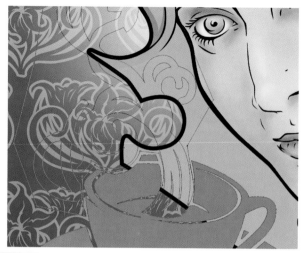

Combining

You can use components together to produce a variety of shape area effects in a single shape layer. However, you can create a final, single shape from your shape layer components by selecting them with the path selection tool and then clicking on the Combine button in the tool options bar. Once you combine the different components, you will lose the ability to move or edit the components individually, because the result of combining is one single shape.

20 | Duplicate the purple teacup shape layer. Target your new duplicate layer and change the fill color to a light green. Choose the path selection tool and use it to select the path component on your duplicate shape layer that hides the steam shape. With the path component selected, click on the intersect shape areas button in the tool options bar. Doing this will only reveal areas on the shape layer where shape components overlap.

21 | Create a new layer in the layers palette and then Control(PC)/Command(Mac)-click on the purple teacup shape layer to generate a selection from the visible contents of the layer. Target your new layer and enable the visibility of the black outline shape layer directly above it in the layers palette. Now, select the brush tool. Use a similar large, soft, round, brush preset and opacity setting to those used previously to paint the shading on the woman's skin. Use darker purple foreground colors to paint shading onto the teacup within the selection border. Adjust opacity and brush size as necessary. Deselect.

Add shadows and highlights

Introduce a series of gradients into path-based selections to add shadows within the steam, and highlights onto the cup and saucer.

1 | Select the pen tool. Ensure that it is set to create paths and that the add to path area function is enabled in the tool options bar. Draw a series of path components to define areas within the steam where shading should occur.

2 | Load the entire path as a selection and create a new layer. Use the gradient tool to create a series of darker green, radial, foreground to transparent gradients within the active selection on the new layer to indicate shaded areas.

3 | Now use the pen tool to create closed path components on the cup and saucer and the coffee's surface. Generate a selection from the entire path and fill the selections with white or mauve, radial, foreground to transparent gradients on the same layer. Deselect.

22 | Next, target all of the layers that make up the teacup and add them to a new group. Grouping layers methodically always helps to keep the layers palette organized. Go back to Illustrator and open up the flower.ai file. Copy all of the contents of the Illustrator file. Return to your working file in Photoshop and set the foreground color to black. Paste the copied flower art into Photoshop as a new shape layer. Position the flower so that it overlaps the woman's hair near her temple on the canvas.

Viewing effects

When you add an effect to your layer, it is shown beneath the layer . To hide the effect in the layers palette, simply click on the expand/collapse button to the right of the layer thumbnail. To view a hidden effect, click on the same button to expand the layer, revealing the effects. To hide an effect on the actual canvas, click on the visibility icon (the eye) to the left of the effect. Repeat the same method to make the effect visible again.

23 | Create a duplicate of this shape layer beneath the original in the layers palette. Disable the visibility of your original flower shape layer and ensure that your duplicate is targeted in the layers palette. As you've done previously with the woman and the teacup, use the direct selection tool to click on a point or line segment of the outer path. Press the delete key twice to invert the area of your shape. Double-click the layer in the layers palette and change the color of the shape layer to a light green, like the green steam rising from the teacup.

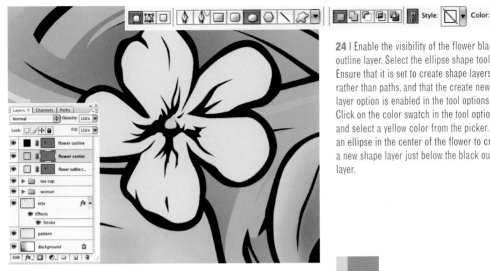

24 | Enable the visibility of the flower black outline layer. Select the ellipse shape tool. Ensure that it is set to create shape layers rather than paths, and that the create new shape layer option is enabled in the tool options bar. Click on the color swatch in the tool options bar and select a yellow color from the picker. Draw an ellipse in the center of the flower to create a new shape layer just below the black outline layer.

Pasting paths

When pasting paths into Photoshop from Illustrator, it is very important to keep an eye on what is currently targeted in the Photoshop Paths palette. To paste illustrator art into Photoshop as a new path, there must be no path targeted in the Paths palette at the time of pasting. If you have a path targeted when you paste, the newly pasted vectors will be added to the currently targeted path as additional path components.

25 | Load a selection from the green flower shape layer by Control(PC)/Command(Mac)-clicking on it in the layers palette. Create a new layer and select the brush tool. As you've done previously with the other image elements, choose a soft, round brush preset and a low opacity setting. Paint inside the selection on the new layer, using a darker green color than the flower petals to add shading. Vary brush size, color, and opacity as necessary to achieve a pleasing result. Deactivate the selection when you're finished and add all of the flower layers to a new group in the layers palette.

26 | Duplicate your group by dragging it onto the create a new layer button at the bottom of the layers palette. Choose Edit-Free Transform from the menu and shift-drag a bounding box corner point inwards slightly to reduce the size of the flower. Click and drag within the center of the bounding box to reposition the duplicated group on the canvas. If you want to rotate your group, just move the mouse outside of the bounding box and then click and drag. When you're finished, press the Enter key to apply the transformation.

Option-drag to duplicate a group or layer

Another method for duplicating a currently targeted layer or group is to simply hold down the alt(PC)/option(Mac) key while dragging with the move tool on the canvas. This will create a duplicate of your layer or group on the canvas wherever you release the mouse button.

27 | Once you've duplicated the flower and changed the size and position, the next step is to change the color. Inside the duplicate group, double-click the light green shape layer to open the picker. Choose a blue color and click OK to change the color of the shape layer. Next, target the layer within the duplicate group that contains the painted shading. Choose Image>Adjustments>Hue/Saturation from the menu. Adjust the saturation until the shading is a darker blue color.

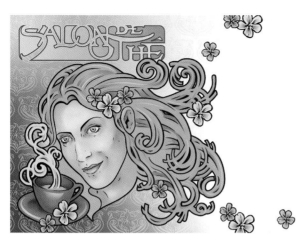

28 | Create numerous duplicates of the flower groups. Alter the color of the petals shape layer and the hue/saturation of the paint layer within various duplicate groups to add some variety in terms of flower color. Free-transform to resize and rotate them as necessary. Scatter the flowers around the canvas area. Move the groups up and down within the layers palette as necessary so that some flowers overlap others on the canvas area. At this point, feel free to edit existing layers and embellish the image further using the plethora of techniques employed so far within this chapter.

Final analysis

Let's take a moment to reflect upon the Illustrator and Photoshop methods that were essential to the success of this Art Noveau masterpiece.

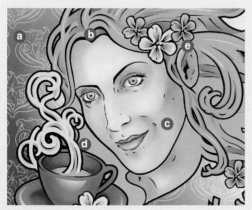

a | Pasting paths from Illustrator into a Photoshop document allows us to produce a sharp-edged selection border from the highly detailed Illustrator vector art. Then, Photoshop paint tools can be used within the selection to introduce a pattern containing various soft, graduated colors.

b | Pasting art as shape layers gives you the option of duplicating your layers and reversing the shape area effects by methodically deleting path components. This is an excellent way to create solid color fill layers to match up with your outline art.

c | Introducing painted strokes as shading into the Photoshop file allows us to soften the harsh, solid, vector appearance of working with shape layers. Underlying shape layer contents can provide the basis for selection borders, allowing you to constrain your painting to an area defined by a selection border.

d | By working with different shape area options and introducing new path components to your shape layers you are able to selectively reveal shape layer content differently from layer to layer, as we did here with the teacup and steam layers.

e | By duplicating the flower group, altering the fill color of the shape layer, editing the hue of the paint layer, adjusting size, and repositioning, we are able to scatter numerous variations of the same flower throughout the scene.

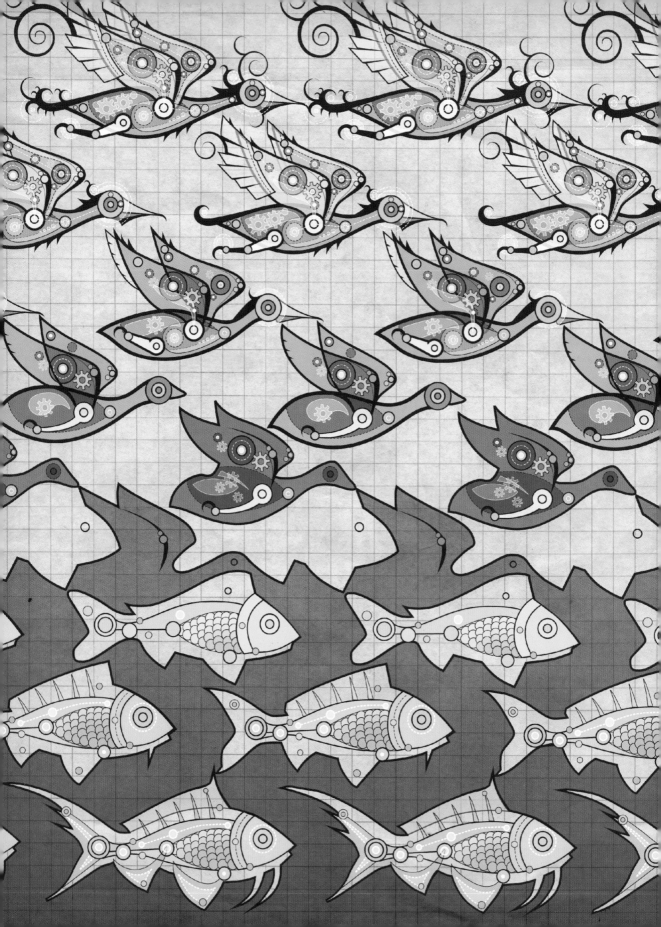

Chapter 19

Changing Patterns: Using Illustrator Files as Smart Objects

I n this chapter, we're going create our very own morphing pattern image, inspired by the incredible morphing pattern art of M.C. Escher. Often described as the poet of the impossible, Escher had a special gift when it came to creating artwork that was far from one-dimensional. His use of positive and negative space together, and his ability to have recognizable shapes gradually evolve out of both of those spaces is mind boggling.

In order to create the image you see before you, I carefully studied a number of evolving Escher masterpieces and came up with a methodical approach to creating something in this vein. The first step is to define a light side and a dark side of the canvas. In this case, light at the top and dark at the bottom. The next step, is to create some light shapes within the dark side and some dark shapes within the light side, shown here as fish and birds gradually blending together. This is initially done as a sketch, which is used as a template in Illustrator. In Illustrator, refined shapes are created, using the template as a guide. The result is an Illustrator file that clearly and precisely represents the regions of light and dark.

The Illustrator file is then incorporated into a Photoshop file as a smart object, and layer compositing techniques are used to add texture on a series of layers. Once the textured composition is built, then the wonderful versatility of working with smart objects is revealed. By the time you finish working your way through this chapter you'll see the limitless possibilities of what can be accomplished by bouncing back and forth between Illustrator and Photoshop, using smart objects as your gateway.

For those of you who have an understanding of Illustrator and access to the program, feel free to follow along in Illustrator as well as Photoshop throughout this chapter. For those of you who are not Illustrator savvy, all of the completed Illustrator files are included on the CD, and you'll be prompted when it is time to bring them into Photoshop.

1 | Open up the sketch.jpg file in Photoshop. You'll notice that every aspect of how the image will flow together has been clearly thought out and drawn on this single sketch. At this point, it is really a matter of bringing the sketch into Illustrator and tracing over it with vector drawing tools. However, when you look at the image as it is, the differentiation between dark and light objects is not immediately apparent. To remedy this, first select the magic wand tool. Use the magic wand tool, with the contiguous option enabled, to click in a space between two fish on the bottom row.

Project files

All of the files needed to follow along with this chapter and create the featured image are available on the accompanying CD. Files for this chapter can be found in the folder: chapter_19.

2 | Click on the foreground color swatch and select a light grey color from the picker. Choose Edit>Fill from the menu. In the fill options, use the foreground color and a multiply or darken blending mode. Next, choose Select>Deselect and then select the brush tool. Choose a hard, round brush preset from the brush preset picker and set the blending mode of the brush to darken in the tool options bar. Use the brush to quickly paint over all of the duck shapes. This is just to give you a clear indication of the division between light and dark in the image. Save and close the file.

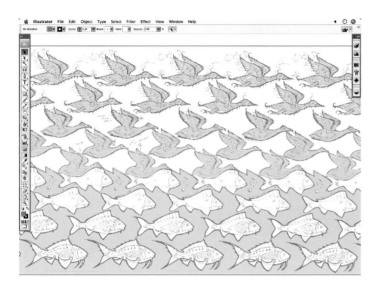

3 | For those of you who are interested in following along with Illustrator and have a basic understanding of how to use the Illustrator toolset, go ahead and launch it. For those of you who won't be using Illustrator, continue to follow along even though you won't be building any Illustrator files outside of Photoshop. You'll be prompted to place the completed Illustrator CD files into Photoshop as the need arises. Illustrator users, create a new art board that is 19 inches wide and 11.5 inches high. Place the sketch that you painted over previously into your Illustrator file.

Create the basic shapes

Use Illustrator's object creation tools and pathfinder functions to build the basics of your morphing composition.

1 | Convert the layer that your placed art is on to a template layer as you'll only be using it to trace over. Start by creating a solid red shape that defines a section of the bottom area that can be duplicated over and over.

2 | Duplicate the shape until it covers the bottom of the placed art and the duplicates nicely overlap each other. Then select all of the duplicate shapes and use the pathfinder palette options to combine them into a single object.

3 | Use Illustrator's path and shape creation tools to create a series of individual birds. Create a different bird for each row as a symbol. Don't worry about including a lot of bird details at this point. Duplicate the birds to complete the rows indicated by the sketch.

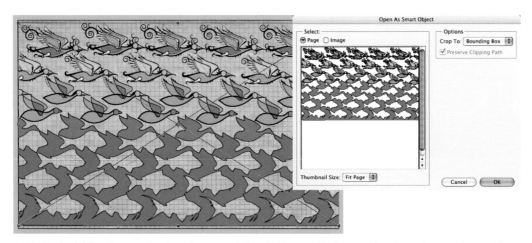

4 | Disable the visibility of your template layer, then save and close the Illustrator file. Return to Photoshop and open up the graph.jpg file. In Photoshop, choose File>Place from the menu. Navigate to the file you created in Illustrator, or, if you aren't using Illustrator to create your own files, navigate to the pattern1.ai file included on the CD. Choose Photoshop as the format and click the Place button. When the Place PDF box appears, leave the crop to menu set at bounding box and click OK. The placed art will be added to the canvas, surrounded by a bounding box.

Art board size

Although you can resize a smart object from Illustrator when it arrives in Photoshop, your art board in Illustrator defines the visible portions of the artwork. Basically, anything that resides within the confines of the art board in Illustrator is part of your smart object. Anything that lies beyond the edge of the art board is not included in the smart object.

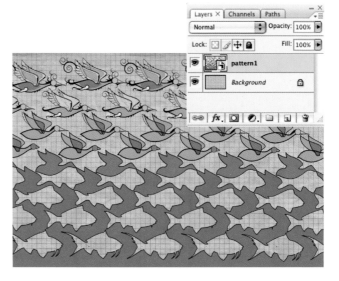

5 | Hold down the shift key and drag the corner of the bounding box outward to increase the size, so that your smart object fills the canvas, bleeding off the bottom and both sides. Click and drag to adjust positioning on the canvas and then press the Enter key to apply the transformation. After you apply the transformation, the placed art is then added to the layers palette as a smart object.

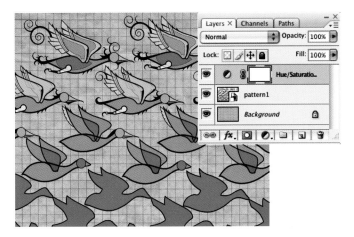

6 I You'll see your new smart object appear in the layers palette. Now, let's boost the overall saturation a little before we go any further. Create a new Hue/Saturation adjustment layer by selecting the Hue/Saturation from the list of options in the create new fill or adjustment layer menu at the bottom of the layers palette. Increase the saturation by about 16, leaving the hue and lightness settings alone, and click OK. Select the magic wand tool. Leave the tolerance set to 32 and ensure that the contiguous and sample all layer options are enabled in the tool options bar.

Add a linear gradient

Begin to embellish your flat, vector smart object, by introducing a gradient into part of it on a new layer.

1 I Click in the red area at the bottom of the canvas with the magic wand, to load a selection from it. Type Control(PC)-Command(Mac)-shift n on the keyboard to create a new layer. Ensure that the new layer is targeted and select the gradient tool.

2 I Choose the foreground to transparent gradient preset in the tool options bar and select the linear gradient method. Click on the foreground color swatch in the toolbar to access the picker. Choose a red color that is darker than the selected area from the picker.

3 I Hold down the shift key while clicking at the bottom of the canvas and dragging upward to the top of the selection. This fills the selection with a gradient from the bottom up. Change your layer blending mode to multiply.

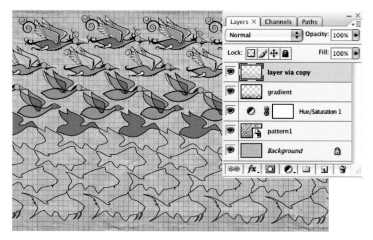

7 | With the current selection still active, target the background layer in the layers palette. Choose Layer> New>Layer Via Copy from the menu. This will create a new layer that contains a copy of the background layer's selected contents. Drag the new layer to the top of the stack in the Layers palette.

Layer Via Copy/Cut

Rather than always returning to the menu when you want to use the Layer Via Copy command, simply type Control(PC)/ Command(Mac)-j on the keyboard instead. Or, if you want to quickly access the Layer Via Cut option, type Control(PC)/ Command(Mac)-shift-j. Just bear in mind that using the cut method will remove your selected contents from the original layer as it creates a new layer, rather than simply copying it.

8 | With the new layer targeted, choose Image>Adjustments>Desaturate from the menu to desaturate the copied background on this layer. Next, choose Image>Adjustments>Curves from the menu and edit the CMYK curve until it begins to look like the curve you see here. Press OK and then set the blending mode of the current layer to multiply in the layers palette. Reduce the opacity of the layer to 85%.

9 | Duplicate your layer by dragging it onto the create a new layer button at the bottom of the layers palette. Change the blending mode of the duplicate layer to soft light and reduce the opacity to 60%. Now that we've built a file in Photoshop that incorporates an Illustrator smart object, as well as gradients and textures on a series of layers, it is time to embellish the artwork contained within the smart object. Double-click the smart object in the Photoshop layers palette and this will open an editable version of your smart object's artwork in Illustrator.

Using symbols

In Illustrator, symbols allow you to reuse one original piece of art over and over again as instances. The beauty of using symbols in creating artwork like this is that you can first build your composition using basic shapes within your symbols. Then you can place the file containing your symbols into your Photoshop composition. Once you have resolved the composition in Photoshop, you can open up the smart object in Illustrator to edit the contents. Because all of the birds are symbol instances, you only need to edit the original symbols themselves for all of the instances to be automatically updated. Working with symbols can be very efficient in terms of the time it can take to do things over and over, allowing you more time to be creative rather than wasting time executing the same procedure repeatedly.

10 | All of the birds included within the original pattern1.ai file are instances of symbols. Therefore adding detail to every instance is simply a matter of editing each original symbol that exists in the vector smart object when it opens within Illustrator. Whether you are using the pattern.ai file or a file of your own, edit each original symbol, adding details to all of the birds. Make the birds in the top row the most detailed. Then make each row less and less detailed as you work your way down to the large red shape along the bottom.

11 | Now, let's take a look at the negative space between the red areas along the bottom. There is no doubt that these are shaped like fish, so we'll need to create another series different creatures, much like we did with the birds originally, to fill the empty spaces along the bottom. In the layers palette, enable the visibility of the template layer once again so that you have something to trace.

Non-Illustrator users

For those of you who are not following along in Illustrator, obviously, you will not be able to edit the smart object within Illustrator. To follow along at this point, begin by targeting your smart object in the Layers palette. Next, choose Layer>Smart Object>Replace Contents from the menu. Navigate to the pattern2.ai file on the CD and click on the Place button. When the Place PDF box appears, leave the cropping options set to bounding box and click OK. This will replace your smart object with the updated Illustrator file. Do not worry if the position doesn't match up, you can use the arrow keys to adjust things. This is explained further on the next page.

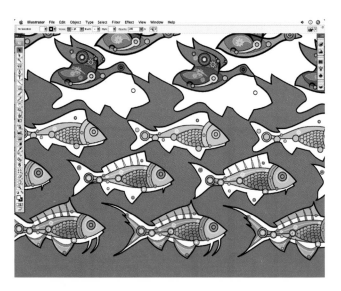

12 | Carefully create a different fish for each row. Then duplicate each row's fish over and over until each empty row is filled with fish. Make the fish in the bottom row the most detailed and complicated. Then, gradually make each row's fish less complicated as you work your way up to the top row. Disable the visibility of the template layer when you're satisfied with the fish you've created. Save your file and close it. Return to your working file in Photoshop.

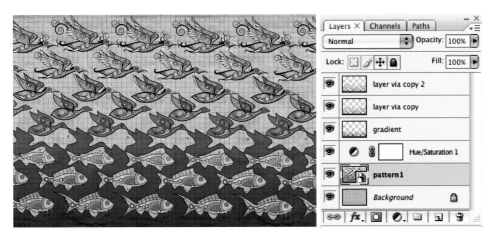

13 | When you return to your Photoshop file, a progress bar will appear, letting you know that your smart objects are being updated. When your smart object is updated, it will be moved on the canvas from its original position. This is due to the fact that when we updated the smart object, we added details like wing tips to the top row of birds, altering the height and width of the smart object's contents. Simply use the arrow keys on the keyboard to gently nudge your object back into position, so that it matches up with the texture and gradient layers.

Examine your evolving masterpiece

Lets take one last look at the numerous benefits of working with Illustrator files as smart objects within Photoshop.

a | Starting with a sketch is essential when creating a composition like this. Quickly adding shading to the sketch in Photoshop allows you to work methodically, and plan your areas of dark and light carefully before you start working in Illustrator.

b | Using the placed sketch as a template to work from in Illustrator allows you to build the basic structure of the composition using Illustrator's object creation tools, pathfinder functions, and symbol capabilities. The result is a highly versatile, carefully structured piece of vector art.

c | Once the vector structure is created, placing it as a smart object into Photoshop allows you to refine the composition, adding texture and background imagery on a series of layers. The result is an interesting hybrid of vector and pixel-based art.

d | Once you have resolved the overall composition in Photoshop, then you can edit your smart objects in Illustrator until your heart's content. When you save the changes, they'll update automatically within Photoshop. The final result is a non-linear, constantly editable composition that is the direct result of combining two of Adobe's leading digital art applications.

Index

About the CD:

All of the files provided on the Creative Photoshop CD are for personal training purposes only. These files are not royalty free stock art or clip art, and are subject to copyright. They are not to be used for published works, commercial projects, reproduced or distributed in any form. All images on this CD remain the sole property of Derek Lea and may not be distributed or reproduced in whole, or in part, without the author's written consent.

Limited warranty and disclaimer of liability

Elsevier, Inc. and anyone else who has been involved in the creation or production of the accompanying code ('the product') cannot and do not warrant the performance or results that may be obtained by using the product. The product is sold 'as is' without warranty of merchantability or fitness for any particular purpose. Elsevier warrants only that the magnetic disc(s) on which the code is recorded is free from defects in material and faulty workmanship under the normal use and service for a period of ninety (90) days from the date the product is delivered. The purchaser's sole and exclusive remedy in the event of a defect is expressly limited to either replacement of the disc(s) or refund of the purchase price, at Elsevier's sole discretion.

In no event, whether as a result of breach of contract, warranty, or tort (including negligence), will Elsevier or anyone who has been involved in the creation or production of the product be liable to purchaser for any damages, including any lost profits, lost savings, or other incidental or consequential damages arising out of the use or inability to use the product or any modifications thereof, or due to the contents of the code, even if Elsevier has been advised on the possibility of such damages, or for any claim by any other party.

Any request for replacement of a defective disc must be postage prepaid and must be accompanied by the original defective disc, your mailing address and telephone number,

and proof of date of purchase and purchase price. Send such requests, stating the nature of the problem, to: Academic Press Customer Service, 6277 Sea Harbor Drive, Orlando, FL 32887, 1-800-321-5068. Elsevier shall have no obligation to refund the purchase price or to replace a disc based on claims of defects in the nature or operation of the product.

Some states do not allow limitation on how long an implied warranty lasts, nor exclusions or limitations of incidental or consequential damage, so the above limitations and exclusions may not apply to you. This warranty gives you specific legal rights, and you may also have other rights which vary from jurisdiction to jurisdiction.

The re-export of United States original software is subject to the United States laws under The Export Administration Act of 1969 as amended. Any further sale of the product shall be in compliance with the United States Department of Commerce Administration Regulations. Compliance with such regulations is your responsibility and not the responsibility of Elsevier.